CW00820791

We thank Art Historians Charles G. Martignette and
Louis K. Meisel for their assistance in this project.

© 1997
Benedikt Taschen
Verlag GmbH
Hohenzollernring 53,
D–50672 Köln

Edited by
Burkhard Riemschneider,
Cologne

Text by
Harald Hellmann,
Cologne

English translation
by Christian Goodden,
Bungay

French translation
by Catherine Henry,
Nancy

Printed in Spain
ISBN 3–8228–7914–2

LOVE METER

HOW DO YOU RATE THIS BABE?

HOT STUFF

LIVE WIRE

ROMANTIC

THRILLER

TEASER

REFINED

AGGRAVATING

SWEETIE PIE

HALF BAKED

LOVABLE

NO DESIRE

THE BEST OF AMERICAN

GIRLIE MAGAZINES

TASCHEN

Posed by Jennie Lee, the
"boom girl" as she's called

Preface

When Tom Wolfe met Robert Harrison in the early 60s, the once notorious publisher was little more than an obscure nonentity. Plagued by a series of court actions, Harrison had been obliged in 1958 to sell his most successful magazine project, the scandal sheet "Confidential". Even if he was still living in the same hotel suite that he had occupied in his heyday, he now looked more like a king resigned to permanent exile. The expansive gestures were still there, and his mind was as sharp as ever, but the number of courtly attendants had dwindled to just two: his lifelong companion and his sister Helen, who had been his girl Friday for over twenty years.

People reduced in such a way tend to offset feelings of nostalgia and melancholy by boasting and exaggerating ever more wildly, so that any listener with an ounce of tact reacts with no more than an amazed "Well, I never!", biting back anything that might sound like a searching question. Harrison's bold new plans came to nothing, and he remained forever the one-time publisher of "Confidential", the mother of all scandal sheets, a magazine which in the mid-50s sometimes had a circulation of 4 million copies.

But at least "Confidential" merited a mention in a reference book: Kenneth Anger's "Hollywood Babylon", a distillation from the innumerable scandal magazines of the 50s. Anger aptly described Harrison as the epitome of the sinister figure. The depiction might lack subtlety, painting the gutter publisher blacker than he really was, but Anger could scarcely conceal his enthusiasm for this character with his sulphurous whiff of the diabolic.

Before he became the most hated man in the United States, Harrison had had another existence. In 1941 he provided an object lesson in free enterprise. A more affecting version of events would put it thus. In those days Harrison worked for Martin Quigley, the upright publisher of "Motion Picture Daily" and "Motion Picture Herald". After work the industrious Harrison stayed on in the editorial offices to single-handedly paste together his first girlie magazine, Beauty Parade. As luck would have it, the work was discovered by Quigley

on – of all days – Christmas Eve. The boss rewarded Harrison for his efforts with the boot. It is a story worthy of Frank Capra. We see the jobless Harrison wandering through New York's night-time streets, protected against the biting wind by only a thin coat, but warmed by a belief in his mission – and a pile of pin-up magazines pressed to his breast.

But Harrison equally well might have sat quite undramatically with his friend, the pin-up artist Earl Moran, at home in his small two-room apartment, pondering how they could cash in on the current craze for pin-ups. Their idea of a magazine which not only showed pin-ups, but also ran two- to four-page humorous photostories was something new and proved a gold mine. The term 'photostories' makes the idea sound more impressive than it actually was. In fact even the most banal theme sufficed to have scantily clad girls capering through comic slapstick situations. Who would have thought that the attempt to move a carpet could lead to so many provocative poses? Because other publishers did not want to follow him into this new territory, Harrison now cleaned up under the motto "Girls, Gags & Giggles". In rapid succession he brought out a series of titles, all following much the same formula, with names such as Titter (America's Merriest Magazine), Wink, Flirt and Eyeful (Glorifying the American Girl).

Eye-catching covers, painted for Harrison by Peter Driben, Earl Morgan or Billy De Vorrs, ensured that the customer could not fail to see the titles at the kiosk. They showed classic pin-ups mostly against a garish background. Driben, Moran and De Vorrs rank among the finest and most acclaimed illustrators of the pin-up era. But they come from a background more respectable than that of their employer Harrison. Except for the self-taught De Vorrs, they had all been through art college – Driben had even studied in Paris – and they were experienced in the fields of calendar art and advertising. In a word, their fresh, tasteful, "clean" pin-up illustrations satisfied all aesthetic standards. And, of course, the cultural critics, waving their Titter or Wink or whatever, have long since seized on these covers, hailing them as "Art!". However, it is only the title illustrations which have been exalted in this way. The magazines themselves many art aficionados would rather see firmly closed.

Why? When it came to the contents of his magazines, Harrison largely took his cue from the tradition of American burlesque – the poorer disreputable relation, so to speak, of vaudeville theatre. The language of the titles was earthier than their tasteful presentation led one to expect.

What in the Old World was originally intended to be a literary parody, a deliberately vulgar farce that made a laughing stock of great and sublime theatrical works, underwent a decisive change in the United States at the end of the 19th century. A key player in this transmission was an English woman named Lydia Thompson, the world's first peroxide blonde. In 1869, at the invitation of P.T. Barnum, she made a guest appearance in the USA with her troupe, the British Blondes. Going beyond the pale was the business of the burlesque, but the British Blondes actually wore pantyhose. In a world where the mere sight of a naked female ankle could drive men to distraction, this was a bold step. But it was a sign of the times, and around 1870 New York stages began putting on burlesque shows which were less parodies of other theatrical productions and more an occasion for showing the female figure in a favourable light. Any suggestions along these lines were gratefully incorporated. For instance, no sooner had the Syrian dancer Fahreda Mahzar, known as Little Egypt, presented her "Egyptian" dance in 1893 at the world exhibition in Chicago than every burlesque show had its own Little Egypt questionably gyrating her hips.

The burlesque shows adopted vaudeville's variety format, transforming themselves into colourful number revues with song and dance routines, sketches, jugglers, acrobats, animal training and above all sex. Their comedy was coarse and bawdy, the jokes smutty, the parodies grotesque. Finally, in the 20th century, when film and later TV began to compete with traditional forms of entertainment, striptease became the dominant element. Indeed, towards the end of the 19th century variety shows had already opened the door to the medium that was to bring about their decline – they started including short films in their programmes. When Harrison founded his girlie-magazine empire, the days of burlesque were numbered. The Second World War helped it stage a last comeback. A whole series of burlesque revue films were even made then: Evelyn West, who

had insured her bosom with Lloyd's of London, appeared in "A Night at the Follies", Ann Corio in "The Sultan's Daughter" and in "Call of the Jungle". "Striporama" saw an array of burlesque stars assemble once more, before they joined the queues for the soup kitchens. In the film "Striporama", produced in 1953 in New York by the Venus Productions Corporation, they all strut their stuff one last time in this rambling and absurd framework story: the great Lili St. Cyr; Rosita Royce who was aided in her stripping by specially trained doves; Georgia Sothern, who had become celebrated for her scandalous appearances in Minsky's Burlesque Theatre; Betty Page appears in sketches with comedians such as Jack Diamond, Mandy Kay and Charles Harris; and for the ladies there was he-man Mr America, who played the harmonica with a belle on his shoulders.

It is precisely this combination of sex and humour that Robert Harrison's magazines went in for, a kind of burlesque show for beneath the pillow. Now and again the titles even alluded to their own roots with pictures of the burlesque queens of the previous century. In many of the comic picture stories the models appear cheek by jowl with burlesque funnymen, who have either been taken from the ranks of venerable revue stars or are simply men decked out in the working garb of the burlesque comic – buffoons in baggy trousers and checker jackets with monster moustaches. Today this kind of humour, which was to have a remarkably long afterlife in the porn film, is found only in dirty postcards at obscure seaside resorts, at least in its printed form. Around his photo-features Harrison arranged legions of cheesecake models in underwear, bikinis or saucy stage costumes, or he revealed showgirls in their dressing rooms (but of course never actually naked – that was better left to the nudist magazines or "art" books). He also introduced – and this without doubt contributed in no small measure to his success – a strong fetishistic interest, an idea said to have come from a particularly well-read lady editor who knew the works of Krafft-Ebing. Now scarcely an issue went by without a model brandishing a whip, long hair is à la mode, girls wrestle with one another or sport boxing gloves, and a delicate Eve Rydell, whose dastardly master has bound her in chains, is being offered for sale

in an oriental bazaar. A notorious workaholic, Harrison frequently insisted on appearing on his own photosets, regularly turning up in the photofeatures if the story permitted. It is hard to imagine that this man, so unprepossessing in the photos but evidently agreeable to any piece of tomfoolery, was destined to become the publisher of the most infamous scandal magazine.

Harrison was able to select his models from the hoards of strippers, showgirls and cheesecake models who were drawn to New York. Most of them could be grateful if at least their pseudonyms or stage names were mentioned in a caption, and only a few ever achieved any degree of celebrity. Even fewer became stars, such as Betty Page, who started appearing in Harrison's magazines in 1951, rapidly becoming one of the most popular models. But the many anonymous models also paraded through the pages as capable, if sometimes rather silly girls. They were always self-possessed and independent and often the superior half where they shared a picture with a male counterpart. And they were prepared to be photographed in poses which, a couple of years later, no one would be seen dead in. Nowadays it is tempting to laugh at the naivety of these stories or even to find them grotesque. But shining through it all is something the model Jonnie Wilson describes in "Betty Page's Annual" when she talks about working with Harrison: she was having the time of her life.

The greasy male figures accompanying the girls in the photos seem to suggest a readership which wants to be reminded as little as possible that elsewhere in the universe there might be handsome, articulate and distinguished men, clothed in well-cut suits. Were one to ask Harrison's advertisers what kind of person typically read the magazines, they would paint a picture of a small, balding, pot-bellied, spotty-faced man who watched from the sidelines at parties. His inadequacy vis-à-vis the opposite sex he would try to remedy by reading books promising "100 successful chat-up lines" or "how to pick up more girls". He was always short of money, a potential victim for any seedy loan shark, but still had enough to buy a magazine to help him through his lonely hours. And certainly the publishers of specialist sex books such as Dr E. Podolsky's "Modern Sex Manual" (for married couples only, of course) thought it well worth devoting a whole-page

advertisement to Harrison's clientele. During the war years the magazines also touted "I Was Hitler's Doctor" by Dr Kurt Krüger, an ex-Nazi – so the reader is constantly reminded – who was (reputedly) Hitler's long-time psychiatrist. The advertisement shows a blubbering Führer pouring out appalling confessions to an incorruptible Dr Krüger, lurking pen-in-hand in the background.

But first and foremost, of course, Harrison's readers were interested in matters sexual. They dreamed of randy girls and hungry thighs. It was a dream that Irving Klaw, the king of the pin-up and one of Harrison's most loyal advertisers, also sought to cater for. In the advertisement sections of Harrison's magazines with their countless mail-order pin-ups, archaeologists of the dark side of popular culture will unearth a veritable Pompeii of sleaze.

Harrison's wildest title was undoubtedly Whisper. A child of the postwar years, this first hit the kiosks in April 1946. Its cover was regularly graced by one of Peter Driben's innumerable pin-up beauties, seen, appropriately enough, through a keyhole. During the 50s the cover illustrations of Whisper were replaced by the pin-up photo, before the whole magazine was visually brought into line with "Confidential", launched in 1952. Whisper, aimed at the adventurous hard-boiled reader, was wild, hard and dirty, serving up a diet of strong stories about bad girls, sex-starved Foreign Legionnaires, horrific murders, the bizarre rites of weird indigenous tribes, and hard-hitting photoreports on street crime. The world as a madhouse. Fittingly, Whisper also featured, among the usual goods on offer, a full-page advertisement for low-cost gravestones with genuine "down-to-earth savings"!

Whisper also dished up the very latest scandals of the type "Gas station rip-off!" or "Mysterious book losses in public libraries!", berating those responsible with the same journalistic indignation as if they had committed some horrendous massacre or unspeakably perverse act.

And Whisper grew ever dirtier, because Robert Harrison had realized that in the fifties the golden age of his girlie magazines was over. Other "more serious" modern titles had meanwhile established themselves on the market which allowed neither burlesque humour nor "smutty" advertisements

between their covers. No matter whether they catered for the adventurous action-hungry reader, as did Georg von Rosen's "Modern Man", or for the well-heeled cultivated city-dweller, like Hugh Hefner's "Playboy", they all sought to attract well-known writers as well as the best cartoonists and photographers. The likes of Harlan Ellison, Allen Ginsberg, Jack Kerouac and James T. Farrell now wrote for these new-style men's magazines, and no longer the inky-fingered small-time hacks who littered Harrison's texts and captions with corny jokes. If you bought one of these modern titles, you could be sure that the lion's share of the budget and most of the care had not been lavished solely on the cover.

Evidently Harrison had no desire to fight for a market share on this battleground. Early 1955 he sold off his by now quaint-looking girlie magazines and devoted his whole energy to becoming denounced and ostracized.

In 1952 Whisper had received support from "Confidential", which had been conceived as a scandal magazine from the outset. The senate investigations into organized crime are supposed to have pointed Harrison down this new, potentially lucrative avenue. More precisely, it was the fact that the hearings of the investigative committee had been broadcast on TV and had notched up unbelievable viewing figures, making committee chairman Senator Estes Kefauver of Tennessee a media star overnight. While his colleague McCarthy was pursuing putative "pied pipers of the Politburo", Kefauver was turning up the heat, with cameras running, on mobster bosses such as Frank Costello or Meyer Lansky and transforming more than America's political culture with his conspiracy theories. Some years later he was seen once more heading another senate committee, this time looking into the causes of juvenile crime, where one of his victims was none other than Irving Klaw. The most famous portrait of Kefauver shows him in a racoon-skin cap – perhaps he too was a casualty of the Davie Crocket mania of 1954, started by the TV programme "Disneyland".

It would be nice if one could say that the medium which had spoilt Harrison's burlesque fun had in the process given him the idea for the most successful magazine project of the decade. And perhaps Harrison only came to interpret events this way subsequently. For the tricks which Whisper and

"Confidential" employed, and even perfected, he had already learned at the start of his career, as an errand boy working for New York's "Daily Graphic". This scandal sheet of the 20s and 30s thought nothing of shamelessly inventing stories, embroidering on the truth, fabricating intimate confessions, and manipulating photographs. It was hardly likely that Harrison would come away from such an apprenticeship without something of these scams rubbing off on him.

They say that a fool is born every minute, but one would have to be extraordinarily gullible not to see that the comely damsel who in Whisper is just being overpowered by dastardly slave-traders, or the stripper in a negligee who has been abducted by brutal Soviets and is forced now to stand in a basin of icy water, only got into their hapless situations through scissors and paste. Just as with contemporary reveal-all magazines, no doubt much of the perusing pleasure derives from the fact that the reader recognizes the phony set-up, even expects it, and enjoys the impudence of the fraud. However, this mechanism does not work as soon as Jesus, Elvis or some prominent person is involved. And precisely this soon became the stock-in-trade of Whisper and "Confidential": to sling mud at any public figure. Unlike many rival magazines, which happily lifted stories from each other, Harrison maintained a network of snoopers, informants and scouts, and dashed with his characteristic energy to conspiratorial meetings, where he did in fact unearth real scandals. And if that produced no results, he blew up trivialities into sensations. In Harrison's case, however, the healthy survival instinct which ensures that such reports are watertight fell by the wayside, so carried away was he by the euphoria of having made "Confidential" the best-selling title in the United States. In 1957 he faced a flood of lawsuits and a year later sold his two scandal sheets. In the hands of various different publishers Whisper and "Confidential" continued to appear, albeit in a more modest guise, until the early 70s.

Harrison subsequently tried his hand at so-called "one-shots", special single-issue magazines devoted to the star or scandal of the moment, and a new scandal sheet which brought less success.

Einleitung

Als Tom Wolfe Anfang der 60er Jahre Robert Harrison begegnete, war der einstmals so berüchtigte Verleger eine schon fast vergessene Größe. Nachdem er mit einer Unzahl von Prozessen überzogen worden war, hatte Harrison 1958 sein erfolgreichstes Magazin, das Skandalblatt „Confidential", verkaufen müssen. Obwohl er noch in derselben Hotelsuite residierte, die er schon zu seiner Glanzzeit bewohnt hatte, wirkte er eher wie ein Monarch im Exil ohne jede Hoffnung auf Rückkehr. Die großen Gesten waren noch da, seine legendäre Agilität war ungebrochen, aber es antwortete nur noch ein bescheidener Hofstaat: seine Lebensgefährtin und seine Schwester Helen, die über zwanzig Jahre seine rechte Hand gewesen war.

Wer an so einem Tiefpunkt angelangt ist, neigt dazu, durch noch wüsteres Bramarbasieren, noch schamlosere Übertreibungen eine Mauer gegen Wehmut und Trauer zu errichten, so daß sich jeder halbwegs feinfühlige Zuhörer auf ein staunendes „Ah" und „Oh" beschränkt und sich jede kritische Nachfrage verkneift. Aus Harrisons neuen, kühnen Plänen wurde nichts Rechtes mehr und er blieb für immer der Ex-Herausgeber des „Confidential", der Mutter aller Skandalmagazine, einem Blatt, das es Mitte der 50er Jahre mit einigen Ausgaben auf 4 Millionen verkaufte Exemplare gebracht hatte. Wenigstens hat „Confidential" in ein Referenzwerk Eingang gefunden: in Kenneth Angers „Hollywood Babylon", diesem immer wieder aufgelegten Destillat aus den unzähligen Skandalmagazinen der 50er Jahre. Anger zeichnet Harrison naheliegenderweise als vorbildlich sinistren Charakter. Auch wenn er auf seiner Palette für Harrison neben Rabenschwarz und Giftgrün nur wenige Nuancen findet, kann er seine Begeisterung für diesen von dezentem Schwefelgeruch umwehten Charakter kaum verhehlen.

Vor dem Leben als meistgehaßter Mann der Vereinigten Staaten gab es noch ein anderes. 1941 schritt Harrison entschlossen ins freie Unternehmertum. Die anrührende Version lautet wie folgt: Harrison arbeitete damals für Martin Quigley, den biederen Verleger von „Motion Picture Daily" und „Motion Picture Herald". Nach Feierabend klebte der strebsame Harrison in den

Redaktionsräumen eigenhändig sein erstes Girlie-Magazin, Beauty Parade, zusammen, was sein Chef ausgerechnet am Heiligabend entdeckte und mit einem Rausschmiß honorierte. Eine Geschichte wie von Frank Capra erdacht. Im dünnen Mantel nur unzureichend gegen den schneidenden Wind geschützt, sehen wir Harrison arbeitslos durchs nächtliche New York streifen, gewärmt nur vom Glauben an seine Mission und einem Stapel vor die Brust gepreßter Pin-up-Magazine.

Vielleicht saß er aber auch ganz undramatisch mit seinem Freund, dem Pin-up-Künstler Earl Moran, zu Hause in seinem kleinen Zwei-Zimmer-Appartement und sann darüber nach, wie man von der herrschenden Pin-up-Begeisterung profitieren könnte. Ihr Konzept eines Heftes, das nicht nur Pin-ups zeigte, sondern zusätzlich zwei- bis vierseitige humoristische Fotostories brachte, war ein Novum und tat eine Goldgrube auf. Fotostories klingt großartiger als es war: Tatsächlich reichte das banalste Motiv, um leichtbekleidete Mädchen durch komische, slapstickhafte Situationen kapriolen zu lassen. Wer hätte gedacht, welche aufregenden Posen ein Mädchen beim Versuch, einen Teppich zu verlegen, einnehmen kann? Weil ihm andere Verleger auf dieses Terrain nicht folgen wollten, stellte Harrison sein Leben fortan unter das Motto „Girls, Gags & Giggles" und schob in rascher Folge Titel wie Titter (America's Merriest Magazine), Wink, Flirt und Eyeful (Glorifying the American Girl) mit ähnlichem Strickmuster nach.

Dafür, daß der Kunde seine Titel am Kiosk nicht übersehen konnte, sorgten die aufdringlichen Cover, die ihm Peter Driben, Earl Moran oder Billy De Vorrs malten: klassische Pin-ups vor meist knalligem Hintergrund. Driben, Moran und De Vorrs zählen zu den besten und anerkanntesten Illustratoren der Pin-up-Ära und verweisen auf einen respektableren Hintergrund als ihr Auftraggeber Harrison. Abgesehen vom Autodidakten De Vorrs hieß das Kunstakademie – Driben hatte gar in Paris studiert –, Kalenderillustration und Werbeagenturen. Kurz gesagt: Die frischen, geschmackvollen, „sauberen" Pin-up-Illustrationen genügten allen ästhetischen Standards. Und längst sind natürlich Kulturbeflissene aufgestanden, winken mit Titter und Wink und den übrigen Magazinen und rufen lauthals „Kunst!". So nobilitiert werden allerdings nur die Titelillustrationen. Die Hefte selbst sähen viele Kunstfreunde gerne zugeklebt.

Warum? Inhaltlich orientierte sich Harrison weitgehend an der Tradition der amerikanischen Burleske, die, wenn man so will, die ärmere, anrüchige Verwandte des Vaudeville war. Die Magazine sprachen eine derbere Sprache, als ihre geschmackvolle Aufmachung erwarten ließ. Was in der Alten Welt ursprünglich eine literarische Parodie meinte, eine manchmal vulgäre Posse, die die hehren, hohen Werke im Theater der Lächerlichkeit preisgab, erlebte in den Vereinigten Staaten Ende des 19. Jahrhunderts eine entscheidende Wandlung. Maßgeblich daran beteiligt war eine stämmige Engländerin namens Lydia Thompson, die erste Wasserstoffblondine der Welt, die 1869 auf Einladung P. T. Barnums mit ihrer Truppe, den British Blondes, in den USA gastierte. Grenzüberschreitung und Normverletzung waren ja das Geschäft der Burleske, aber die British Blondes trugen Strumpfhosen. In einer Welt, in der Männer bereits beim Anblick einer unverhüllten weiblichen Fessel in Raserei verfielen, war das ein kühner Schritt. Aber dies war der neue Geist, und ab 1870 präsentierten New Yorker Bühnen Burlesque Shows, die weniger Parodien anderer Theaterproduktionen waren als vielmehr Anlaß, die weibliche Figur ins rechte Licht zu rücken. Jede Anregung in diese Richtung wurde dankbar integriert. Nachdem etwa die Syrierin Fahreda Mahzar, die als Little Egypt bekannt wurde, 1893 auf der Weltausstellung in Chicago ihren „ägyptischen" Tanz vorgeführt hatte, wartete kurz darauf jede Burlesque Show mit ihrer eigenen Little Egypt auf, die verrufen ihr Becken kreisen ließ.

Die Burlesque Shows übernahmen das Varieté-Format des Vaudeville und wurden zu einer bunten Nummernrevue mit Gesang, Tanz, Sketchen, Jongleuren, Akrobaten, Tierdressuren und vor allem Sex. Ihre Komik war derb und zotig, die Witze waren schmutzig, die Parodien wüst. Im 20. Jahrhundert, als der Film und später das Fernsehen dem traditionellen Entertainment Konkurrenz zu machen begannen, wurde schließlich der Striptease das dominierende Element. Tatsächlich hatten Varieté-Shows schon Ende des 19. Jahrhunderts dem Medium, das ihren Niedergang auslösen sollte, die Tür geöffnet und Kurzfilme ins Programm genommen. Als Harrison sein Girlie-Magazin-Imperium begründete, war der Burleske kein langes Leben mehr beschieden. Der Zweite

Weltkrieg verhalf ihr zu einem letzten Comeback. Es wurde sogar eine ganze Reihe burlesker Revuefilme gedreht: Evelyn West etwa, die ihren Busen bei Lloyd's in London versichert hatte, trat in „A Night at the Follies" auf, Ann Corio in „The Sultan's Daughter" und in „Call of the Jungle". In dem 1953 in New York von der Venus Productions Corporation produzierten Film „Striporama" versammelte sich noch einmal ein Aufgebot der Stars der Burleske, bevor die Mehrzahl von ihnen vor die Suppenküchen zog. In eine skurrile Rahmenhandlung eingebettet, treten auf: die große Lili St. Cyr; Rosita Royce, die sich von ihren dressierten Tauben beim Ausziehen helfen ließ; die durch ihre skandalösen Auftritte in Minsky's Burlesque Theaters berühmt gewordene Georgia Sothern; Betty Page erscheint in Sketchen mit Komikern wie Jack Diamond, Mandy Kay und Charles Harris, und für die Damen gab es den muskelbepackten Mr. America, der mit einer Schönen auf den Schultern Harmonika spielt. Auf genau diese Kombination von Sex und Komik setzten auch die Magazine Robert Harrisons, eine Art Burlesque Show für unter das Kopfkissen. Gelegentlich verwies man gar mit den Aufnahmen legendärer Burlesque-Queens des vergangenen Jahrhunderts auf die eigenen Wurzeln. In vielen der komischen Bildergeschichten treten neben den Models Komiker der Burleske auf, entweder aus den Reihen altehrwürdiger Revuestars oder einfach Männer, die man in die Dienstkleidung des burlesken Komikers gesteckt hat: Hanswurste in sackartigen Hosen und grobkarierten Jacketts mit gigantischen Schnurrbärten. Diese Form des Humors, der im Sexfilm erstaunlich lange überleben sollte, ist im Printbereich nur noch auf Postkartenständern besonders entlegener Ausflugslokale zu finden. Um seine Fotofeatures arrangierte Harrison zahllose Cheesecake-Models in Unterwäsche, in Badeanzügen oder verwegenen Bühnenkostümen, oder er zeigte Showgirls in der Garderobe (natürlich niemals wirklich nackt, da hielt man sich besser an Nudistenmagazine oder „Kunst"-Bücher), und – und dies hat sicherlich nicht unwesentlich zu seinem Erfolg beigetragen – ein breites Spektrum an Fetischmaterial. Es heißt, Harrison sei hier der Anregung einer ungewöhnlich belesenen und mit Krafft-Ebing vertrauten Redakteurin gefolgt. So kommt dann bald kaum ein Heft ohne Model mit Peitsche aus, das Hohelied langer Haare wird angestimmt,

Mädchen ringen miteinander oder schwingen Boxhandschuhe, und eine zarte Eve Rydell, die ihr ruchloser Herr in Ketten gelegt hat, wird auf einem orientalischen Basar angeboten. Als notorischer Workaholic ließ Harrison es sich nicht nehmen, regelmäßig auf den Fotosets zu erscheinen und, wenn die Geschichte es anbot, selbst eine Rolle in der Geschichte zu übernehmen. Es fällt schwer, sich bei diesem auf den Fotos so durchschnittlich aussehenden, aber offensichtlich zu jeder Albernheit bereiten Mann den späteren Herausgeber des berüchtigsten Skandalmagazins vorzustellen. Seine Models konnte Harrison aus dem großen Heer der Stripperinnen, Showgirls und Cheesecake-Models, die es nach New York getrieben hatte, wählen. Die meisten konnten dankbar sein, wenn ihnen eine Bildunterschrift wenigstens einen Künstlernamen verlieh, und nur wenige erlangten jemals einen größeren Bekanntheitsgrad. Noch weniger wurden zum Star, wie Betty Page, die ab 1951 in Harrisons Magazinen zu sehen war und bald zu einem der beliebtesten Models wurde. Aber auch die vielen Namenlosen erscheinen als patente, manchmal etwas tölpelhafte Mädchen, jedoch immer selbständig und entschlossen und in den Situationen, in denen ihnen die Regie einen männlichen Mitspieler ins Bild stellte, regelmäßig als der überlegene Part. Und sie waren bereit, sich in Posen fotografieren zu lassen, in denen sich ein paar Jahre später niemand mehr hätte tot erwischen lassen. Heute ist man versucht, über die Naivität dieser Geschichten zu lachen oder sie gar grotesk zu finden. Aber es scheint durch, was das Model Jonnie Wilson, im ,,Betty Page's Annual" zur Arbeit mit Harrison befragt, beteuerte: Sie habe den Spaß ihres Lebens dabei gehabt.

Die schmierigen Männergestalten, die den Mädchen auf den Fotos zur Seite gestellt wurden, lassen das Selbstbild einer Käuferschicht erahnen, die zweifellos so selten wie möglich an die deprimierende Tatsache erinnert werden wollte, daß es anderenorts in diesem Universum attraktive, redegewandte und edle Männer geben könnte, die gutgeschnittene Anzüge tragen. Würde man den Anzeigenkunden fragen, wie er die Leserschaft einschätzt, so würde er ein Bild zeichnen von einem kleinwüchsigen, von Pickeln übersäten Mann, der auf Parties einsam in der Ecke steht und zusieht, wie sein letztes Kopfhaar auf seinem Spitzbauch landet. Soziale Kontakte, an denen es ihm entschieden mangelt,

versucht er durch aus Handbüchern angelesene Witze und Anekdoten zu erzwingen. Notorisch knapp bei Kasse und daher empfänglich für jedes fadenscheinige Versprechen auf schnellen Reichtum, hat er immerhin noch das Geld, sich durch Lektüre über einsame Stunden hinweg zu trösten.

So war Harrisons Klientel den Verlegern sexualkundlicher Fachbücher wie Dr. E. Podolsky „Modern Sex Manual" (selbstverständlich für verheiratete Paare) durchaus eine ganzseitige Anzeige wert. Zu den skurrileren Werken zählt da sicher „I was Hitler's Doctor" von Dr. Kurt Krüger, „Ex-Nazi und langjährigem Psychiater Hitlers", das während der Kriegsjahre beharrlich beworben wurde. Die Anzeige zeigt Hitler, wie er kläglich flennend dem im Hintergrund lauernden, unbestechlichen Dr. Krüger schreckliche Geständnisse ins Psychiaterhandbuch diktiert.

In erster Linie aber loderte in Harrisons Leser natürlich die durch ehehygienische Bedenken kaum abgeschwächte Flamme sexueller Begierde. Auf seine Träume von lockeren Schenkeln und Mädchen mit hoher Fallgeschwindigkeit setzte auch Irving Klaw, der König des Pin-ups, als einer der treuesten Inserenten in Harrisons Magazinen. Archäologen auf der Nachtseite der Populärkultur finden im Anzeigenteil mit seinen zahlreichen Pin-up-Mailordern ein wahres Pompeji des Sleazes.

Das Wildeste unter Harrisons Heften war sicherlich Whisper, ein Nachkriegskind, das im April 1946 zum ersten Mal an die Kioske kam. Auf dem Cover war regelmäßig eine der zahllosen von Peter Driben gemalten Pin-up-Schönheiten abgebildet, sinnigerweise durchs Schlüsselloch gesehen. In den 50er Jahren wurden die Illustrationen erst durch Pin-up-Fotos ersetzt, und schließlich paßte sich Whisper auch optisch dem 1952 gestarteten „Confidential" an.

Whisper visierte den abenteuerlustigen, abgebrühten Leser an, war wild, hart und schmutzig und wartete mit wüsten Geschichten über böse Mädchen, sexhungrige Fremdenlegionäre, grausame Mordfälle, bizarre Riten seltsamer Eingeborenenstämme und rüden Fotoberichten über Straßenkriminalität auf: die ganze Welt ein Tollhaus. Passenderweise findet sich in Whisper neben

den vertrauten Annoncen auch eine ganzseitige Anzeige, die mit echten „Down-to-earth savings" besonders günstige Grabsteine bewarb.

Zum Stil von Whisper gehörte es aber auch, brandheiße Skandale wie „Betrügen uns Tankwarte beim Ölwechsel?" oder „Skandalöse Bücherdiebstähle in öffentlichen Bibliotheken!" mit der gleichen journalistischen Empörung zu geißeln wie gräßliche Massaker und unglaubliche Perversitäten.

Und Whisper wurde immer schmutziger, denn Robert Harrison hatte erkannt, daß die goldene Zeit für seine klassischen Girlie-Magazine in den 50ern endgültig vorbei war. Längst hatten sich „seriösere" moderne Magazine auf dem Markt etabliert, die weder den burlesken Humor noch die „schmutzigen" Anzeigen in ihren Heften zuließen. Ob sie sich nun wie etwa Georg von Rosens „Modern Man" an den abenteuerlustigen, actionhungrigen Leser richteten oder wie Hugh Hefners „Playboy" an den solventen, kultivierten Städter, sie alle bemühten sich um namhafte Autoren und die besten Karikaturisten und Fotografen. Für die modernen Männermagazine schrieben Leute wie Harlan Ellison, Allen Ginsberg, Jack Kerouac, James T. Farrell und nicht mehr die keinen Kalauer auslassenden Sensationsschreiber, die mit tintigen Fingern Bildunterschriften für Harrison ersannen. Wenn man eines dieser modernen Hefte erwarb, konnte man gewiß sein, daß die größte Sorgfalt und der größte Teil des Etats nicht allein für das Cover verwandt worden waren.

Harrison wollte sich offensichtlich nicht auf diesen Kampfplatz um Marktanteile begeben. Anfang 1955 stieß er seine mittlerweile antiquiert wirkenden Girlie Magazines ab und konzentrierte sich voller Elan darauf, geächtet und gebrandmarkt zu werden.

1952 hatte Whisper Unterstützung von „Confidential" erhalten, das von Anfang an als Skandalmagazin konzipiert war. Die Senatsuntersuchungen zum organisierten Verbrechen sollen Harrison diesen neuen, gewinnversprechenden Weg gewiesen haben. Genauer gesagt, die Tatsache, daß die Anhörungen des Untersuchungsausschusses (zum organisierten Verbrechen) im Fernsehen übertragen wurden, unglaubliche Einschaltquoten erreichten und ihren Vorsitzenden, Senator Estes Kefauver aus Tennessee, über Nacht zum Medienstar machten.

Während sein Kollege McCarthy vermeintlichen „Pied Pipers of the Politburo" nachstellte, nahm Kefauver vor laufender Kamera Gangstergrößen wie Frank Costello oder Meyer Lansky ins Gebet und veränderte mit seinen Verschwörungstheorien mehr als nur die politische Kultur in Amerika. Einige Jahre später sah man ihn erneut an der Spitze eines Senatsausschusses, diesmal ging es um die Ursachen der Jugendkriminalität, und eines seiner Opfer sollte Irving Klaw werden. Das berühmteste Porträt von Kefauver zeigt ihn unter einer Waschbärenmütze, vielleicht war auch er ein Opfer der durch die TV-Sendung „Disneyland" ausgelösten Davie-Crocket-Manie des Jahres 1954 geworden.

Es wäre ja nur recht und billig, wenn das Medium, das Harrison den burlesken Spaß verdorben hatte, ihm so den Anstoß zu dem erfolgreichsten Magazinprojekt des Jahrzehnts gegeben hätte. Vielleicht hat es sich Harrison auch nur im nachhinein so zurechtgelegt. Denn die Praktiken, die Whisper und „Confidential" anwandten und vielleicht perfektionierten, hatte er schon zu Beginn seiner Karriere im Zeitungswesen kennengelernt, als Laufbursche beim New Yorker „Daily Graphic": einem Revolverblatt der 20er und 30er Jahre, in dem das dreiste Erfinden von Geschichten, das „Wahrlügen", das Türken intimer Geständnisse und das Fälschen von Fotografien zur täglichen Routine gehörten. Kaum wahrscheinlich, daß Harrison das vergessen hätte.

Sicherlich ist die Welt nicht knapp versorgt mit Narren, aber man muß schon außergewöhnlich leichtgläubig sein, um nicht zu erkennen, daß die Schöne, die in Whisper gerade von schurkischen Sklavenjägern übermannt wird, oder die Stripperin im Negligé, die von brutalen Sowjets entführt wurde und nun in einer Schüssel mit Eiswasser stehen muß, nur durch Schere und Klebstoff in diese mißliche Lage geraten sind. Wie bei den modernen Enthüllungszeitschriften dürfte ein Großteil des Lesespaßes daher rühren, daß man den Schwindel erkennt, ja voraussetzt, und sich über die Frechheit der Lüge amüsiert. Allerdings greift dieser Mechanismus nicht, sobald Jesus, Elvis oder irgendein auch nur halbwegs Prominenter beteiligt ist. Und genau das wurde bald zum Hauptgeschäft von Whisper und „Confidential": jede Gestalt des öffentlichen Lebens mit Schmutz zu bewerfen. Anders als viele seiner Konkurrenten, die ihre

Geschichten gerne voneinander abschrieben, unterhielt Harrison ein dichtes Netz von Informanten, Spitzeln und Zuträgern und eilte mit dem ihm eigenen Elan zu konspirativen Treffen, bei denen er tatsächliche Skandale ausgrub. Gelang ihm das nicht, blies er Nichtigkeiten zu Sensationen auf. Allerdings blieb der gesunde Selbsterhaltungstrieb, der dafür sorgt, daß solche Meldungen hieb- und stichfest sind, bei Harrison auf der Strecke, der sich von seinem allgemeinen Schwung und der Begeisterung, „Confidential" zum meistverkauften Heft der Vereinigten Staaten gemacht zu haben, mitreißen ließ. 1957 sah sich Harrison einer Flut von Prozessen gegenüber, und ein Jahr später verkaufte er seine beiden Skandalblätter. Unter wechselnden Verlegern überlebten Whisper und „Confidential", bescheiden geworden, noch bis Anfang der 70er Jahre.

Harrison versuchte sich danach mit sogenannten „one-shots", Sonderheften, die sich einem gerade angesagten Star oder Skandal widmeten, und wenig erfolgreich mit einem neuen Skandalblättchen.

Introduction

Lorsqu'au début des années 60, Tom Wolfe rencontra Robert Harrison, l'éditeur à la réputation jadis si sulfureuse n'était déjà plus qu'un personnage presque oublié. A la suite d'une foule de procès, Harrison avait dû se résoudre en 1958 à vendre celui de ses magazines qui avait connu le plus de succès, le journal à sensation «Confidential». Même s'il occupait toujours la même suite de l'hôtel où il résidait déjà du temps de sa splendeur, il faisait plutôt l'effet d'un monarque en exil privé de tout espoir de retour. Certes, l'ampleur du geste demeurait et sa vivacité était intacte, mais elles n'avaient plus pour auditoire qu'une cour des plus modestes, à savoir sa compagne et sa sœur Helen, qui avait été son bras droit pendant plus de vingt ans.

Quand on est descendu si bas au point de toucher le fond, on a tendance à exagérer la fanfaronnade et à aller plus loin encore dans la surenchère dans le seul but d'ériger, contre la nostalgie de la perte, un mur propre à décourager toute interrogation critique, de sorte que l'interlocuteur un tant soit peu délicat s'en tiendra à l'exclamation étonnée d'un «ah» ou d'un «oh». Quoiqu'audacieux, les nouveaux projets d'Harrison n'aboutirent pas, et il demeura pour toujours l'ancien éditeur de «Confidential», le père de tous les magazines à sensation, une publication qui au milieu des années 50 avait vendu en quelques numéros 4 millions d'exemplaires. Mais «Confidential» aura du moins pris place dans un ouvrage de référence, à savoir cette bible des innombrables magazines à sensation des années 50, et sans cesse rééditée, qu'est «Hollywood Babylon» de Kenneth Anger. Celui-ci fait d'Harrison le type même du caractère ombrageux. Mais même si, entre le noir corbeau et le vert criard, sa palette ne connaît guère de nuances, elle ne parvient qu'à peine à dissimuler l'enthousiasme que lui inspire ce personnage autour duquel flotte une légère odeur de soufre.

Avant de devenir l'homme le plus détesté des Etats-Unis, comment Harrison avait-il mené sa vie. En 1941, il s'était lancé résolument dans la libre entreprise. On peut donner de la chose une version émouvante : Harrison travaillait alors pour le brave Martin Quigley, l'éditeur de «Motion Picture Daily» et

de «Motion Picture Herald». Après les heures de travail, Harrison restait dans les salles de rédaction où il s'appliquait à coller de sa propre main Beauty Parade, son premier Girlie Magazine, ce que son patron découvrit la veille même de Noël ; en guise de félicitations, celui-ci le flanqua dehors. Une histoire qui semble tout droit sortie d'un film de Frank Capra. On imagine Harrison, qu'un manteau léger protège mal du vent cinglant, errer, sans travail, dans la nuit de New York, réchauffé par sa seule foi en sa mission et une pile de magazines de pin up pressée contre sa poitrine.

Mais peut-être que, à mille lieues d'en faire un drame, il était tout simplement chez lui, dans son deux-pièces, en train de réfléchir avec son ami le dessinateur de pin up Earl Moran, à la façon dont ils pourraient tirer profit de l'engouement dont les pin up faisaient alors l'objet. Leur conception d'une publication qui non seulement montrerait des pin up, mais raconterait en photos des histoires humoristiques de deux à quatre pages, était une première qui devait leur ouvrir une mine d'or. Le terme d' «histoires en photos» est un bien grand mot : en réalité, le sujet le plus banal était prétexte à faire caracoler des filles en tenue légère dans des situations drôles, voire des gags. Qui aurait pensé qu'une fille en train d'essayer de poser un tapis pouvait prendre des poses aussi excitantes ? Comme les autres éditeurs refusaient de le suivre sur ce terrain, Harrison plaça dès lors son existence sous la bannière «Girls, Gags & Giggles» (des filles, des gags et des petits gloussements), et des titres comme Titter (America's Merriest Magazine), Wink, Flirt et Eyeful (Glorifying the American Girl), tous conçus sur le même modèle, se succédèrent à une vitesse fulgurante.

Avec les couvertures tape-à-l'œil de Peter Driben, Earl Moran ou Billy De Vorrs, qui représentaient des pin up classiques sur un fond le plus souvent très vif, Harrison pouvait être sûr que le client ne raterait pas ses titres sur les présentoirs. Driben, Moran et De Vorrs comptent parmi les meilleurs et les plus reconnus des illustrateurs des années pin up, et ils ont des antécédents respectables, ce qui n'est pas le cas de leur commanditaire Harrison. A l'exception de l'autodidacte De Vorrs, ils étaient tous diplômés des Beaux-Arts; Driben avait même fait des études à Paris et acquis par ailleurs une expérience en matière de calendriers d'art et dans des agences de publicité. Bref, la fraîcheur, le bon goût, la «propreté»

des images de pin up satisfaisaient à toutes les normes esthétiques. Et bien entendu, il y a longtemps que le public cultivé salue les qualités artistiques de Titter, Wink et les autres titres. Mais seule la couverture a de telles lettres de noblesse. Quant aux magazines eux-mêmes, beaucoup d'amateurs d'art préfèrent les voir fermés.

Pourquoi ? Au niveau du contenu, Harrison s'est en grande partie inspiré de la tradition américaine du théâtre burlesque, qui était si l'on veut le parent pauvre et louche du vaudeville. Les magazines parlaient une langue plus crue que ne le laissait supposer le bon aloi de leur présentation.

Ce qui sur le vieux continent avait valeur de parodie littéraire, de farce volontiers triviale qui tournait en ridicule le sublime des grandes œuvres du répertoire théâtral, connut dans les Etats-Unis du 19e siècle une mutation décisive dans laquelle une robuste Anglaise du nom de Lydia Thompson, la première blonde oxygénée du monde, joua un rôle de premier plan. En 1869, elle répondit en effet à l'invitation de P.T. Barnum et entama avec sa troupe, les British Blondes, une tournée aux Etats-Unis. Le dépassement des limites et la transgression des normes étaient certes l'affaire du théâtre burlesque, mais les British Blondes portaient des collants. Dans un monde où les hommes devenaient fous à la seule vue d'une cheville féminine dévoilée, voilà qui était d'une grande audace. Mais tel était l'esprit nouveau, et à partir de 1870, les scènes new-yorkaises se mirent à présenter des spectacles burlesques qui étaient bien moins des parodies d'autres productions théâtrales que prétextes à montrer le corps féminin sous son vrai jour. Toute idée qui allait dans ce sens était adoptée avec gratitude. Peu après que la Syrienne Fahreda Mahzar, plus connue sous le nom de Little Egypt, eut présenté sa danse «égyptienne» à l'Exposition Universelle de Chicago de 1893, chaque spectacle burlesque voulut avoir sa propre Little Egypt qui, elle aussi, saurait rouler des hanches.

Se calquant sur le schéma du vaudeville et du music-hall, les spectacles burlesques devinrent des revues très colorées qui associaient le chant, la danse, les sketches, les numéros de jongleurs, d'acrobates et d'animaux dressés, et surtout le sexe. Le comique en est lourd et paillard, les blagues cochonnes et les

parodies grossières. Au 20e siècle, quand le cinéma et plus tard la télévision commencèrent à faire concurrence aux divertissements traditionnels, le strip-tease finit par en devenir l'élément principal. Les spectacles de music-hall avaient en réalité ouvert la porte, dès la fin du 19e siècle, au média qui devait sonner leur glas en acceptant de programmer des courts métrages. Au moment où Harrison fondait son empire de Girlie Magazines, on ne donnait plus cher de la vie du théâtre burlesque. La Seconde Guerre mondiale lui fournit l'occasion d'un dernier retour en vogue. On tourna même toute une série de films de music-hall : Evelyn West, qui avait pris une assurance pour ses seins chez Lloyd's à Londres, joua dans «A Night at the Follies», Ann Corio dans «The Sultan's Daughter» et «Call of the Jungle». «Striporama» rassembla encore toute une brochette de stars de la comédie burlesque qui, par la suite, devaient pour la plupart faire la queue à la soupe populaire. Production new-yorkaise de 1953 de Venus Productions Corporations, «Striporama» les fait toutes apparaître une dernière fois dans les situations grotesques d'un récit-cadre figé : la grande Lili St Cyr ; Rosita Royce, que ses colombes dressées aident à se déshabiller ; Georgia Sothern, que les scandales provoqués par ses apparitions aux Minsky's Burlesque Theaters ont rendue célèbre ; Betty Page apparaît dans des sketches en compagnie de comiques tels que Jack Diamond, Mandy Kay et Charles Harris, sans oublier pour les dames le Mr. America tout en muscles qui joue de l'harmonica, une belle sur les épaules. C'est sur cette même combinaison de sexe et de comique que misent, eux aussi, les magazines de Robert Harrison, une sorte de show burlesque à mettre sous l'oreiller. Il arrivait même que les photos de grandes reines du burlesque du siècle précédent renvoient le spectateur à ses propres racines. A côté des modèles figuraient dans nombre des histoires drôles en images des comiques de la scène burlesque, soit qu'ils fussent sortis des rangs de vénérables vétérans du music-hall, soit qu'il s'agît simplement d'hommes qu'on avait affublés de l'uniforme du comique burlesque : des pitres à moustaches gigantesques dans des pantalons qui tombaient comme des sacs et des vestes à gros carreaux. Dans le domaine de l'imprimé, on ne trouve plus cette forme d'humour, qui curieusement devait survivre longtemps dans le film porno, que sur les présentoirs de cartes postales d'auberges de campagne particulièrement perdues. Autour de

ses vedettes, Harrison disposait toute une flopée de pin up en sous-vêtements, maillots de bain ou dans des costumes de scène osés, à moins qu'il montrât des girls dans les loges (qui bien entendu n'étaient jamais complètement nues, il valait mieux pour cela s'en tenir aux publications naturistes ou aux livres «d'art») en déployant – ce qui certainement ne compta pas pour peu dans le succès qu'il devait rencontrer – une vaste panoplie de fétiches. Harrison se serait en cela conformé à la suggestion d'une rédactrice d'une érudition peu commune, qui était une intime de Krafft-Ebing. C'est à peine si désormais un numéro sortait sans que le modèle eût un fouet, les longues chevelures étaient à l'honneur, on voyait des filles avec des gants de boxe lutter entre elles, et une tendre Eva Rydell, que son maître infâme avait enchaînée, était à vendre sur un bazar oriental. Le bourreau de travail notoire qu'était Harrison insistait pour apparaître régulièrement dans le décor des photos et, lorsque le scénario le permettait, dans l'histoire elle-même. Il est difficile d'imaginer en regardant ces photos, que cet homme d'apparence si insignifiante, quoique manifestement prêt à n'importe quelle bêtise, allait devenir l'éditeur le plus décrié des magazines à sensation. Harrison pouvait choisir ses modèles parmi la grande armée des strip-teaseuses, girls et pin up qu'il avait fait venir à New York. Elles pouvaient pour la plupart s'estimer heureuses si une légende sous l'image leur concédait la mention d'un pseudonyme, et rares furent celles qui parvinrent jamais à dépasser ce niveau de notoriété. Plus rares encore furent celles qui accédèrent au statut de star comme Betty Page, que l'on put voir à partir de 1951 dans les magazines d e Harrison et qui devait rapidement devenir l'un des modèles les plus populaires. Mais les plus nombreuses, les anonymes, apparaissent elles aussi comme des filles formidables qui, même si elles étaient parfois un peu lourdaudes, se montraient toujours énergiques et décidées et qui, lorsque la mise en scène leur adjoignait un partenaire masculin, savaient régulièrement tirer la couverture à elles. Et elles étaient prêtes à se faire photographier dans des poses dont plus personne, quelques années plus tard, n'aurait pu se remettre. On est tenté aujourd'hui de sourire de la naïveté de ces histoires et même de les trouver grotesques. On y détecte néanmoins ce que déclarait le modèle Jonnie Wilson, interrogée par le «Betty Page's Annual» sur son travail avec Harrison : elle aurait connu là le grand bonheur de sa vie.

Le côté adipeux des figures masculines que l'on voit sur les photos à côté des filles, laisse deviner par analogie une catégorie d'acheteurs dont il est évident qu'elle veut s'entendre rappeler le moins souvent possible le fait déprimant qu'il puisse y avoir, ailleurs dans cet univers, des hommes distingués, qui s'expriment facilement et qui portent des costumes bien coupés. Si l'on demandait au client de publicité comment il se représente le lecteur type, il dessinerait un homme de petite taille, couvert de boutons, qui dans les soirées reste tout seul dans un coin à observer la chute de son dernier cheveu sur son gros ventre. Il essaie de forcer les contacts, dont il manque singulièrement, en racontant des histoires drôles et des anecdotes qu'il a lues dans des manuels. Radin notoire, ce qui par conséquent fait de lui la proie désignée des requins véreux de la finance, il lui reste quand même toujours de quoi se payer quelques heures de réconfort par la lecture solitaire. Aussi les éditeurs d'ouvrages spécialisés dans la sexualité tels que «Modern Sex Manual» (bien évidemment à l'intention des couples mariés) du Dr E. Podolsky considéraient-ils que la clientèle de Harrison valait tout à fait la peine de passer une annonce publicitaire en pleine page. Pendant la guerre, les magazines de Harrison firent également la promotion de «I was Hitler's Doctor» du Dr Kurt Krüger, cet ancien nazi – c'est du moins ce qu'on ne cesse de répéter – qui soi-disant avait été pendant de longues années le psychiatre d'Hitler. La publicité représente le führer en train de pleurnicher pitoyablement tout en faisant de terribles aveux au Dr Krüger qui, en retrait, tend l'oreille et les consigne dans son carnet sans se laisser ébranler.

Mais c'est surtout la flamme de la concupiscence qui, cela va sans dire, embrasait les lecteurs de Harrison. Irving Klaw, le roi du phénomène pin up, misait lui aussi sur ces rêves de cuisses souples et de filles à haute vitesse de chute, en devenant l'un des plus fidèles annonceurs des magazines de Harrison. Les archéologues de la culture populaire dans ce qu'elle a de moins reluisant sont en présence, avec la partie publicitaire (des magazines de Harrison) et ses nombreuses propositions de vente par correspondance, d'un véritable Pompéi de la trivialité.

Celle qui allait le plus loin parmi les publications de Harrison fut certainement Whisper, un rejeton de l'après-guerre qui sortit pour la première fois

en kiosque en avril 1946. La couverture représentait régulièrement une des innombrables beautés que Peter Driben, judicieusement, peignait à travers le trou d'une serrure ; ce n'est que dans les années 50 que les photos de pin up remplacèrent les peintures ou les dessins, et Whisper finit par s'harmoniser, même du point de vue de son look, avec «Confidential», lancé en 1952. Le lecteur qu'émoustillait le goût de l'aventure était la cible de prédilection de Whisper, magazine hard qui racontait des histoires de filles cruelles, de légionnaires affamés de sexe, parlait d'affaires criminelles sordides et de rites bizarres que pratiquaient d'étranges tribus indigènes, et proposait des reportages photos particulièrement corsés sur la criminalité urbaine. Bref, le monde était représenté comme une immense maison de fous.

Pour ne pas s'arrêter en si bon chemin, on trouve également dans Whisper, à côté des annonces publicitaires habituelles, une publicité pleine page pour des pierres tombales à des prix particulièrement avantageux.

Il était également caractéristique de Whisper de fustiger des scandales d'actualité brûlante du type «Sommes-nous escroqués par les pompistes quand nous faisons faire la vidange ?» ou «Scandaleux vols d'ouvrages dans des bibliothèques publiques» avec la même indignation que d'épouvantables massacres ou d'incroyables perversités.

Alors Whisper devint de plus en plus hard, car Robert Harrison avait compris que dans les années 50, l'âge d'or de ses Girlie Magazines était définitivement révolu. Depuis longtemps, des magazines modernes «plus sérieux» qui n'admettaient ni l'humour burlesque, ni les annonces «cochonnes», avaient fait leur entrée sur le marché. Qu'ils s'adressent, comme par exemple «Modern Man» de Georg von Rosen, à un lecteur ayant le goût de l'aventure et affamé d'action, ou comme «Playboy», de Hugh Hefner, au citadin solvable et cultivé, tous recherchaient des auteurs de renom ainsi que les meilleurs photographes et caricaturistes. Des gens comme Harlan Ellison, Allen Ginsberg, Jack Kerouac, James T. Farrell écrivirent pour ces magazines masculins modernes, et non plus ces écrivailleurs qui ne rataient jamais un calembour pour faire sensation et inventaient, les doigts maculés d'encre, des légendes pour les images de Harrison. Quand on faisait l'acquisition d'une de ces publications modernes, on pouvait être certain que le plus grand

soin et la plus grosse part du budget n'avaient pas été mobilisés par la seule couverture.

Manifestement, Harrison ne tenait pas à entrer dans l'arène où se taillaient les parts de marché. Début 1955, il se détourna de ses Girlie Magazines devenus entre-temps obsolètes pour consacrer toute son énergie à se faire honnir et stigmatiser.

Whisper avait obtenu en 1952 le soutien financier de «Confidential», conçu dès son origine comme un magazine à sensation. Ce sont vraisemblablement les enquêtes du sénat sur le crime organisé qui ont mis Harrison sur cette nouvelle piste qui promettait de rapporter gros, ou plus exactement le fait que les audiences de la commission d'enquête étaient retransmises à la télévision, qu'elles atteignaient des taux d'écoute incroyables et qu'en une nuit, elles firent de leur président, le sénateur Estes Kefauver du Tennessee, une star médiatique. Tandis que son collègue McCarthy faisait la chasse aux présumés «joueurs de flûte du Bureau Politique», Kefauver passait un savon, devant les caméras, à de grandes pointures du gangstérisme comme Frank Costello ou Meyer Lansky, et il n'y eut pas que la seule culture politique américaine à être transformée par ses thèses de complots. Quelques années plus tard, on le revit à la tête d'une commission sénatoriale qui enquêtait cette fois sur la délinquance des jeunes, et dont l'une des victimes devait être Irving Klaw. Le portrait le plus célèbre de Kefauver le représente une casquette de raton laveur sur la tête; peut-être était-il lui aussi victime de cette Davie-Crocket-mania qu'avait déchaînée en 1954 l'émission de télévision «Disneyland».

Il n'aurait été que juste que le média qui avait gâché l'amour de Harrison pour le burlesque l'eût incité, par la même occasion, à concevoir le plus grand magazine à succès de la décennie. Mais peut-être Harrison n'a-t-il eu cette idée qu'après coup. Car les pratiques étant utilisées et peut-être perfectionnées par Whisper et «Confidential», il avait déjà eu l'occasion de se familiariser avec elles dès ses débuts dans le journalisme, alors qu'il n'était encore que coursier pour «Daily Graphic», une revue à sensation new-yorkaise des années 20 et 30 dans laquelle les affabulations les plus éhontées, le «mentir vrai», les aveux déformés

et les photos truquées faisaient partie de la routine quotidienne. Il est peu vraisemblable que Harrison ait oublié tout cela. Les idiots ne sont certes pas une denrée rare dans ce monde, mais enfin il faut être singulièrement naïf pour ne pas se rendre compte que la belle dont viennent de s'emparer de perfides chasseurs d'esclaves dans Whisper, ou encore que la strip-teaseuse en déshabillé, que des brutes de Soviets ont enlevée et qui à présent a les pieds dans un bassin d'eau glacée, ne doivent leur désagréable situation qu'aux ciseaux et à la colle. Comme dans les magazines modernes censés publier des révélations, l'intérêt du lecteur devait en majeure partie provenir du fait qu'il détectait les présupposés bobards et s'amusait de l'incongruité du mensonge. Mais le procédé ne fonctionne plus à partir du moment où interviennent Jésus, Elvis ou n'importe quelle célébrité, même si elle est seulement en voie d'en devenir une. Et c'est justement cela, c'est-à-dire cette volonté de couvrir de boue tous les personnages publics, qui constitua bientôt le fonds de commerce de Whisper et de «Confidential». A la différence de nombre de ses concurrents qui copiaient leurs histoires les uns sur les autres, Harrison entretenait un réseau compact d'informateurs, d'indicateurs et de balances et courait, avec la fougue qui était la sienne, à des rendez-vous clandestins dont il exhuma des scandales bien réels. Et s'il n'en trouvait pas, il échafaudait des histoires à sensation à partir de trois fois rien. Mais le solide instinct de conservation qui fait veiller à l'absolue véracité de ces révélations, faisait défaut à Harrison, qui se laissa emporter par son élan et l'enthousiasme d'avoir fait de «Confidential» la publication la plus vendue aux Etats-Unis. Il se vit exposé en 1957 à un déluge de plaintes, et un an plus tard il dut se résoudre à vendre ses deux magazines à sensation. Changeant souvent d'éditeur, Whisper et «Confidential» parurent encore, mais sans plus faire de tapage, jusqu'au début des années 70.

Par la suite, Harrison tenta sa chance avec ce qu'on appelle les «one-shots», c'est-à-dire des numéros spéciaux consacrés à une toute nouvelle star ou à un scandale, et il publia un nouveau petit journal à sensation qui n'eut guère de succès.

BEA
PAR
The World's

UTY
ADE

oveliest Girls

1942–1956

Beauty Parade was Harrison's first girlie magazine. The early issues look very tame, but they already feature the photostories characteristic of all Harrison's magazines: scantily clad models at some harmless hobby or grappling with some object with a will of its own. A typical picture story runs as follows: a model in panties, bra, high heels and perhaps saucy headgear strives through a number of scenes to erect a deckchair, but to no avail. Mildly peeved, she has a little rest before finally chopping the chair to pieces to make a campfire. The girl would also be wearing panties, bra and high heels if the story were set in the Arctic or on the Moon. Over time, and as elements of burlesque comedy were integrated into the stories, the humour grew somewhat earthier. But Harrison only hit on the right mixture when he began to add a fetishistic angle to his wholesome and ever cheerful cheesecake models. Initially Harrison cited himself as the publisher, but later the names on the imprint page changed quicker than you could say "Oh-la-la!".

Beauty Parade war Robert Harrisons erstes Girlie Magazine. Die frühen Nummern wirken noch recht verhalten, aber sie bieten bereits die für alle Harrison-Magazine typischen Fotostories, die leichtbekleidete Models bei einem harmlosen Hobby oder im Kampf mit der Tücke des Objekts zeigen. Eine typische Bilderstory verläuft etwa so: Ein Model in Schlüpfer, BH, High Heels und mit vielleicht verwegener Kopfbedeckung müht sich einige Szenen hindurch vergebens, einen Liegestuhl aufzubauen, erholt sich dann milde verstimmt, um schließlich mit neuem Elan den Stuhl kleinzuhacken und ein Lagerfeuer daraus zu machen. Schlüpfer, BH und High Heels würde das Mädchen auch tragen, wäre die Geschichte in der Arktis oder auf dem Mond angesiedelt. Im Laufe der Zeit und mit der Integration männlicher Hanswurste in die Stories wurde der Humor etwas derber. Die richtige Erfolgsmischung aber war erst gefunden, als Harrison begann, den unverdorbenen und stets gutgelaunten Cheesecake-Models Fetischmotive zur Seite zu stellen. Zeichnete Harrison anfangs selber als Herausgeber, wechselten die Namen im „Impressum" später schneller als man „oh-là-là" sagen konnte.

Beauty Parade est le premier Girlie Magazine de Robert Harrison. Les premiers numéros sont encore très sages, mais ils contiennent déjà les histoires en photos qu'on retrouvera dans tous les magazines de Harrison et les modèles en petite tenue en train de se livrer à un innocent hobby ou aux prises avec la malignité des choses. Voici par exemple un scénario typique : un modèle en petite culotte, soutien-gorge, hauts talons et peut-être un bibi effronté s'évertue en vain à mettre sur pied une chaise longue ; légèrement contrariée, elle se repose quelques instants avant de se précipiter dans un regain d'énergie sur la chaise, d'en faire du petit bois et finalement de la jeter au feu. La fille porterait de la même façon un slip, un soutien-gorge et des hauts talons si l'histoire se passait dans l'Arctique ou sur la lune. Au fil du temps et à mesure que les histoires intégraient des éléments du comique burlesque, l'humour allait devenir un peu plus lourd. Ce n'est que lorsque Harrison se mit à flanquer les gentilles pin up de fétiches que l'amalgame fut véritablement réussi. Si dans les premiers temps, c'était Harrison lui-même qui signait en tant que directeur de publication, par la suite on vit fréquemment les noms de l'éditorial.

BEAUTY PARADE

SE
2

THE MOST
Beautiful
Girls
IN THE
World

Ann Clark

PHOTO BY
MICHAEL
DENNING

19

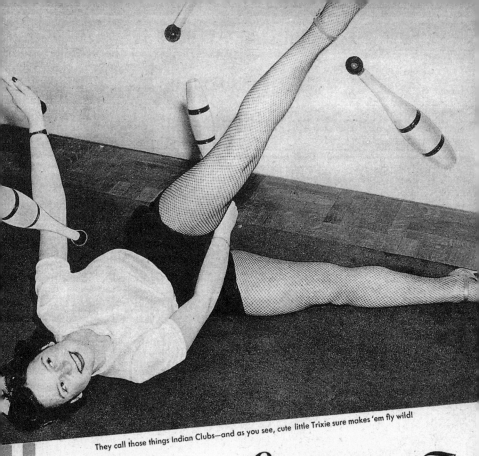

They call those things Indian Clubs—and as you see, cute little Trixie sure makes 'em fly wild!

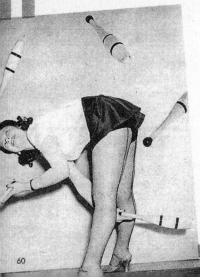

Swing It
LADY

Trixie is full of tricks that keep her in trim, but she's at her best when she throws the Indian Clubs around. Like W. C. Fields, Trixie is a first-class juggler and she has adopted that good American motto, Keep 'em Flying. We know you won't be able to keep your eye on the clubs, so let's admit right now that Trixie has two of the trickiest gams we've ever seen, and a smile that sends us out of the world. Swing it, Trixie, you're a hot melody in motion—and you're in the groove! Benny Goodman may be the king of swing, but you're the queen!

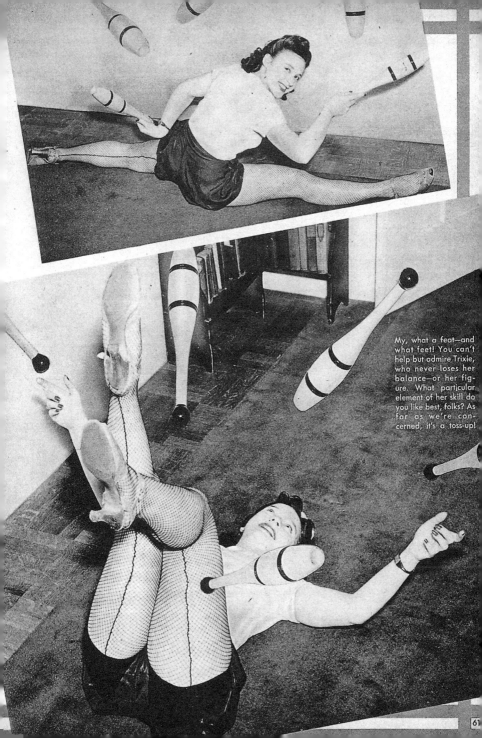

My, what a feat—and what feet! You can't help but admire Trixie, who never loses her balance—or her figure. What particular element of her skill do you like best, folks? As far as we're concerned, it's a toss-up!

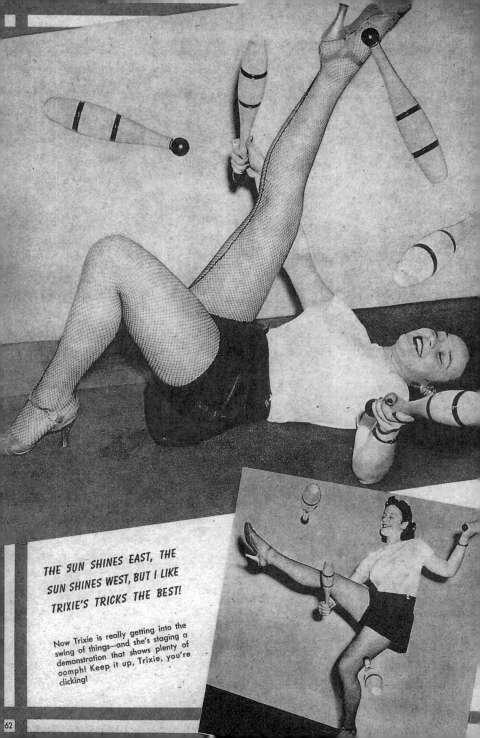

THE SUN SHINES EAST, THE SUN SHINES WEST, BUT I LIKE TRIXIE'S TRICKS THE BEST!

Now Trixie is really getting into the swing of things—and she's staging a demonstration that shows plenty of oomph! Keep it up, Trixie, you're clicking!

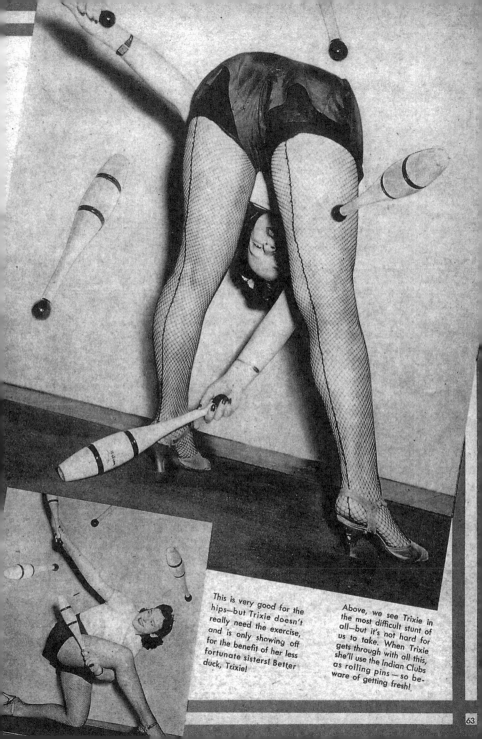

This is very good for the hips—but Trixie doesn't really need the exercise, and is only showing off for the benefit of her less fortunate sisters! Better duck, Trixie!

Above, we see Trixie in the most difficult stunt of all—but it's not hard for us to take. When Trixie gets through with all this, she'll use the Indian Clubs as rolling pins — so beware of getting fresh!

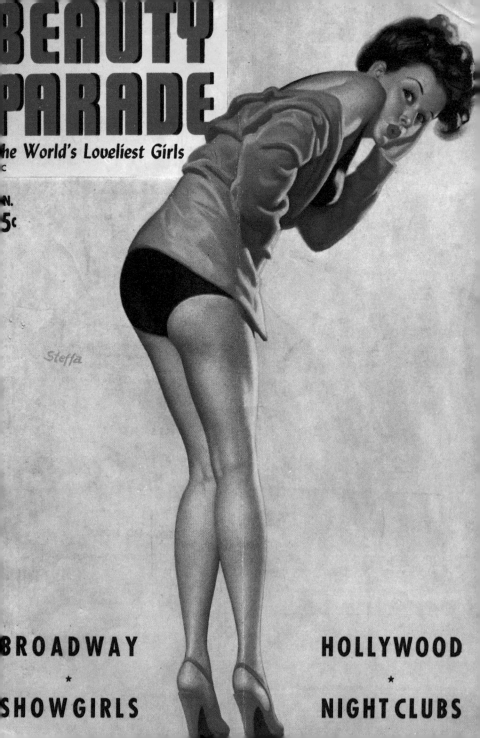

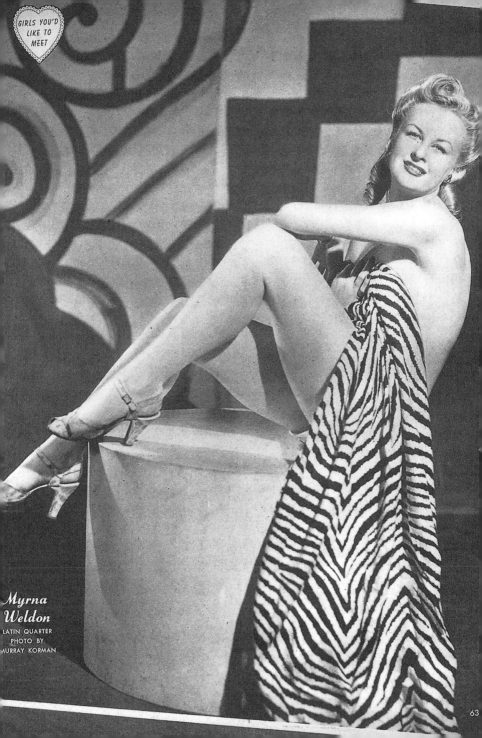

*Myrna
Weldon*
LATIN QUARTER
PHOTO BY
MURRAY KORMAN

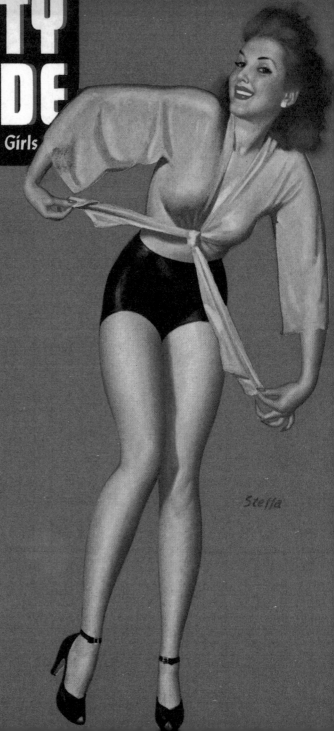

BEAUTY PARADE

The World's Loveliest Girls

RCH
5c

Steffa

BROADWAY
★
SHOWGIRLS
★
HOLLYWOOD
★
MODELS
★
NIGHTLIFE

JULY
25¢

BEAUTY PARADE

The World's Loveliest Girls

Steffa

Whirl
OF *Girls*

BROADWAY

HOLLYWOOD

NITECLUBS

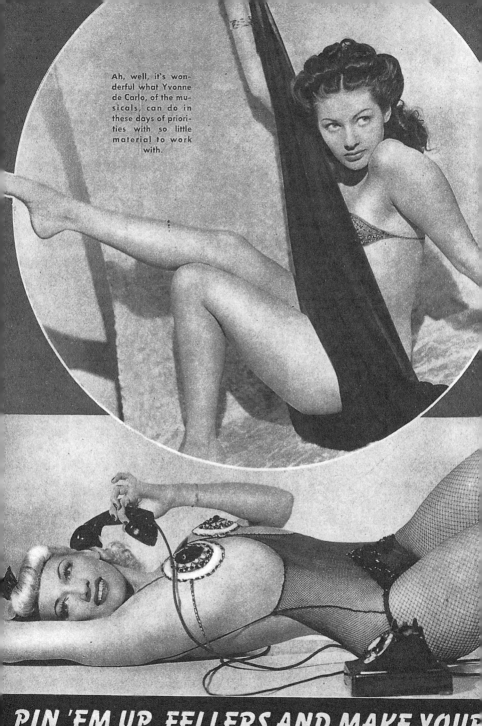

Ah, well, it's wonderful what Yvonne de Carlo, of the musicals, can do in these days of priorities with so little material to work with.

PIN 'EM UP, FELLERS AND MAKE YOU

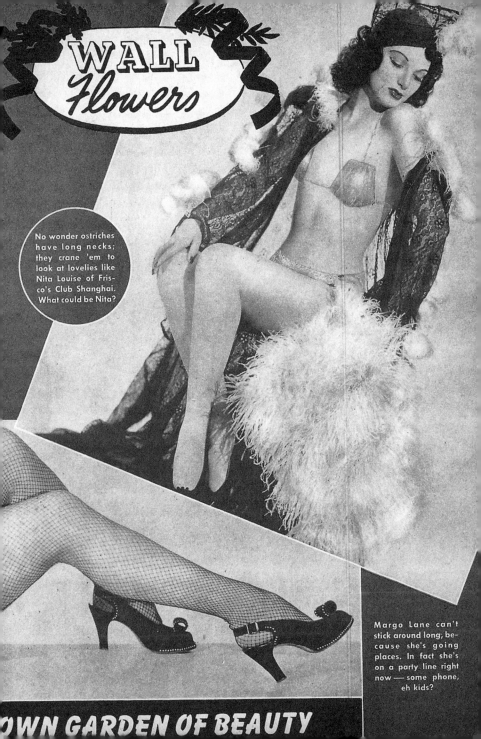

WALL
Flowers

No wonder ostriches have long necks; they crane 'em to look at lovelies like Nita Louise of Frisco's Club Shanghai. What could be Nita?

Margo Lane can't stick around long, because she's going places. In fact she's on a party line right now — some phone, eh kids?

OWN GARDEN OF BEAUTY

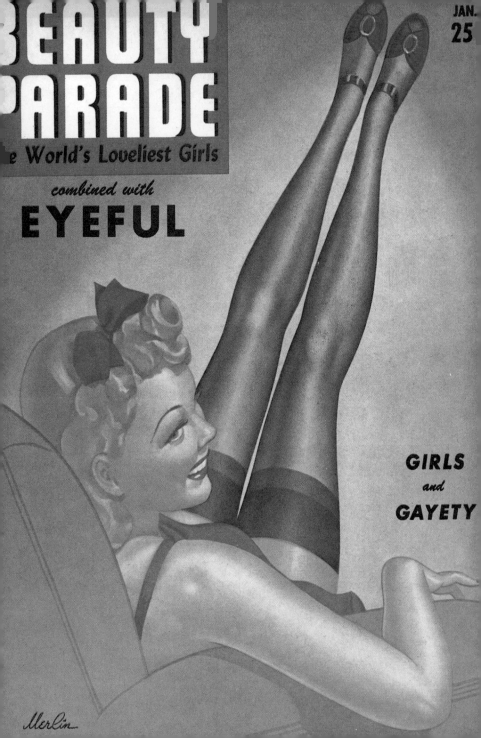

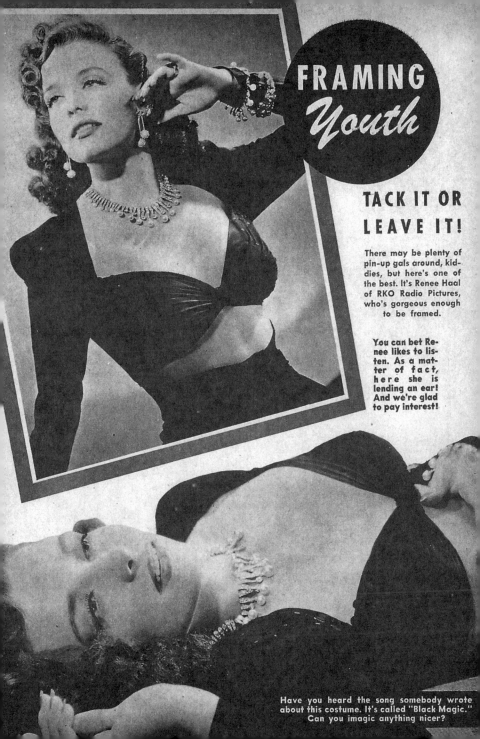

FRAMING *Youth*

TACK IT OR LEAVE IT!

There may be plenty of pin-up gals around, kiddies, but here's one of the best. It's Renee Haal of RKO Radio Pictures, who's gorgeous enough to be framed.

You can bet Renee likes to listen. As a matter of fact, here she is lending an ear! And we're glad to pay interest!

Have you heard the song somebody wrote about this costume. It's called "Black Magic." Can you imagic anything nicer?

BEAUTY PARADE

The World's Loveliest Girls

25c

OVER 100
PIN-UP
Beauties

**BROADWAY
HOLLYWOOD
NITELIFE**

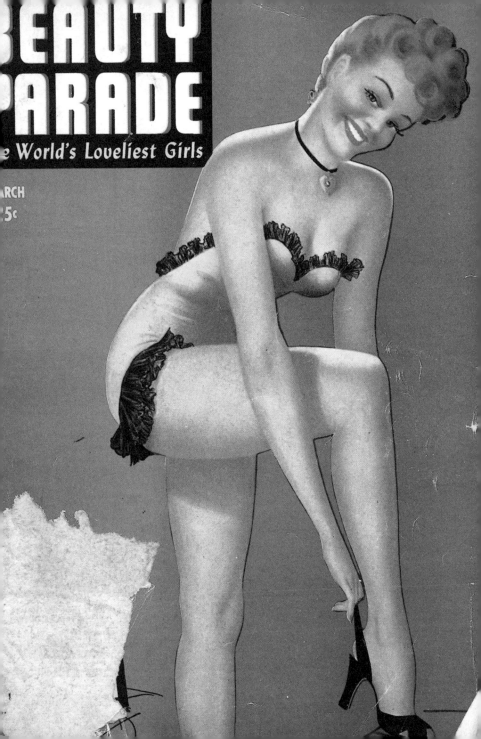

BEAUTY PARADE

e World's Loveliest Girls

ARCH
5c

BEAUTY PARADE

he World's Loveliest Girls

Billy DeVorss

SHOWGIRLS ★ MODELS ★ PIN-UPS

BEAUTY PARADE

The World's Loveliest Girls

NOVEMBER

25¢

PETER

SHOWGIRLS ★ MODELS ★ PIN-UPS

THE
MILKY
WAY

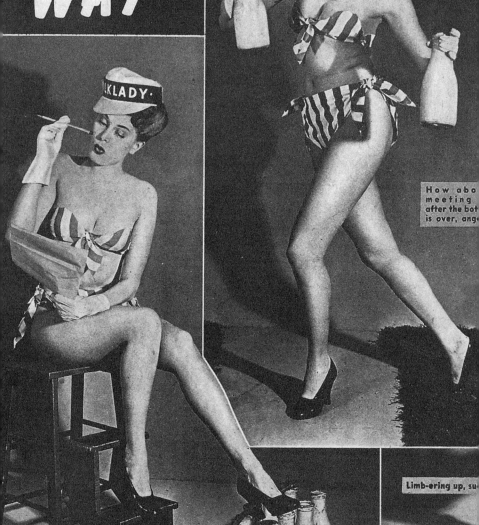

How abo
meeting
after the bot
is over, ang

Limb-ering up, su

Well, well, sittin'
pretty, eh, sugar?

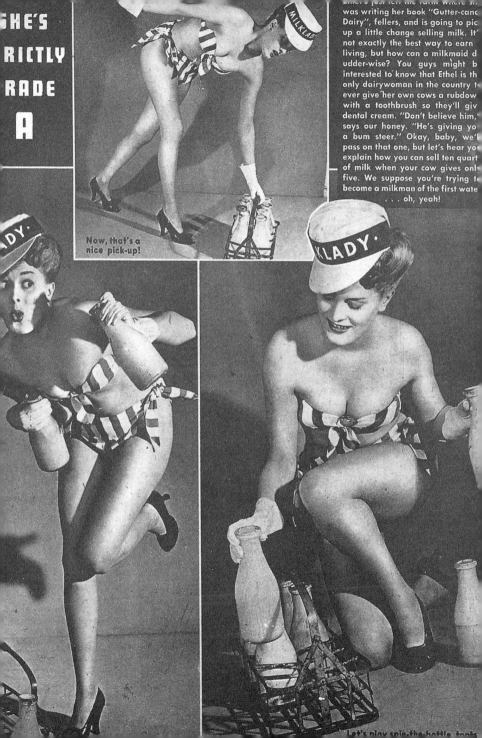

HE'S STRICTLY TRADE A

...her's just left the farm where she was writing her book "Gutter-canc Dairy", fellers, and is going to pic up a little change selling milk. It' not exactly the best way to earn living, but how can a milkmaid d udder-wise? You guys might b interested to know that Ethel is th only dairywoman in the country t ever give her own cows a rubdow with a toothbrush so they'll giv dental cream. "Don't believe him, says our honey. "He's giving yo a bum steer." Okay, baby, we'l pass on that one, but let's hear yo explain how you can sell ten quart of milk when your cow gives onl five. We suppose you're trying t become a milkman of the first wate . . . oh, yeah!

Now, that's a nice pick-up!

Let's play spin-the-bottle teets

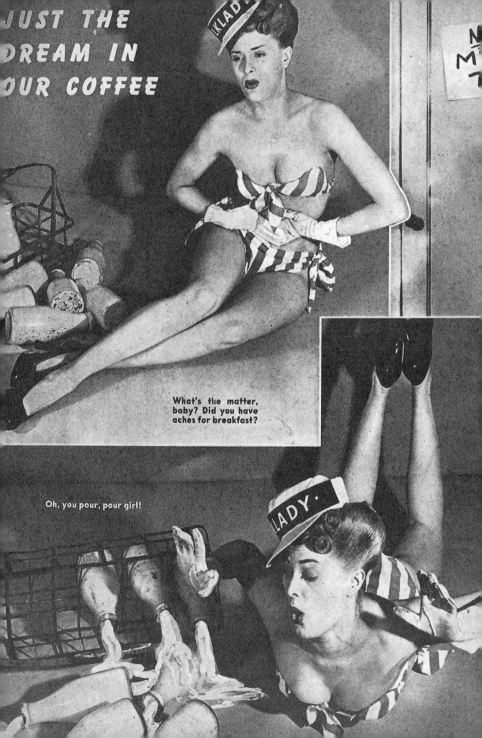

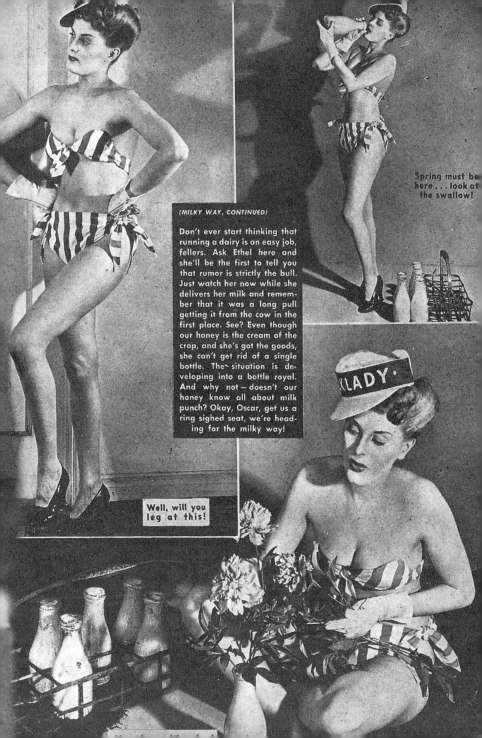

Spring must be here . . . look at the swallow!

(MILKY WAY, CONTINUED)

Don't ever start thinking that running a dairy is an easy job, fellers. Ask Ethel here and she'll be the first to tell you that rumor is strictly the bull. Just watch her now while she delivers her milk and remember that it was a long pull getting it from the cow in the first place. See? Even though our honey is the cream of the crop, and she's got the goods, she can't get rid of a single bottle. The situation is developing into a bottle royal. And why not — doesn't our honey know all about milk punch? Okay, Oscar, get us a ring sighed seat, we're heading for the milky way!

Well, will you leg at this!

BEAUTY
PARADE

he World's Loveliest Girls

JANUA
25

SHOWGIRLS ★ MODELS ★ PIN-UPS

BEAUTY PARADE

he World's Loveliest Girls

ARCH
5c

PETER
DRIBEN—

MODELS ★ PIN-UPS SHOW GIRLS

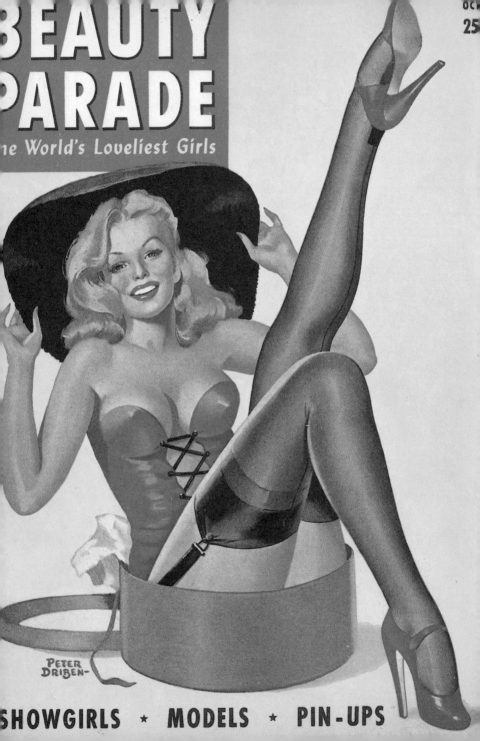

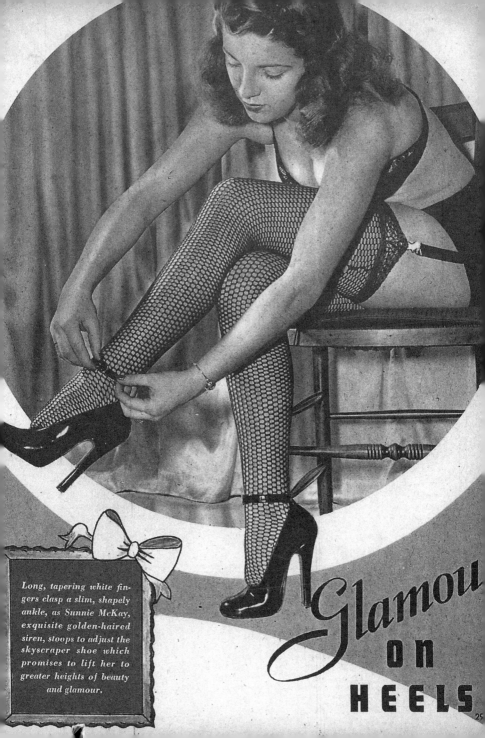

Long, tapering white fingers clasp a slim, shapely ankle, as Sunnie McKay, exquisite golden-haired siren, stoops to adjust the skyscraper shoe which promises to lift her to greater heights of beauty and glamour.

Glamour
ON
HEELS

25

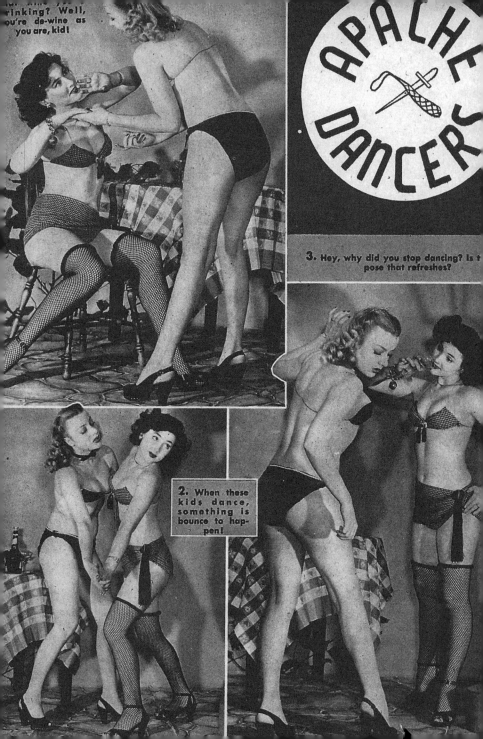

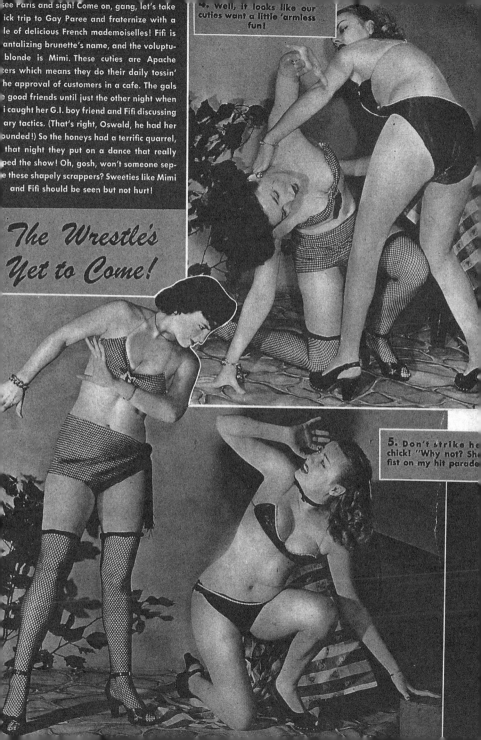

...ee Paris and sigh! Come on, gang, let's take ...ick trip to Gay Paree and fraternize with a ...le of delicious French mademoiselles! Fifi is ...antalizing brunette's name, and the voluptu- ...blonde is Mimi. These cuties are Apache ...ters which means they do their daily tossin' ...he approval of customers in a cafe. The gals ...e good friends until just the other night when ...i caught her G.I. boy friend and Fifi discussing ...ary tactics. (That's right, Oswald, he had her ...ounded!) So the honeys had a terrific quarrel, ...that night they put on a dance that really ...ped the show! Oh, gosh, won't someone sep- ...e these shapely scrappers? Sweeties like Mimi ...and Fifi should be seen but not hurt!

The Wrestle's Yet to Come!

4. Well, it looks like our cuties want a little 'armless fun!

5. Don't strike he chick! "Why not? She fist on my hit parade

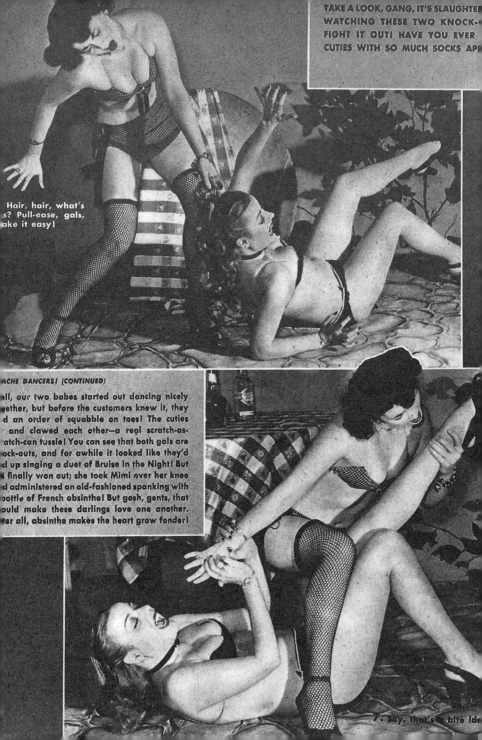

Hair, hair, what's
s? Pull-ease, gals,
ake it easy!

ACHE DANCERS! (CONTINUED)

ell, our two babes started out dancing nicely
gether, but before the customers knew it, they
d an order of squabble on toes! The cuties
and clawed each other—a real scratch-as-
atch-can tussle! You can see that both gals are
ock-outs, and for awhile it looked like they'd
d up singing a duet of Bruise in the Night! But
finally won out; she took Mimi over her knee
d administered an old-fashioned spanking with
bottle of French absinthe! But gosh, gents, that
ould make these darlings love one another.
ter all, absinthe makes the heart grow fonder!

7 - Say, that's a bire Ide

THESE GALS
KNOW ALL THE
Tangles!

ey, kids, how
meeting us after
brawl is over?

*Today's
Weather:*
FAIR
and
UHAMMER!

9. So it ended up with a
spanking! Just a couple of
slap-hippy cuties!

BEAUTY PARADE

he World's Loveliest

DE
25

SHOWGIRLS
*
MODELS
*
PIN-UPS

PETER
DRIBENT

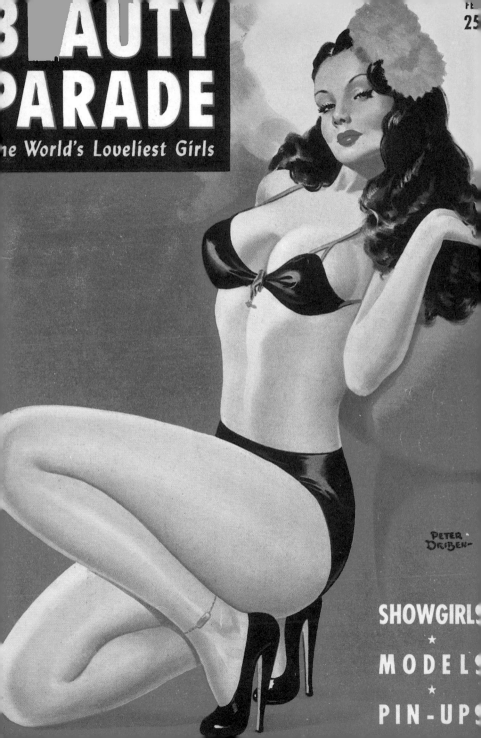

BEAUTY PARADE

The World's Loveliest Girls

FE

25

PETER
DRIBEN

SHOWGIRLS
★
MODELS
★
PIN-UPS

Surrender

Abject misery and sufferin
are etched strongly on the de
icate features of Agnes Dan
who depicts a slave-girl upe
an ancient auction bloc
Like the unhappy lovelies
old, Agnes assumes the po
of fearful surrender.

BEAUTY PARADE

47

PARADE

e World's Loveliest Girls

25c

SHOWGIRLS
*
MODELS
*
PIN-UPS

PETER
DRIBEN—

TITIAN TEMPTRES

Long, lustrous, gorgeously glistening tresses drop in rich, silken rivulets down the alabaster, gently curved back of luscious looking Betty Howell. This fascinating, golden adornment is not the least of Betty's many charms which encompass a small 24 inch waist 'mid full 35 inch bust and hips.

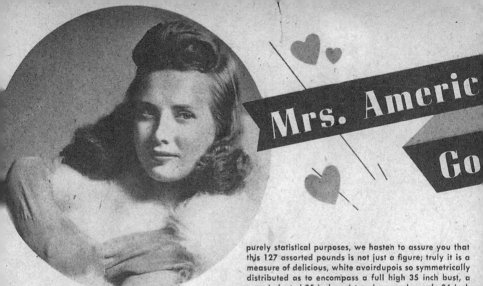

Mrs. Americ
Go

NO, GENTLEMEN, she's not eligible, but if you are perspicacious you'll read on, so that you can set your standards for the future "missus" along these very curvaceous lines. If ever you set up ideals for the perfect wife type we're sure that at their very wildest they failed to meet the actual possessions of blonde, buxom and beautiful Peggy Payne, the gal who has everything including a husband. However, if you overlook that one very important item, we'll set out to prove that this is as tantalizing a tootsie as you'll ever meet.

Just a few short years ago, this sweet Southern siren set out for fame and fortune via a modeling career "up No'th." No sooner had she planted her stakes at a wholesale house in New York that things began to "pop." Peggy took the town by storm, and left a trail of broken hearts behind as she walked off with one gloriously lucky man, Charles Danny Payne, a vocalist with a band.

But even so final a conquest failed to stop the unconquerable Peggy for she entered a beauty contest where just one glance from the judges proclaimed her Miss "Perfect." But at this intersection fate stepped in to obstruct her—but just temporarily. It seemed that as a married woman, Peggy could not compete against the other maidens. So though Atlantic City did not see her that year, she became a national figure by entering and winning the Mrs. America contest.

One-hundred and 48 gorgeous girls of all assorted sizes, shapes and descriptions pitted their lush, white bodies for the great honor which Peggy copped with little effort.

It was then that the nation in general was privileged to observe this stunning creature as she set out in a triumphant tour across the country to prove that girls can be glamorous though married.

The particular girl in this case was the true, living example. Peggy stands five feet six and one half inches in her stocking feet and weighs a full 127 pounds. But for purely statistical purposes, we hasten to assure you that this 127 assorted pounds is not just a figure; truly it is a measure of delicious, white avoirdupois so symmetrically distributed as to encompass a full high 35 inch bust, a wee, indented 25 inch waist and a round, ample 36 inch hip measure.

Lovely Peggy makes no effort whatsoever to keep her weight down—she's had far too many a compliment on her buxom beauty! Food is a passion without which Peggy would be frustrated indeed. High on her list of delicious things to eat, Peggy lists strawberry shortcake, cheese blintzes, potato pancakes and steak.

Currently, the luscious Mrs. Payne, voted Mrs. Broadway for 1947, is wowing them in nightclub engagements, while keeping a bright, blue eye peeled for Hollywood offers. When gorgeous Peggy hits the film mecca, we're bound to predict she'll set the town afire, and sadden the hearts of the Hollywood wolves.

Yet, though pretty Peggy Payne may wear a "TAKEN" sign prominently displayed across her gorgeous chest, we're sure the boys will never stop looking—and hoping that they'll cop a prize as delightfully luscious for their own in the matrimonial sweepstakes.

Meet Luscious Peggy Payne, a Curvey Cookie who Scores as the Nation's Top Wife

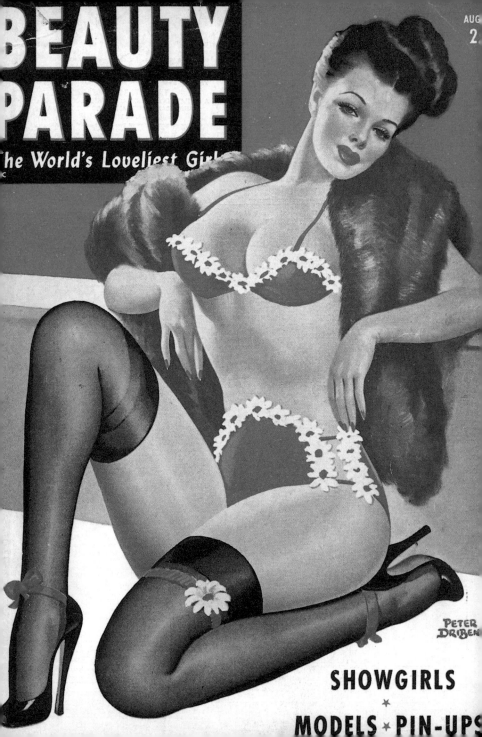

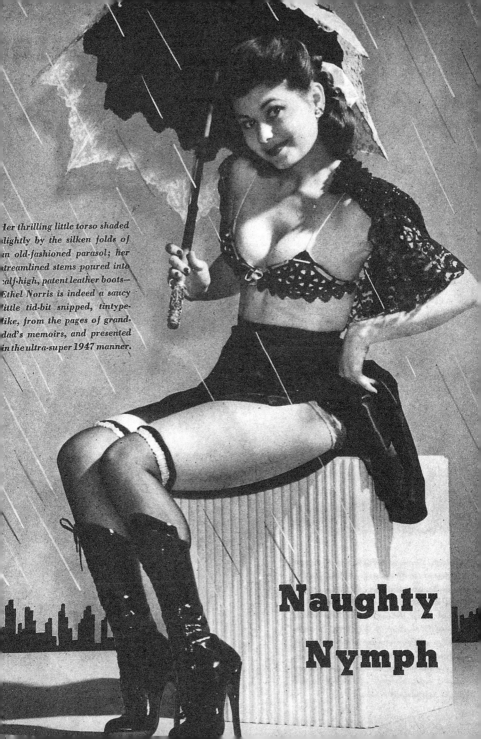

Her thrilling little torso shaded slightly by the silken folds of an old-fashioned parasol; her streamlined stems poured into calf-high, patent leather boots— Ethel Norris is indeed a saucy little tid-bit snipped, tintype-like, from the pages of grand-dad's memoirs, and presented in the ultra-super 1947 manner.

Naughty
Nymph

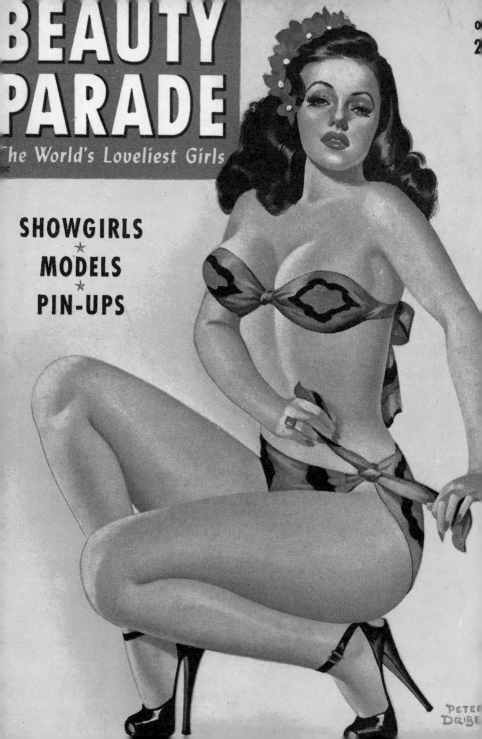

BEAUTY PARADE

The World's Loveliest Girls

FEB.
25c

PETER
DRIBEN

SHOWGIRLS ★ MODELS ★ PIN-UPS

Dear Diary

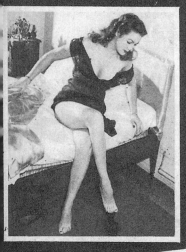

Tuesday

Dear Diary—

Well, you'll never believe it, but that little call was on the level. I really am going to be in a Broadway show. It was noon this morning before the phone started to ring. The same voice as yesterday spoke to me. This time everything was clear. "Miss Andre," he said, "it was very unfortunate that we didn't get together conversationally yesterday." Then I blubbered and explained how surprised I was. "Look, Miss Andre," he continued, "I saw your picture in BEAUTY PARADE. Bob Harrison, the publisher, tells me you're a very talented girl. I want you for my show, "Tee For Two."

Monday

Dear Diary—

What a day! And it all started so early, too. Heck, there it was, only 10:30 in the morning (middle of the night, as a matter of fact) and the blankety-blank phone kept ringing like blazes. Gosh, it was loud enough to wake the dead, and for all that last night had been a killer, I was still too alive to be a corpse. A masculine voice said, "Miss Andre—Miss Eve Andre? How would you like to be in my show?" Well, if ever there was a time for a girl to say "yes," that was it. So I simply shouted into the phone —"Yes, oh, yes." "That's fine," said the voice, hanging up. After I recovered from the shock, and finished counting the dough, I realized I hadn't asked who was calling.

A Hectic Week In The Life O

Thursday

Dear Diary—

I've got 33 sides which in theatrical lingo means I'm practically next door to a star. I guess I'll never memorize all the lines I have to say and all the songs I have to sing, to say nothing of all the steps I have to dance. Boy, I never knew it was this hard being an actress. Why, I hardly have any time left for any kind of real love life. Maybe it's too early in the game to judge, but from where I sit it looks like a lot of work, and I do mean work. We rehearse till we drop, then I rush home, drop my clothes, drop onto the sofa and rehearse some more, while the phone rings like mad, and the men in my life begin to think that Evie doesn't live here any more.

Wednesday

Dear Diary—

Well, I got the job. I walked into the Superb Theatre all shakes. A stageful of girls, all of whom looked prettier than I, greeted my eye. But the director seemed to know all about me. I got up on the stage, and it seemed as if all the floodlights in captivity centered on me. "How tall are you," the director asked. "I'm 5 feet 6 inches tall. I weigh 118 pounds, have a 36 bust, a 25 inch waist and 36 inch hips —I'm a Methodist and I come from Santa Barbara." I blurted. "Thank you," said the director, "I really wanted to know your height but the extra information helps. And incidentally, how about your telephone number?" After that it was all easy.

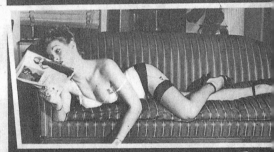

Friday

Dear Diary—

I spoke to Mr. White personally today, which, if I haven't said so before, is a great and rare privilege. He made me back off while he took a good look at my legs. "Joe" he said to the press agent, "These are the gams we're going to publicize. Take her around to the photographer and let's make some super-sexy cheesecake photos. This baby's got stuff. Just look at her eyes, too." We ran off to a studio where a photographer had me strip, and then draped me in black velvet looking for the oomphiest effects. Do you think it's right, Diary, for me to send the very "oomphiest" photo of all to BEAUTY PARADE, even before I get to be a star?

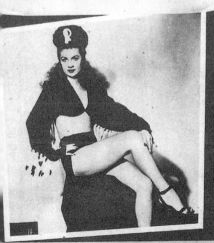

Evie Andre, A Luscious Model

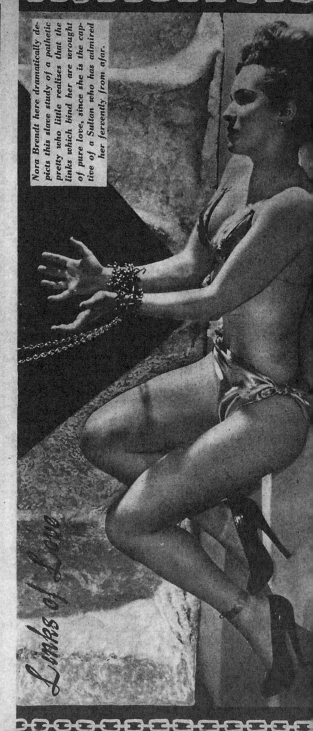

Nora Brendt here dramatically depicts this slave study of a pathetic pretty who little realizes that the links which bind her are wrought of pure love, since she is the captive of a Sultan who has admired her fervently from afar.

Links of Love

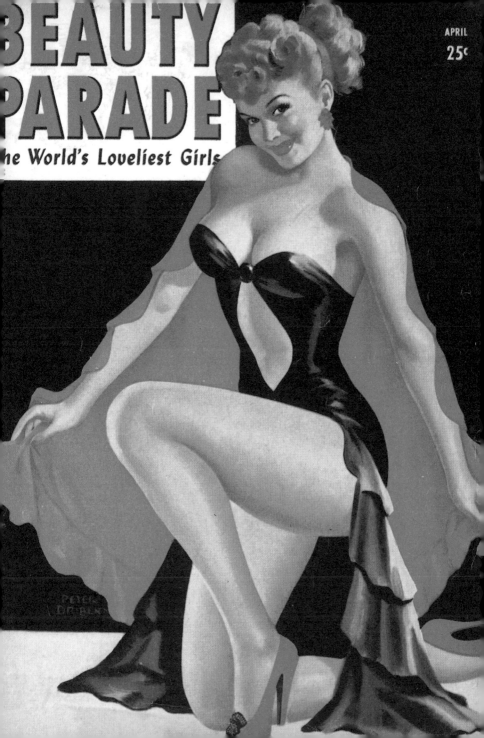

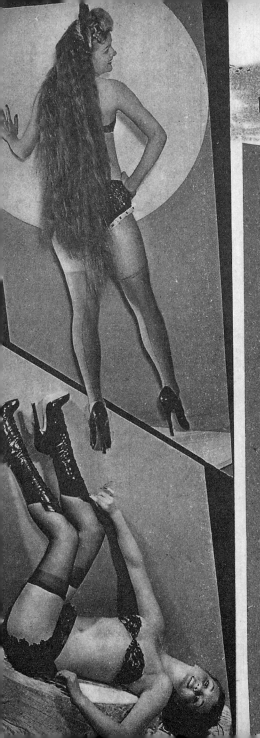

Correspon

beauty parade's gener

ence Corner

osed office

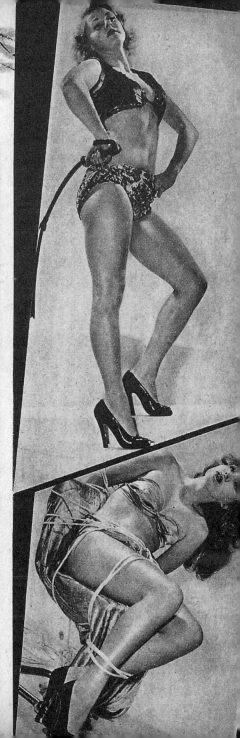

Pottsville, Pa.

Editor,

You are right when you say it takes a woman of great theatrical ability to adequately enact the role of a dominant woman. This is a part that calls for (1) physical strength and ferocity so she really looks like she stepped out of the jungle, (2) a savage expression that shows she means business, and (3) a pose where you can see her determination and desire to dominate. I saw a female animal trainer at the circus this year who had all those qualifications. How about picking out a Savage Siren just for me, Editor? I'll really appreciate it.

SLAVE TO BEAUTY

Freeport, L. I.

Dear Sir:

Yours is a unique and wonderful magazine. Permit me to say at last how much I've enjoyed it.

Although you are progressing in a direction that I certainly like, I do have a request--if it has not already been granted in the plans for your next issue. Please let's have more and more and more beautiful slave girls, some in the lovely misery of surrender, chained hand and foot or roped severely and tightly. Perhaps I speak for the majority--I don't know. But at least one of your ardent fans would be most highly pleased. May I say thanks.

H. S. L.

BEAUTY PARADE

The World's Loveliest Girls

48 JUNE
25¢

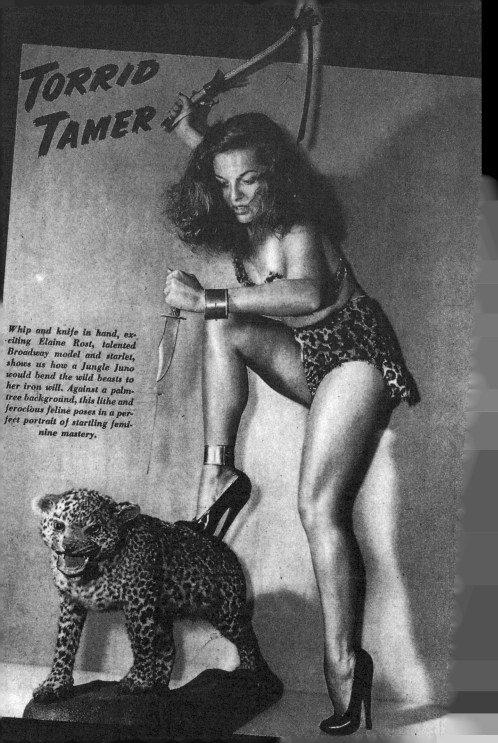

TORRID TAMER

Whip and knife in hand, exciting Elaine Rost, talented Broadway model and starlet, shows us how a Jungle Juno would bend the wild beasts to her iron will. Against a palm-tree background, this lithe and ferocious feline poses in a perfect portrait of startling feminine mastery.

BEAUTY PARADE

The World's Lovel...

PDC

AUGUST
25¢

PETER
DRIBEN

SHOWGIRLS ★ MODELS ★ PIN-UPS

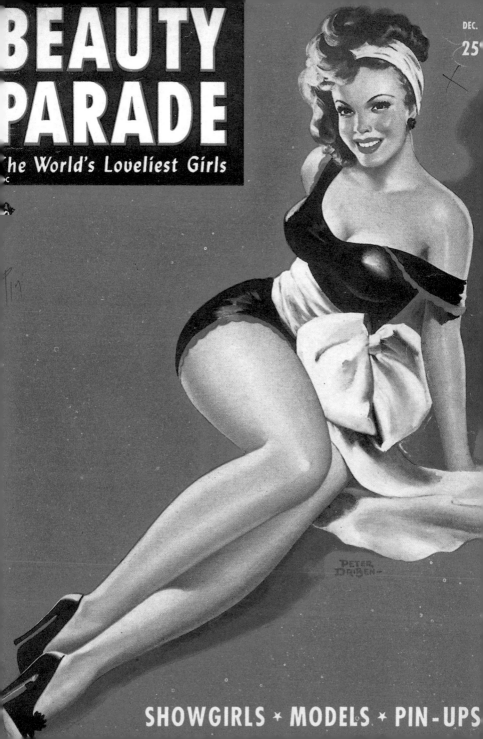

BEAUTY PARADE

the World's Loveliest Girls

DEC.

25¢

PETER DRIBEN

SHOWGIRLS ★ MODELS ★ PIN-UPS

BEAUTY PARADE

PARADE

The World's Loveliest Girls

FEB.

25¢

SHOWGIRLS
MODELS
PIN-UPS

PETER
DRIBEN

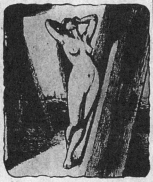

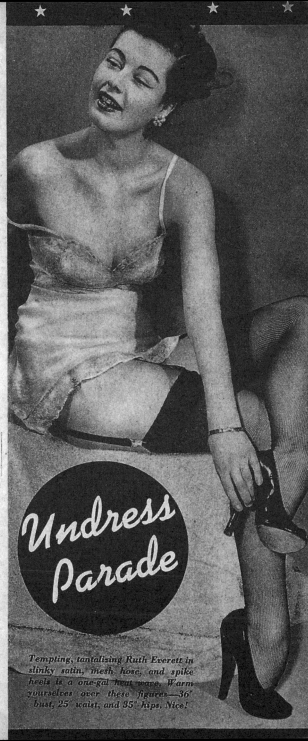

Undress Parade

Tempting, tantalizing Ruth Everett in slinky satin, mesh hose, and spike heels is a one-gal heat wave. Warm yourselves over these figures—36" bust, 25" waist, and 35" hips. Nice!

BEAUTY PARADE

The World's Loveliest Girls

APRIL

25¢

Levorss

SHOW GIRLS ★ MODELS ★ PIN-UPS

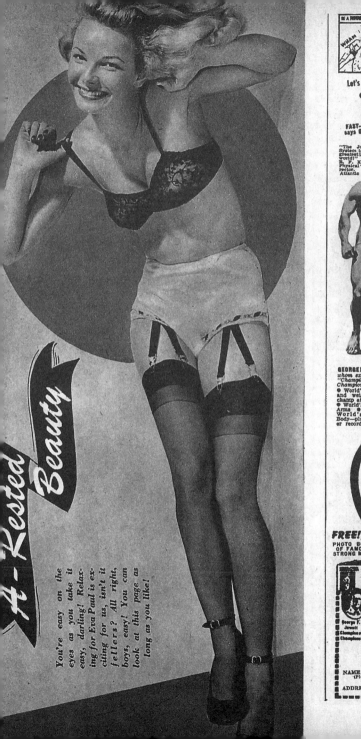

A-Rested Beauty

You're easy on the eyes as you take it easy, darling! Relaxing for Eva Paul is exciting for us, isn't it fellers? All right, boys, easy! You can look at this page as long as you like!

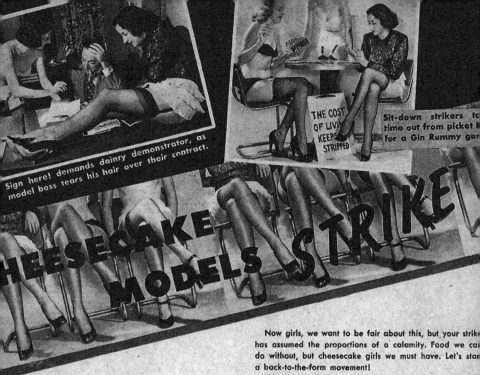

Sign here! demands dainty demonstrator, as model boss tears his hair over their contract.

THE COST OF LIVING KEEPS STRIPPED

Sit-down strikers t_ time out from picket _ for a Gin Rummy ga_

CHEESECAKE MODELS STRIKE

WHAT gives here? Now the gals who model for those pictures we love have gone on strike! To the hills men, it's the end of the world! It seems the babes want more for wearing less, and they've gone and formed a union, The United Cheesecake Models.

The girls have opened a campaign to get the male public on their side (where else would we be) and to force the bosses to pay them more because the cost of living keeps them stripped. Is that bad, boys?

Fortunately we were able to get some pictures of the picket line—and such picket lines you never saw! They have invaded the offices of the lucky dogs who hire their charms, and tried to force them to sign a contract covering their demands. So far the bosses haven't given in. What are those guys made of, stone?

City authorities view the strike with alarm, and are keeping a watchful eye on the proceedings. We don't blame them—so are thousands of other males.

We've interviewed several of the picketing pretties, and believe us, they do have a leg to stand on in this controversy. Their picket line has curves and their strike is going to be no bust.

Even the law treads lightly in dealing with these striking strikers. The girls stand right up to the cops, and many a tough gendarme forgets his hardboiled routine when confronted by one of these scantily clad demonstrators. We know how you feel, flatfoot!

Now girls, we want to be fair about this, but your strik_ has assumed the proportions of a calamity. Food we ca_ do without, but cheesecake girls we must have. Let's star_ a back-to-the-form movement!

We have a plan to settle the dispute. If the bosses won'_ give in, the customers should be glad to pass the hat. O_ the other hand, why not let the strike go on? That picke_ line is something to see! Yeah, you shed it, girls!

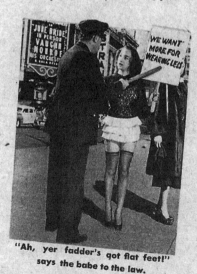

"Ah, yer fadder's got flat feet!" says the babe to the law.

Glamorous Gals With The Gams Want More F_

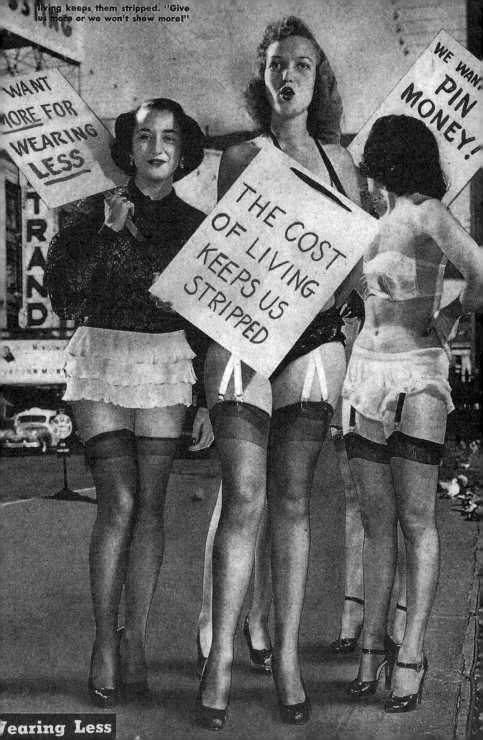

BEAUTY PARADE

he World's Loveliest Girls

JUNE
25c

PETER
DRIBEN

SECRETS OF A STRIPPER
Page 26

SPANKINGS FOR WIVES
Page 36

BEAUTY PARADE

e World's Loveliest Girls

STRIPPER'S
AUCTION
Page 24

KISSING AROUND
THE WORLD Page 12

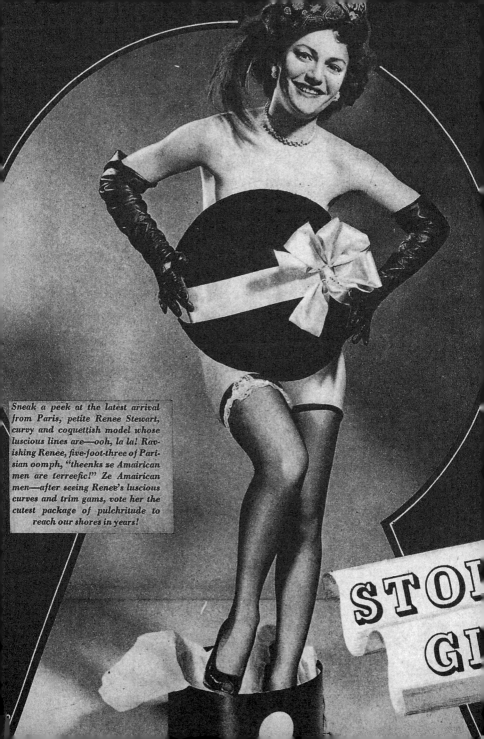

Sneak a peek at the latest arrival from Paris, petite Renee Stewart, curvy and coquettish model whose luscious lines are—ooh, la la! Ravishing Renee, five-foot-three of Parisian oomph, "theenks ze Amairican men are terreefic!" Ze Amairican men—after seeing Renee's luscious curves and trim gams, vote her the cutest package of pulchritude to reach our shores in years!

STOL
GI

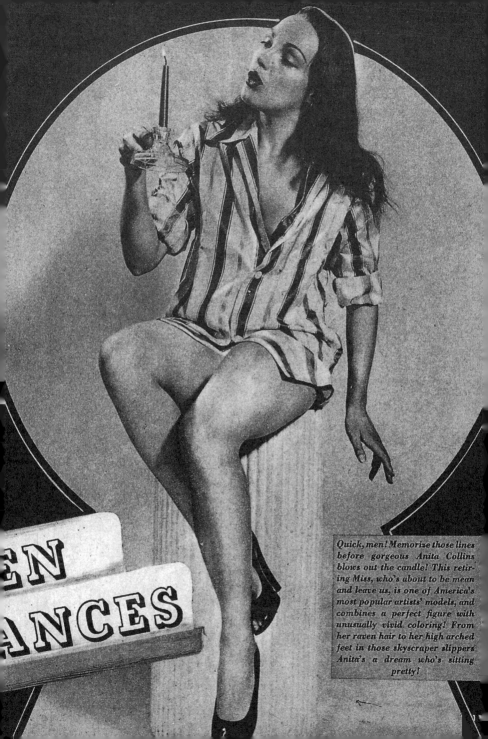

EN
ANCES

Quick, men! Memorize those lines before gorgeous Anita Collins blows out the candle! This retiring Miss, who's about to be mean and leave us, is one of America's most popular artists' models, and combines a perfect figure with unusually vivid coloring! From her raven hair to her high arched feet in those skyscraper slippers Anita's a dream who's sitting pretty!

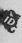

BEAUTY PARADE

The World's Loveliest Gi

SE

2.

BEAUTY and the BEAST

Page 34

USED MAGAZINES
221 OCCIDENTAL A

DC

SECRETS OF A FEMALE IMPERSONATO

eina's curvy con
ours peek teasing
rough the flowers

Another view of the bru-
nette bombshell with the
beautiful, dimpled back.

A Toast to Ren

Peering coquettishly over a white, dimpled shoulder, Rosita would make anybody's hot toddy hotter still.

mber

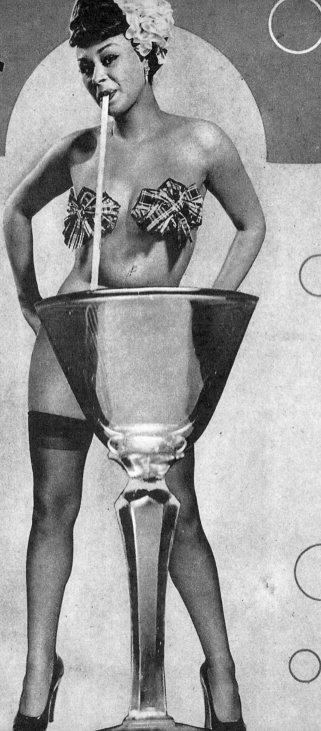

DRINK to me only with thine eyes Baby—says red-headed Rosita Davis, daring dancer at New York's Savannah Club, seen here taking a wee sip of the cup that cheers. A dynamic dish, Rosita has a pair of the most shapely legs around and in her six-inch high heels, she's an exciting toast all over town, say audiences. With her 35-inch bust and other admirable measurements, she's a dazzling darling, eh?

★

ead!

BEAUTY PARADE

NOV.
25¢

The World's Lovelies

NAUGHTY
PARIS
NIGHTLIFE

PETER
DRIBEN

SEX IN THE
HILLS

BEAUTY PARADE

e World's Loveliest Girls

JAN.
25¢

BEAUTY ON THE MAT

NO BABE IS HARD TO GET

PETER DRIBEN

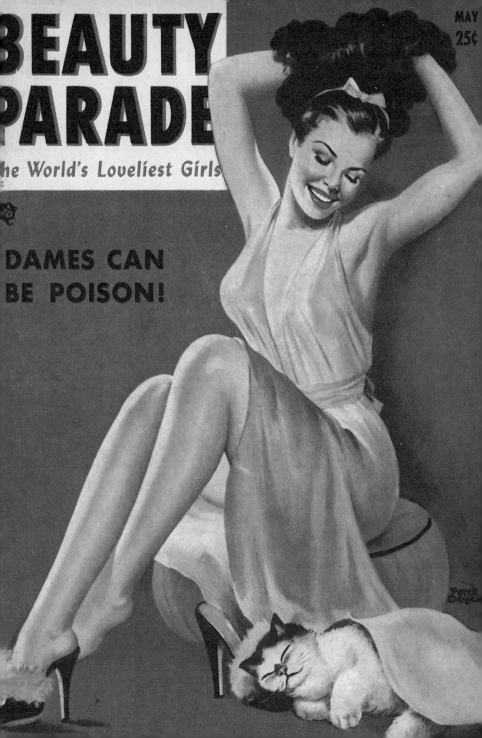

NOV.
25¢

BEAUTY PARADE

he World's Lov

FABULOUS
BACHELOR
GIRL!

PETER
DRIBEN

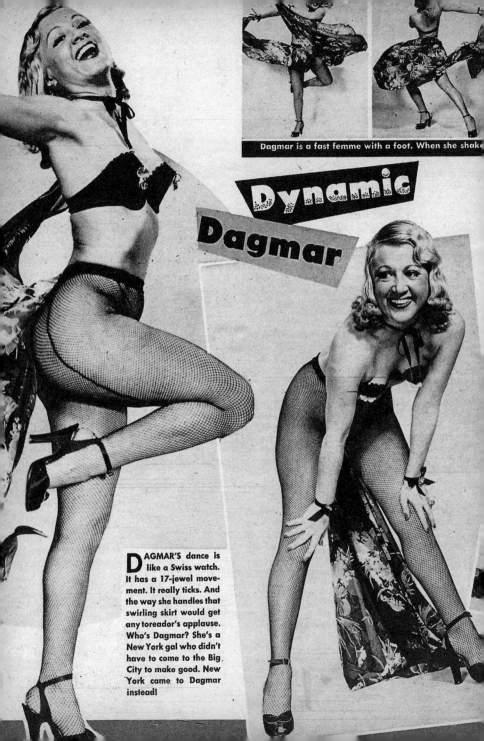

Dagmar is a fast femme with a foot. When she shake[s]

Dynamic
Dagmar

DAGMAR'S dance is like a Swiss watch. It has a 17-jewel movement. It really ticks. And the way she handles that swirling skirt would get any toreador's applause. Who's Dagmar? She's a New York gal who didn't have to come to the Big City to make good. New York came to Dagmar instead!

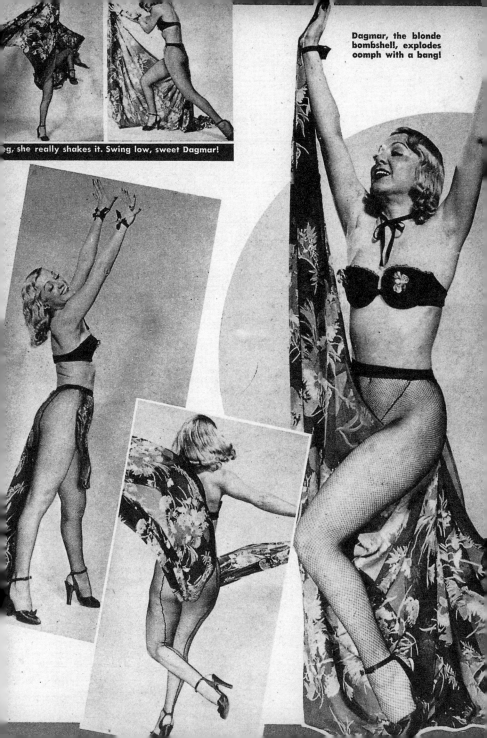

g, she really shakes it. Swing low, sweet Dagmar!

Dagmar, the blonde
bombshell, explodes
oomph with a bang!

BEAUTY PARADE

51

JAN.

25¢

PARADE

he World's Loveliest Gir

PETER
DRIBEN

DANCIN' DYNAMITE!

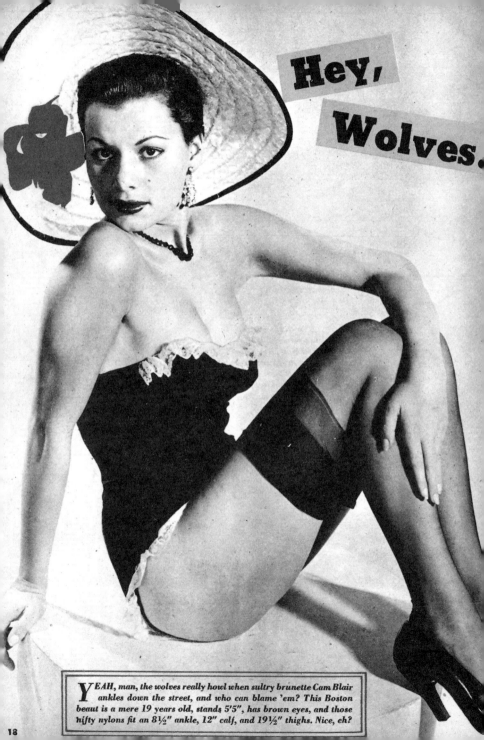

Hey,
Wolves.

YEAH, man, the wolves really howl when sultry brunette Cam Blair ankles down the street, and who can blame 'em? This Boston beaut is a mere 19 years old, stands 5'5", has brown eyes, and those nifty nylons fit an 8½" ankle, 12" calf, and 19½" thighs. Nice, eh?

BEAUTY PARADE

The World's Loveliest Girls

MARCH

25¢

SPECIAL ISSUE FOR GUYS

HUNDREDS OF

Beautiful Dolls

PETER DRIBEN

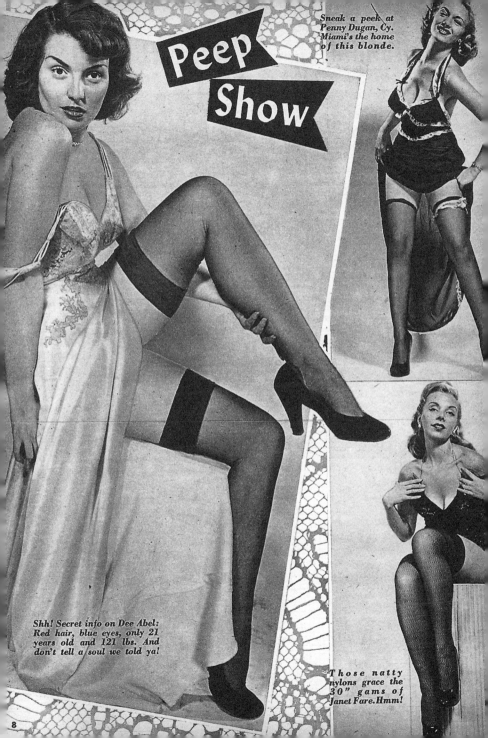

Peep Show

Sneak a peek at Penny Dugan, Cy. Miami's the home of this blonde.

Shh! Secret info on Dee Abel: Red hair, blue eyes, only 21 years old and 121 lbs. And don't tell a soul we told ya!

Those natty nylons grace the 30" gams of Janet Fare. Hmm!

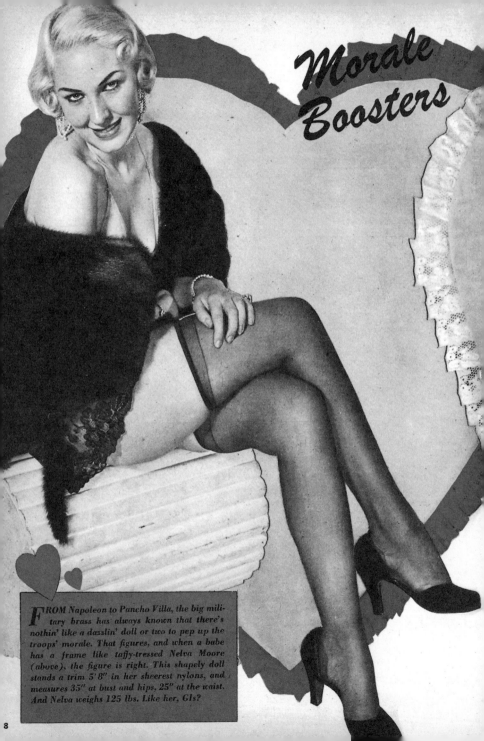

Morale Boosters

FROM Napoleon to Pancho Villa, the big military brass has always known that there's nothin' like a dazzlin' doll or two to pep up the troops' morale. That figures, and when a babe has a frame like taffy-tressed Nelva Moore (above), the figure is right. This shapely doll stands a trim 5' 8" in her sheerest nylons, and measures 35" at bust and hips, 25" at the waist. And Nelva weighs 125 lbs. Like her, GIs?

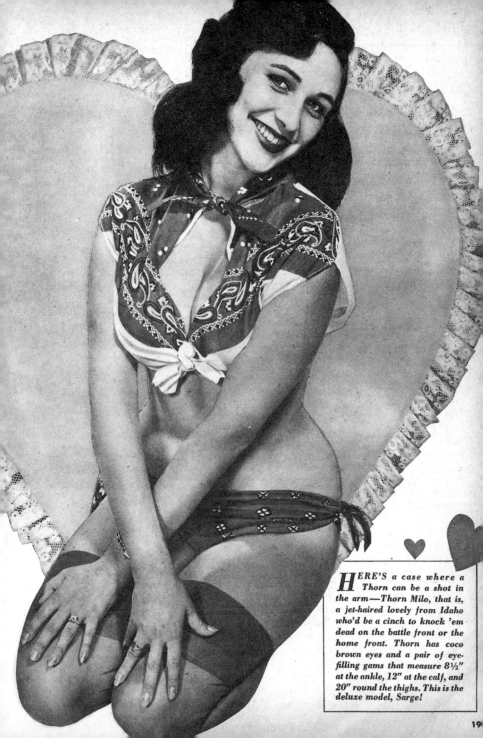

HERE'S a case where a Thorn can be a shot in the arm—Thorn Milo, that is, a jet-haired lovely from Idaho who'd be a cinch to knock 'em dead on the battle front or the home front. Thorn has coco brown eyes and a pair of eye-filling gams that measure 8½" at the ankle, 12" at the calf, and 20" round the thighs. This is the deluxe model, Sarge!

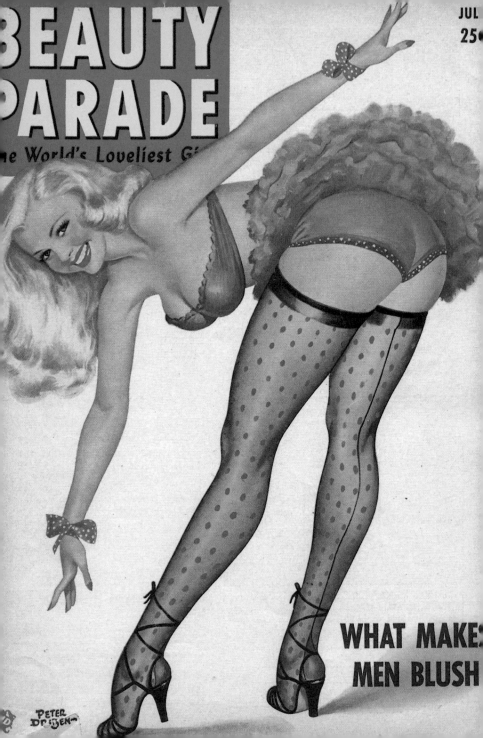

BEAUTY PARADE

SEPT.
25¢

the World's Loveliest Girls

IS BROADWAY GETTING HOTTER?

PETER DRIBEN

Seven Types of *Babes!*

LOOK 'EM OVER, AND DECIDE FOR YOURSELF. YOU'RE ON YOUR OWN!

THEY'RE nobody's sweetheart now! They may be awfully pretty pal, but they're poison! Run, don't walk, to the nearest escape hatch if you meet any of these seven deadly dames. Once they get their hooks into you, they'll make a toothache feel like bliss, and you'll head for the North Pole. Take Clara, the Weeping Willow, or Sickly Sue who's always got a headache. Yessir, take 'em, boys — and duck 'em in the nearest river!

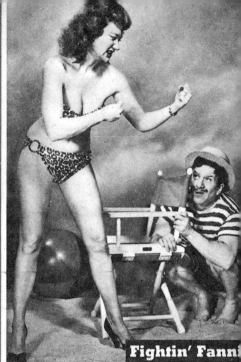

Fightin' Fanni

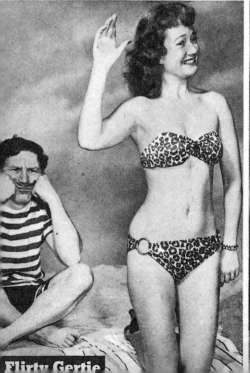

Flirty Gertie

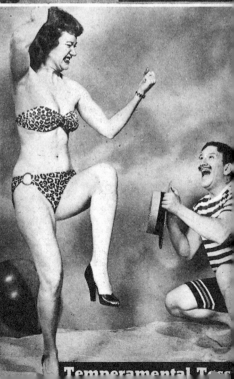

Temperamental Tess

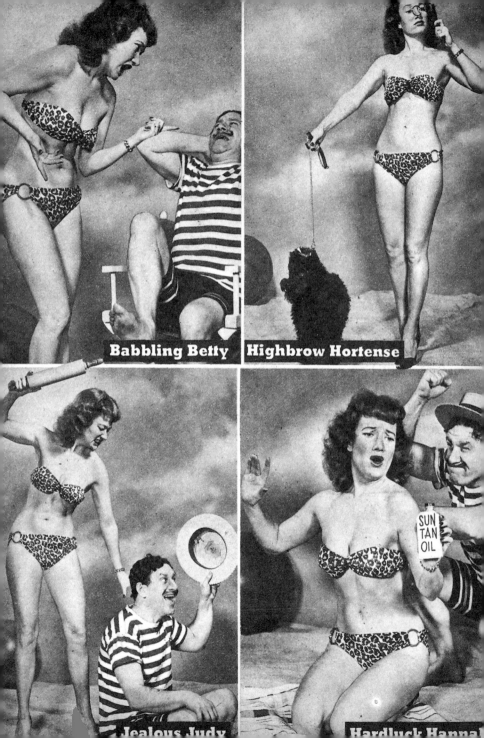

Babbling Betty **Highbrow Hortense**

Jealous Judy **Hardluck Hanna**

SUN
TAN
OIL

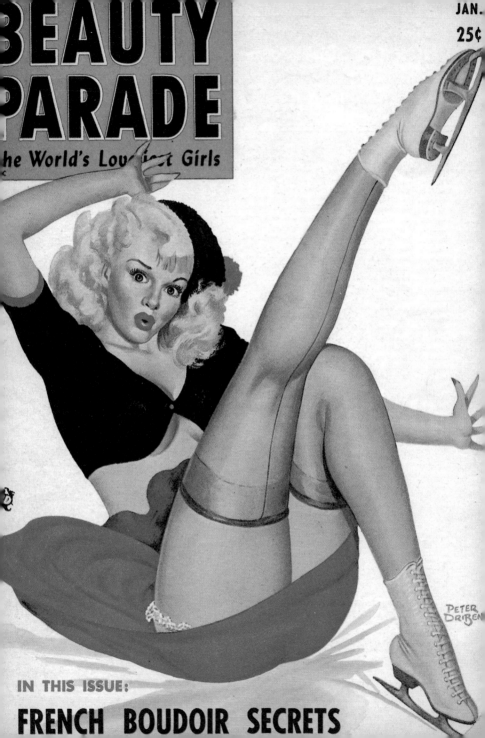

BEAUTY PARADE

he World's Lov iest Girls

JAN.

25¢

PETER
DRIBEN

IN THIS ISSUE:

FRENCH BOUDOIR SECRETS

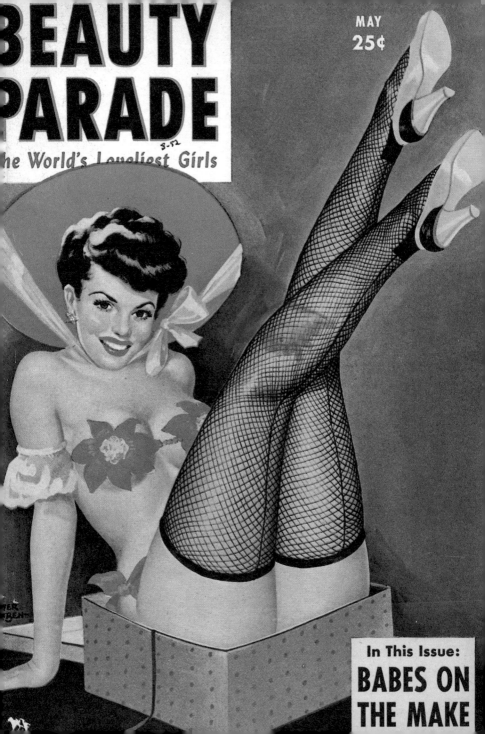

BEAUTY PARADE

SEP. 1.

25¢

e World's Loveli 1952

Peter
Driben-

IN THIS ISSUE:
THE BASHFUL STRIPPER!

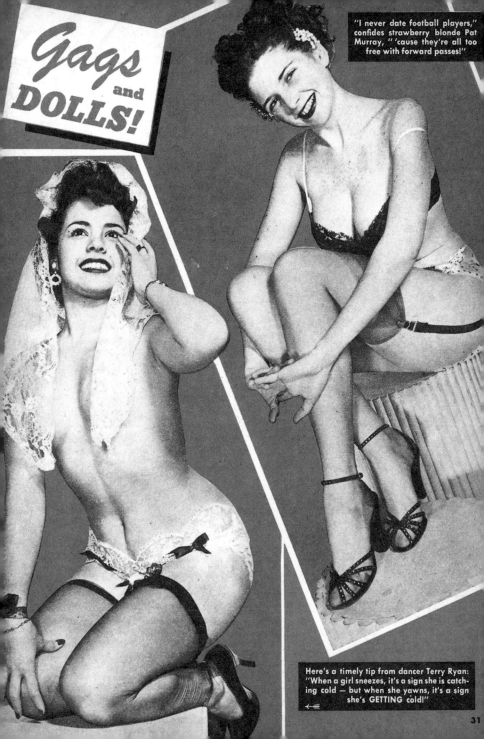

Gags and DOLLS!

"I never date football players," confides strawberry blonde Pat Murray, "'cause they're all too free with forward passes!"

Here's a timely tip from dancer Terry Ryan: "When a girl sneezes, it's a sign she is catching cold — but when she yawns, it's a sign she's GETTING cold!"

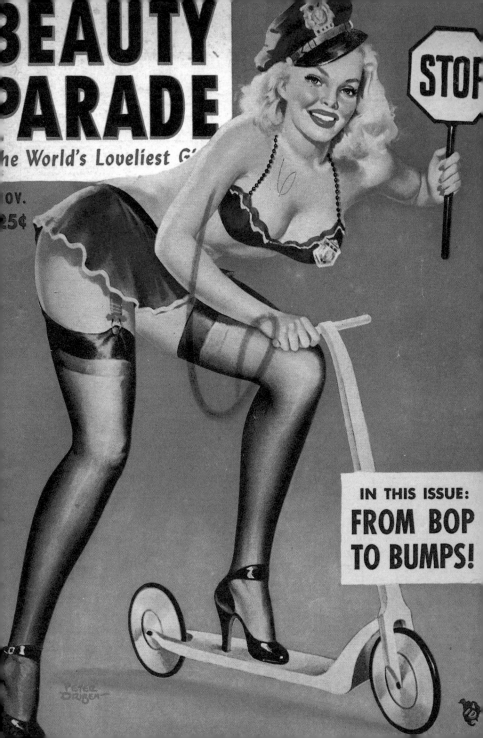

BEAUTY PARADE

The World's Loveliest G...

NOV.
25¢

STOP

IN THIS ISSUE:
FROM BOP TO BUMPS!

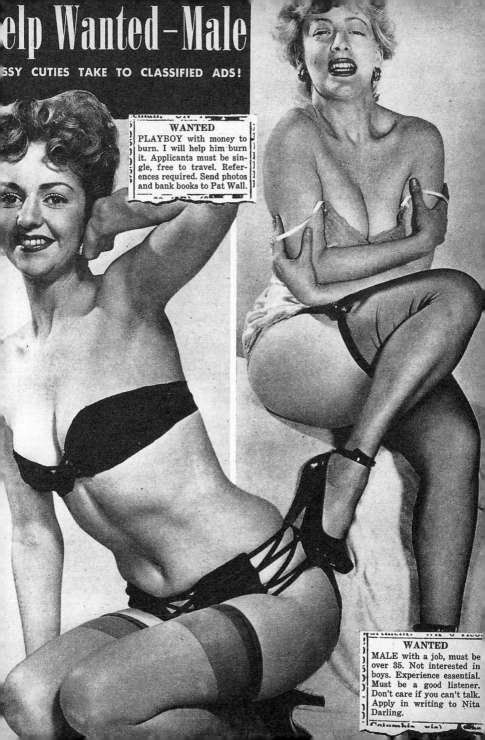

elp Wanted—Male

SSY CUTIES TAKE TO CLASSIFIED ADS!

WANTED
PLAYBOY with money to burn. I will help him burn it. Applicants must be single, free to travel. References required. Send photos and bank books to Pat Wall.

WANTED
MALE with a job, must be over 35. Not interested in boys. Experience essential. Must be a good listener. Don't care if you can't talk. Apply in writing to Nita Darling.

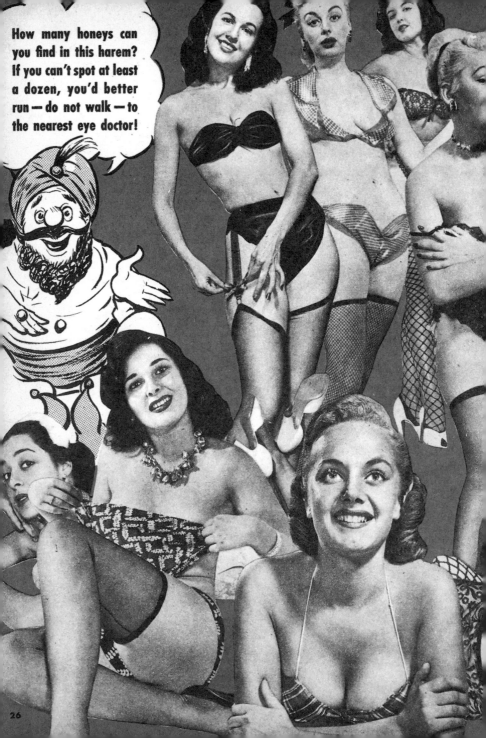

How many honeys can you find in this harem? If you can't spot at least a dozen, you'd better run — do not walk — to the nearest eye doctor!

26

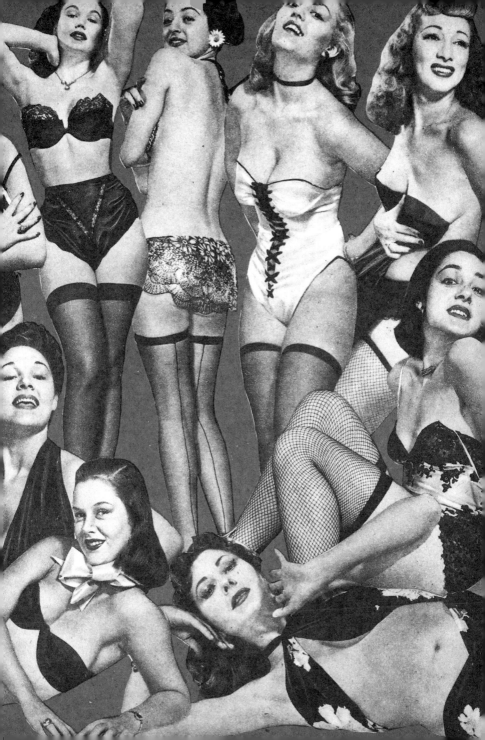

BEAUTY PARADE

The World's Loveliest

JAN

25¢

The
**FARMER'S
NAUGHTY
DAUGHTER!**
SEE PAGE 24

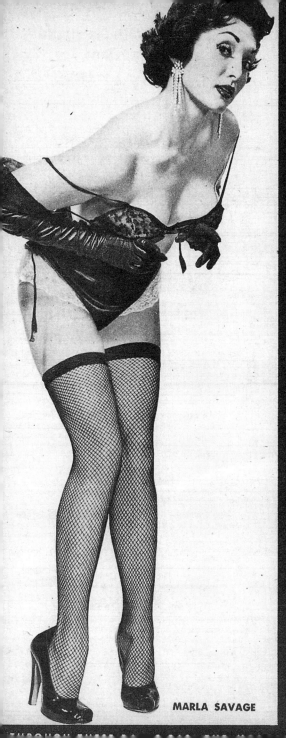

MARLA SAVAGE

BEAUTY PARADE

Trade-Mark Reg. U. S. Pat. Off.

VOL. 11　　JANUARY 1953　　NUMBER 6

L. BENNETT, Editor　　　　　REALE, Art Director

★

Contents

★

★

Beauty Parade is published bi-monthly by Beauty Parade, Inc., 201 West 52nd Street, New York, N. Y. Copyright 1952 by Beauty Parade, Inc. Entered as second-class matter August 26, 1948, at the post office at New York, N. Y., under the act of March 3, 1879. Single copy 25c — Yearly subscription $1.50 — Foreign subscription $2.50. All rights reserved by Beauty Parade, Inc. All material submitted will be given careful attention, but such material must be accompanied by sufficient postage for return and is submitted at the author's risk. Printed in U. S. A.

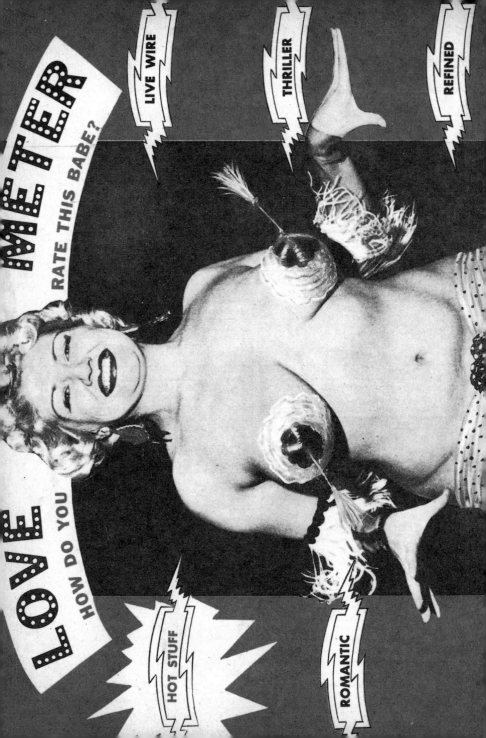

SWEETIE PIE

HALF BAKED

NO DESIRE

AGGRAVATING

LOVABLE

Posed by Jennie Lee, the
"Bazoom girl," as she's called
on the Burley circuit! Jennie
rates high, eh Johnnie?

MAR.

25¢

BEAUTY PARADE

The World's Loveliest Girls

GALS WEAR THE PANTS!
See page 10

IN THIS ISSUE:

NAUGHTIEST STRIP IN GAY PAREE!

PETER DRIBEN

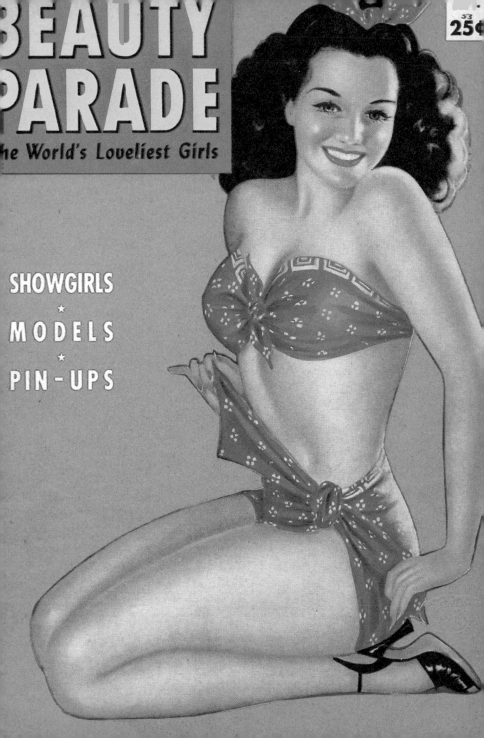

The SPIDER And The GUY!

1.

"Aha!" said the Spider.
"And what do I spy?"

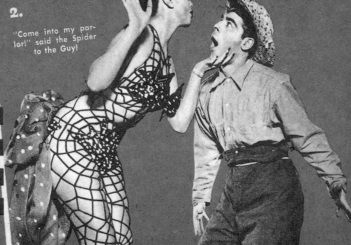

2.

"Come into my parlor!" said the Spider to the Guy!

HERE ONCE WAS

MAN NAMED JEB

VHO GOT CAUGHT

N A WENCH'S WEB!

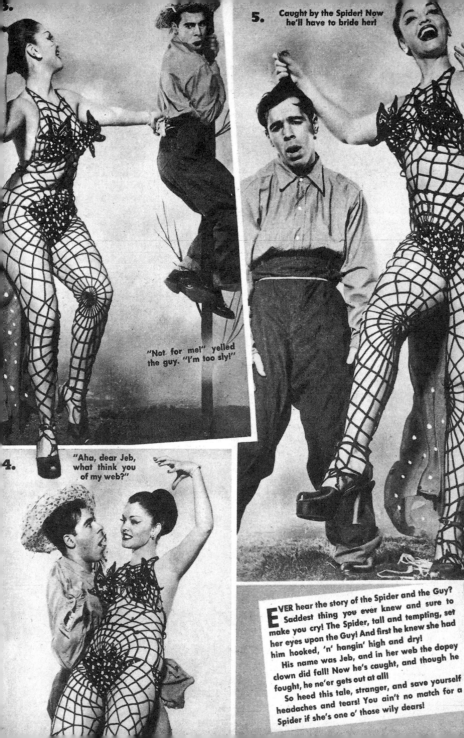

5. Caught by the Spider! Now he'll have to bride her!

"Not for me!" yelled the guy. "I'm too sly!"

4. "Aha, dear Jeb, what think you of my web?"

EVER hear the story of the Spider and the Guy? Saddest thing you ever knew and sure to make you cry! The Spider, tall and tempting, set her eyes upon the Guy! And first he knew she had him hooked, 'n' hangin' high and dry!

His name was Jeb, and in her web the dopey clown did fall! Now he's caught, and though he fought, he ne'er gets out at all!

So heed this tale, stranger, and save yourself headaches and tears! You ain't no match for a Spider if she's one o' those wily dears!

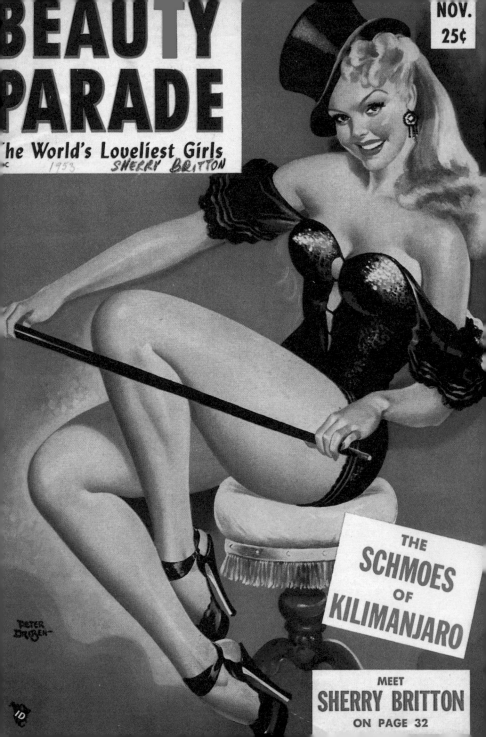

JULY
25¢

BEAUTY PARADE

The World's Loveliest Girls

Whirl
OF *Girls*

BROADWAY
HOLLYWOOD
NITECLUBS

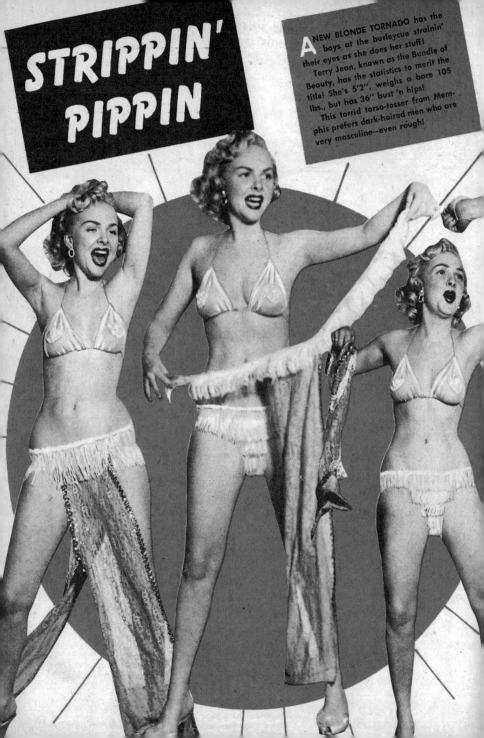

STRIPPIN' PIPPIN

A NEW BLONDE TORNADO has the boys at the burleycue strainin' their eyes as she does her stuff! Terry Jean, known as the Bundle of Beauty, has the statistics to merit the title! She's 5'2", weighs a bare 105 lbs., but has 36" bust 'n hips!

This torrid torso-tosser from Memphis prefers dark-haired men who are very masculine—even rough!

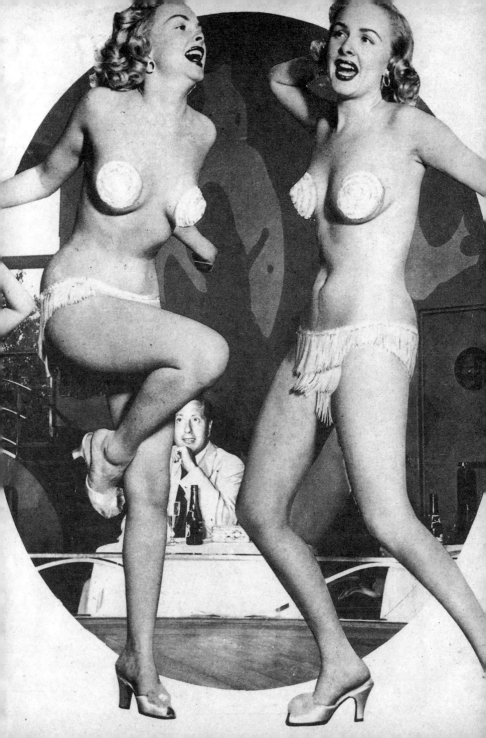

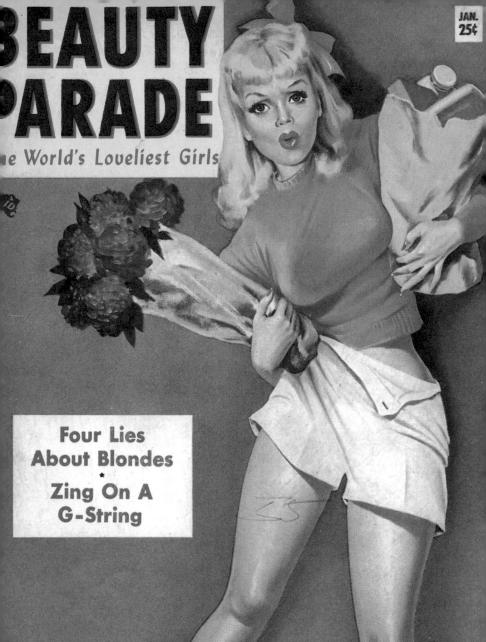

BEAUTY PARADE

The World's Loveliest Girls

JAN. 25¢

Four Lies
About Blondes
*
Zing On A
G-String

PETER DRIBEN

BEAUTY PARADE

e World's Lovelie

55
APR.
25c

NAUGHTY
PARIS
NIGHTLIFE

CLASSIFIED
CHASSIS!

PETER
DRIBEN

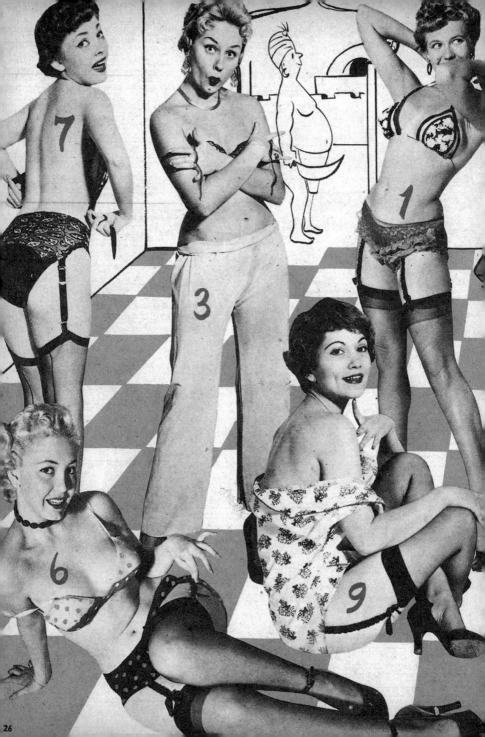

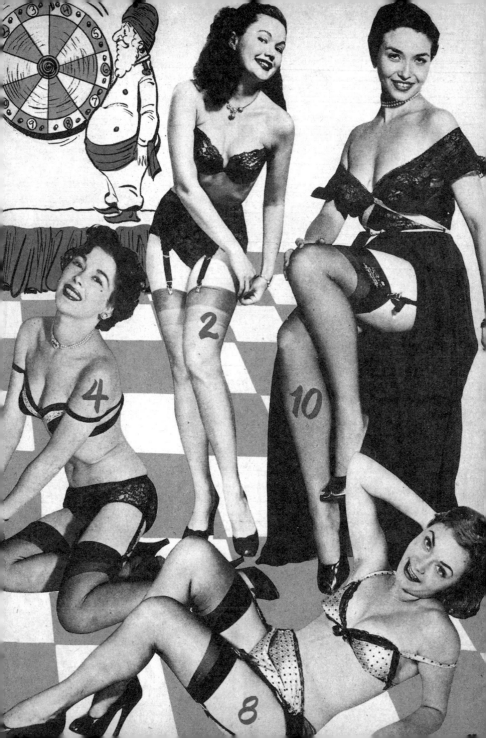

BEAUTY PARADE

he World's Lovel

OCT
25¢

PETER DRIBEN

TOO TORRID FOR T.V.

3

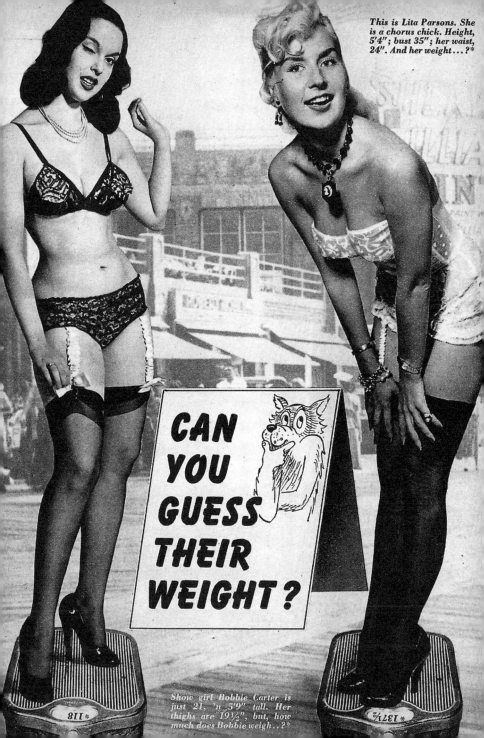

This is Lita Parsons. She is a chorus chick. Height, 5'4"; bust 35"; her waist, 24". And her weight...?*

CAN YOU GUESS THEIR WEIGHT?

Show girl Bobbie Carter is just 21, 'n 5'9" tall. Her thighs are 19½", but, how much does Bobbie weigh..?*

*118

*137½

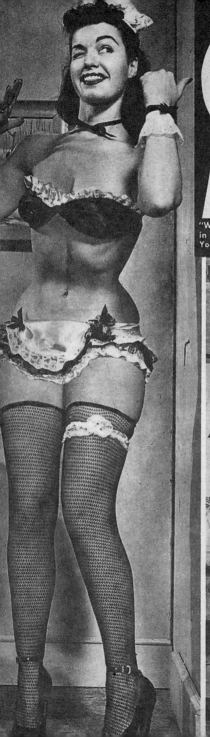

"Why ees eet I don't look so good in ze lace scanties like Madame?" You look pretty good, Marie gal!

...what the French Maid saw!

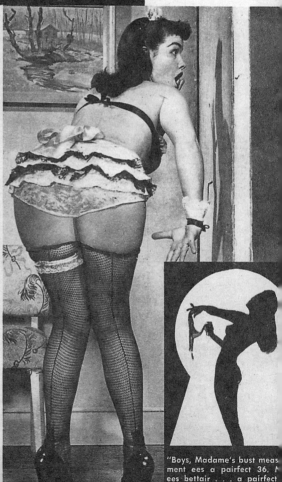

"Boys, Madame's bust meas ment ees a pairfect 36. N ees bettair . . . a pairfect

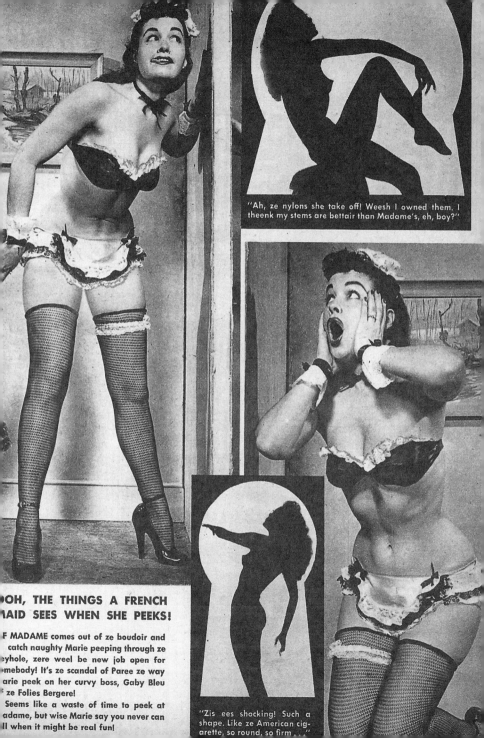

"Ah, ze nylons she take off! Weesh I owned them. I theenk my stems are bettair than Madame's, eh, boy?"

OOH, THE THINGS A FRENCH MAID SEES WHEN SHE PEEKS!

IF MADAME comes out of ze boudoir and catch naughty Marie peeping through ze keyhole, zere weel be new job open for somebody! It's ze scandal of Paree ze way Marie peek on her curvy boss, Gaby Bleu of ze Folies Bergere!

Seems like a waste of time to peek at Madame, but wise Marie say you never can tell when it might be real fun!

"Zis ees shocking! Such a shape. Like ze American cigarette, so round, so firm . . ."

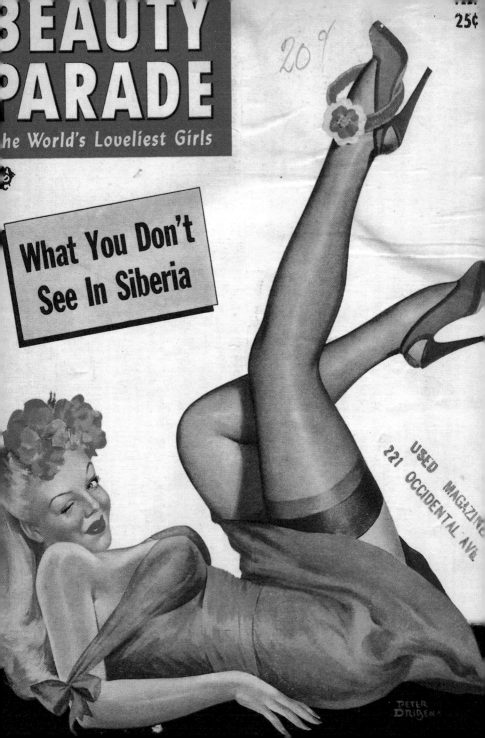

BEAUTY PARADE

The World's Loveliest Girls

FEB.

25¢

20¢

What You Don't See In Siberia

USED MAGAZINE
221 OCCIDENTAL AVE.

PETER DRIBEN

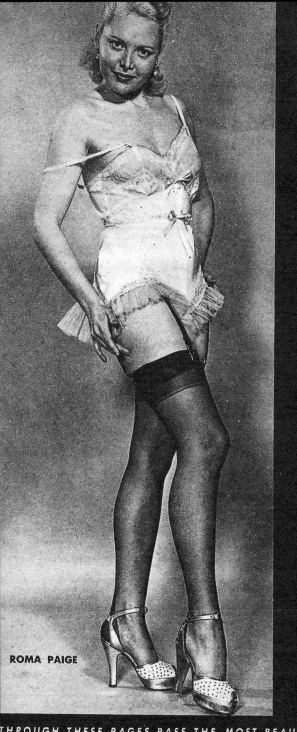

ROMA PAIGE

BEAUTY PARADE

Trade-Mark Reg. U. S. Pat. Off.

VOLUME 15 FEBRUARY 1956 NUMBER 1

L. BENNETT, Editor REALE, Art Director

★

Contents

★

★

Beauty Parade is published bi-monthly by Beauty Parade, Inc., 1697 Broadway, New York 19, N. Y. Copyright 1955 by Beauty Parade, Inc. Entered as second-class matter August 26, 1948, at the post office at New York, N. Y., under the act of March 3, 1879. Single copy 25c — Yearly subscription $1.50 — Foreign subscription $2.50. All rights reserved by Beauty Parade, Inc. All material submitted will be given careful attention, but such material must be accompanied by sufficient postage for return and is submitted at the author's risk. Printed in U. S. A.

THROUGH THESE PAGES PASS THE MOST BEAUTIFUL GIRLS IN THE WORLD

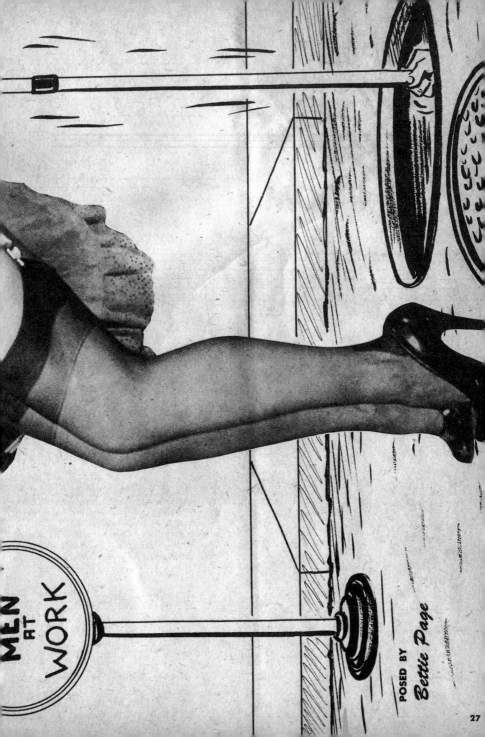

MEN AT WORK

POSED BY *Bettie Page*

27

EYE
Glorifying the

FUL

American Girl

Why change a successful recipe? The subtitle trumpeted "Girls, Gags & Giggles", and that was what the pages served up. Besides ogling starlets in swimwear, backstage photos from the nightclub world or harem beauties, the reader could chortle over cartoons or follow the progress of models through two- to four-page photostories as they flitted through their apartments, washed their nylons in the sink, romped around the swimming pool in marine look, or demonstrated incredible incompetence attempting some technical task. That each of them, no matter how intimate the surroundings or sweltening the heat, was wearing enough by today's standards to fully clothe a crowded pool was not just to appease the censors. Harrison himself found nudity offensive. It was only after the war that Eyeful, like the other magazines, managed to appear on a steady bimonthly basis.

When Eyeful bade its readers goodbye in April 1955, the pin-up paintings on its covers had long been superseded by photos. The subtitle now proclaimed "Glorifying the American Girl", and Betty Page posed as the centrefold, having started out on her road to fame in Harrison's magazines four years earlier.

Warum ein Erfolgsrezept ändern? „Girls, Gags & Giggles"
prangte auf dem Titel, und das war Programm. Zwischen Cartoons, Starlets in
Bademoden, Backstagefotos aus der Nachtclubwelt oder Haremsschönheiten darf
man verfolgen, wie Models in zwei- bis vierseitigen Fotostories Fliegen durch ihr
Appartement jagen, ihre Nylons im Spülstein waschen, im Marinelook am Pool her-
umtollen oder außergewöhnliches Ungeschick bei handwerklichen Arbeiten demon-
strieren. Daß jedes von ihnen auch im privatesten Rahmen und bei außerordent-
licher Hitze genug Stoff am Leib trug, um damit ein gut besuchtes Strandbad
heutiger Tage komplett anzukleiden, lag nicht nur am Respekt vor den Zensur-
behörden. Es heißt, Harrison selbst habe Nacktheit als anstößig empfunden.
 Wie die anderen Magazine erlangte auch Eyeful erst nach dem
Krieg eine regelmäßige zweimonatige Erscheinungsweise. Als sich Eyeful im April
1955 vom Leser verabschiedete – der Untertitel lautete nun „Glorifying the
American Girl" –, posierte Betty Page als Centerfold. Vier Jahre zuvor hatte sie in
Harrisons Magazinen ihren Weg zum Ruhm angetreten.

 Pourquoi changer une formule qui marche ? Le sous-titre accro-
cheur «Girls, Gags & Giggles» était en soi tout un programme. Entre les dessins
humoristiques, les starlettes en costumes de bain, les photos qui montraient
les coulisses des boîtes de nuit et les belles pensionnaires de harems, on pouvait
suivre, racontées sur deux, trois ou quatre pages de photos, les péripéties de
modèles qui, sans jamais connaître l'ennui, chassaient les mouches dans leur
appartement, lavaient leurs bas en nylon dans l'évier, folâtraient en costume
marin au bord de la piscine ou déployaient une singulière maladresse au niveau
des tâches manuelles. Le fait que chacune d'elles portât, même dans l'intimité
ou par une chaleur accablante, suffisamment de tissu pour vêtir aujourd'hui
toute une armée de baigneurs ne tenait pas seulement à la crainte de la censure.
Harrison lui-même aurait en réalité ressenti la nudité comme quelque chose de
choquant. Comme pour les autres magazines, ce n'est qu'après la guerre que la
parution de Eyeful prit son rythme de croisière d'un numéro tous les deux mois.
 Lorsqu'en avril 1955, Eyeful prit congé de ses lecteurs et prit
comme nouveau sous-titre «Glorifying the American Girl», Betty Page occupa la
double page centrale. Quatre ans plus tôt, elle avait commencé à gravir le sentier
de la gloire en posant dans les magazines de Harrison.

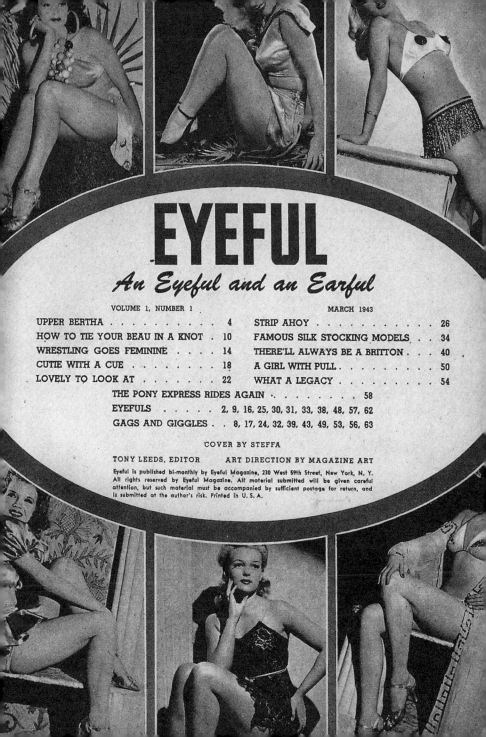

EYEFUL

An Eyeful and an Earful

VOLUME 1, NUMBER 1 MARCH 1943

COVER BY STEFFA

TONY LEEDS, EDITOR ART DIRECTION BY MAGAZINE ART

Eyeful is published bi-monthly by Eyeful Magazine, 230 West 59th Street, New York, N. Y. All rights reserved by Eyeful Magazine. All material submitted will be given careful attention, but such material must be accompanied by sufficient postage for return, and is submitted at the author's risk. Printed in U.S.A.

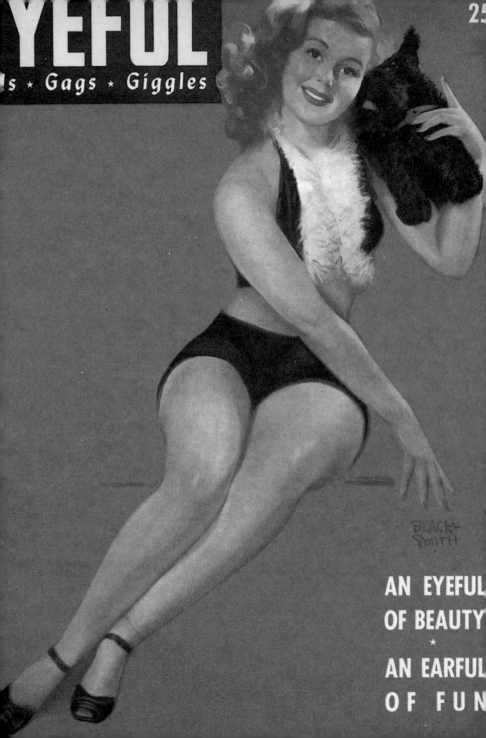

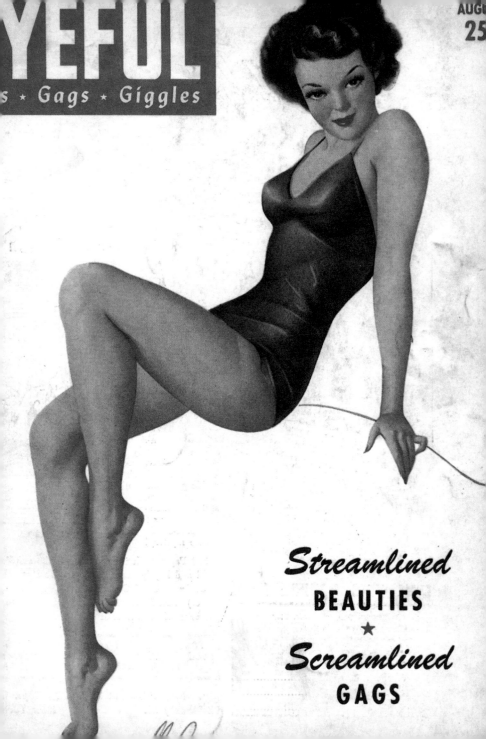

YEFUL

s ★ Gags ★ Giggles

AUGU

25

Streamlined
BEAUTIES
★
Screamlined
GAGS

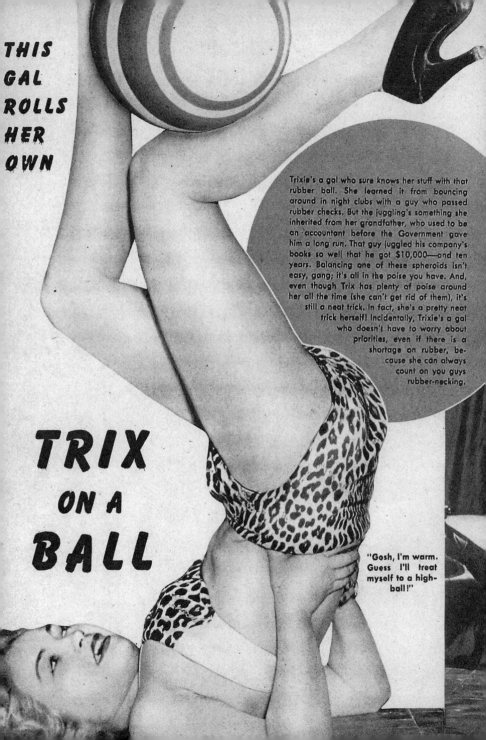

THIS GAL ROLLS HER OWN

TRIX ON A BALL

Trixie's a gal who sure knows her stuff with that rubber ball. She learned it from bouncing around in night clubs with a guy who passed rubber checks. But the juggling's something she inherited from her grandfather, who used to be an accountant before the Government gave him a long run. That guy juggled his company's books so well that he got $10,000—and ten years. Balancing one of these spheroids isn't easy, gang; it's all in the poise you have. And, even though Trix has plenty of poise around her all the time (she can't get rid of them), it's still a neat trick. In fact, she's a pretty neat trick herself! Incidentally, Trixie's a gal who doesn't have to worry about priorities, even if there is a shortage on rubber, because she can always count on you guys rubber-necking.

"Gosh, I'm warm. Guess I'll treat myself to a high-ball!"

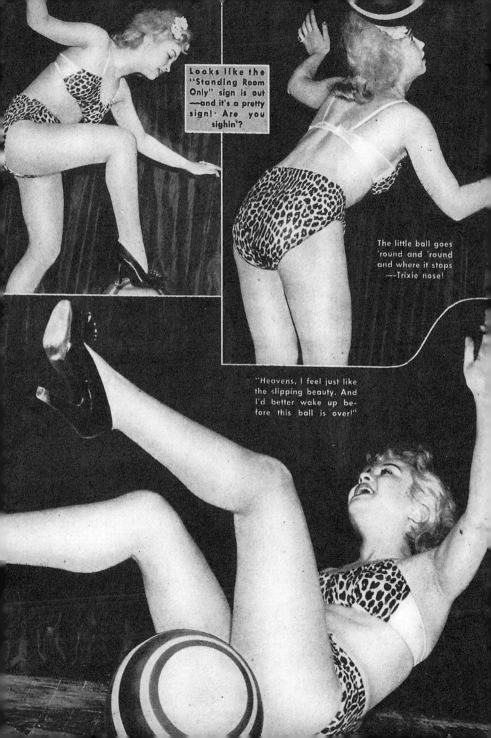

Looks like the "Standing Room Only" sign is out —and it's a pretty sign!· Are you sighin'?

The little ball goes 'round and 'round and where it stops ---Trixie nose!

"Heavens, I feel just like the slipping beauty. And I'd better wake up before this ball is over!"

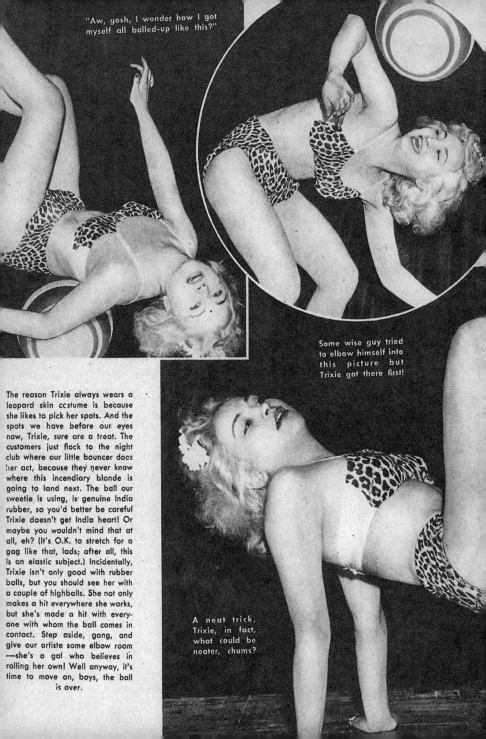

"Aw, gosh, I wonder how I got myself all balled-up like this?"

Some wise guy tried to elbow himself into this picture but Trixie got there first!

The reason Trixie always wears a leopard skin costume is because she likes to pick her spots. And the spots we have before our eyes now, Trixie, sure are a treat. The customers just flock to the night club where our little bouncer does her act, because they never know where this incendiary blonde is going to land next. The ball our sweetie is using, is genuine India rubber, so you'd better be careful Trixie doesn't get India heart! Or maybe you wouldn't mind that at all, eh? (It's O.K. to stretch for a gag like that, lads; after all, this is an elastic subject.) Incidentally, Trixie isn't only good with rubber balls, but you should see her with a couple of highballs. She not only makes a hit everywhere she works, but she's made a hit with everyone with whom the ball comes in contact. Step aside, gang, and give our artiste some elbow room —she's a gal who believes in rolling her own! Well anyway, it's time to move on, boys, the ball is over.

A neat trick, Trixie, in fact, what could be neater, chums?

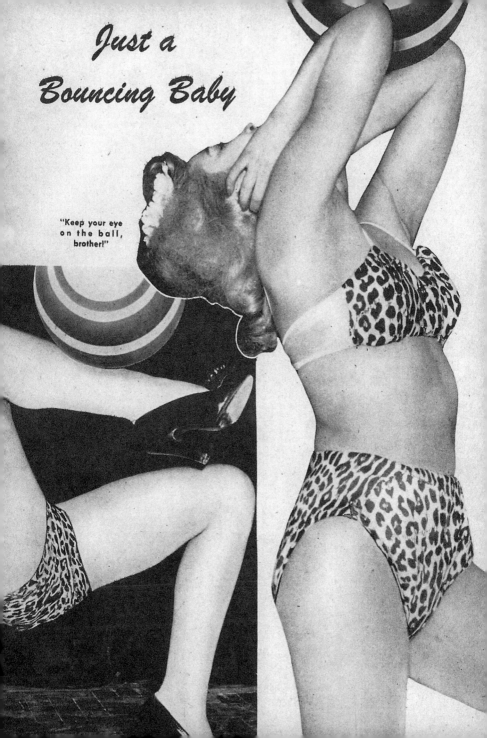

Just a Bouncing Baby

"Keep your eye on the ball, brother!"

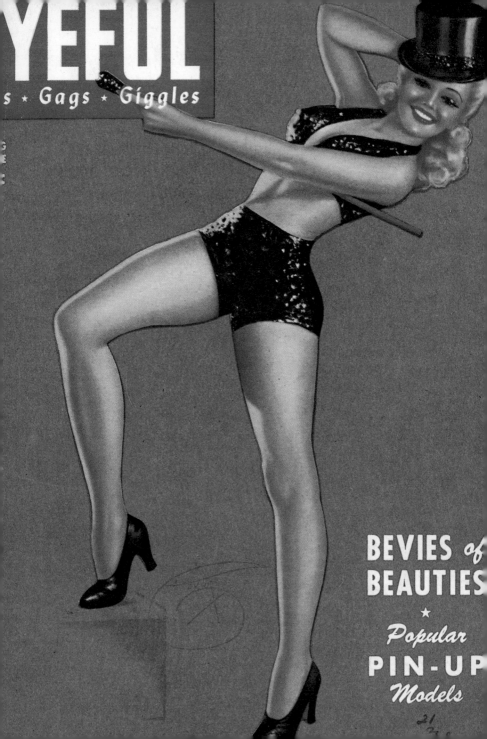

Something
for the BUOYS

One thing the Hollywood lovelies like to do with their time off is swim. And no wonder. You see, an eyeful like Carole Landis gets along swimmingly everywhere, in fact, she sure is some one to wave about! Well, we think we'll go fishing now, down by the sea. Just to see if we can Landis a honey like Carole. Or do you Carole a lot for her yourself? After all, you must admit she is a sight to sea!

This is one of the new swim suits — swimply lovely — and no waste either.

h! Beauty an
e Beach —
water peach

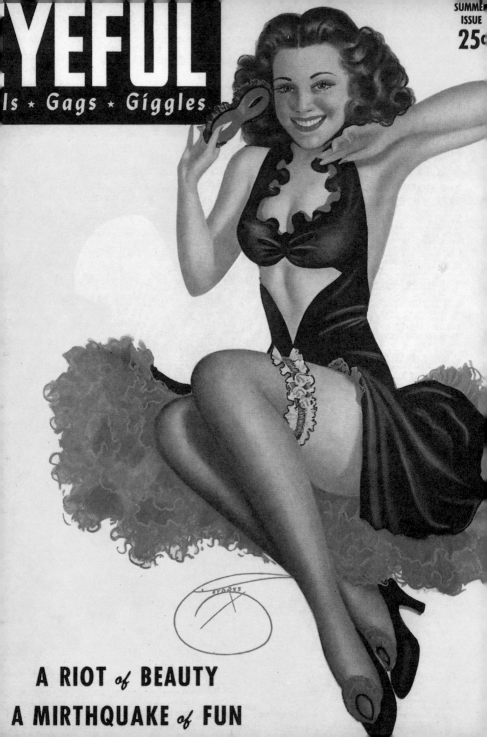

Here's lovely Minerva Chancellor, boys, an Earl Carroll sighfull, and she's sure a sigh for your ayes.

Sighs Right!

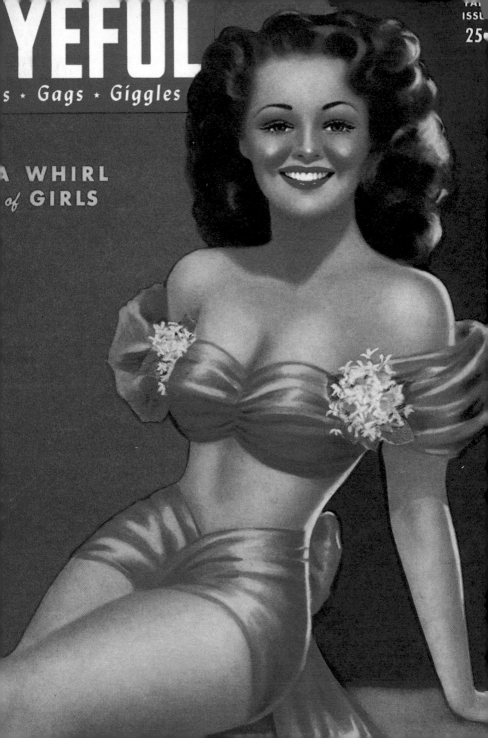

Sheer
DEAR-
LIGHTS!

...y smoke,
...at Shirley
...rtin! Isn't
...puff-ection!

Here's Jean Fraser, but look out, soft
shoulder and dangerous curves ahead!

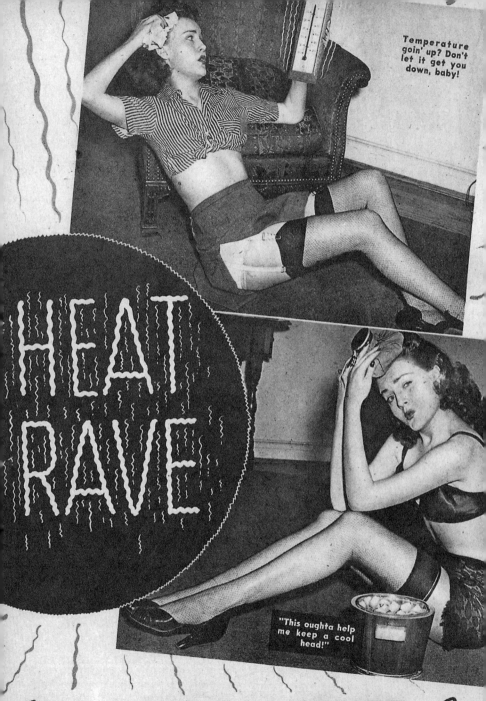

Temperature goin' up? Don't let it get you down, baby!

HEAT RAVE

"This oughta help me keep a cool head!"

Meet a STEAM-LINED Cut

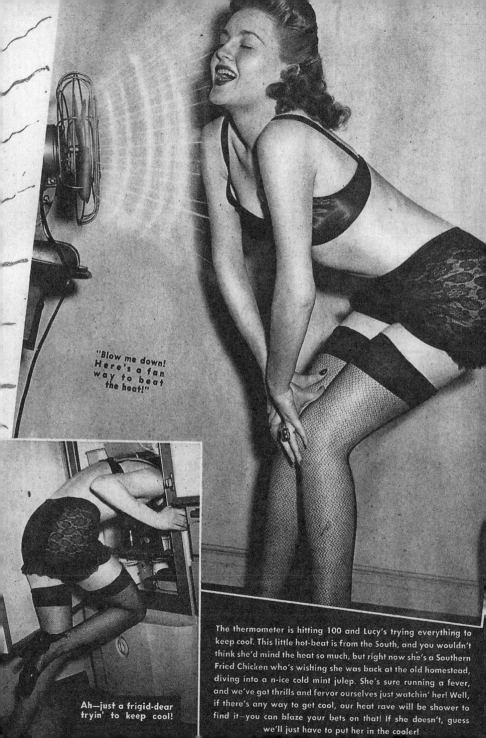

"Blow me down! Here's a fan way to beat the heat!"

Ah—just a frigid-dear tryin' to keep cool!

The thermometer is hitting 100 and Lucy's trying everything to keep cool. This little hot-beat is from the South, and you wouldn't think she'd mind the heat so much, but right now she's a Southern Fried Chicken who's wishing she was back at the old homestead, diving into a n-ice cold mint julep. She's sure running a fever, and we've got thrills and fervor ourselves just watchin' her! Well, if there's any way to get cool, our heat rave will be shower to find it—you can blaze your bets on that! If she doesn't, guess we'll just have to put her in the cooler!

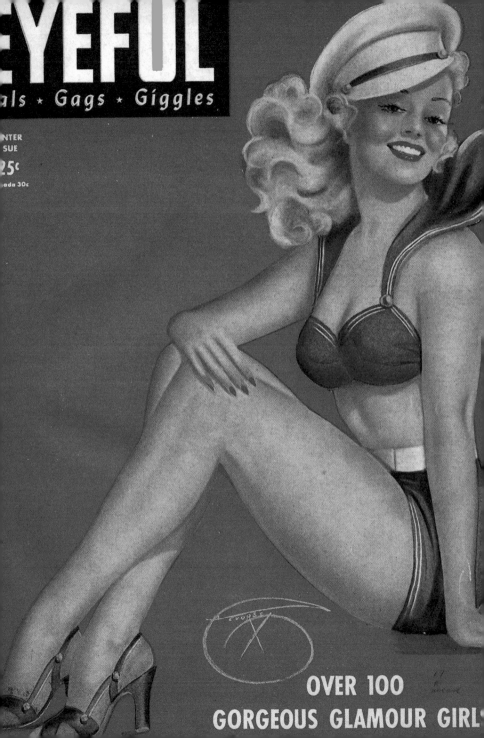

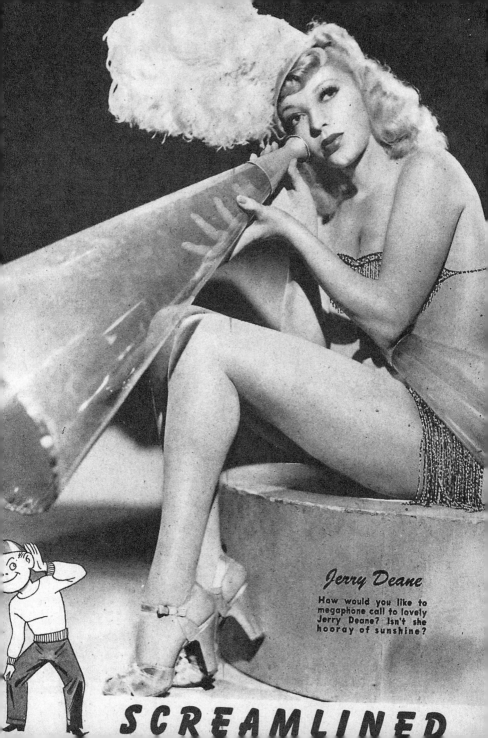

Jerry Deane

How would you like to megaphone call to lovely Jerry Deane? Isn't she hooray of sunshine?

SCREAMLINED

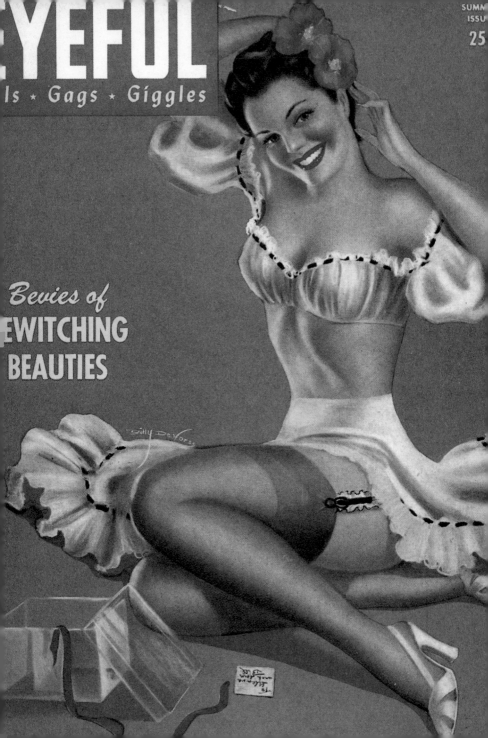

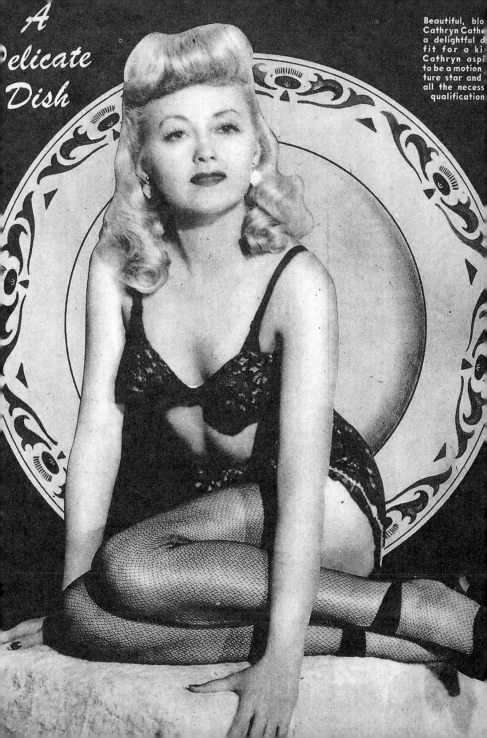

A Delicate Dish

Beautiful, blo
Cathryn Cathe
a delightful d
fit for a ki
Cathryn aspi
to be a motion
ture star and
all the necess
qualification

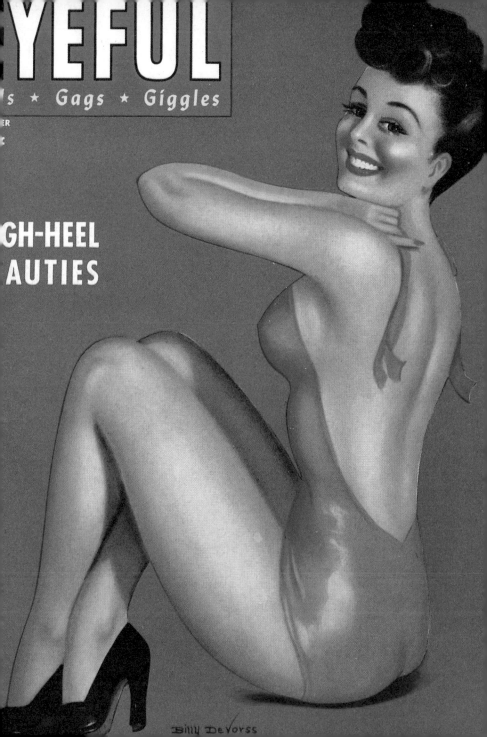

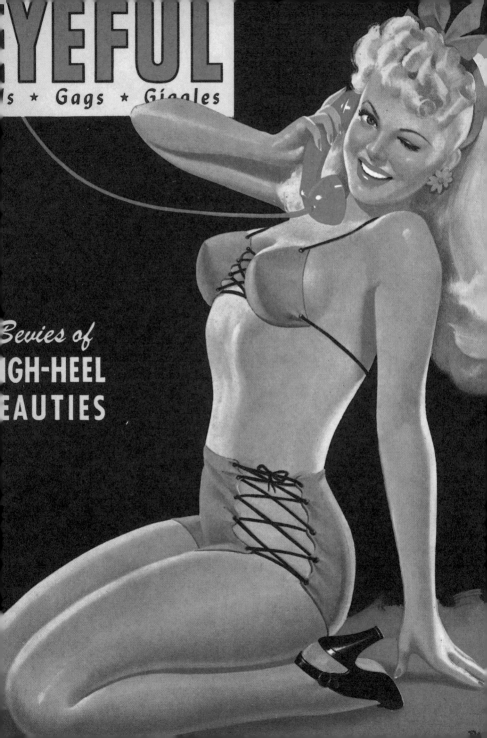

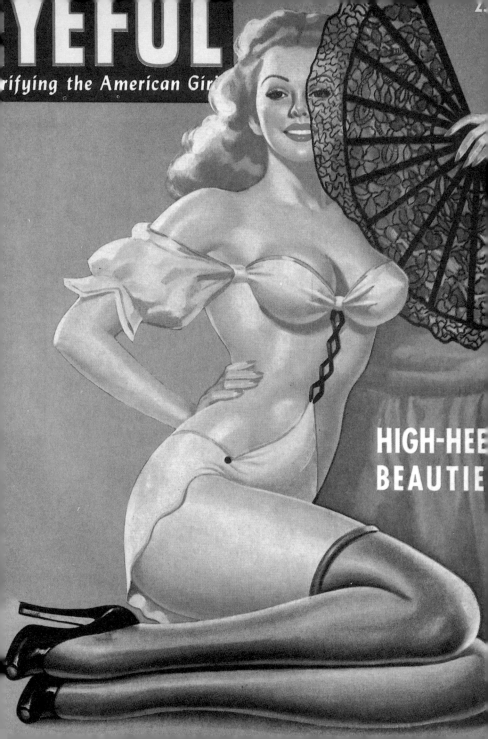

Bound Beauty

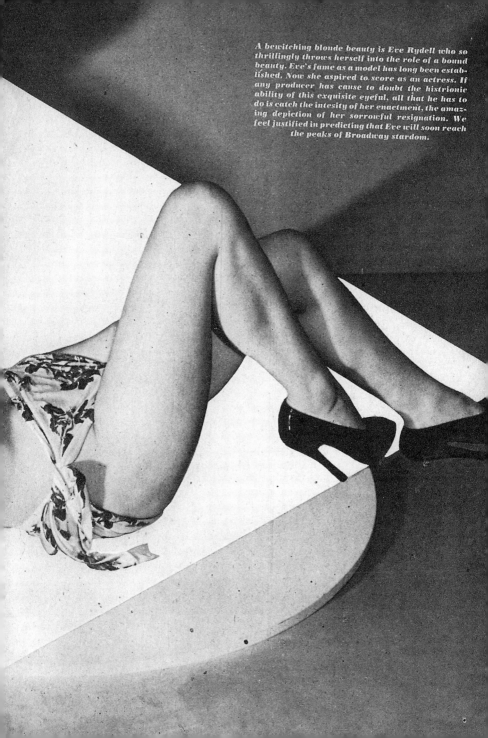

A bewitching blonde beauty is Eve Rydell who so thrillingly throws herself into the role of a bound beauty. Eve's fame as a model has long been established. Now she aspired to score as an actress. If any producer has cause to doubt the histrionic ability of this exquisite eyeful, all that he has to do is catch the intesity of her enactment, the amazing depiction of her sorrowful resignation. We feel justified in predicting that Eve will soon reach the peaks of Broadway stardom.

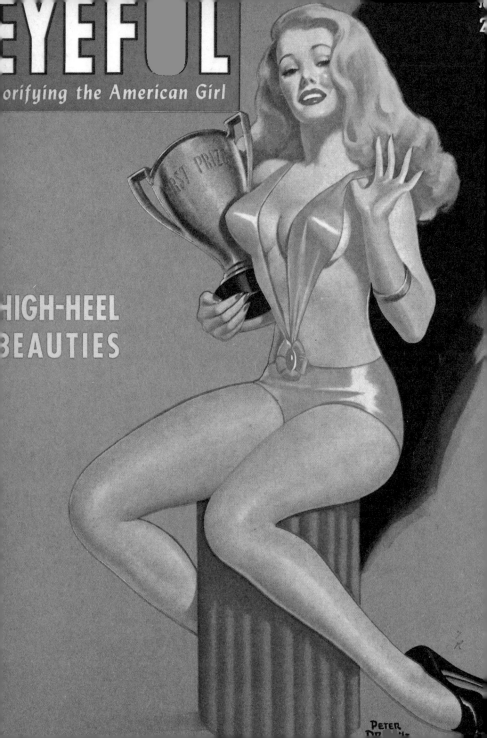

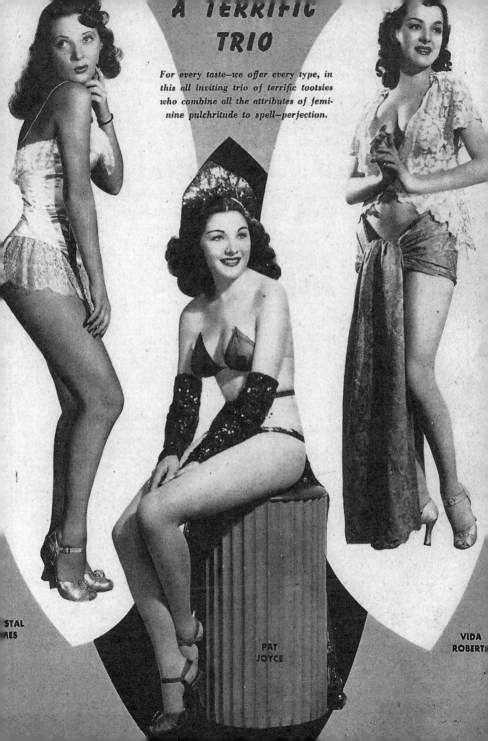

A TERRIFIC TRIO

For every taste—we offer every type, in this all inviting trio of terrific tootsies who combine all the attributes of feminine pulchritude to spell—perfection.

STAL
ES

PAT
JOYCE

VIDA
ROBERT

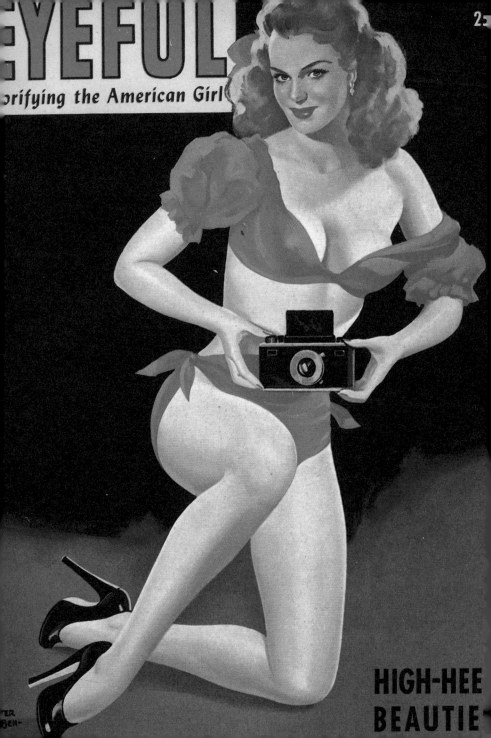

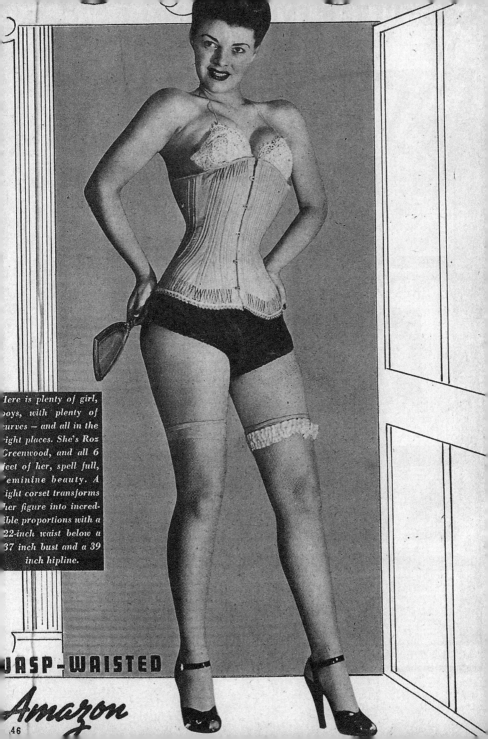

Here is plenty of girl, boys, with plenty of curves — and all in the right places. She's Roz Greenwood, and all 6 feet of her, spell full, feminine beauty. A tight corset transforms her figure into incredible proportions with a 22-inch waist below a 37 inch bust and a 39 inch hipline.

WASP-WAISTED

Amazon

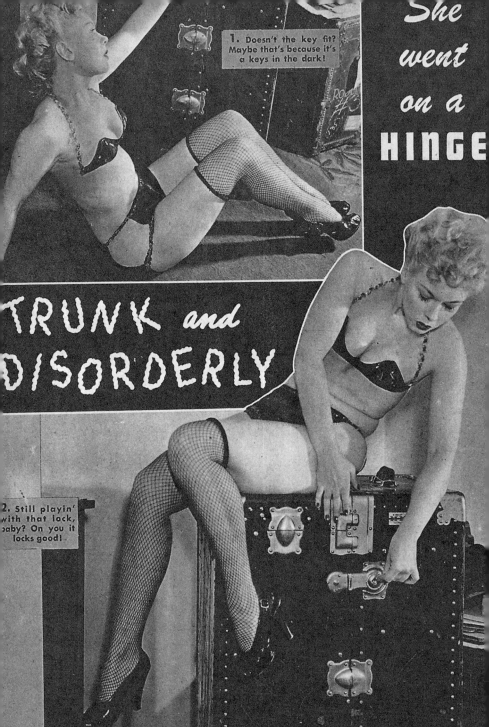

She
went
on a
HINGE

1. Doesn't the key fit? Maybe that's because it's a keys in the dark!

TRUNK and
DISORDERLY

2. Still playin' with that lock, baby? On you it locks good!

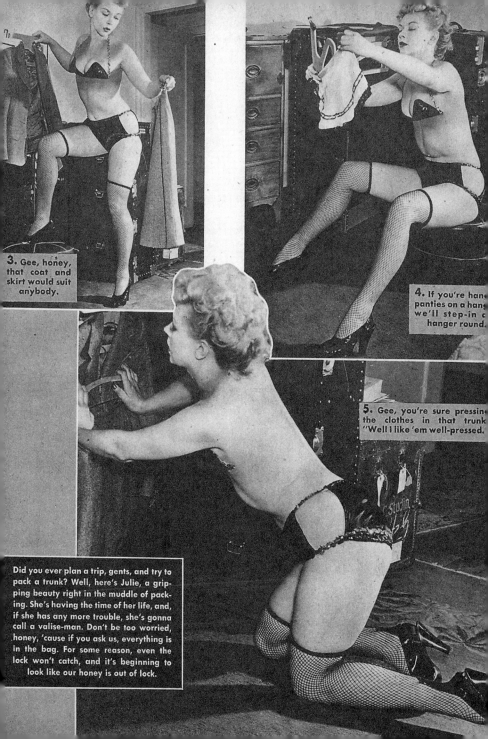

3. Gee, honey, that coat and skirt would suit anybody.

4. If you're han... panties on a hang... we'll step-in c... hanger round.

5. Gee, you're sure pressin... the clothes in that trunk "Well I like 'em well-pressed.

Did you ever plan a trip, gents, and try to pack a trunk? Well, here's Julie, a gripping beauty right in the muddle of packing. She's having the time of her life, and, if she has any more trouble, she's gonna call a valise-man. Don't be too worried, honey, 'cause if you ask us, everything is in the bag. For some reason, even the lock won't catch, and it's beginning to look like our honey is out of lock.

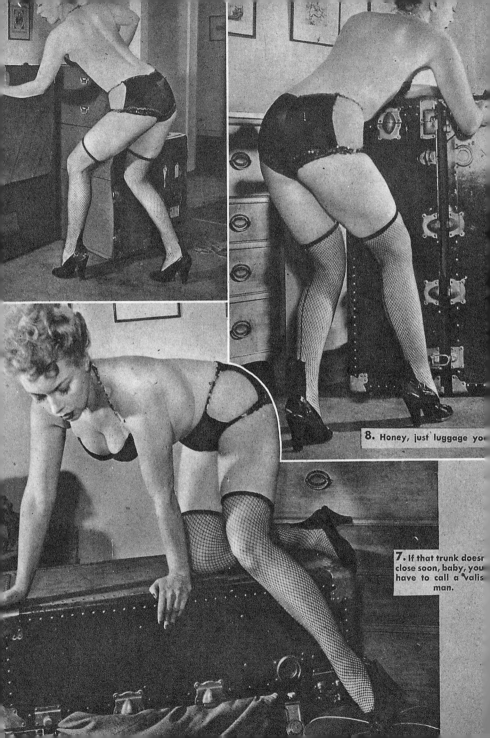

8. Honey, just luggage yo

7. If that trunk doesr close soon, baby, you have to call a 'valis man.

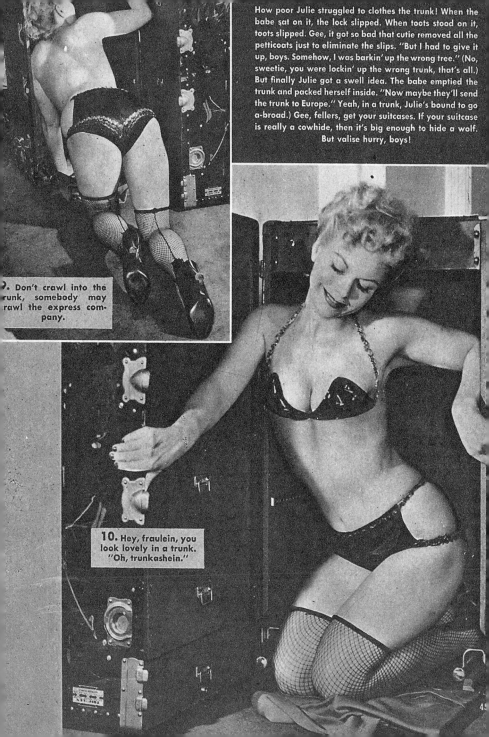

How poor Julie struggled to clothes the trunk! When the babe sat on it, the lock slipped. When toots stood on it, toots slipped. Gee, it got so bad that cutie removed all the petticoats just to eliminate the slips. "But I had to give it up, boys. Somehow, I was barkin' up the wrong tree." (No, sweetie, you were lockin' up the wrong trunk, that's all.) But finally Julie got a swell idea. The babe emptied the trunk and packed herself inside. "Now maybe they'll send the trunk to Europe." Yeah, in a trunk, Julie's bound to go a-broad.) Gee, fellers, get your suitcases. If your suitcase is really a cowhide, then it's big enough to hide a wolf. But valise hurry, boys!

. Don't crawl into the runk, somebody may rawl the express company.

10. Hey, fraulein, you look lovely in a trunk. "Oh, trunkashein."

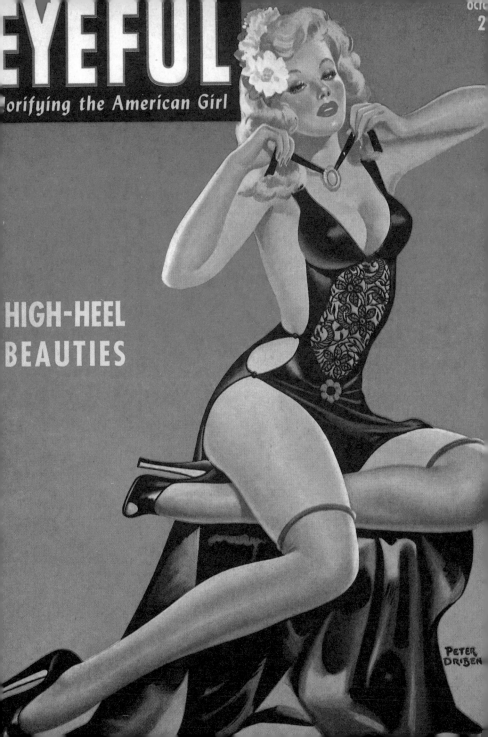

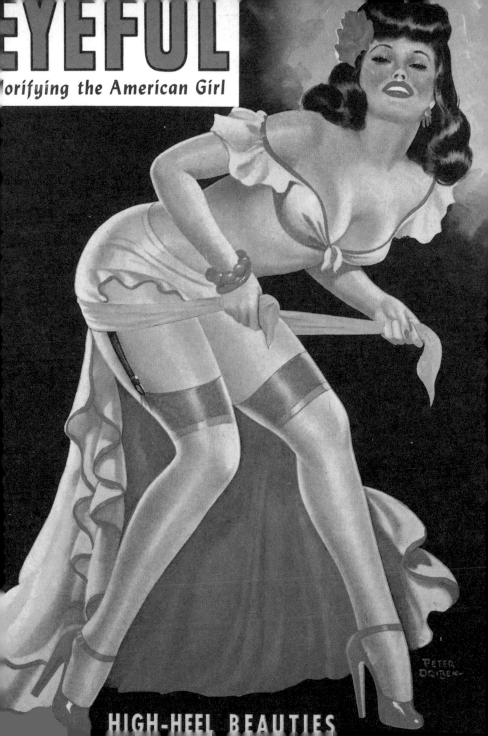

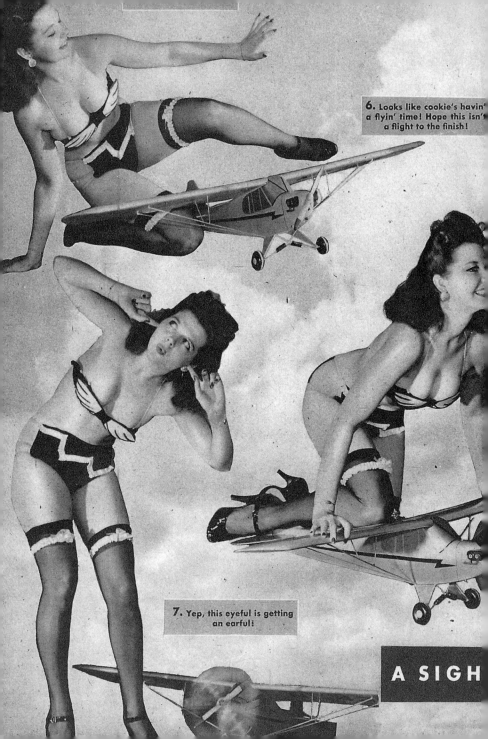

6. Looks like cookie's havin' a flyin' time! Hope this isn't a flight to the finish!

7. Yep, this eyeful is getting an earful!

A SIGH

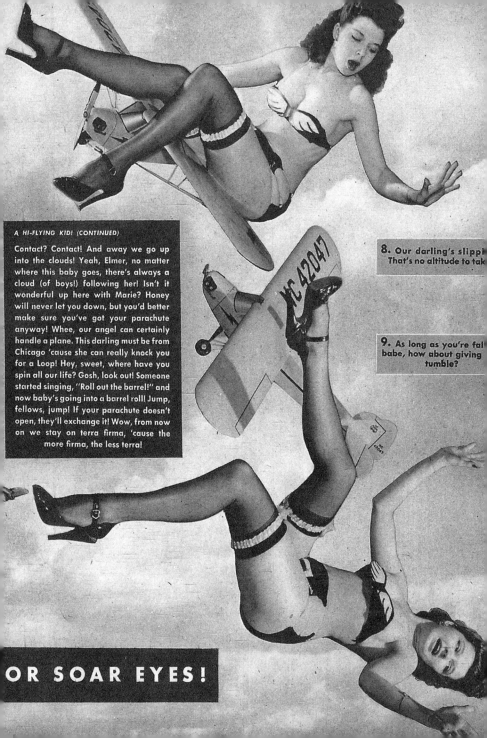

A HI-FLYING KID! (CONTINUED)

Contact? Contact! And away we go up into the clouds! Yeah, Elmer, no matter where this baby goes, there's always a cloud (of boys!) following her! Isn't it wonderful up here with Marie? Honey will never let you down, but you'd better make sure you've got your parachute anyway! Whee, our angel can certainly handle a plane. This darling must be from Chicago 'cause she can really knock you for a Loop! Hey, sweet, where have you spin all our life? Gosh, look out! Someone started singing, "Roll out the barrel!" and now baby's going into a barrel roll! Jump, fellows, jump! If your parachute doesn't open, they'll exchange it! Wow, from now on we stay on terra firma, 'cause the more firma, the less terra!

8. Our darling's slipp'
That's no altitude to tak

9. As long as you're fal
babe, how about giving
tumble?

OR SOAR EYES!

EYEFUL

orifying the American Girl

FEB.
25¢

PETER
DRIBEN

HIGH-HEEL BEAUTIES

Help yourself to half-a-dozen long-stemmed

BETTY HOWELL—Buxom
bachelor's button

garder

MLLE. FLEURETTE —
coquettish camelia

rican beauties.

f glamour

BARBARA TRACY—
gorgeous gardenia

CATHEY COVIN—cur-
vaceous carnation

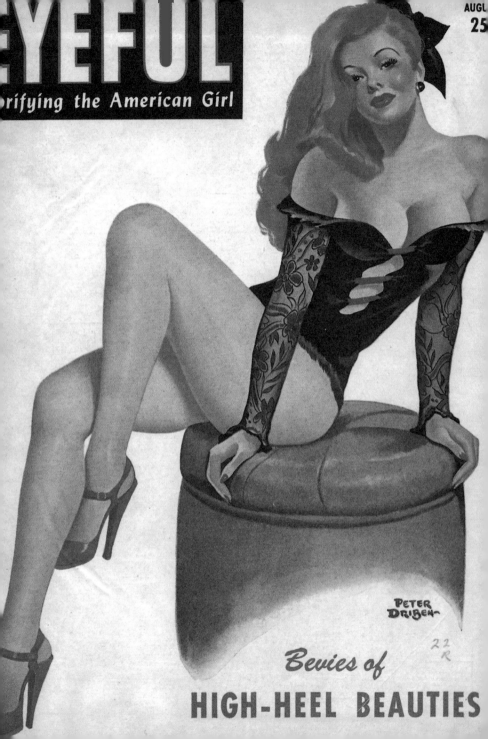

Precious Pixy

Here's a precious little package of feminine loveliness all done up in a slinky black chemise, destined for immediate delivery to the environs of your bedazzled eyes. So feast upon the many charms of slim and svelte Penny Enders—charms that encompass a 34 inch bust, a slight 25 inch waist, and 34 inch hips.

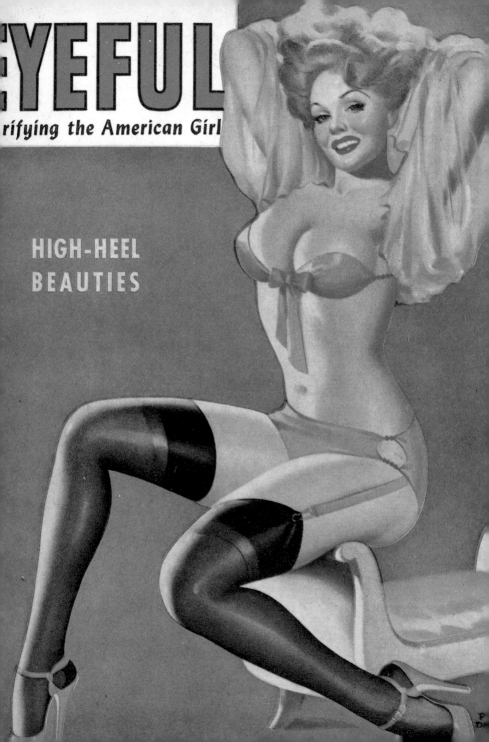

EYEFUL
rifying the American Girl

HIGH-HEEL
BEAUTIES

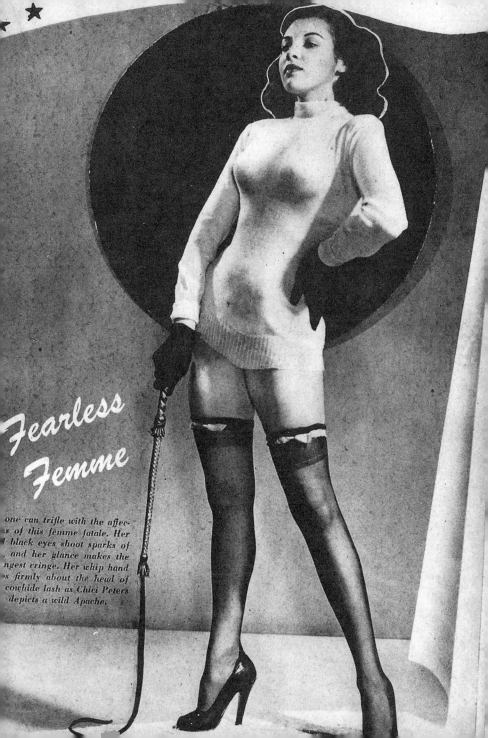

Fearless Femme

one can trifle with the affec-
s of this femme fatale. Her
black eyes shoot sparks of
and her glance makes the
ngest cringe. Her whip hand
s firmly about the head of
cowhide lash as Chici Peters
depicts a wild Apache.

EYEFUL

orifying the American Girl

SILK STOCKING SIRENS

PETER DRIBEN

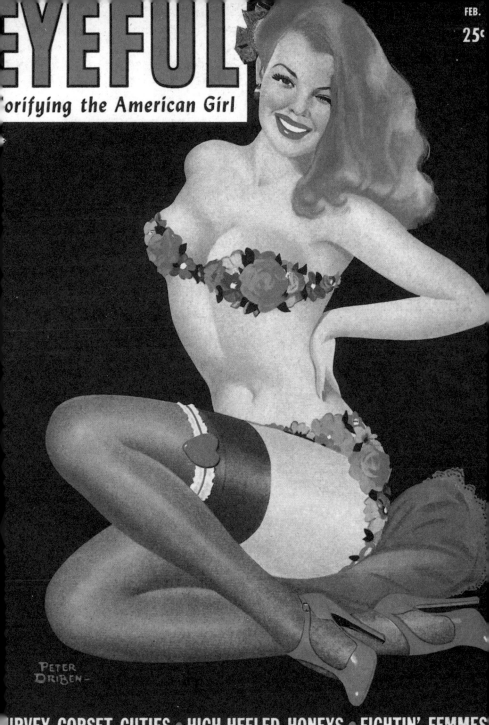

EYEFUL

FEB.

25c

Glorifying the American Girl

PETER DRIBEN

URVEY CORSET CUTIES • HIGH-HEELED HONEYS • FIGHTIN' FEMMES

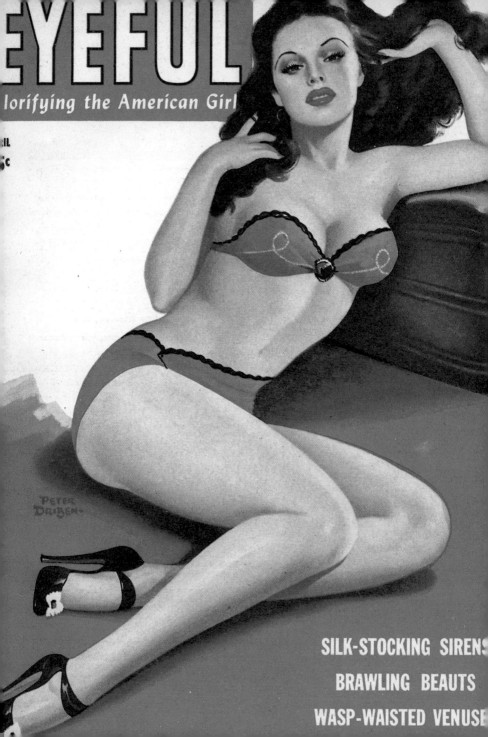

EYEFUL

Glorifying the American Girl

JUN

25

PETER
DRIBEN

HIGH-HEELED HONEYS

GRAPPLING GALS

CURVEY CORSET CUTIES

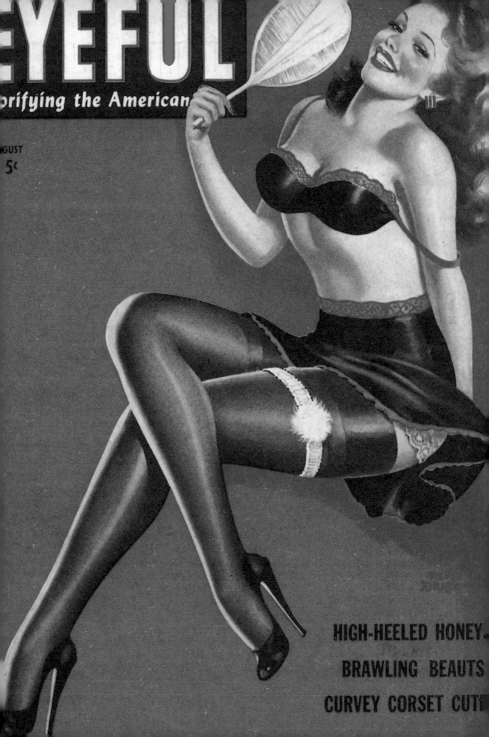

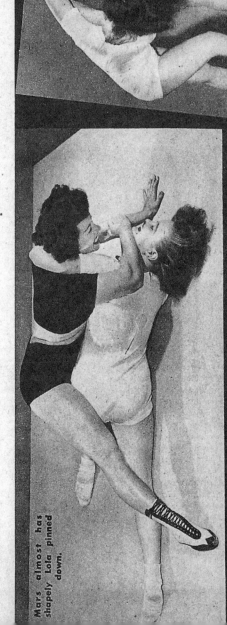

This strangle hold...

MEET Mars Bennett, gents; she's the grappling gal wearing the black trunks, and she's the new queen of America's mat maidens. Mars is one of the country's foremost aerial acrobats, and when she was challenged to a wrestling match by blonde and shapely Lola Montague, beautifully muscled Mars took to the new sport like a duck to water. Mars has the natural coordination and agility that would make her tops in any field, and

Mars almost has shapely Lola pinned down.

Queen of the Mat!

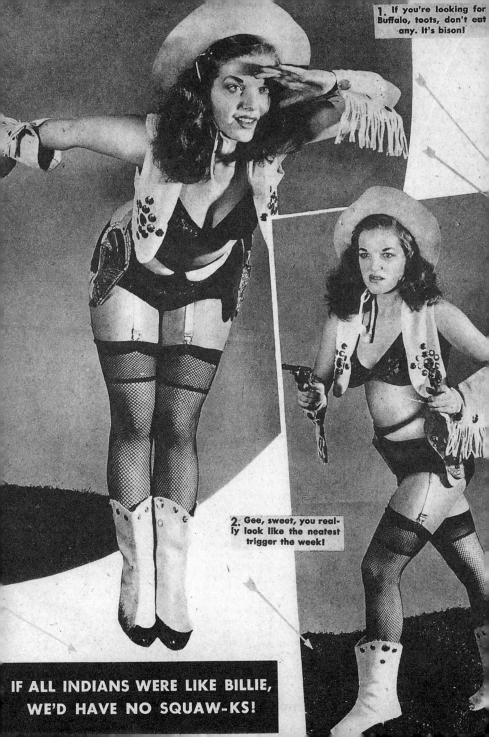

1. If you're looking for Buffalo, toots, don't eat any. It's bison!

2. Gee, sweet, you really look like the neatest trigger the week!

IF ALL INDIANS WERE LIKE BILLIE, WE'D HAVE NO SQUAW-KS!

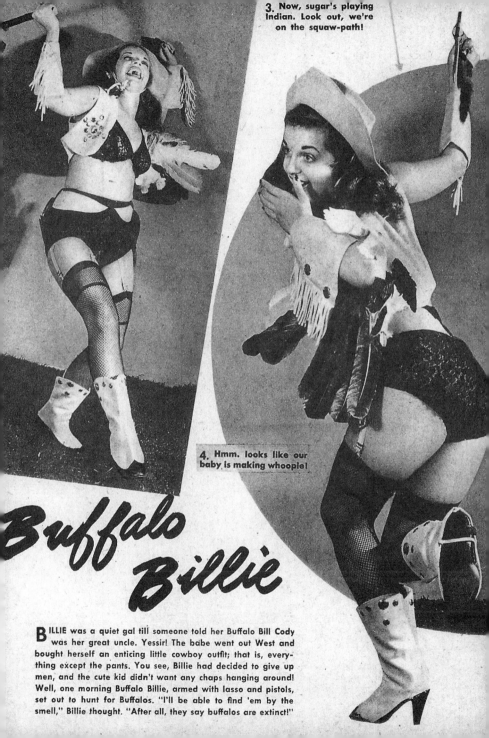

3. Now, sugar's playing Indian. Look out, we're on the squaw-path!

4. Hmm. looks like our baby is making whoopie!

Buffalo Billie

BILLIE was a quiet gal till someone told her Buffalo Bill Cody was her great uncle. Yessir! The babe went out West and bought herself an enticing little cowboy outfit; that is, everything except the pants. You see, Billie had decided to give up men, and the cute kid didn't want any chaps hanging around! Well, one morning Buffalo Billie, armed with lasso and pistols, set out to hunt for Buffalos. "I'll be able to find 'em by the smell," Billie thought. "After all, they say buffalos are extinct!"

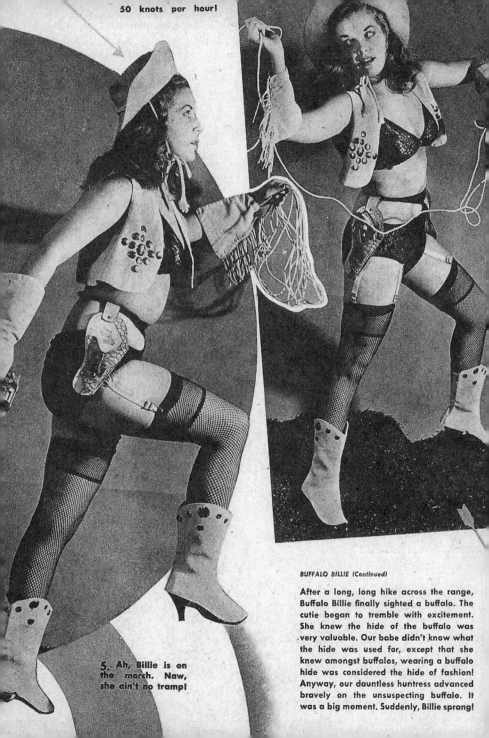

50 knots per hour!

5. Ah, Billie is on the march. Naw, she ain't no tramp!

BUFFALO BILLIE (Continued)

After a long, long hike across the range, Buffalo Billie finally sighted a buffalo. The cutie began to tremble with excitement. She knew the hide of the buffalo was very valuable. Our babe didn't know what the hide was used for, except that she knew amongst buffalos, wearing a buffalo hide was considered the hide of fashion! Anyway, our dauntless huntress advanced bravely on the unsuspecting buffalo. It was a big moment. Suddenly, Billie sprang!

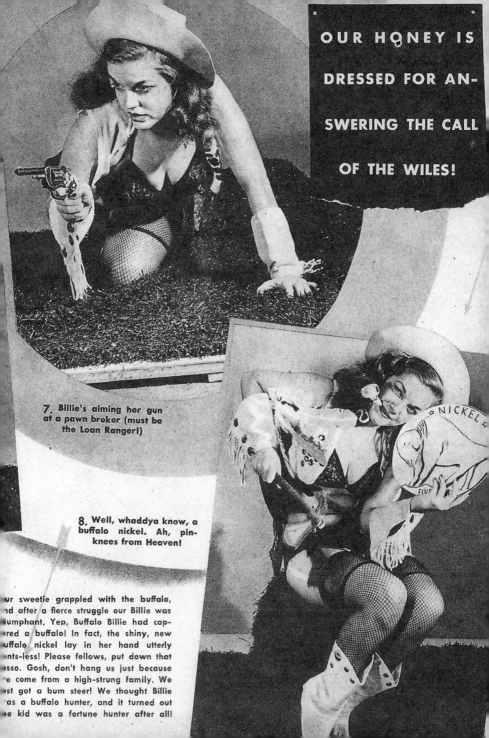

OUR HONEY IS DRESSED FOR AN-SWERING THE CALL OF THE WILES!

7. Billie's aiming her gun at a pawn broker (must be the Loan Ranger!)

8. Well, whaddya know, a buffalo nickel. Ah, pin-knees from Heaven!

ur sweetie grappled with the buffalo, nd after a fierce struggle our Billie was iumphant. Yep, Buffalo Billie had cap-red a buffalo! In fact, the shiny, new uffalo nickel lay in her hand utterly nts-less! Please fellows, put down that sso. Gosh, don't hang us just because e come from a high-strung family. We st got a bum steer! We thought Billie as a buffalo hunter, and it turned out e kid was a fortune hunter after all!

EYEFUL

orifying the American Girl

OCT.

25c

HIGH-HEELED HONEYS

FIGHTIN' FEMMES

LONG-HAIRED LOVELIES

PETER DRIBEN

EYEFUL

25c

orifying the American C

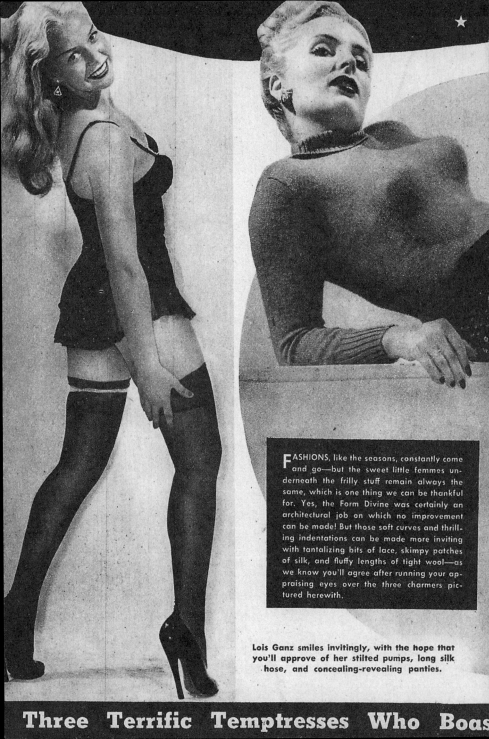

FASHIONS, like the seasons, constantly come and go—but the sweet little femmes underneath the frilly stuff remain always the same, which is one thing we can be thankful for. Yes, the Form Divine was certainly an architectural job on which no improvement can be made! But those soft curves and thrilling indentations can be made more inviting with tantalizing bits of lace, skimpy patches of silk, and fluffy lengths of tight wool—as we know you'll agree after running your appraising eyes over the three charmers pictured herewith.

Lois Ganz smiles invitingly, with the hope that you'll approve of her stilted pumps, long silk hose, and concealing-revealing panties.

Three Terrific Temptresses Who Boas

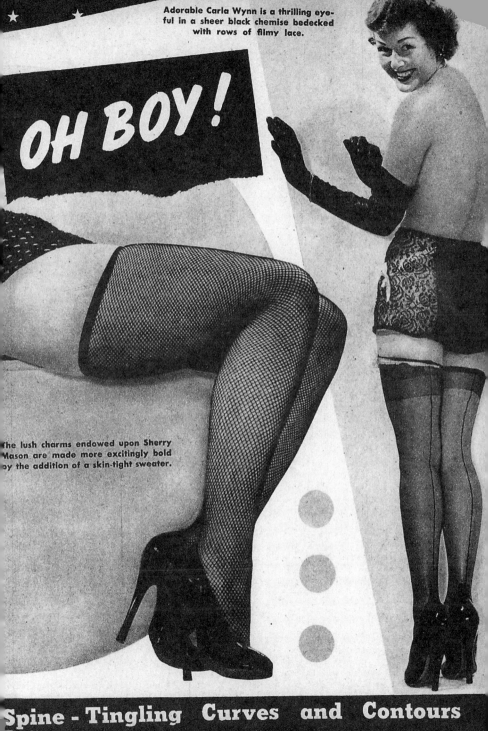

Adorable Carla Wynn is a thrilling eyeful in a sheer black chemise bedecked with rows of filmy lace.

OH BOY!

The lush charms endowed upon Sherry Mason are made more excitingly bold by the addition of a skin-tight sweater.

Spine - Tingling Curves and Contours

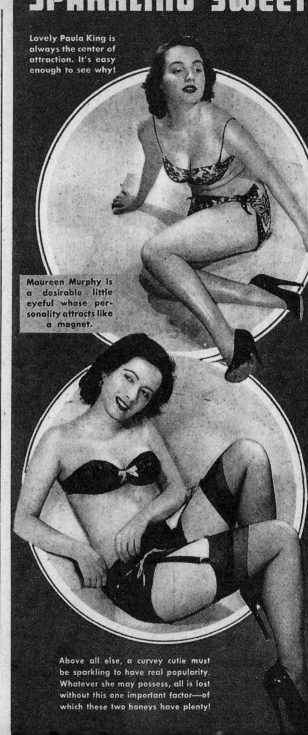

Lovely Paula King is always the center of attraction. It's easy enough to see why!

Maureen Murphy is a desirable little eyeful whose personality attracts like a magnet.

Above all else, a curvey cutie must be sparkling to have real popularity. Whatever she may possess, all is lost without this one important factor—of which these two honeys have plenty!

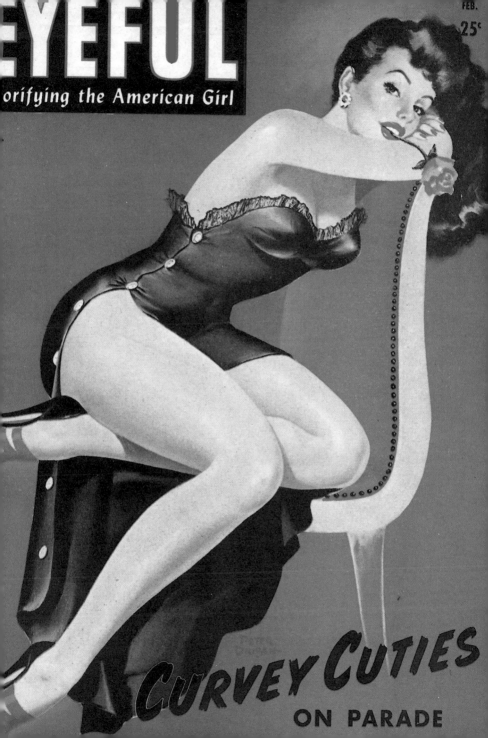

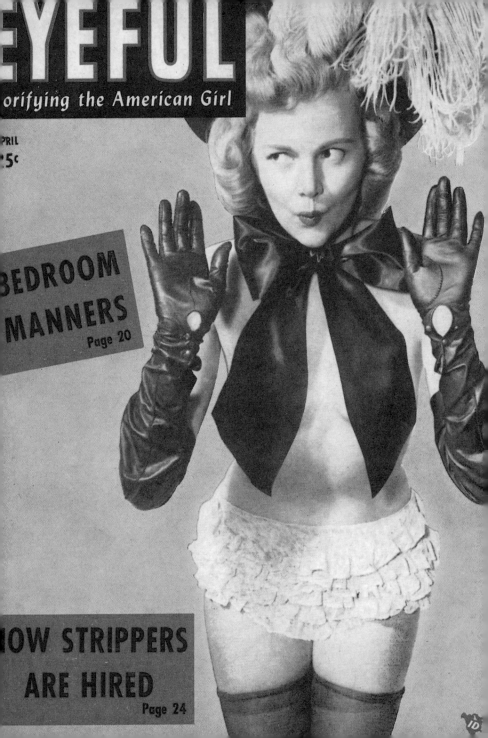

EYEFUL

orifying the American Girl

PRIL
25c

BEDROOM
MANNERS
Page 20

OW STRIPPERS
ARE HIRED
Page 24

EYEFUL

25¢

orifying the American Girl

KISSES CAUSE
TROUBLE Page 30

BODY FOR
HIRE Page 20

Bachelor G

Calendar (top left): SUN MON ... 1 2 3 4 5 / 6 7 8 9 10 11 12 / 13 14 15 16 17 18 19 / ... 27 ...

SUNDAY

Big Date Nite! On Sunday, baby goes places with the number one guy!

MONDAY

Wash Day! Th bachelor cutie rinse out almost non-ex istent dainties.

THURSDAY

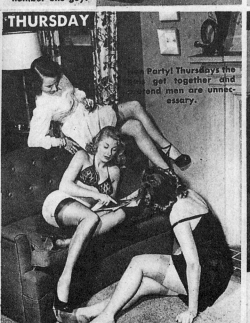

...en Party! Thursdays the ...gals get together and ...tend men are unnec- essary.

FRIDAY

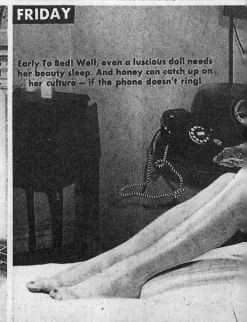

Early To Bed! Well, even a luscious doll needs her beauty sleep. And honey can catch up on her culture — if the phone doesn't ring!

Here's the inside dope o.. how a lovely ba..

rl's Calendar

1949

	Thu	Fri	Sat
5	6	7	1
12	13	14	8
19	20	21	15
			22

TUESDAY

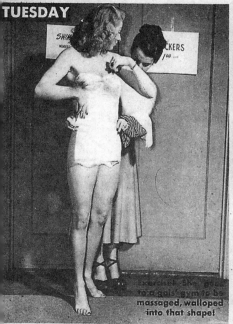

...exercise! She goes to a gals' gym to be massaged, walloped into that shape!

WEDNESDAY

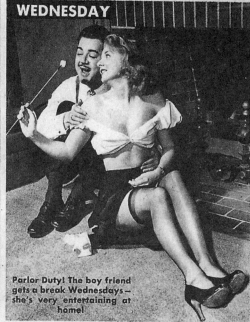

Parlor Duty! The boy friend gets a break Wednesdays— she's very entertaining at home!

SATURDAY

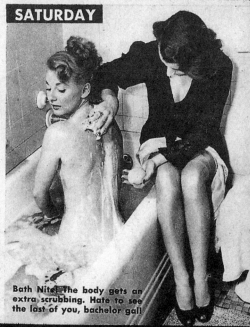

Bath Nite! The body gets an extra scrubbing. Hate to see the last of you, bachelor gal!

or gal spends her time all during the week

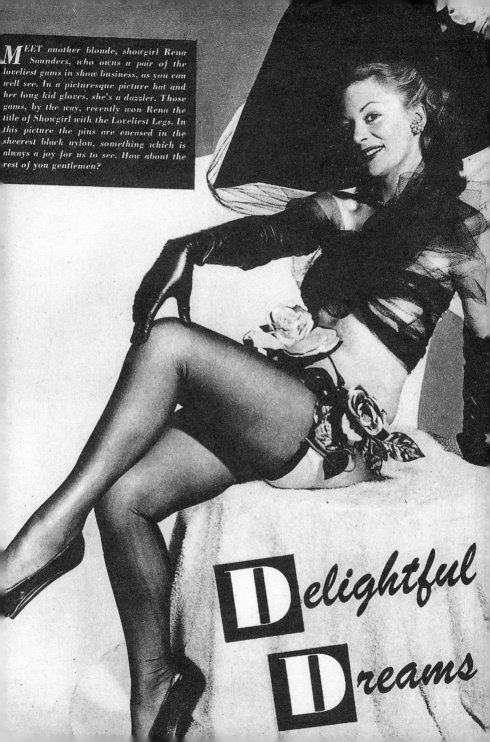

MEET another blonde, showgirl Rena Saunders, who owns a pair of the loveliest gams in show business, as you can well see. In a picturesque picture hat and her long kid gloves, she's a dazzler. Those gams, by the way, recently won Rena the title of Showgirl with the Loveliest Legs. In this picture the pins are encased in the sheerest black nylon, something which is always a joy for us to see. How about the rest of you gentlemen?

Delightful

Dreams

Xmas CAROL

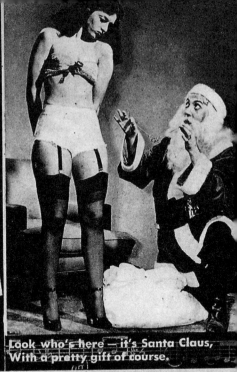

Look who's here — it's Santa Claus,
With a pretty gift of course.

But then, alas, the Babe says No!
You and your gifts have gotta go!

What's wrong my dear, you seem so sad?
What must I do to make you glad?

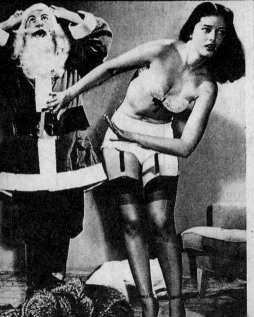

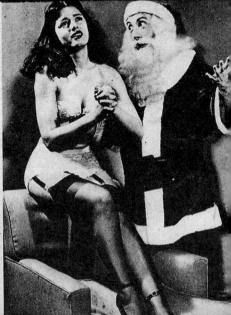

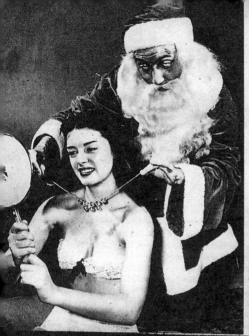

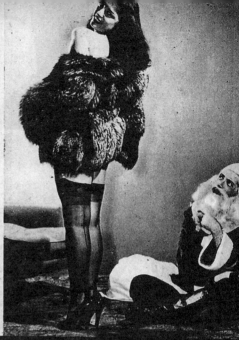

Now that's a mighty lovely gift,
Enough to give this chick a lift.

Gosh, that coat looks mighty fine,
And Santa thinks he's making time.

Listen toots, now could it be
That for Xmas you want me?

Yeah, you're the one I'm thinking of
Don't give me anything but love!

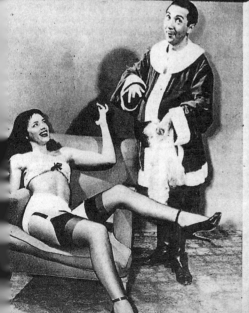

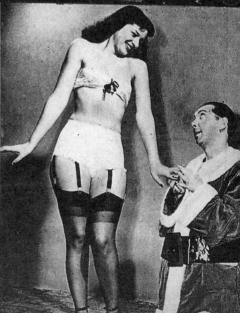

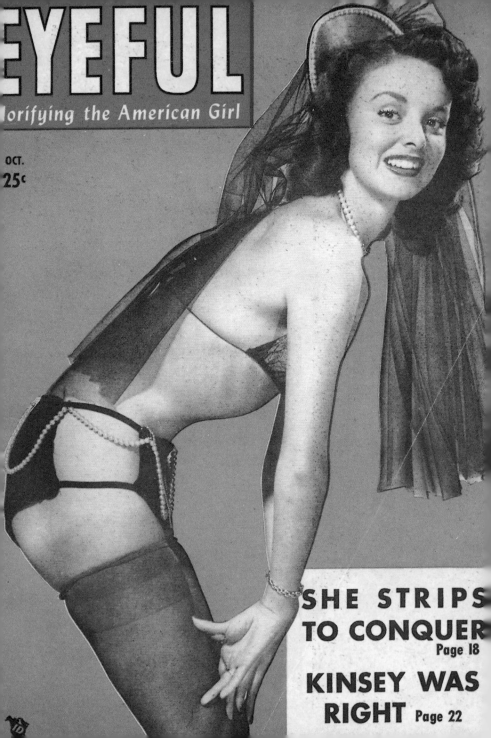

EYEFUL
Glorifying the American Girl

OCT.
25c

SHE STRIPS TO CONQUER
Page 18

KINSEY WAS RIGHT Page 22

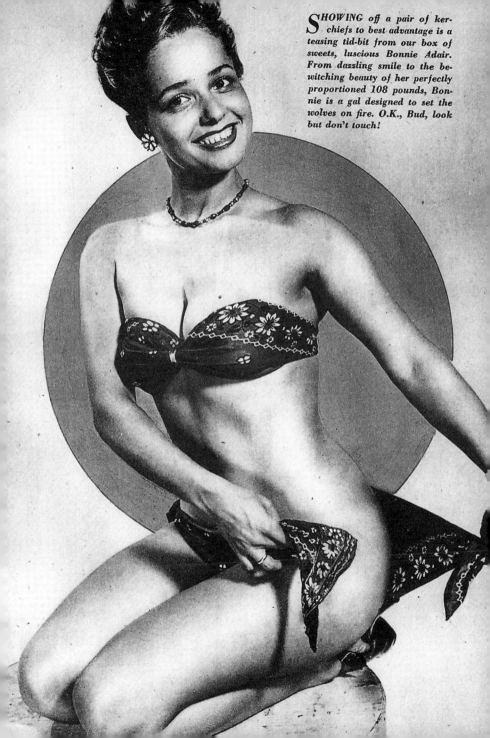

*S*HOWING off a pair of ker-
chiefs to best advantage is a
teasing tid-bit from our box of
sweets, luscious Bonnie Adair.
From dazzling smile to the be-
witching beauty of her perfectly
proportioned 108 pounds, Bon-
nie is a gal designed to set the
wolves on fire. O.K., Bud, look
but don't touch!

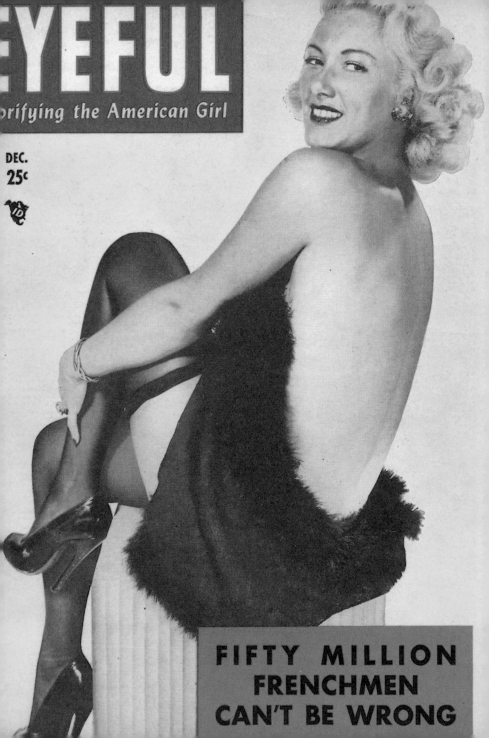

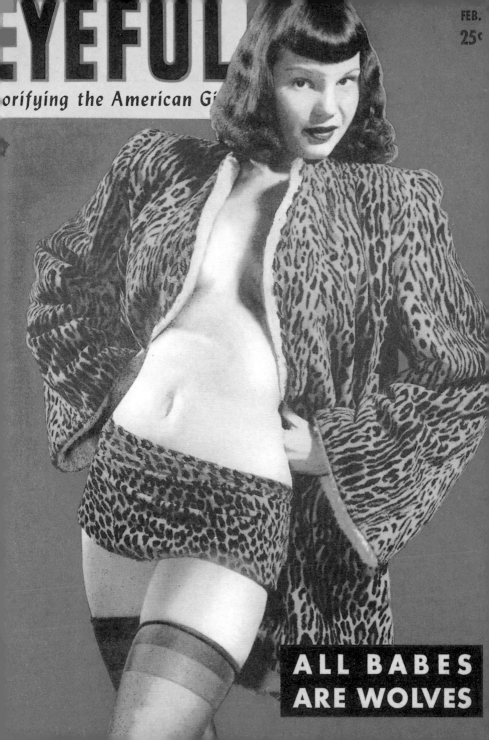

EYEFUL

FEB.

25¢

orifying the American Girl

ALL BABES
ARE WOLVES

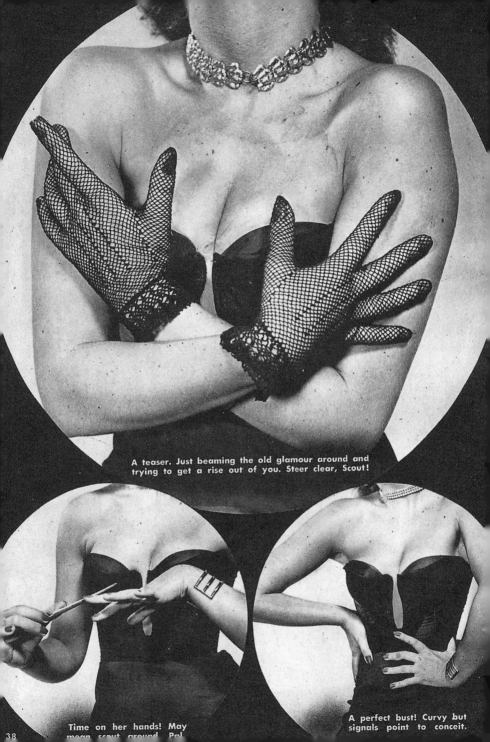

A teaser. Just beaming the old glamour around and trying to get a rise out of you. Steer clear, Scout!

Time on her hands! May mean scout around, Pal.

A perfect bust! Curvy but signals point to conceit.

38

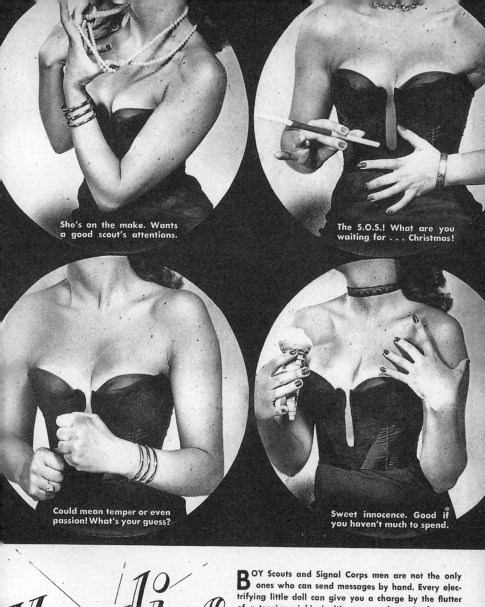

She's on the make. Wants a good scout's attentions.

The S.O.S.! What are you waiting for . . . Christmas!

Could mean temper or even passion! What's your guess?

Sweet innocence. Good if you haven't much to spend.

Handies

BOY Scouts and Signal Corps men are not the only ones who can send messages by hand. Every electrifying little doll can give you a charge by the flutter of a teasing pinkie inviting you to love. At the same time, she can shut off your current, make you blow a fuse, when her hands signal, "No, no!" just when the goal is in sight.

So don't be a Tenderfoot! Learn the code and be her Scout Master! Put plenty of feeling into this subject and you'll be surprised at how far you progress as teacher makes some interesting revelations.

here's A Message Of Love At Her Fingertips

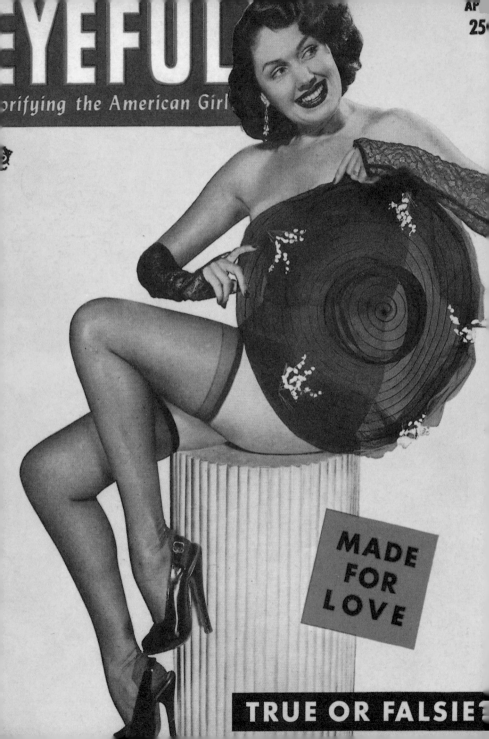

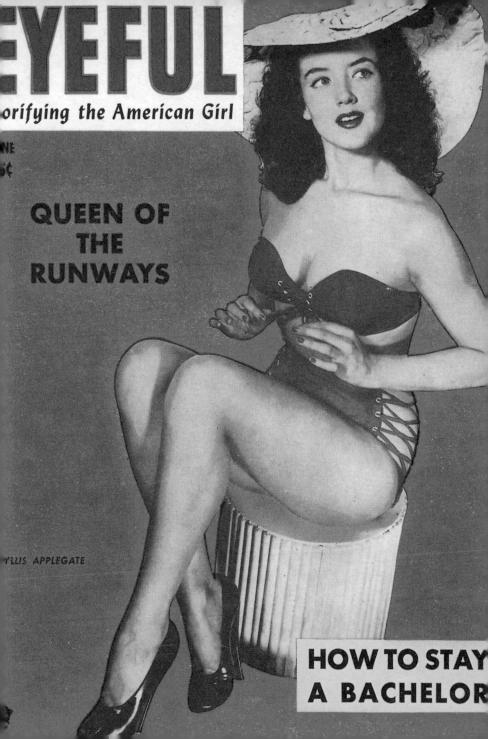

EYEFUL

orifying the American Girl

NE
5¢

QUEEN OF THE RUNWAYS

YLLIS APPLEGATE

HOW TO STAY A BACHELOR

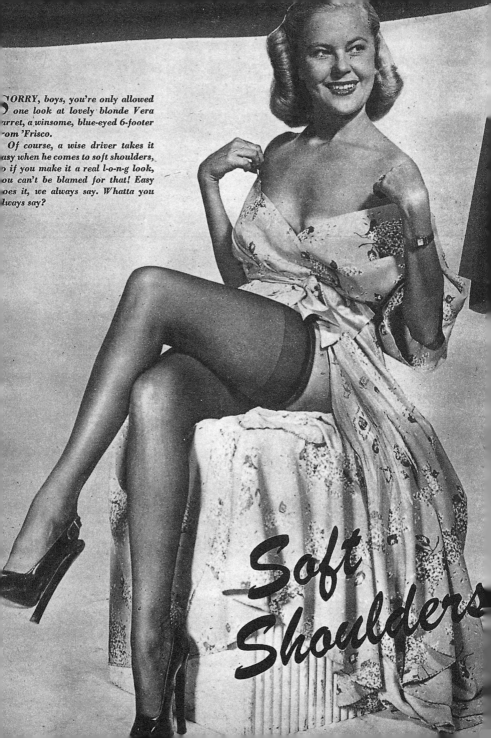

SORRY, boys, you're only allowed one look at lovely blonde Vera Surret, a winsome, blue-eyed 6-footer from 'Frisco.

Of course, a wise driver takes it easy when he comes to soft shoulders, so if you make it a real l-o-n-g look, you can't be blamed for that! Easy does it, we always say. Whatta you always say?

Soft Shoulders

EYEFUL
Glorifying the American Girl

25

MARY COLLINS

BLIND DATES
CAN BE FUN

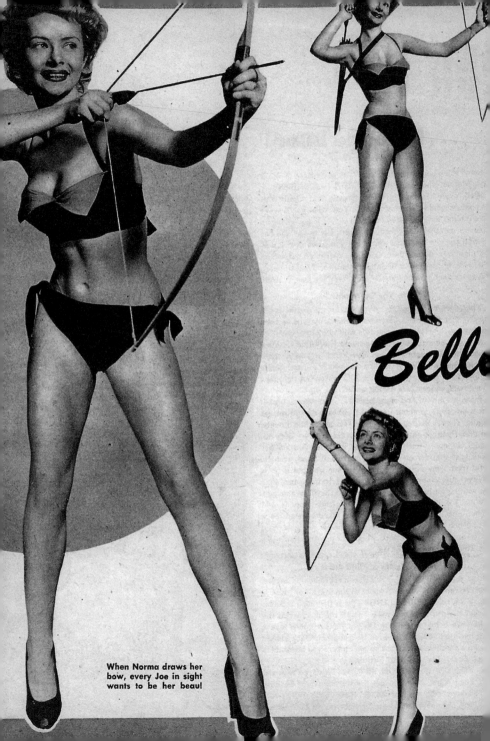

Belle

When Norma draws her bow, every Joe in sight wants to be her beau!

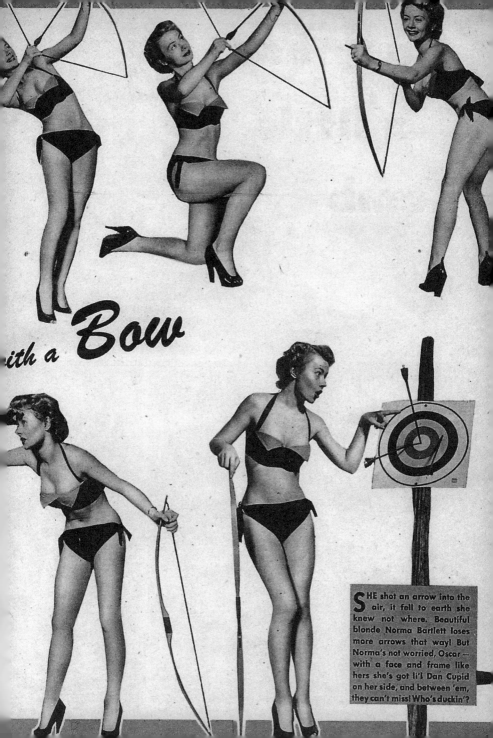

ith a *Bow*

SHE shot an arrow into the air, it fell to earth she knew not where. Beautiful blonde Norma Bartlett loses more arrows that way! But Norma's not worried, Oscar — with a face and frame like hers she's got li'l Dan Cupid on her side, and between 'em, they can't miss! Who's duckin'?

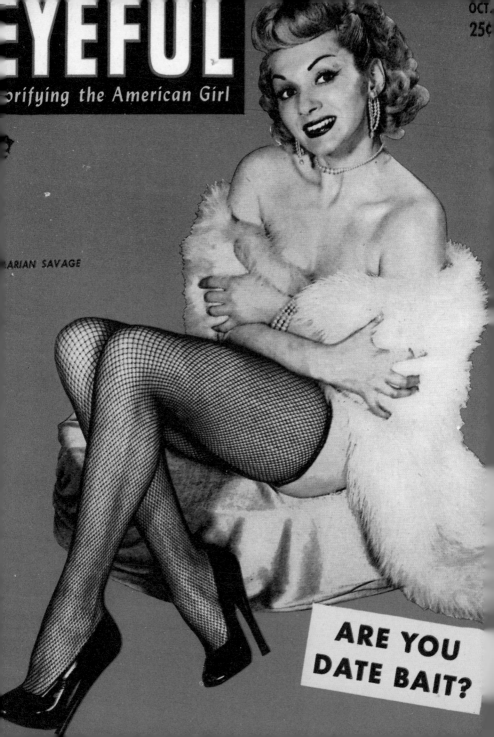

EYEFUL

orifying the American Girl

OCT.

25¢

ARIAN SAVAGE

ARE YOU DATE BAIT?

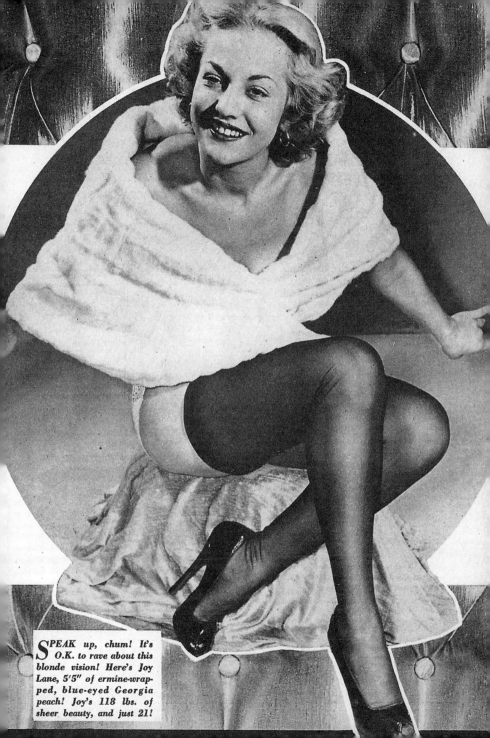

*S*PEAK up, chum! It's
O.K. to rave about this
blonde vision! Here's Joy
Lane, 5'5" of ermine-wrap-
ped, blue-eyed Georgia
peach! Joy's 118 lbs. of
sheer beauty, and just 21!

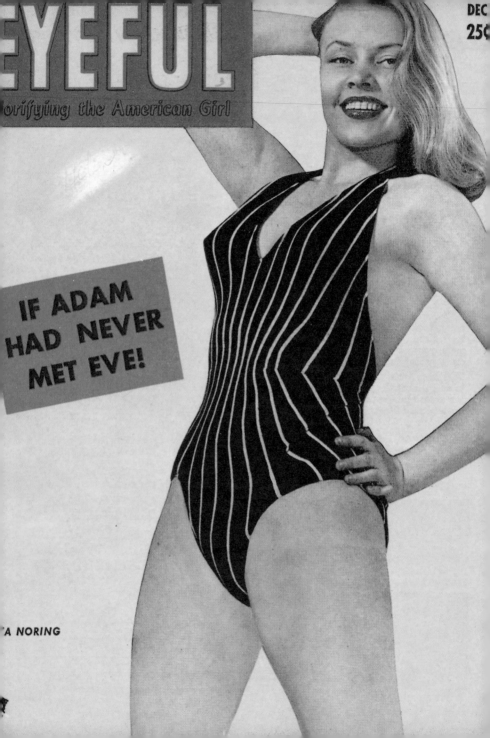

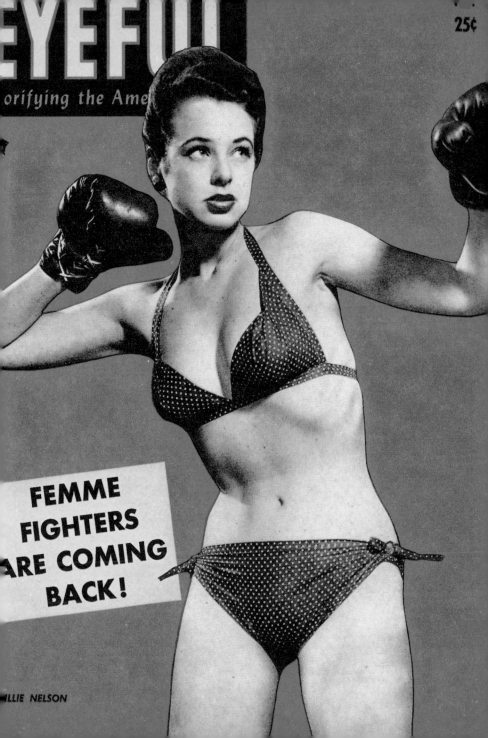

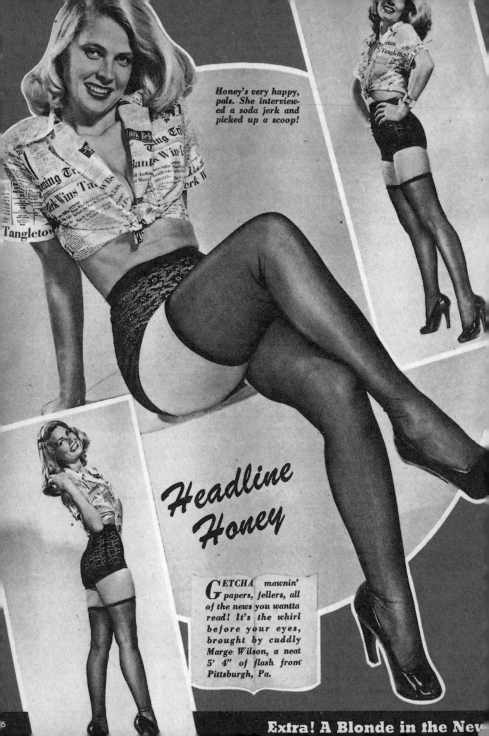

Honey's very happy, pals. She interviewed a soda jerk and picked up a scoop!

Headline Honey

GETCHA mawnin' papers, fellers, all of the news you wantta read! It's the whirl before your eyes, brought by cuddly Marge Wilson, a neat 5' 4" of flash from Pittsburgh, Pa.

Extra! A Blonde in the New

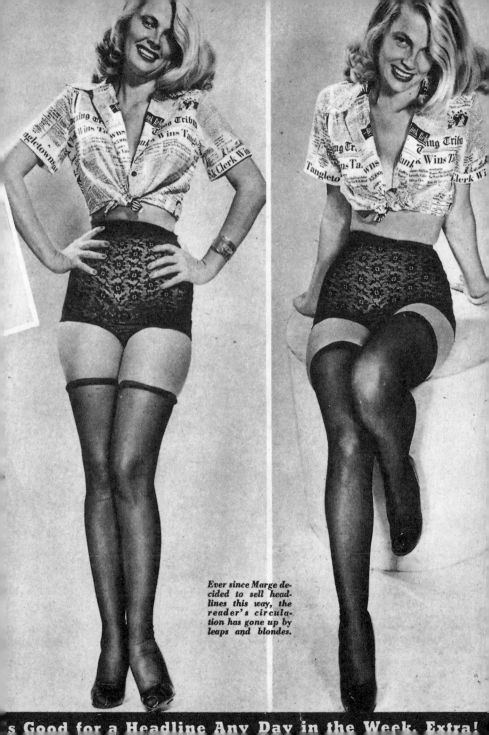

Ever since Marge decided to sell head-lines this way, the reader's circula-tion has gone up by leaps and blondes.

s Good for a Headline Any Day in the Week. Extra!

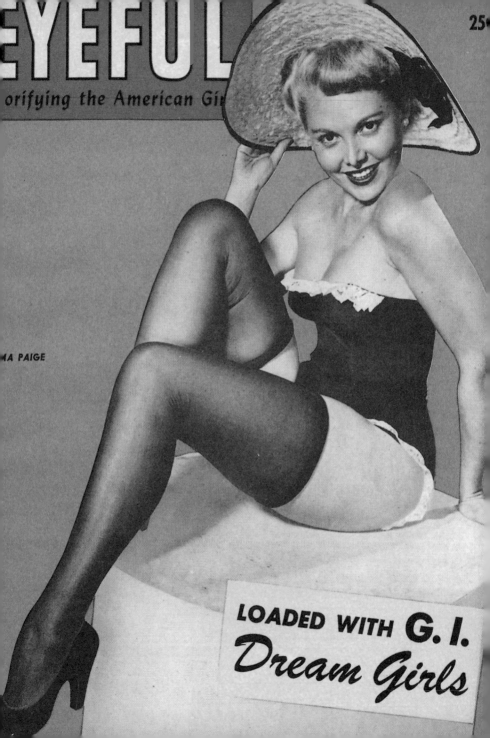

EYEFUL

25¢

orifying the American Girl

MA PAIGE

LOADED WITH G. I.
Dream Girls

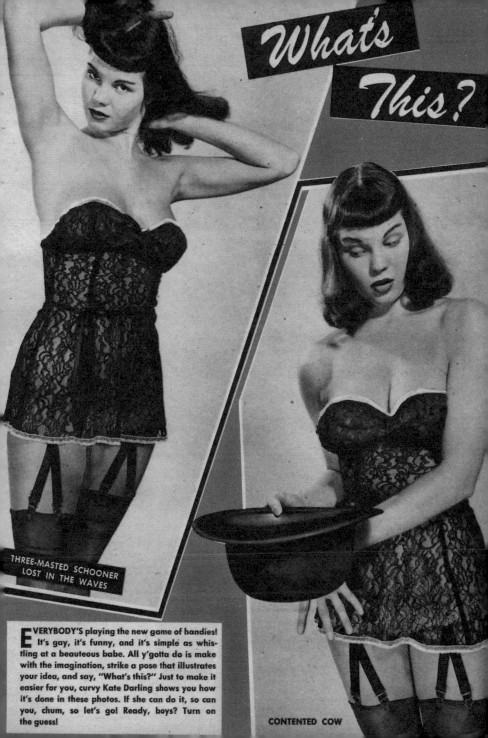

What's This?

THREE-MASTED SCHOONER
LOST IN THE WAVES

EVERYBODY'S playing the new game of handies!
It's gay, it's funny, and it's simple as whis-
tling at a beauteous babe. All y'gotta do is make
with the imagination, strike a pose that illustrates
your idea, and say, "What's this?" Just to make it
easier for you, curvy Kate Darling shows you how
it's done in these photos. If she can do it, so can
you, chum, so let's go! Ready, boys? Turn on
the guess!

CONTENTED COW

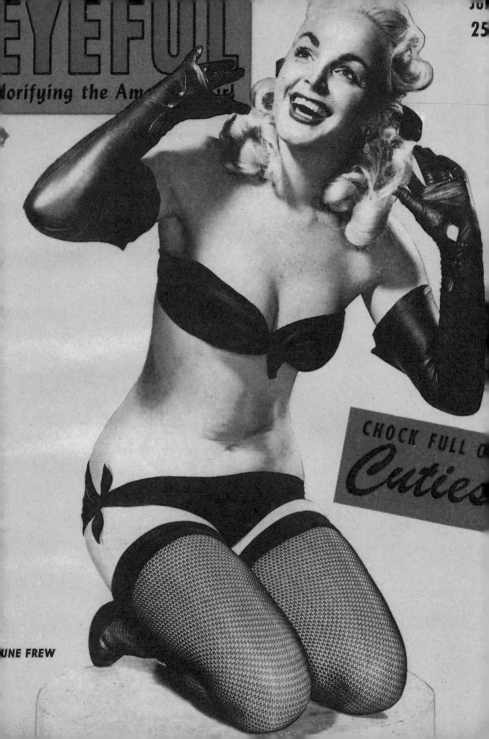

EYEFUL

Glorifying the American Girl

JU

25

CHOCK FULL O

Cuties

UNE FREW

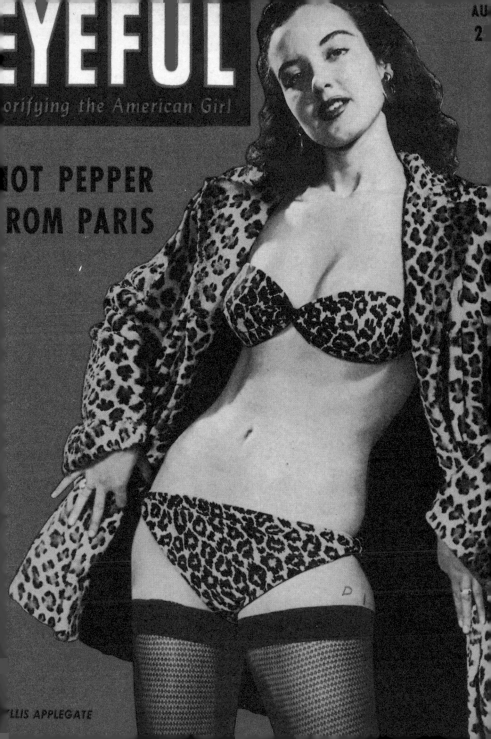

EYEFUL
orifying the American Girl

OT PEPPER
ROM PARIS

AU
2

LLIS APPLEGATE

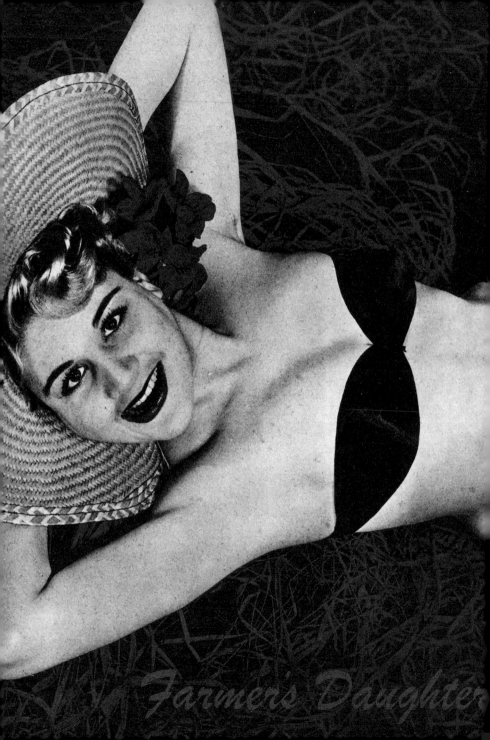

Farmer's Daughter

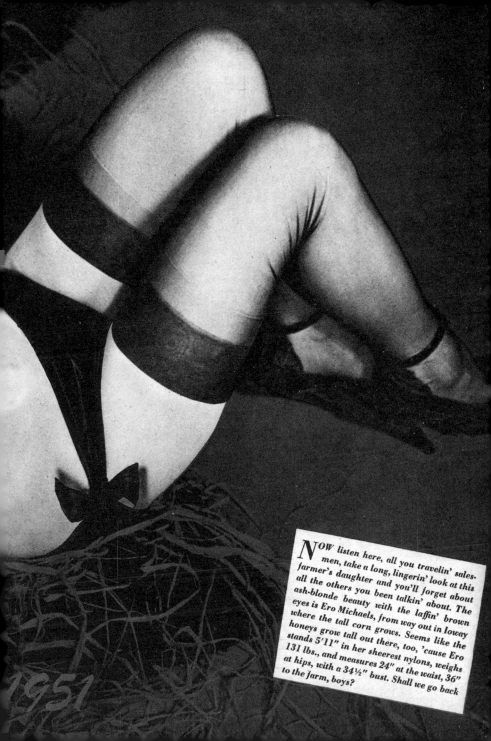

Now listen here, all you travelin' sales-men, take a long, lingerin' look at this farmer's daughter and you'll forget about all the others you been talkin' about. The ash-blonde beauty with the laffin' brown eyes is Ero Michaels, from way out in Ioway where the tall corn grows. Seems like the honeys grow tall out there, too, 'cause Ero stands 5'11" in her sheerest nylons, weighs 131 lbs., and measures 24" at the waist, 36" at hips, with a 34½" bust. Shall we go back to the farm, boys?

1951

LANA YEARNER and VAN PLOTNICK in
elle from Mexico

EE WHAT HAPPENS TO A SOUSE OF HE BORDER IN SEVEN DIZZY REELS!

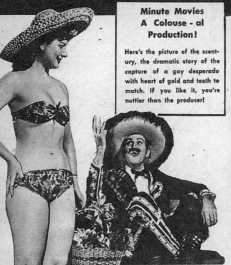

Minute Movies
A Colouse - al
Production!

Here's the picture of the scentury, the dramatic story of the capture of a gay desperado with heart of gold and teeth to match. If you like it, you're nuttier than the producer!

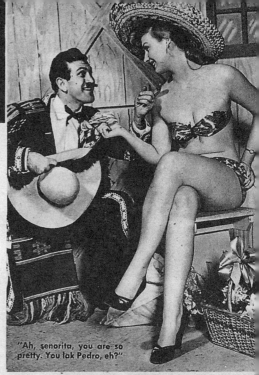

"Ah, senorita, you are so pretty. You lak Pedro, eh?"

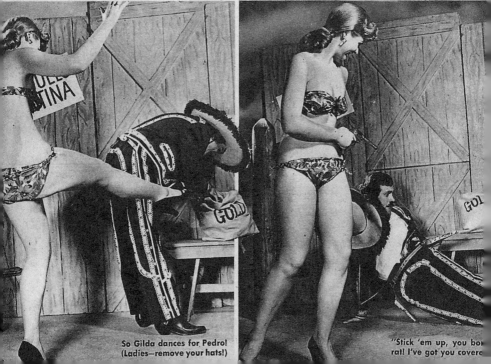

So Gilda dances for Pedro!
(Ladies—remove your hats!)

"Stick 'em up, you bor rat! I've got you covere

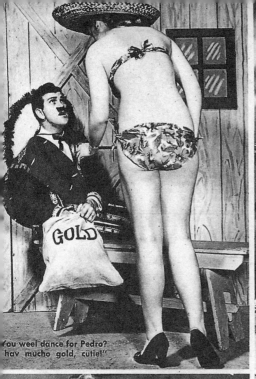

'ou weel dance for Pedro? hav mucho gold, cutie!"

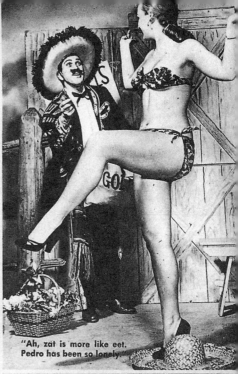

"Ah, zat is more like eet. Pedro has been so lonely."

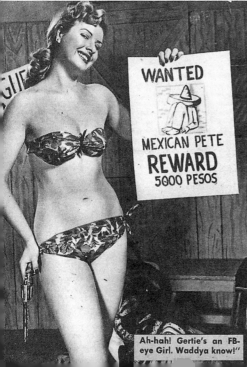

Ah-hah! Gertie's an FB-eye Girl. Waddya know!"

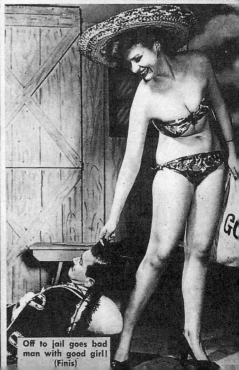

Off to jail goes bad man with good girl! (Finis)

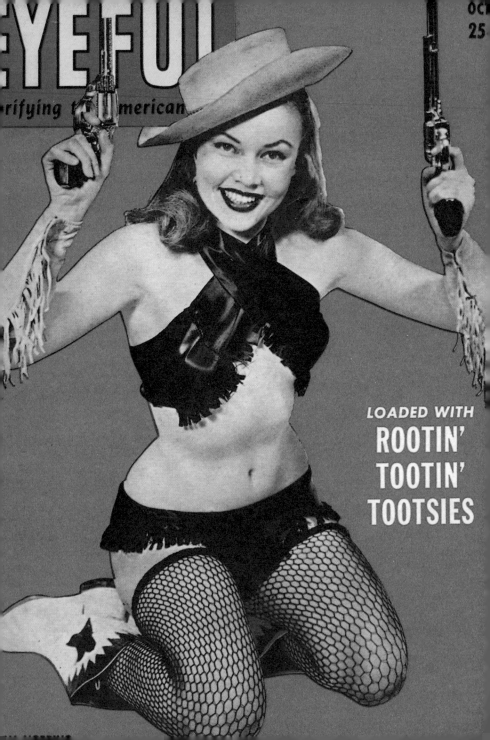

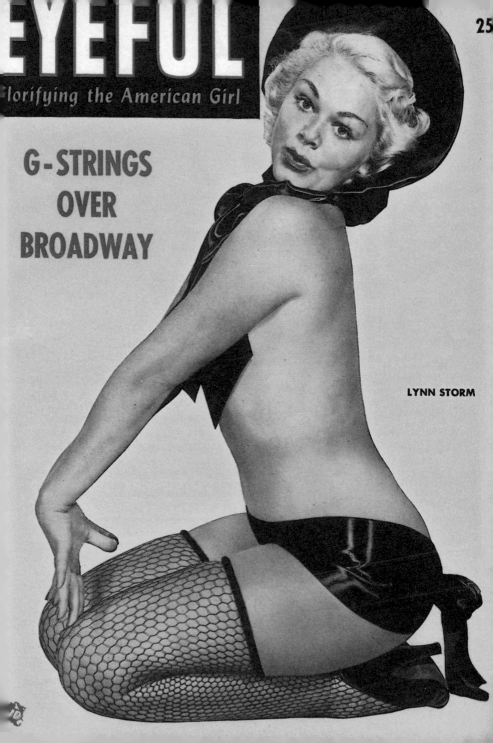

EYEFUL

Glorifying the American Girl

25¢

G-STRINGS OVER BROADWAY

LYNN STORM

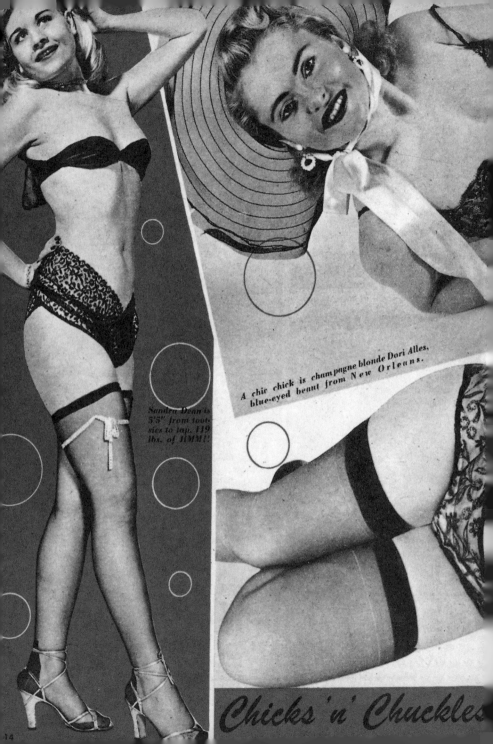

A chic chick is champagne blonde Dori Alles,
blue-eyed beaut from New Orleans.

Sandra Dean is
5'5" from toot-
sies to top, 119
lbs. of HMM!!

Chicks 'n' Chuckles

14

Ah! Here's Jane Russ,
a cuddlesome bundle
o' woo, 34-25-35" at
bust, waist 'n' hips.

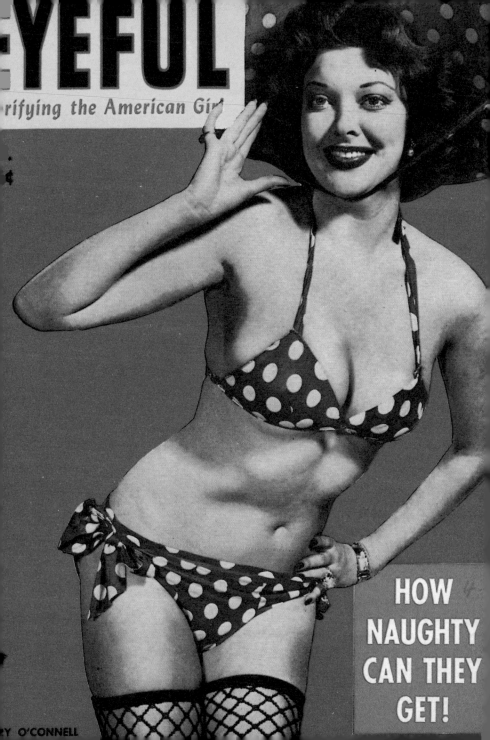

EYEFUL

…rifying the American Girl

HOW NAUGHTY CAN THEY GET!

…Y O'CONNELL

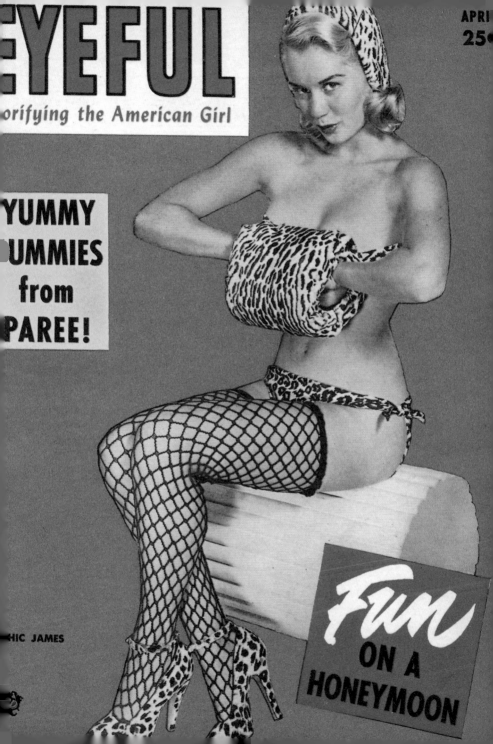

"I DON'T WANT A MAN WITH A FUTURE — I WANT A FUTURE WITH A MAN!"

Posed by Marla Savage, 21-year-old Broadway dancer and model. Marla is 5'3", 116 lbs., with brown hair and hazel eyes.

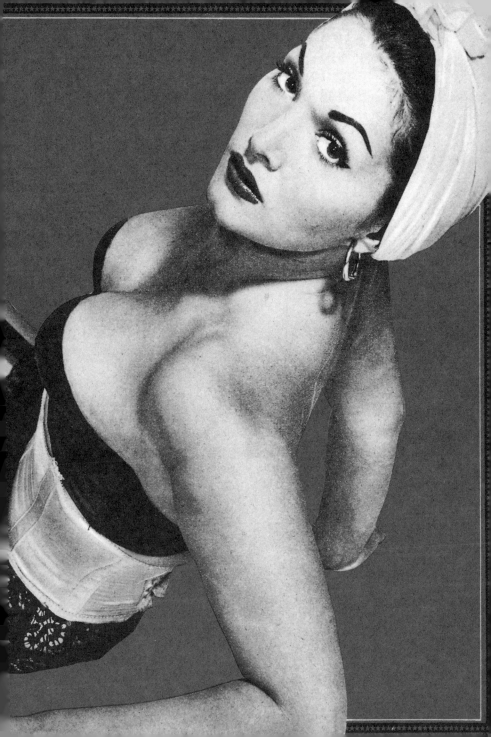

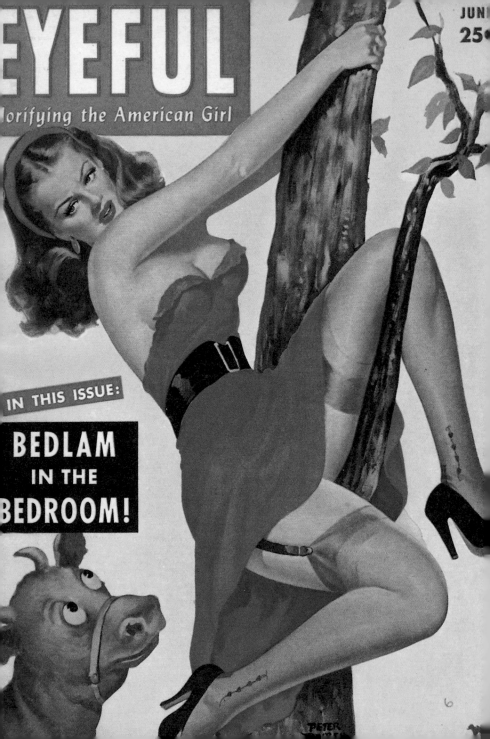

EYEFUL

rifying the American Girl

AUGUST
25¢

n This Issue:

IVE WAYS
TO TAKE
A BATH!

STAY
Lovely

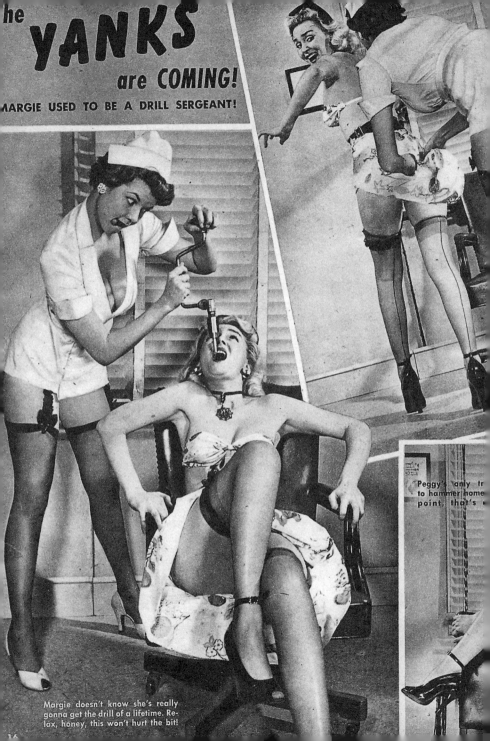

he YANKS are COMING!

MARGIE USED TO BE A DRILL SERGEANT!

Peggy's only tr to hammer home point, that's

Margie doesn't know she's really gonna get the drill of a lifetime. Relax, honey, this won't hurt the bit!

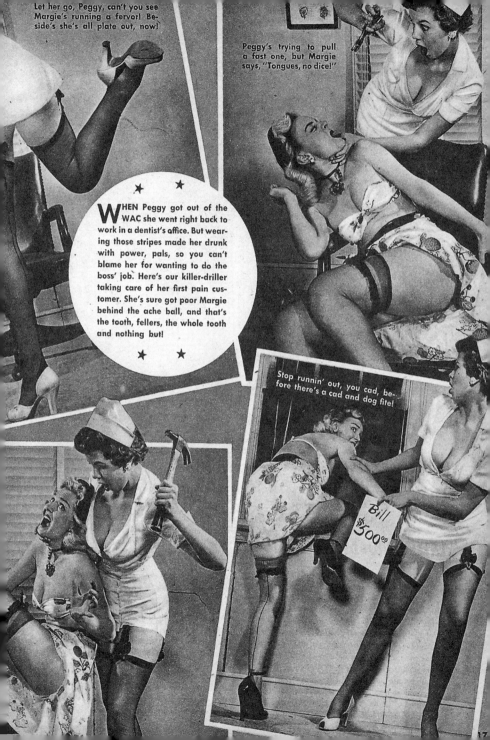

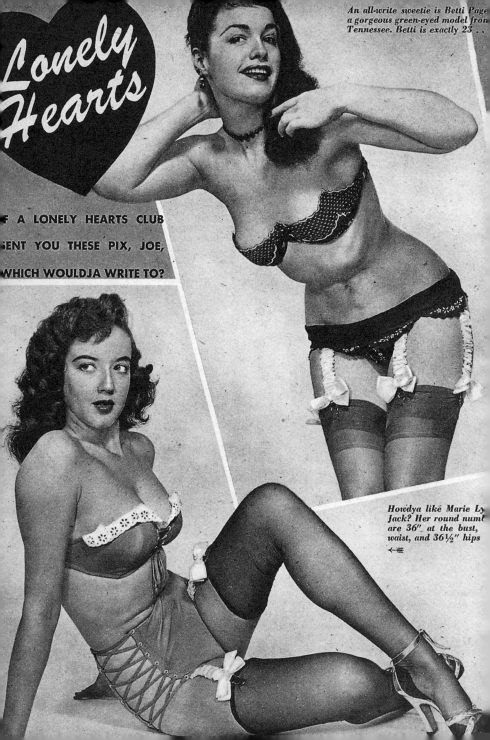

Lonely Hearts

An all-write sweetie is Betti Page a gorgeous green-eyed model from Tennessee. Betti is exactly 23 . .

F A LONELY HEARTS CLUB
ENT YOU THESE PIX, JOE,
WHICH WOULDJA WRITE TO?

Howdya like Marie Ly
Jack? Her round numt
are 36" at the bust,
waist, and 36½" hips

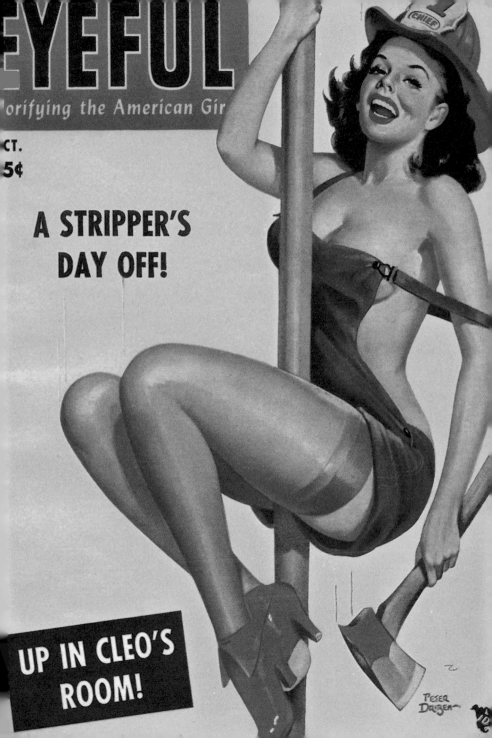

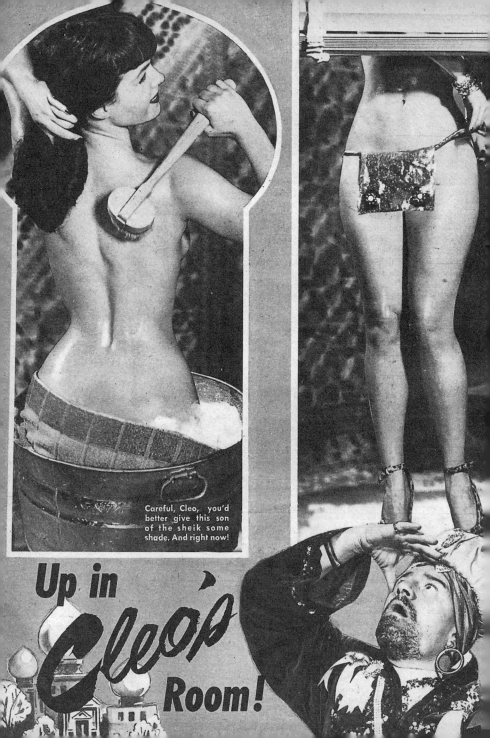

Careful, Cleo, you'd better give this son of the sheik some shade. And right now!

Up in Cleo's Room!

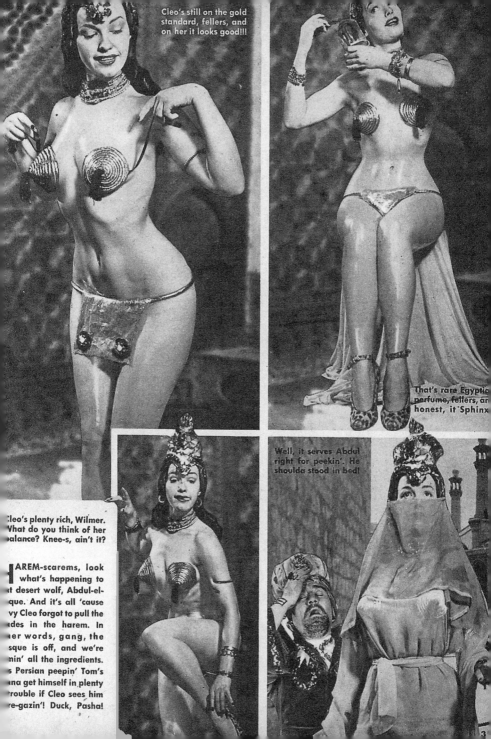

Cleo's still on the gold standard, fellers, and on her it looks good!!!

That's rare Egyptic perfume, fellers, an' honest, it 'Sphinx

Well, it serves Abdul right for peekin'. He shoulda stood in bed!

Cleo's plenty rich, Wilmer. What do you think of her balance? Knee-s, ain't it?

HAREM-scarems, look what's happening to t desert wolf, Abdul-el- que. And it's all 'cause vy Cleo forgot to pull the des in the harem. In er words, gang, the sque is off, and we're min' all the ingredients. s Persian peepin' Tom's na get himself in plenty rouble if Cleo sees him e-gazin'! Duck, Pasha!

3

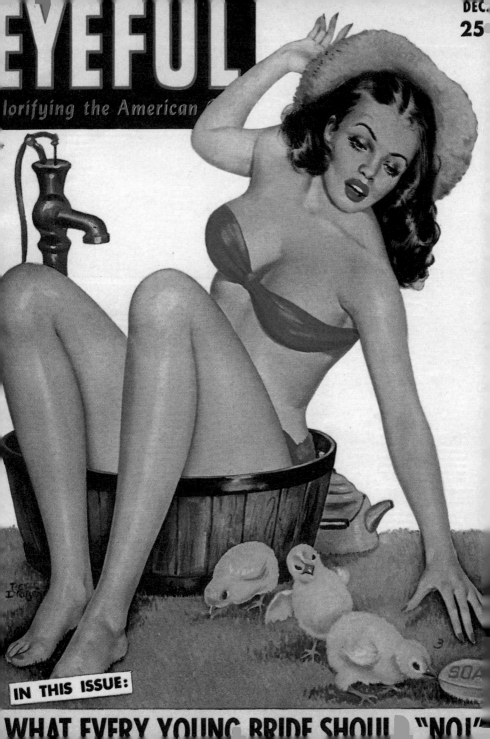

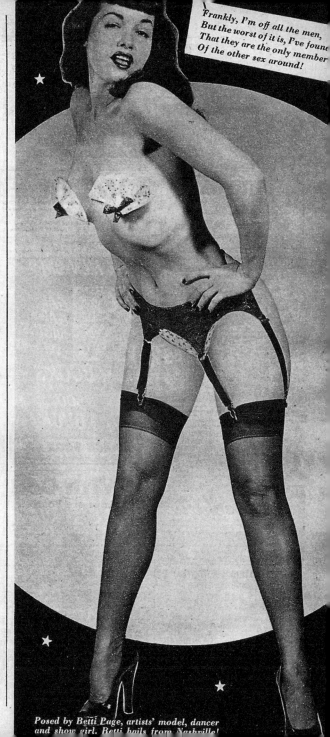

'Frankly, I'm off all the men,
But the worst of it is, I've found
That they are the only member
Of the other sex around!

Posed by Betti Page, artists' model, dancer
and show girl. Betti hails from Nashville!

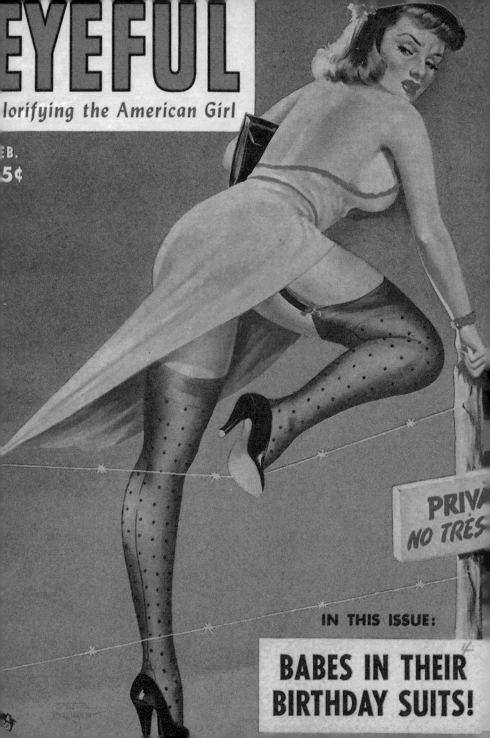

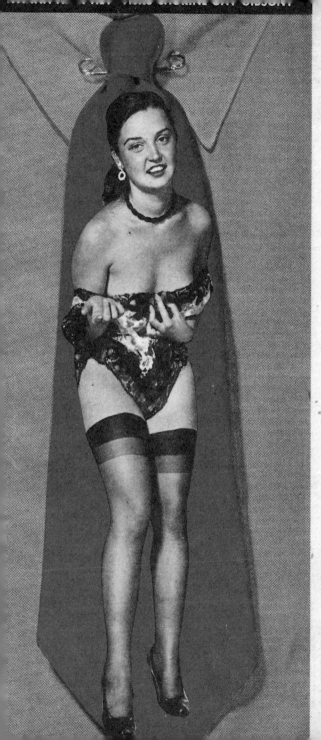

3°

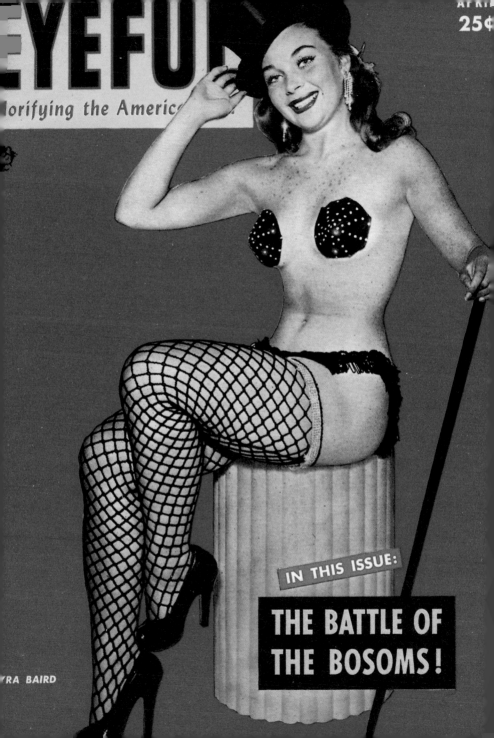

EYEFU[L]

[Gl]orifying the America[n]

APRI[L]

25¢

IN THIS ISSUE:

THE BATTLE OF
THE BOSOMS!

[MY]RA BAIRD

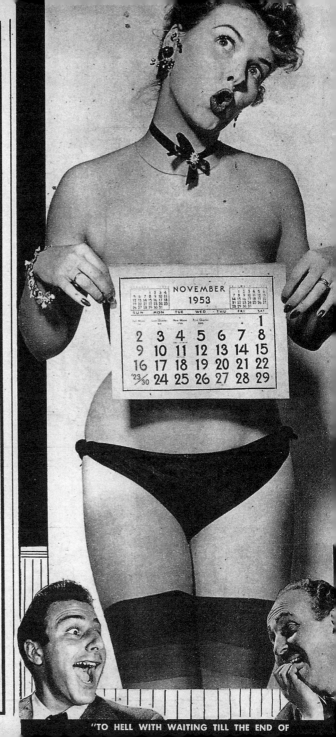

"TO HELL WITH WAITING TILL THE END OF

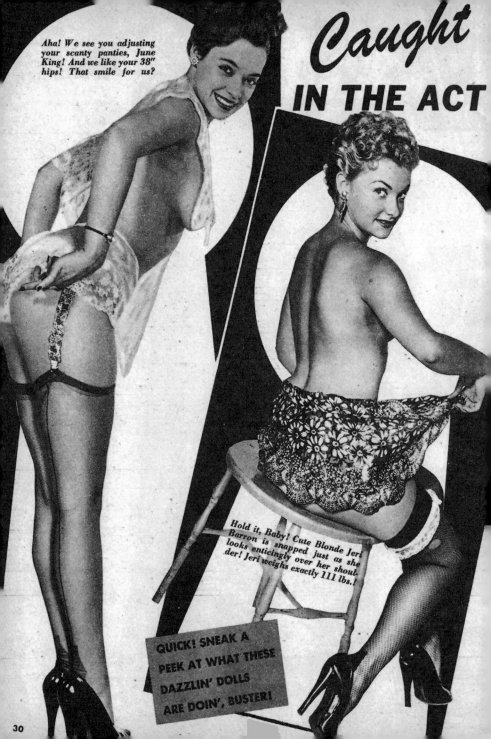

Aha! We see you adjusting your scanty panties, June King! And we like your 38" hips! That smile for us?

Caught
IN THE ACT

Hold it, Baby! Cute Blonde Jeri Barron is snapped just as she looks enticingly over her shoulder! Jeri weighs exactly 111 lbs.!

QUICK! SNEAK A PEEK AT WHAT THESE DAZZLIN' DOLLS ARE DOIN', BUSTER!

30

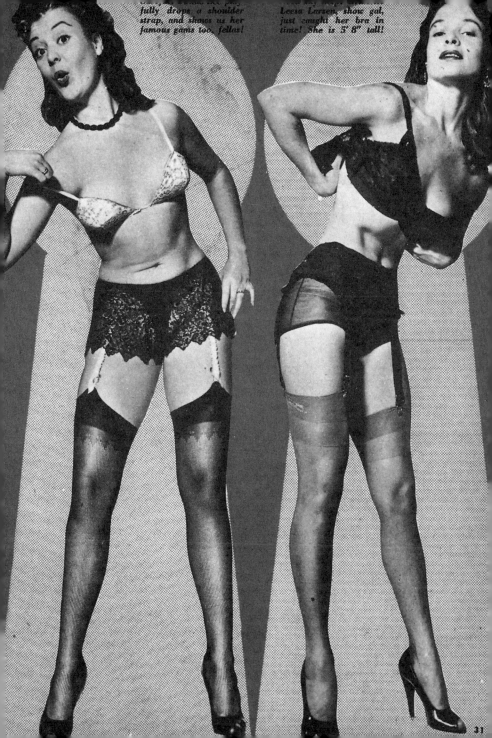

fully drops a shoulder
strap, and shows us her
famous gams too, fellas!

Leesa Larsen, show gal,
just caught her bra in
time! She is 5' 8" tall!

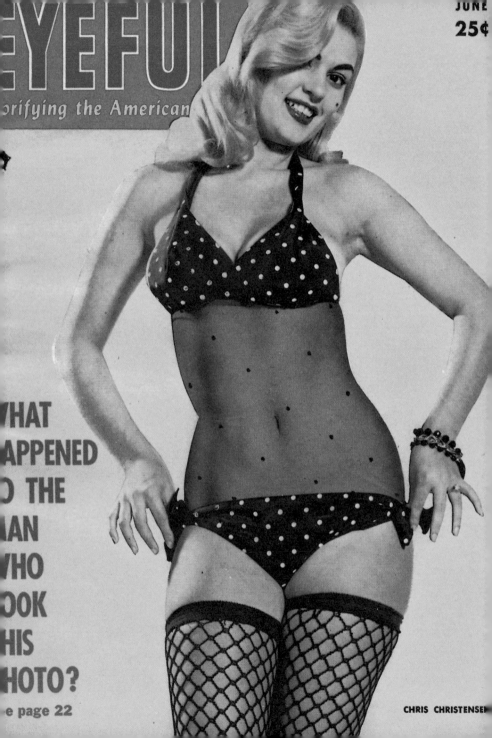

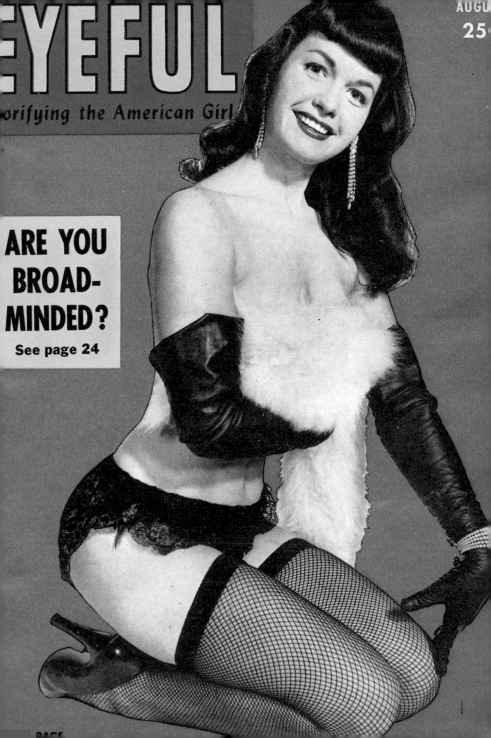

JULIUS
Teaser

Julius Sees 'Er!

Julius Wows 'Er!

3. Julius Woos 'Er!

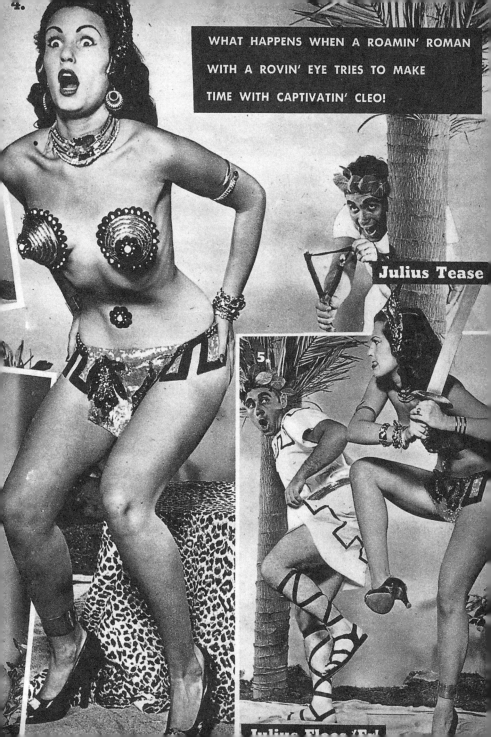

4.

WHAT HAPPENS WHEN A ROAMIN' ROMAN WITH A ROVIN' EYE TRIES TO MAKE TIME WITH CAPTIVATIN' CLEO!

Julius Tease

5

Julius Flees 'Er

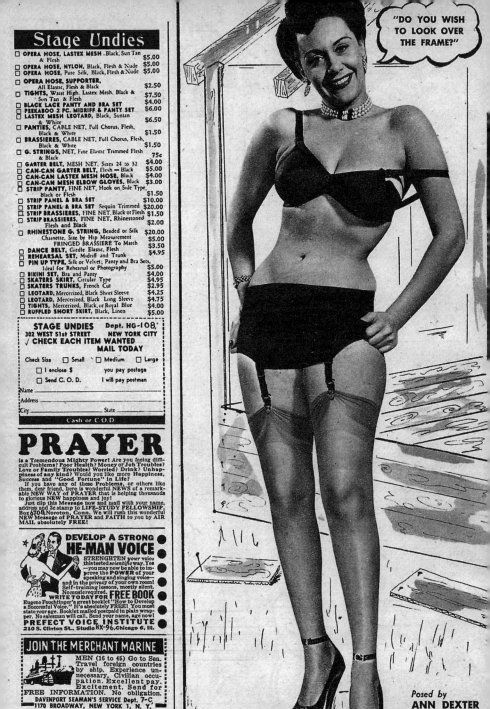

"DO YOU WISH TO LOOK OVER THE FRAME?"

Posed by
ANN DEXTER

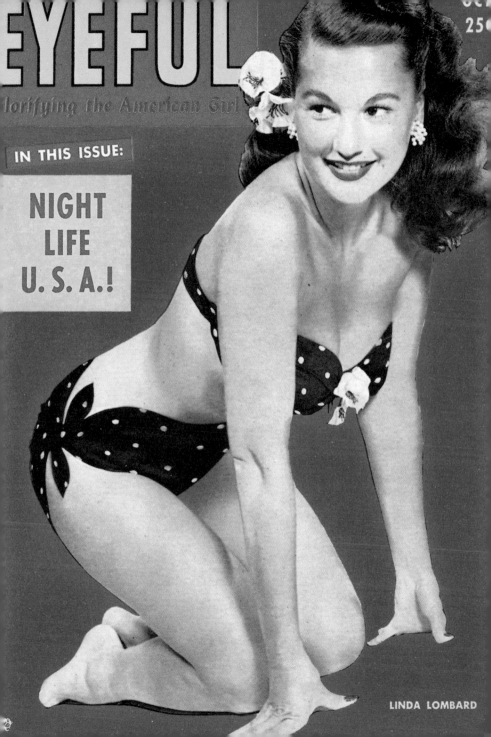

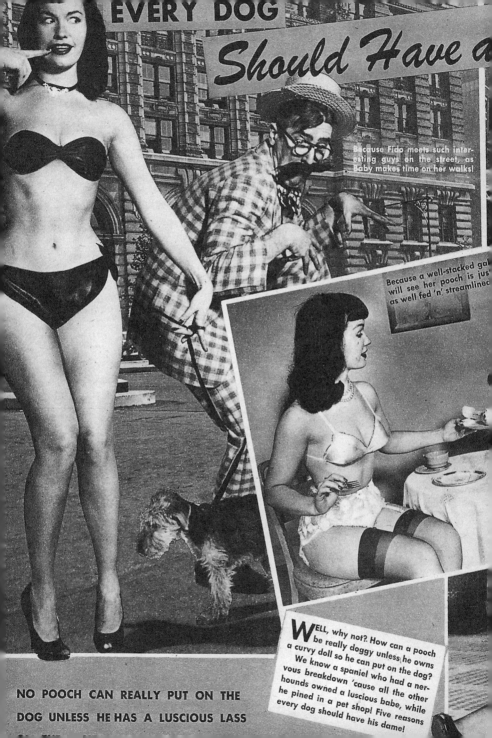

EVERY DOG

Should Have a

Because Fido meets such interesting guys on the street, as Baby makes time on her walks!

Because a well-stacked gal will see her pooch is just as well fed 'n' streamlined!

WELL, why not? How can a pooch be really doggy unless he owns a curvy doll so he can put on the dog? We know a spaniel who had a nervous breakdown 'cause all the other hounds owned a luscious babe, while he pined in a pet shop! Five reasons every dog should have his dame!

NO POOCH CAN REALLY PUT ON THE
DOG UNLESS HE HAS A LUSCIOUS LASS

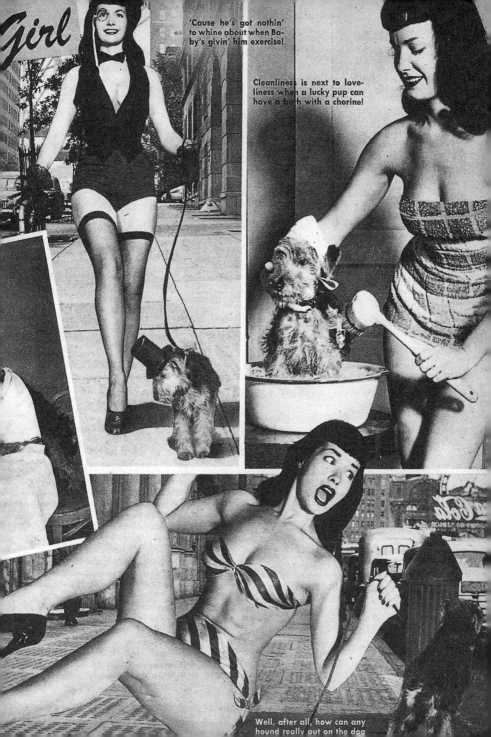

Girl

'Cause he's got nothin' to whine about when Baby's givin' him exercise!

Cleanliness is next to loveliness when a lucky pup can have a bath with a chorine!

Well, after all, how can any hound really put on the dog

United Shapes of America

THE CLASSIEST

CHASSIS FROM

COAST TO COAST!

*Meet Claire James, the model we hope
is the shape of things to come! She*

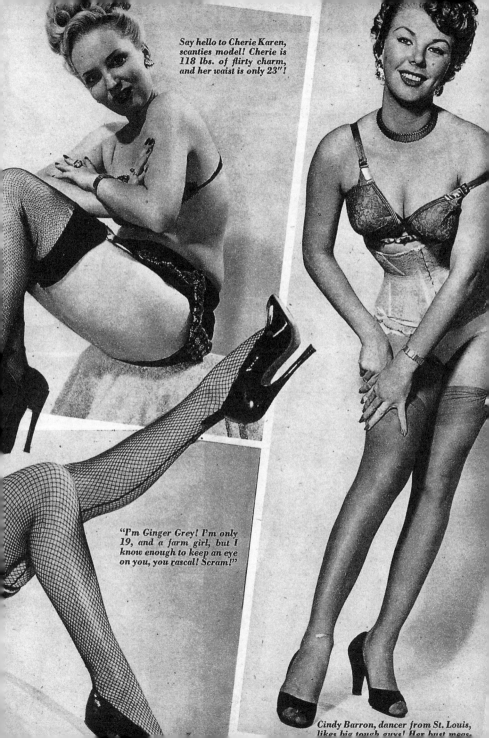

Say hello to Cherie Karen, scanties model! Cherie is 118 lbs. of flirty charm, and her waist is only 23"!

"I'm Ginger Grey! I'm only 19, and a farm girl, but I know enough to keep an eye on you, you rascal! Scram!"

Cindy Barron, dancer from St. Louis, likes big tough guys! Her bust meas-

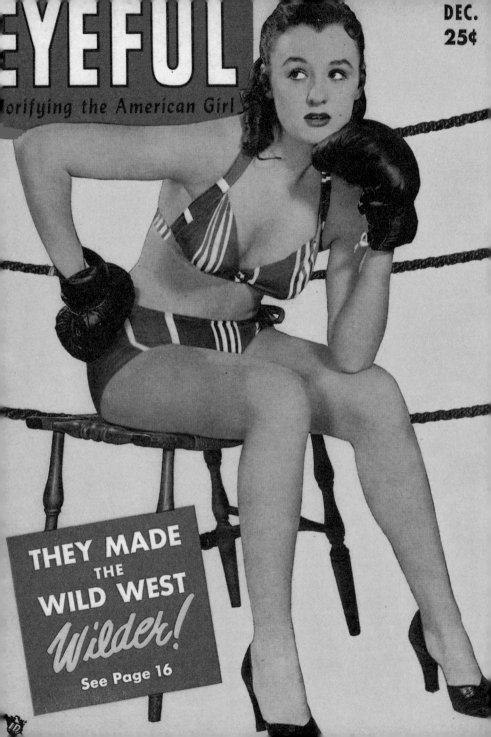

EYEFUL

Glorifying the American Girl

DEC.
25¢

THEY MADE
THE
WILD WEST
Wilder!
See Page 16

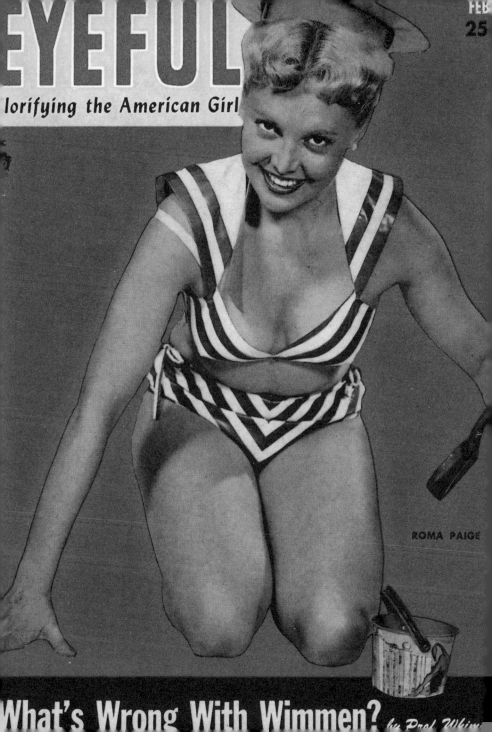

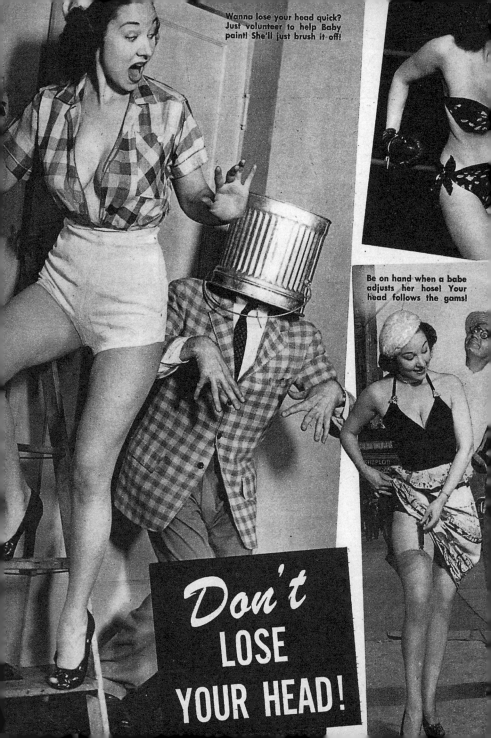

Wanna lose your head quick? Just volunteer to help Baby paint! She'll just brush it off!

Be on hand when a babe adjusts her hose! Your head follows the gams!

Don't LOSE YOUR HEAD!

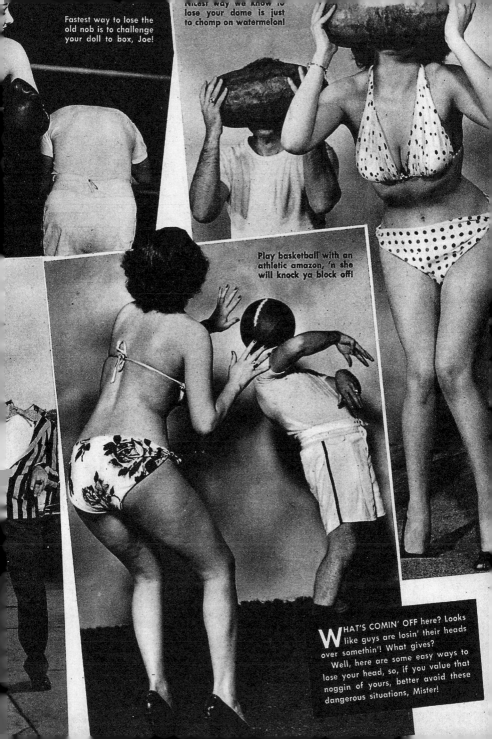

Fastest way to lose the old nob is to challenge your doll to box, Joe!

Nicest way we know to lose your dome is just to chomp on watermelon!

Play basketball with an athletic amazon, 'n she will knock ya block off!

WHAT'S COMIN' OFF here? Looks like guys are losin' their heads over somethin'! What gives? Well, here are some easy ways to lose your head, so, if you value that noggin of yours, better avoid these dangerous situations, Mister!

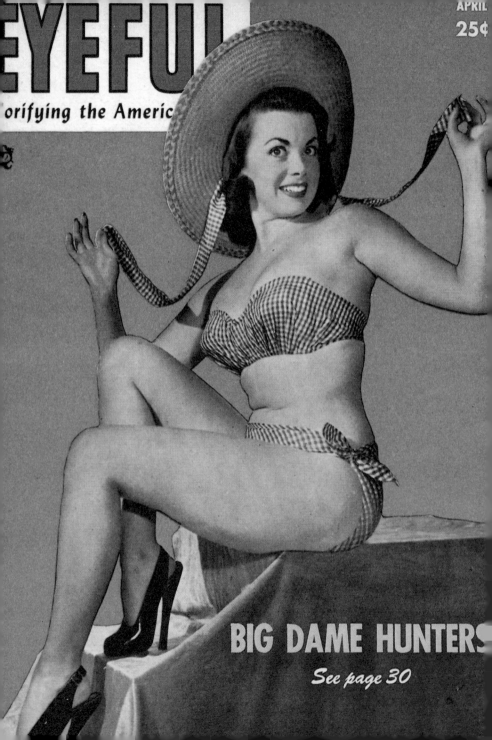

EYE FUL

orifying the Americ

APRIL
25¢

BIG DAME HUNTERS
See page 30

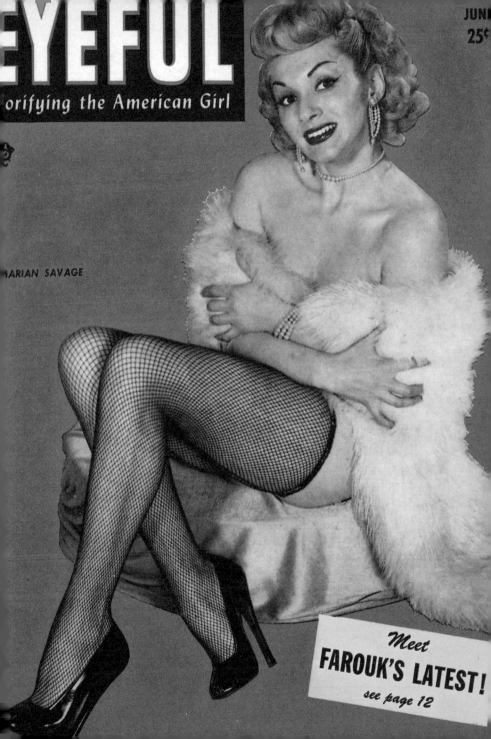

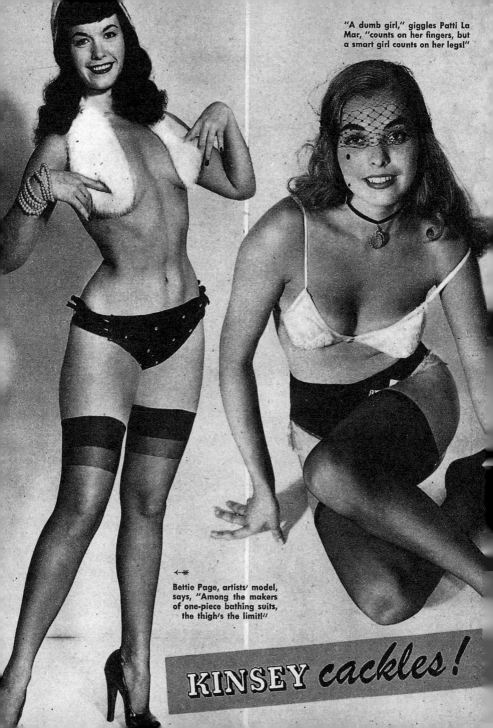

"A dumb girl," giggles Patti La Mar, "counts on her fingers, but a smart girl counts on her legs!"

Bettie Page, artists' model, says, "Among the makers of one-piece bathing suits, the thigh's the limit!"

KINSEY *cackles!*

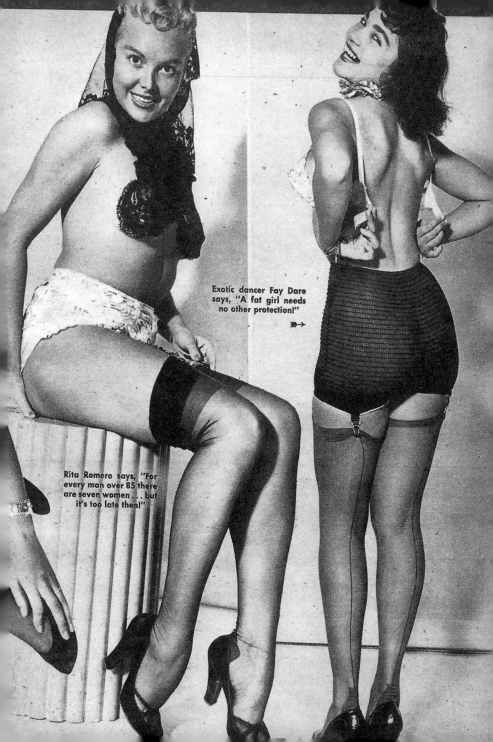

Exotic dancer Fay Dare says, "A fat girl needs no other protection!"

➡➡→

Rita Romero says, "For every man over 85 there are seven women . . . but it's too late then!"

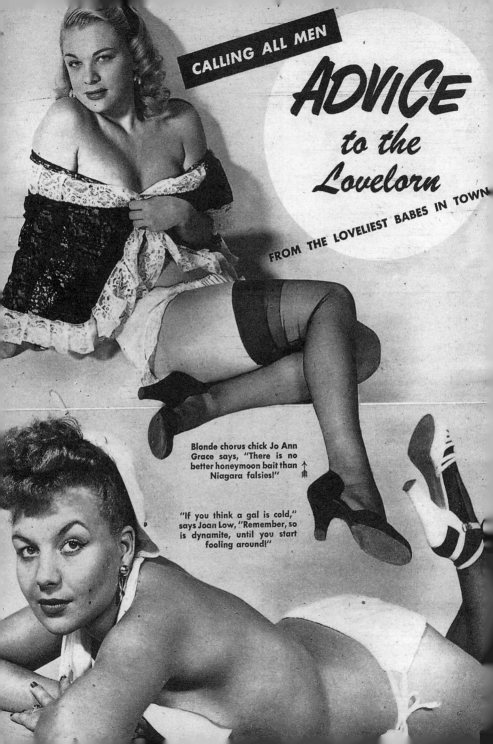

CALLING ALL MEN

ADVICE
to the
Lovelorn

FROM THE LOVELIEST BABES IN TOWN

Blonde chorus chick Jo Ann Grace says, "There is no better honeymoon bait than Niagara falsies!"

"If you think a gal is cold," says Joan Low, "Remember, so is dynamite, until you start fooling around!"

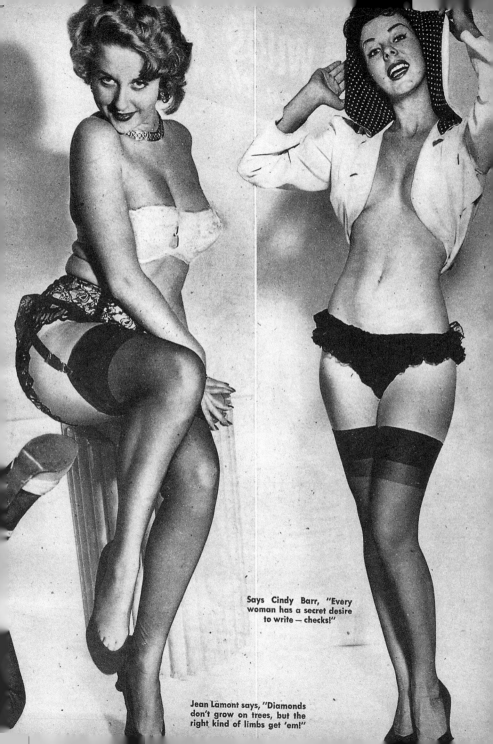

Says Cindy Barr, "Every
woman has a secret desire
to write — checks!"

Jean Lamont says, "Diamonds
don't grow on trees, but the
right kind of limbs get 'em!"

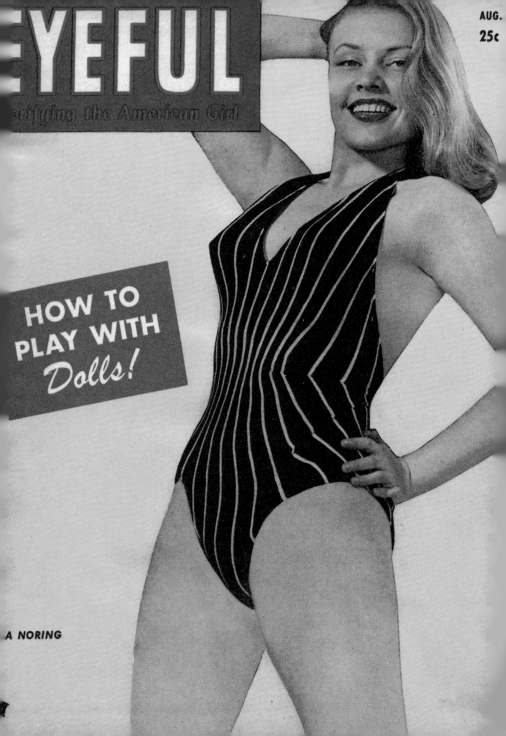

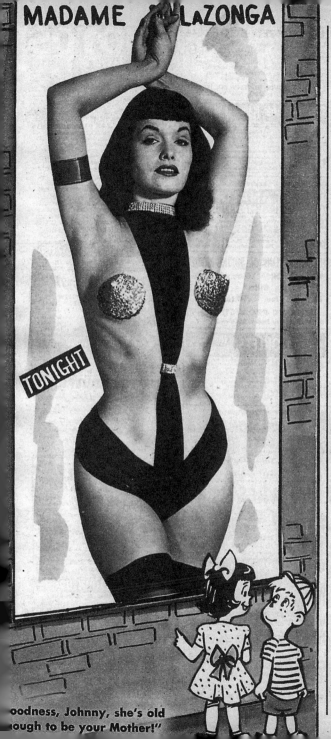

EYEFUL

orifying the American Gi

Oct.
25¢

ALL BABES
ARE WOLVES

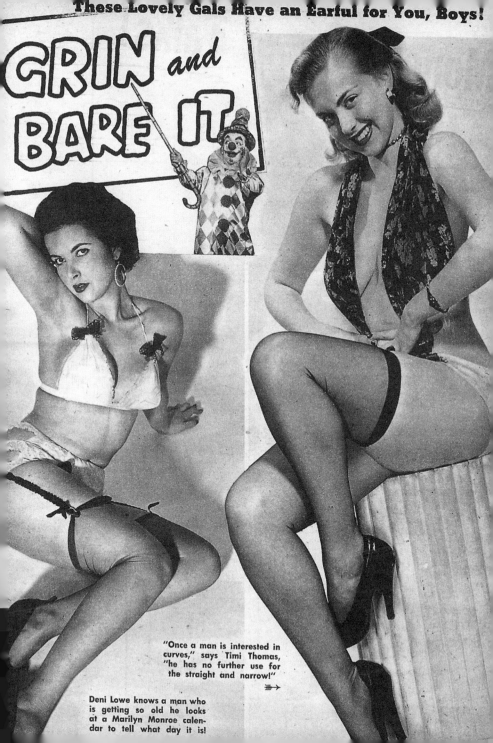

These Lovely Gals Have an Earful for You, Boys!

GRIN and BARE IT

"Once a man is interested in curves," says Timi Thomas, "he has no further use for the straight and narrow!"

Deni Lowe knows a man who is getting so old he looks at a Marilyn Monroe calendar to tell what day it is!

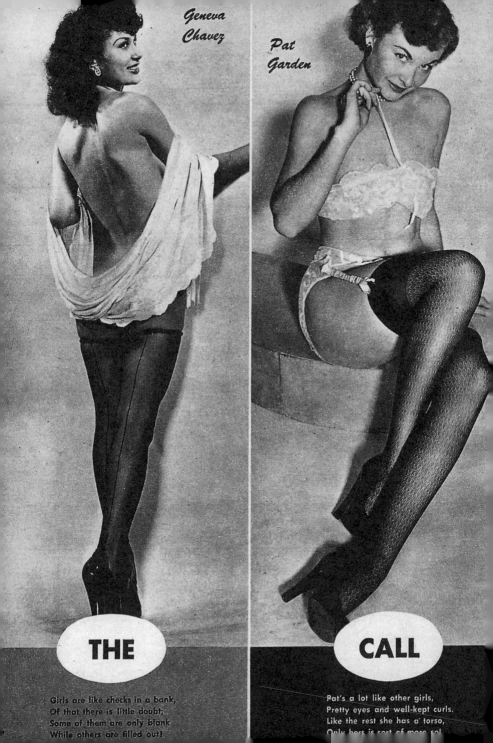

Geneva
Chavez

Pat
Garden

THE

CALL

Girls are like checks in a bank,
Of that there is little doubt,
Some of them are only blank
While others are filled out!

Pat's a lot like other girls,
Pretty eyes and well-kept curls.
Like the rest she has a' torso,
Only hers is sort of more so

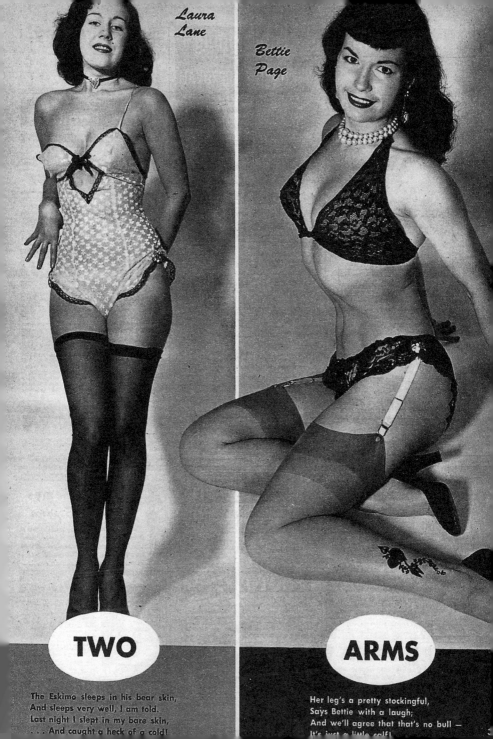

Laura
Lane

Bettie
Page

TWO

ARMS

The Eskimo sleeps in his bear skin,
And sleeps very well, I am told.
Last night I slept in my bare skin,
. . . And caught a heck of a cold!

Her leg's a pretty stockingful,
Says Bettie with a laugh;
And we'll agree that that's no bull —
It's just a little calf!

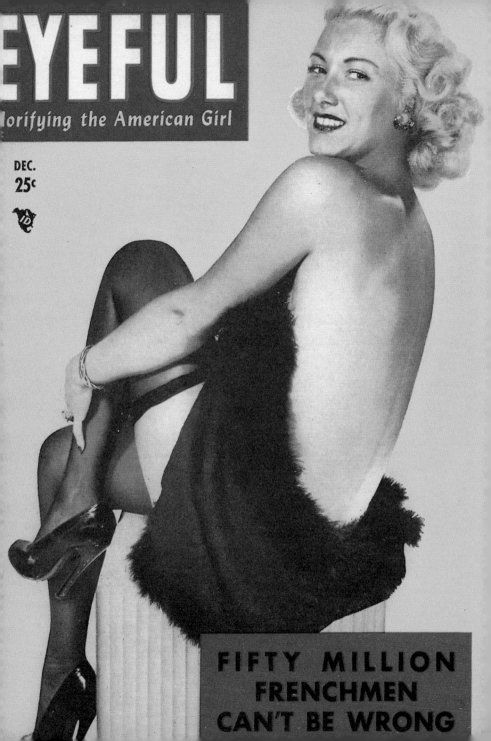

EYEFUL

Glorifying the American Girl

DEC.
25¢

FIFTY MILLION FRENCHMEN CAN'T BE WRONG

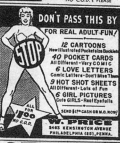
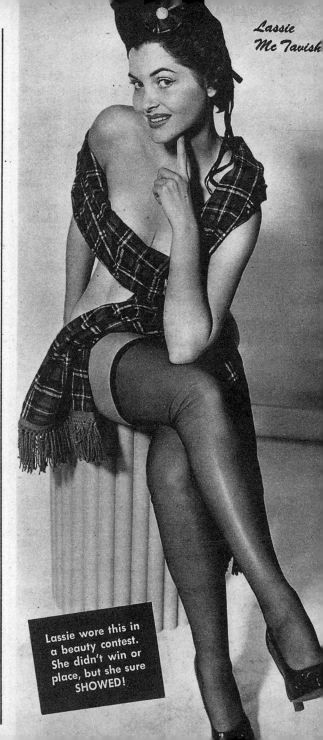

Lassie
Mc Tavish

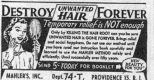

Lassie wore this in a beauty contest. She didn't win or place, but she sure SHOWED!

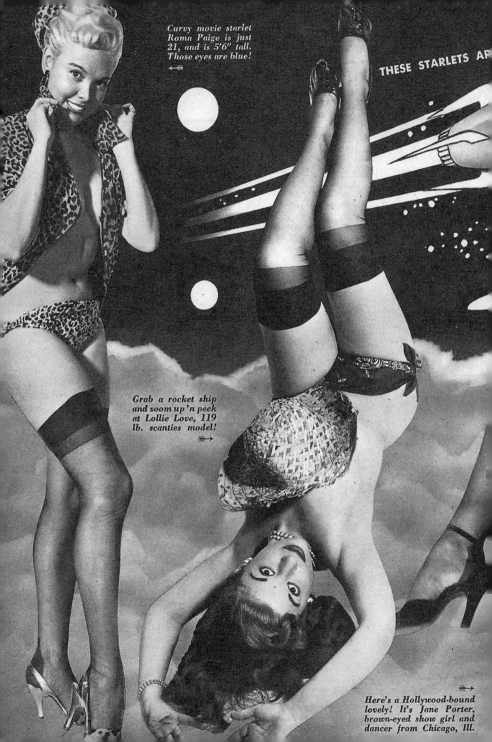

Curvy movie starlet Roma Paige is just 21, and is 5'6" tall. Those eyes are blue!
←

THESE STARLETS AR

Grab a rocket ship and zoom up'n peek at Lollie Love, 119 lb. scanties model!
→→

Here's a Hollywood-bound lovely! It's Jane Porter, brown-eyed show girl and dancer from Chicago, Ill.
→→

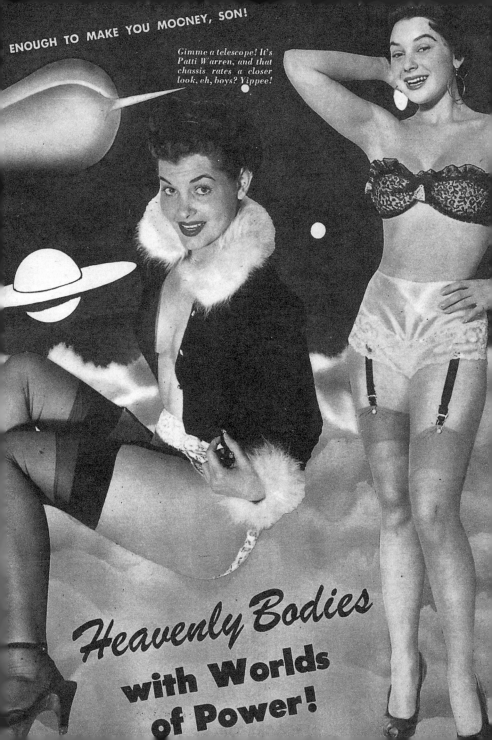

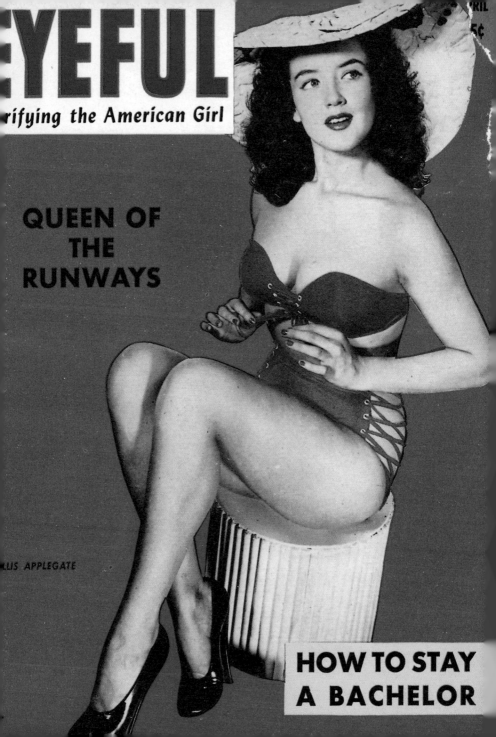

EYEFUL

rifying the American Girl

APRIL

5¢

QUEEN OF THE RUNWAYS

.LIS APPLEGATE

HOW TO STAY A BACHELOR

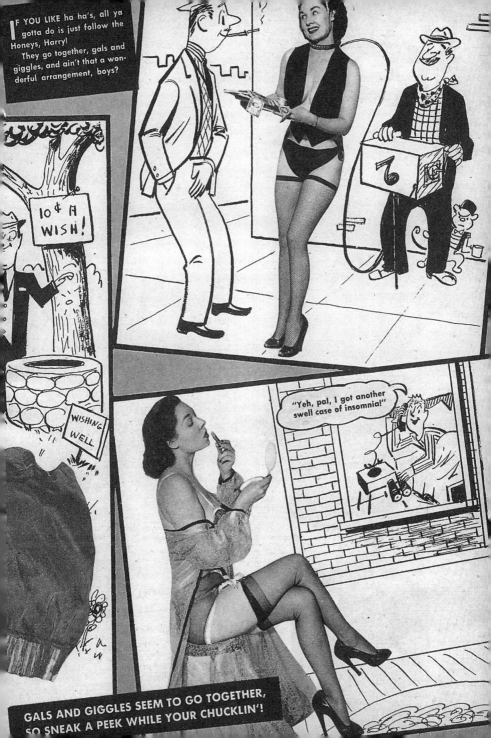

iest Magazine

1943–1955

It was Peter Driben who created most of the cover illustrations for Harrison's magazines, closely followed by Earl Moran and Billy de Vorrs. However, the first issue of Titter was adorned by a work from the pin-up artist Merlin Enabit (1903–1979). Enabit, the "wizard of colour", true to his first name, decided to make his own paints organically from natural dyes and even published a highly successful book on the subject, in the 70s. Besides featuring innumerable bathing belles and the usual photostories, Titter also made frequent allusions to its roots in the burlesque, celebrating the good old days of the cancan. During its first year, an object much plugged in the advertisement section was the legendary tie which glowed in the dark. This was supposed to bewitch the bashful lady of one's dreams with its subtle invitation: "Will you kiss me in the dark, baby?". It was an accessory pre-eminently suitable for export to the Old World, which still had to live with the blackout.

Die meisten Coverillustrationen der Harrison-Magazine stamm-
ten von Peter Driben, ihm dicht auf Earl Moran und Billy De Vorss. Die Start-
nummer von Titter zierte ein Werk des Pin-up-Künstlers Merlin Enabit
(1903–1979). Enabit, der „Wizard of Color", verstand seinen Vornamen als
Auftrag. Seine Farben stellte er auf natürlicher Basis selbst her und veröffent-
lichte in den 70er Jahren sogar ein recht erfolgreiches Buch darüber. Neben den
zahllosen Badenixen und den typischen Fotostories wies auch Titter immer wieder
auf seine Wurzeln in der Burleske hin und pries die guten alten Tage des Cancan.
Im Startjahr heftigst im Anzeigenteil beworben wurde die legendäre, im Dunkeln
leuchtende Krawatte, die jede noch so zurückhaltende Dame durch die subtile
Frage: „Will you kiss me in the dark, baby?" becircen sollte. Ein offensichtlich
für den Export in die Alte Welt, die noch mit der Verdunklung leben mußte,
geeignetes Produkt.

La plupart des couvertures des magazines de Harrison étaient
dues à Peter Driben, que suivaient de très près Earl Moran et Billy De Vorrs.
C'est une œuvre du dessinateur Merlin Enabit (1903–1979) qui fit la couverture
du premier numéro. Enabit, le «magicien de la couleur», concevait son prénom
comme une mission. Il fabriquait lui-même ses couleurs à partir de matières
naturelles, et il alla jusqu'à publier dans les années 70 un ouvrage sur le sujet qui
connut un assez grand succès. A côté des innombrables naïades et des histoires
en photos classiques, Titter ne cessait de renvoyer à ses origines burlesques avec
une prédilection pour le bon vieux temps du cancan. La première année, la partie
publicitaire mit le paquet sur la fameuse cravate fluorescente qui était censée
ensorceler la plus réticente des dames de cœur à qui l'on posait la subtile
question: «Veux-tu m'embrasser dans le noir, baby?». Produit qui semblait se
prêter remarquablement à l'exportation sur le vieux continent, où il fallait vivre
encore avec le black-out.

titter

America's Merriest Magazine

AUG

25

A Mirthquake
of **GIRLS, GAGS**
and **GAYETY**

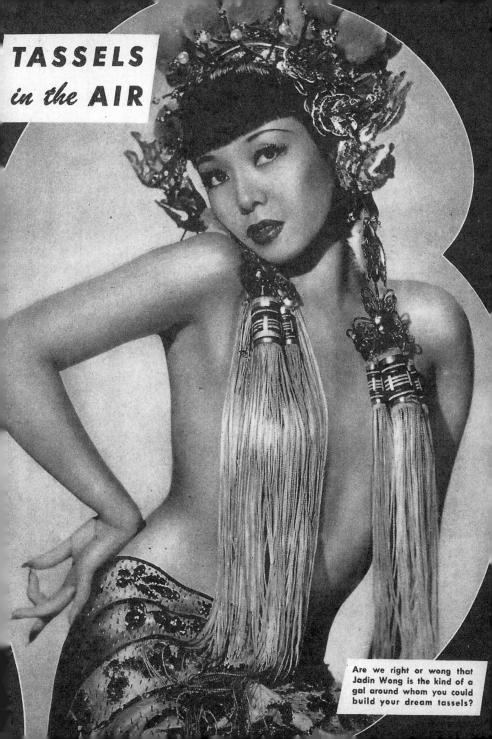

TASSELS
in the AIR

Are we right or wong that Jadin Wong is the kind of a gal around whom you could build your dream tassels?

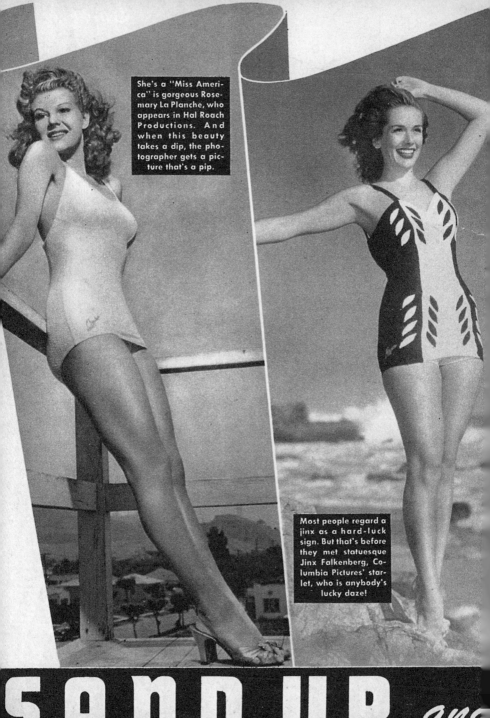

She's a "Miss America" is gorgeous Rosemary La Planche, who appears in Hal Roach Productions. And when this beauty takes a dip, the photographer gets a picture that's a pip.

Most people regard a jinx as a hard-luck sign. But that's before they met statuesque Jinx Falkenberg, Columbia Pictures' starlet, who is anybody's lucky daze!

SEND UP *and*

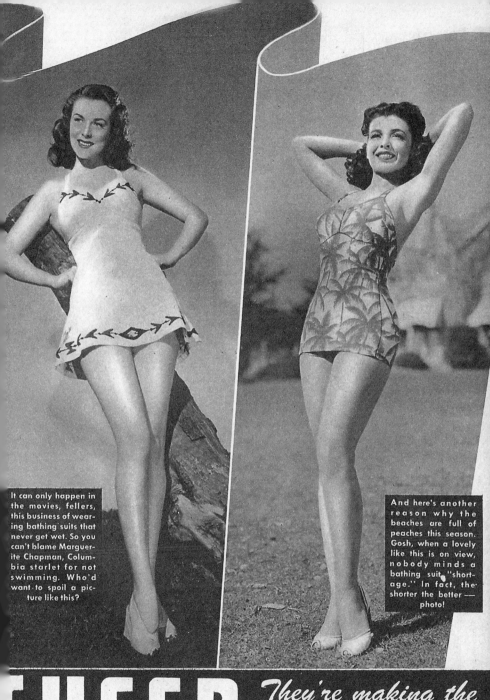

It can only happen in the movies, fellers, this business of wearing bathing suits that never get wet. So you can't blame Marguerite Chapman, Columbia starlet for not swimming. Who'd want to spoil a picture like this?

And here's another reason why the beaches are full of peaches this season. Gosh, when a lovely like this is on view, nobody minds a bathing suit "shortage." In fact, the shorter the better — photo!

CHEER

They're making the wild waves wilder!

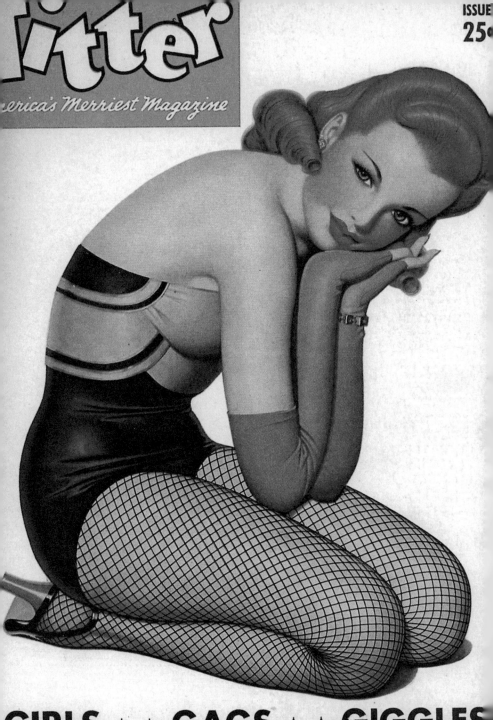

ISSUE
25¢

itter

erica's Merriest Magazine

GIRLS ★ ★ GAGS ★ ★ GIGGLES

Titter

America's Merriest Magazine

FEB.

25¢

GIRLS
★
GAGS
★
GIGGLES

Titter

America's Merriest Magazine

NG
UE
5c

GIRLS and **GAGS**

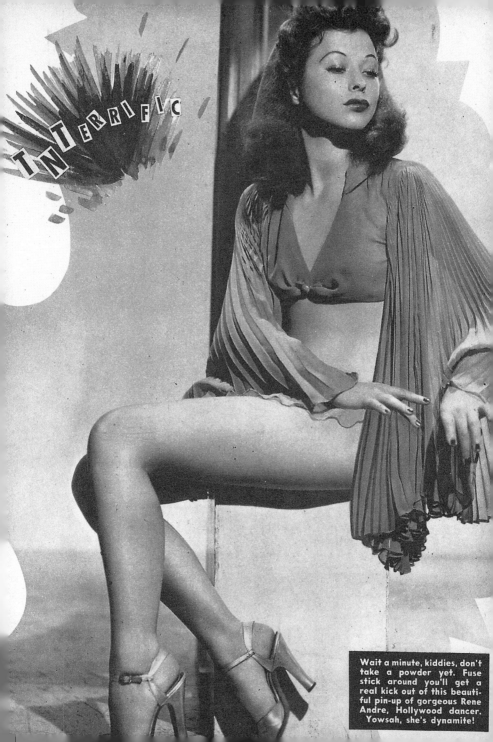

TNTERRIFIC

Wait a minute, kiddies, don't take a powder yet. Fuse stick around you'll get a real kick out of this beautiful pin-up of gorgeous Rene Andre, Hollywood dancer. Yowsah, she's dynamite!

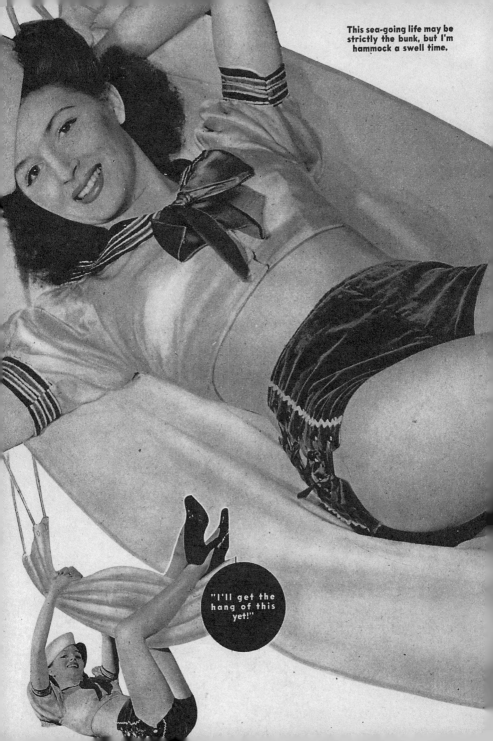

This sea-going life may be strictly the bunk, but I'm hammock a swell time.

"I'll get the hang of this yet!"

Swing IT SISTER!

Now, don't lose your head honey!

Titter

America's Merriest Magazine

SUMMER
ISSUE
25c

GALS
and
GAGS

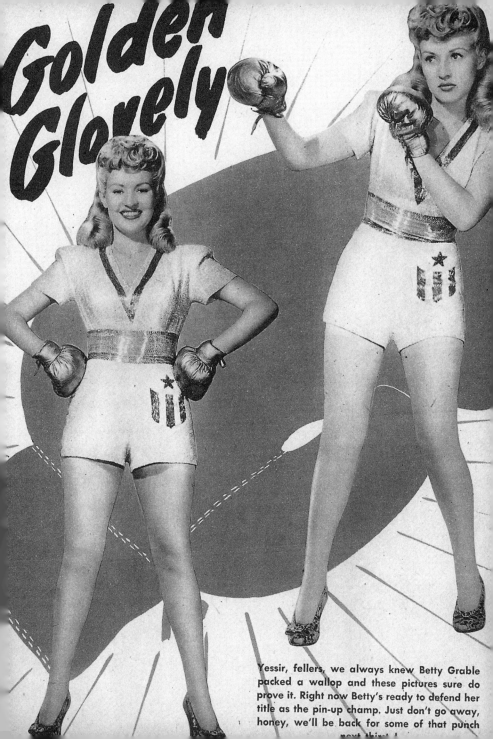

Golden Glovely

Yessir, fellers, we always knew Betty Grable packed a wallop and these pictures sure do prove it. Right now Betty's ready to defend her title as the pin-up champ. Just don't go away, honey, we'll be back for some of that punch

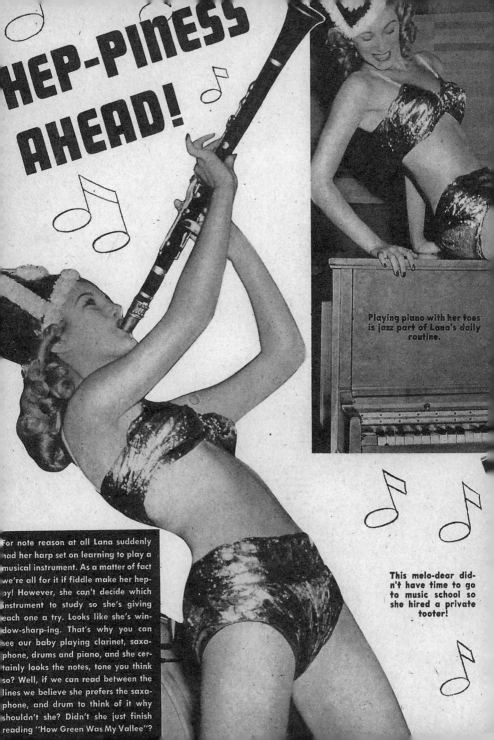

HEP-PINESS AHEAD!

Playing piano with her toes is jazz part of Lana's daily routine.

For note reason at all Lana suddenly had her harp set on learning to play a musical instrument. As a matter of fact we're all for it if fiddle make her hep-py! However, she can't decide which instrument to study so she's giving each one a try. Looks like she's window-sharp-ing. That's why you can see our baby playing clarinet, saxophone, drums and piano, and she certainly looks the notes, tone you think so? Well, if we can read between the lines we believe she prefers the saxophone, and drum to think of it why shouldn't she? Didn't she just finish reading "How Green Was My Vallee"?

This melo-dear didn't have time to go to music school so she hired a private tooter!

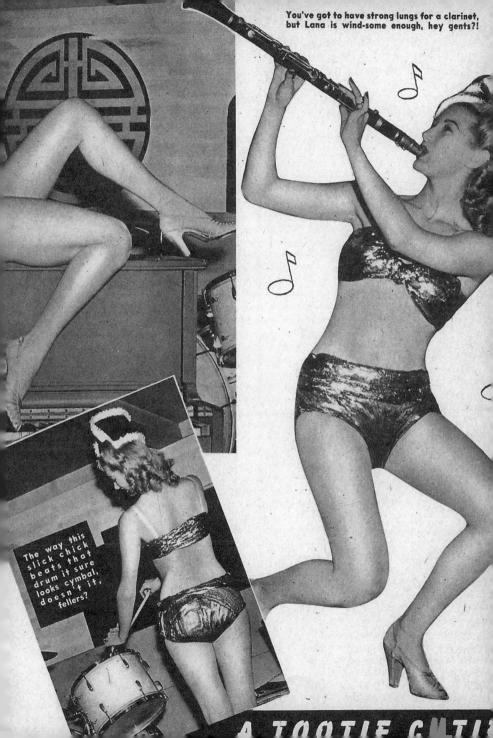

You've got to have strong lungs for a clarinet, but Lana is wind-some enough, hey gents?!

The way this slick chick beats that drum it sure looks cymbal, doesn't it, fellers?

A TOOTIE CUTI

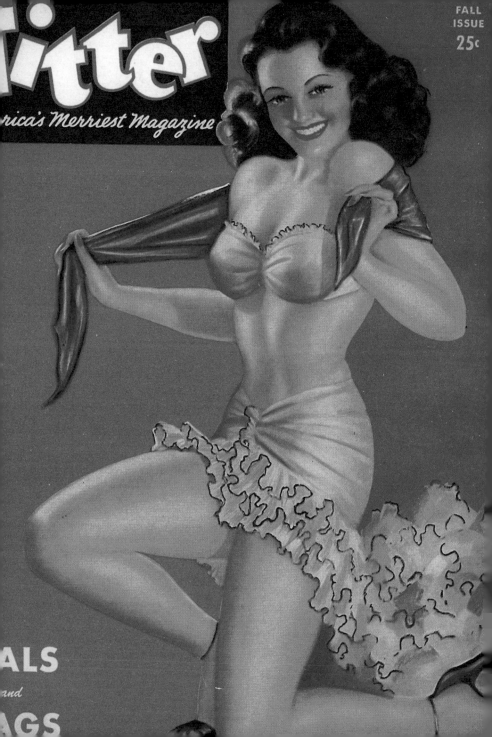

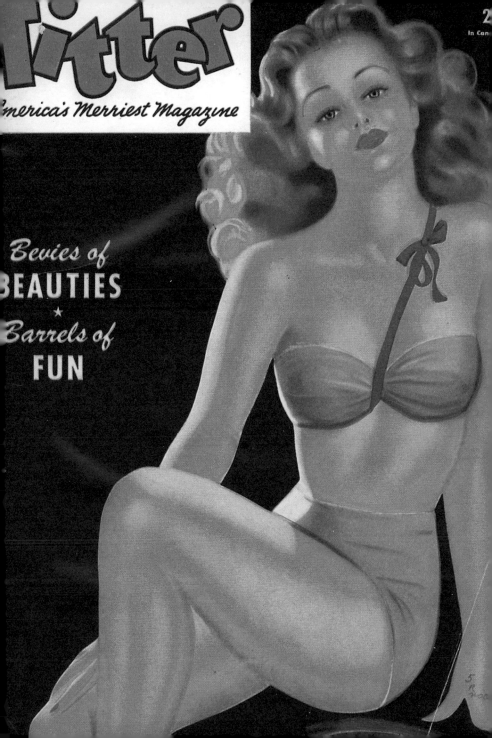

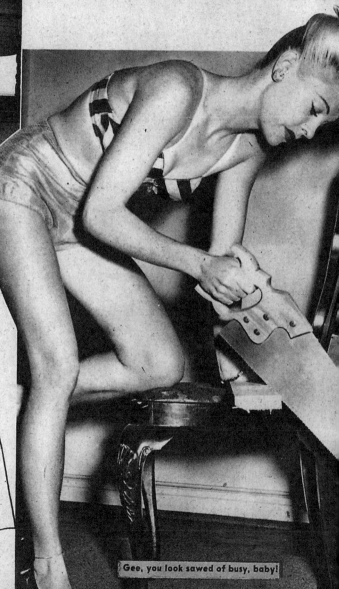

Coast
OF THE TOWN

..., Nail, the Gang's All
...e! Aren't you tired of
...in' like that, honey?

...TTLE thing like gas
...rationing isn't gonna
...Beth, fellers! She's al-
...s on the go, anyway,
...d now she's makin' her-
...f a scooter so she'll be
...ble to scoot around town
...henever she feels like it!
...eth found you don't need
...much material to build one
...of these things (not with
...the build you've got to start
...with, anyway, baby!) — so
...after rounding up some
...wheels and a couple of
...boards, she was all set to
...start playin' planks! Well,
...more power to you, honey!
...You're makin' a wheel good
...try, so we know you'll get
...it made scooter or later!

Gee, you look sawed of busy, baby!

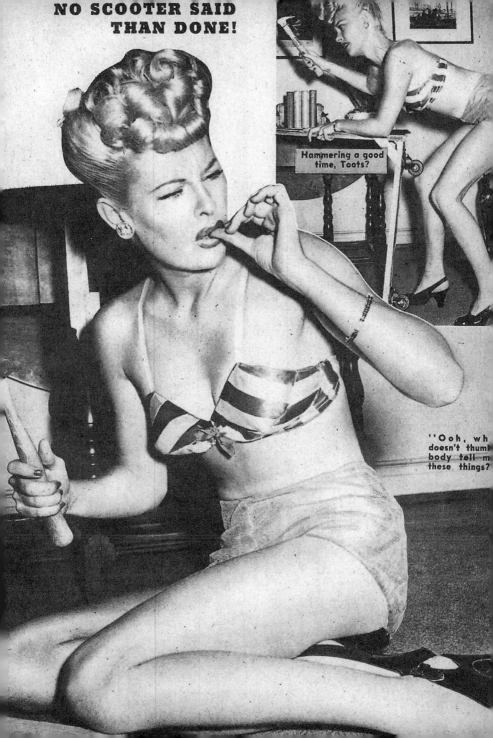

NO SCOOTER SAID
THAN DONE!

Hammering a good
time, Toots?

"Ooh, wh
doesn't thum
body tell m
these things?

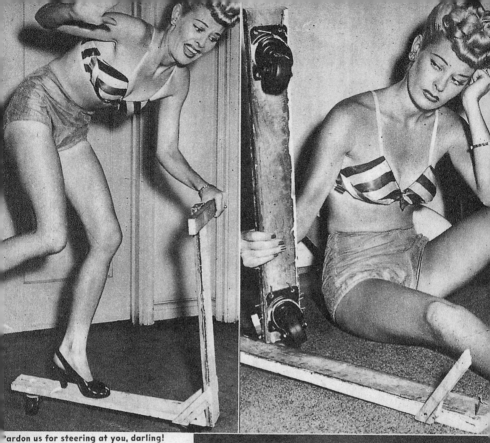

Pardon us for steering at you, darling!

(AST OF THE TOWN—CONTINUED)

rollin' fun, gang! Beth's
nd that buildin' a scooter's a
e way to steer up excitement!
e says she's not much of a me-
nic, but we think she's done
scooter job as anyone could!
e, baby, if you didn't mechan-
nistakes you just wouldn't be
man! Now that she's really got
ngs rollin', though, Beth's
da proud of her scooter, espe-
ly since it didn't coast her a
t! She's just hopin' she won't
d up traffic, 'cause she'd hate
be caught with a stallin' car!
, you'll do all ride, honey!
e, you've made a traffic hit
with us already!

What you need is floor-wheel brakes, toots!

It doesn't look like everything's all ride ride now.

Did you fall for us, sweet?

She's Wheel Tweet, Boys!

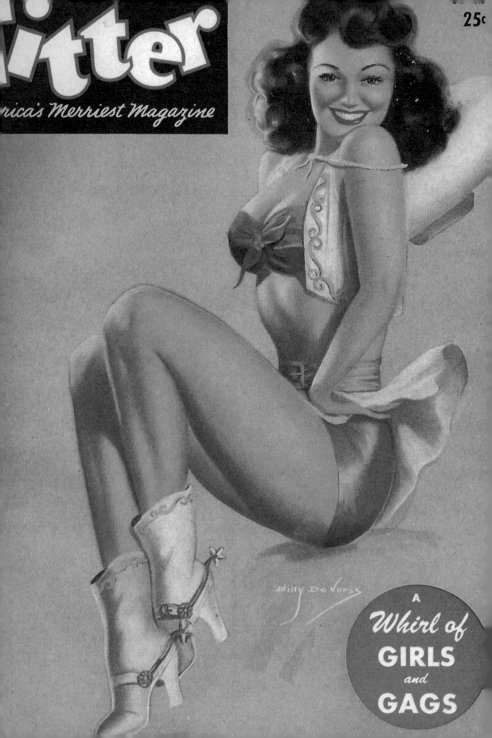

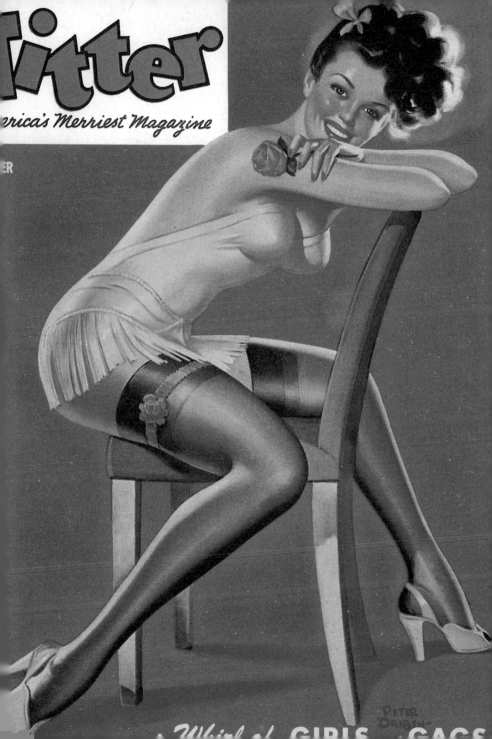

itter

merica's Merriest Magazine

Whirl of GIRLS and GAGS

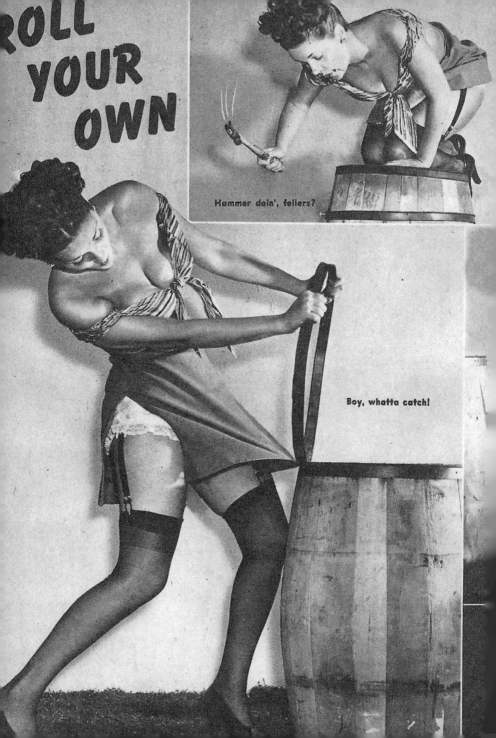

ROLL YOUR OWN

Hammer doin', fellers?

Boy, whatta catch!

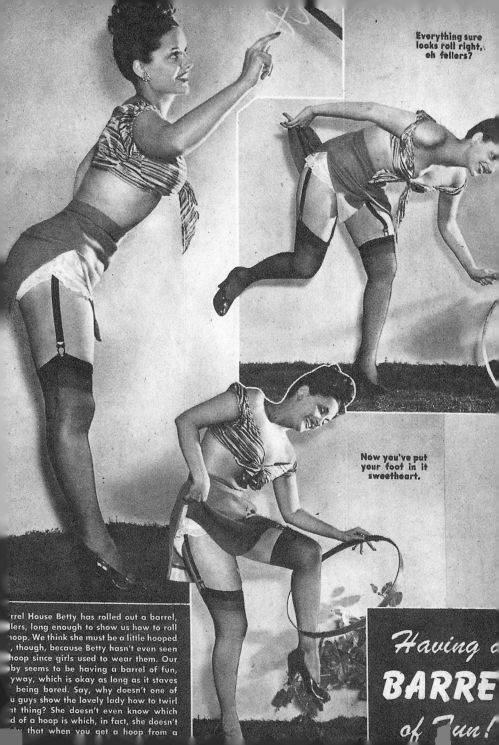

Everything sure
looks roll right,
eh fellers?

Now you've put
your foot in it
sweetheart.

rrel House Betty has rolled out a barrel,
lers, long enough to show us how to roll
oop. We think she must be a little hooped
, though, because Betty hasn't even seen
hoop since girls used to wear them. Our
by seems to be having a barrel of fun,
yway, which is okay as long as it staves
being bored. Say, why doesn't one of
u guys show the lovely lady how to twirl
t thing? She doesn't even know which
d of a hoop is which, in fact, she doesn't
that when you get a hoop from a

Having a
BARRE
of Fun!

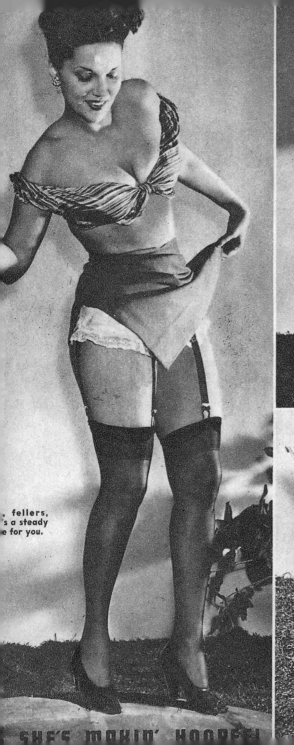

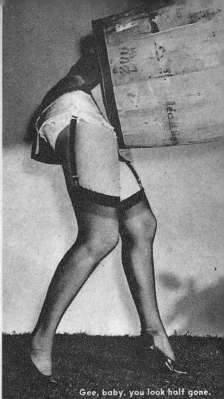

Gee, baby, you look half gone.

Maybe she
could support a
family too.

, fellers,
's a steady
e for you.

SHE'S MAKIN' HOOPEE!

Well, fellers, Betty seems to be having a tough time trying to make that hoop roll. She just can't seem to learn to tap it with a stick—the right way, probably because she's been tapping too many kegs, lately at the old barrel house. Well, even if you can't make a hoop-mobile, honey, you sure have a neat bag of tricks to do with a barrel. Yessir, gang, she's really doin' roll right—as long as she doesn't fall off the thing. Say, beautiful, why don't you fall off the wagon instead, it'd be much more fun and wheel be a-round, we hoop—we hoop!

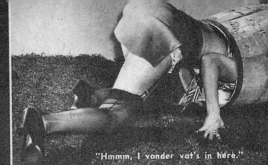

"Hmmm, I vonder vat's in here."

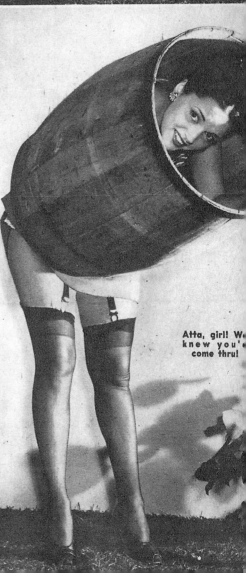

Atta, girl! W
knew you'
come thru!

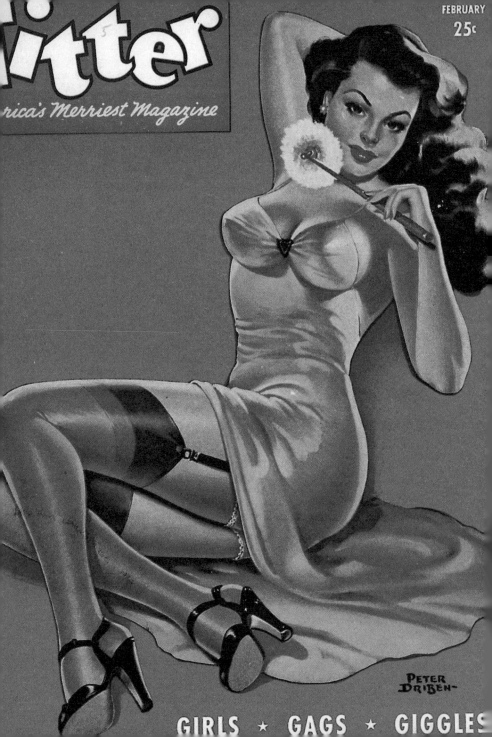

FEBRUARY
25¢

itter

rica's Merriest Magazine

PETER
DRIBEN

GIRLS ★ GAGS ★ GIGGLES

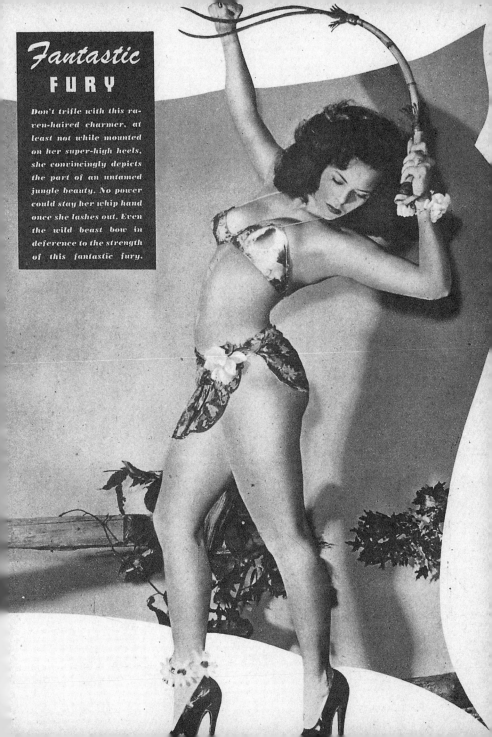

Fantastic
FURY

*Don't trifle with this ra-
ven-haired charmer. at
least not while mounted
on her super-high heels,
she convincingly depicts
the part of an untamed
jungle beauty. No power
could stay her whip hand
once she lashes out. Even
the wild beast bow in
deference to the strength
of this fantastic fury.*

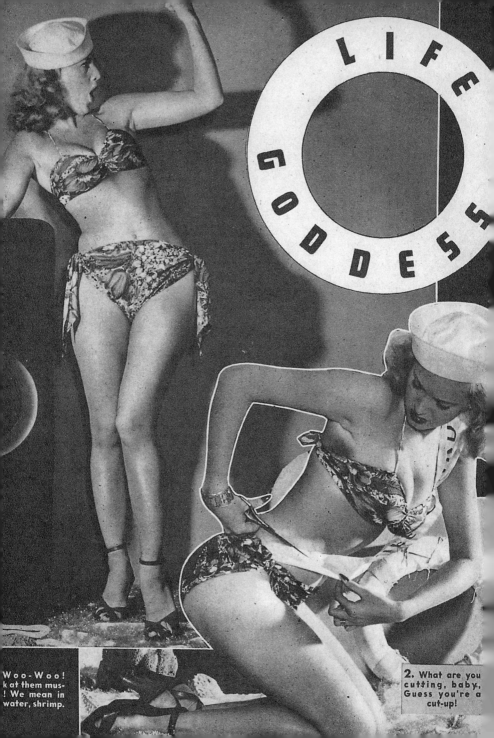

LIFE GODDESS

Woo-Woo!
k at them mus-
! We mean in
water, shrimp.

2. What are you
cutting, baby,
Guess you're a
cut-up!

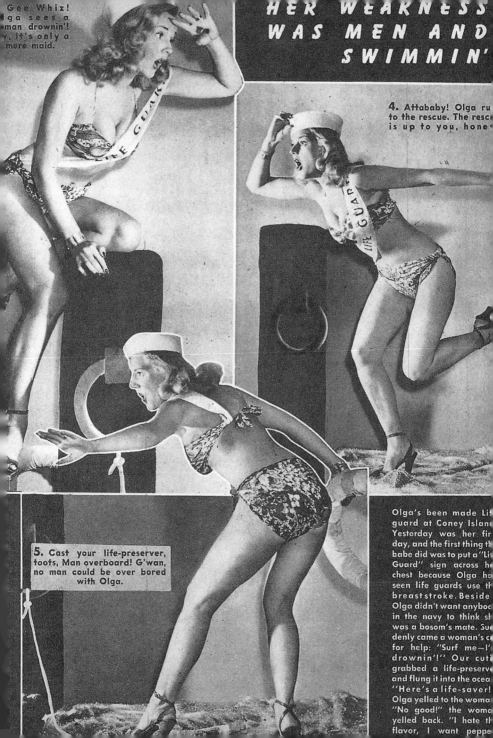

Gee Whiz! Olga sees a man drownin'! Gosh, it's only a swimmer maid.

HER WEAKNESS WAS MEN AND SWIMMIN'

4. Attababy! Olga runs to the rescue. The rescue is up to you, honey!

5. Cast your life-preserver, toots, Man overboard! G'wan, no man could be over bored with Olga.

Olga's been made Lifeguard at Coney Island. Yesterday was her first day, and the first thing the babe did was to put a "Life Guard" sign across her chest because Olga had seen life guards use the breast stroke. Besides, Olga didn't want anybody in the navy to think she was a bosom's mate. Suddenly came a woman's call for help: "Surf me—I'm drownin'!" Our cutie grabbed a life-preserver and flung it into the ocean. "Here's a life-saver!" Olga yelled to the woman. "No good!" the woman yelled back. "I hate that flavor, I want peppe...

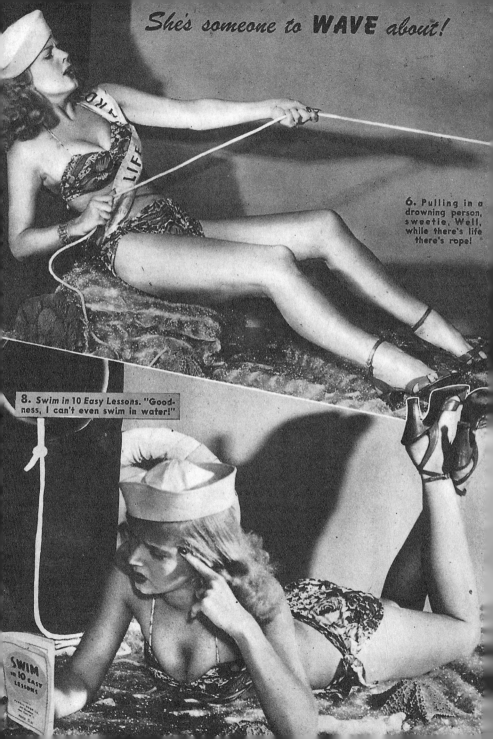

She's someone to **WAVE** about!

6. Pulling in a drowning person, sweetie. Well, while there's life there's rope!

8. Swim in 10 Easy Lessons. "Goodness, I can't even swim in water!"

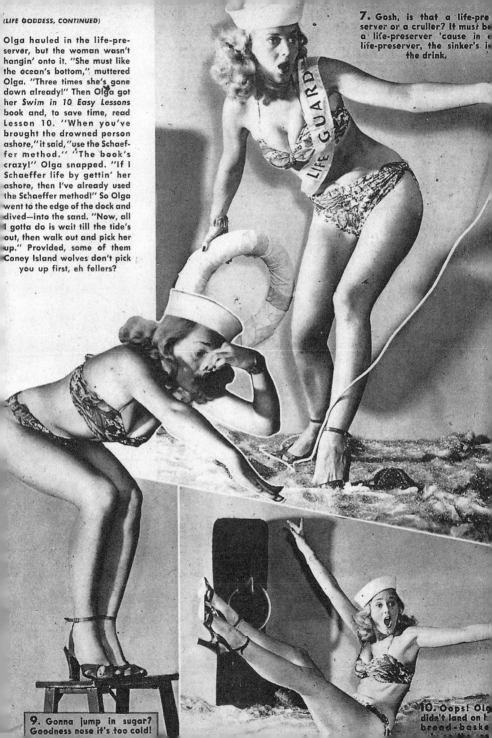

Olga hauled in the life-preserver, but the woman wasn't hangin' onto it. "She must like the ocean's bottom," muttered Olga. "Three times she's gone down already!" Then Olga got her *Swim in 10 Easy Lessons* book and, to save time, read Lesson 10. "When you've brought the drowned person ashore," it said, "use the Schaeffer method." "The book's crazy!" Olga snapped. "If I Schaeffer life by gettin' her ashore, then I've already used the Schaeffer method!" So Olga went to the edge of the dock and dived—into the sand. "Now, all I gotta do is wait till the tide's out, then walk out and pick her up." Provided, some of them Coney Island wolves don't pick you up first, eh fellers?

7. Gosh, is that a life-preserver or a cruller? It must be a life-preserver 'cause in a life-preserver, the sinker's in the drink.

9. Gonna jump in sugar? Goodness nose it's too cold!

10. Oops! Olga didn't land on her bread-basket.

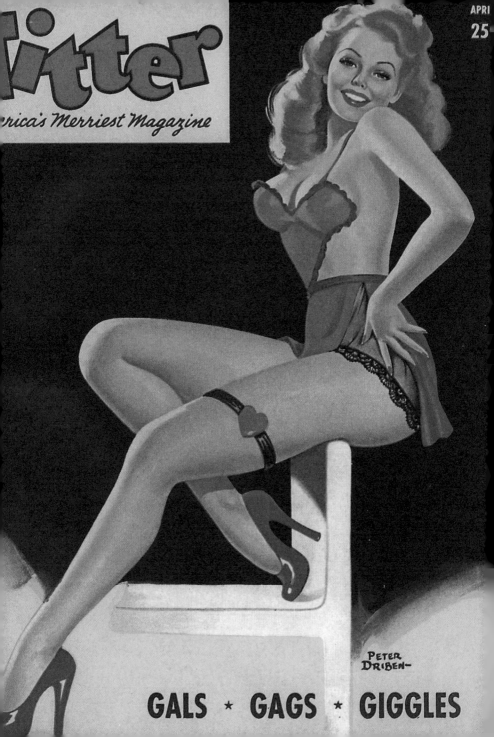

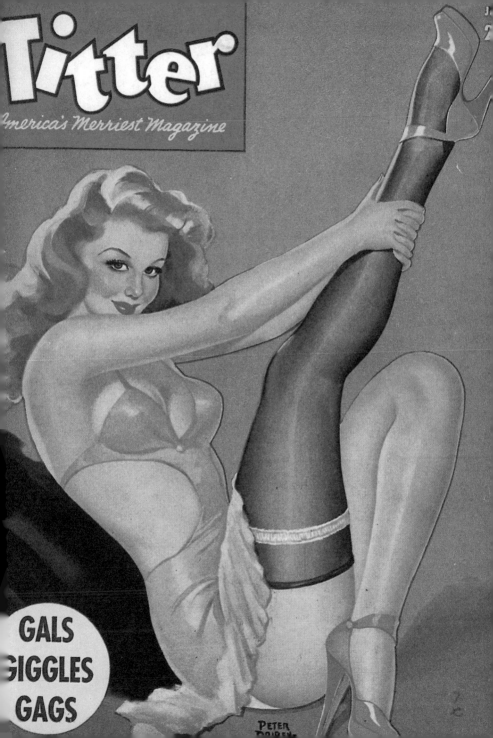

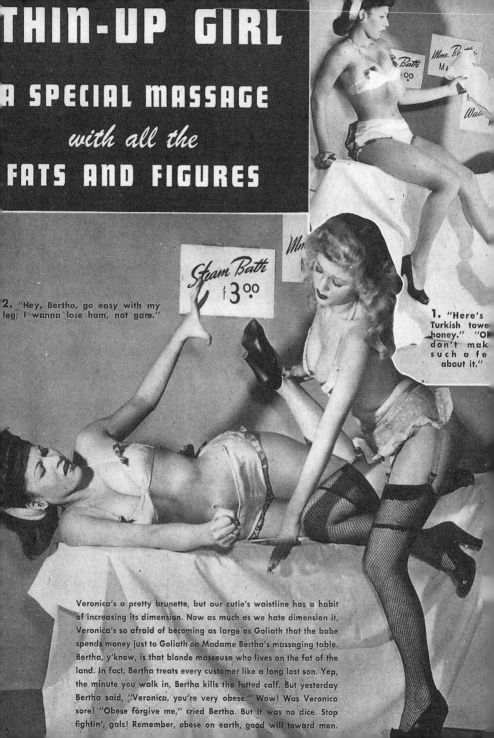

THIN-UP GIRL

A SPECIAL MASSAGE
with all the
FATS AND FIGURES

1. "Here's Turkish towe honey." "Ol don't mak such a fe about it."

2. "Hey, Bertha, go easy with my leg; I wanna lose ham, not gam."

Steam Bath $3.00

Veronica's a pretty brunette, but our cutie's waistline has a habit of increasing its dimension. Now as much as we hate dimension it, Veronica's so afraid of becoming as large as Goliath that the babe spends money just to Goliath on Madame Bertha's massaging table. Bertha, y'know, is that blonde masseuse who lives on the fat of the land. In fact, Bertha treats every customer like a long lost son. Yep, the minute you walk in, Bertha kills the fatted calf. But yesterday Bertha said, "Veronica, you're very obese." Wow! Was Veronica sore! "Obese forgive me," cried Bertha. But it was no dice. Stop fightin', gals! Remember, obese on earth, good will toward men.

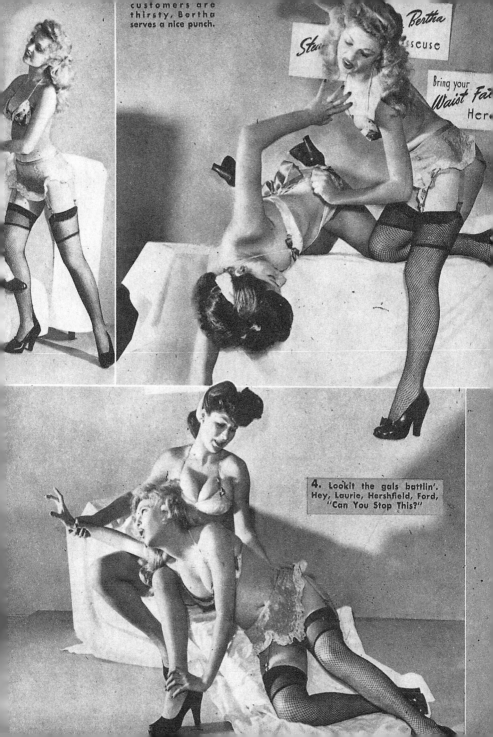

customers are
thirsty, Bertha
serves a nice punch.

Bertha

Ste sscuse

Bring your
Waist Fat
Here

4. Lookit the gals battlin'.
Hey, Laurie, Hershfield, Ford,
"Can You Stop This?"

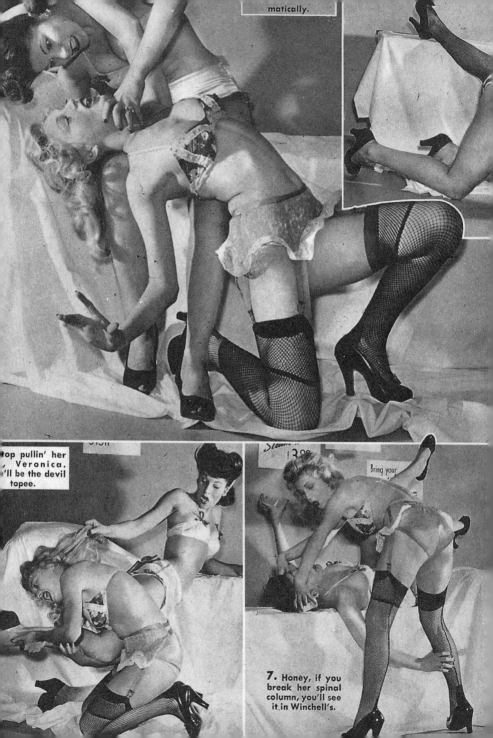

matically.

top pullin' her
Veronica.
'll be the devil
topee.

Bring your

$3.90

7. Honey, if you
break her spinal
column, you'll see
it in Winchell's.

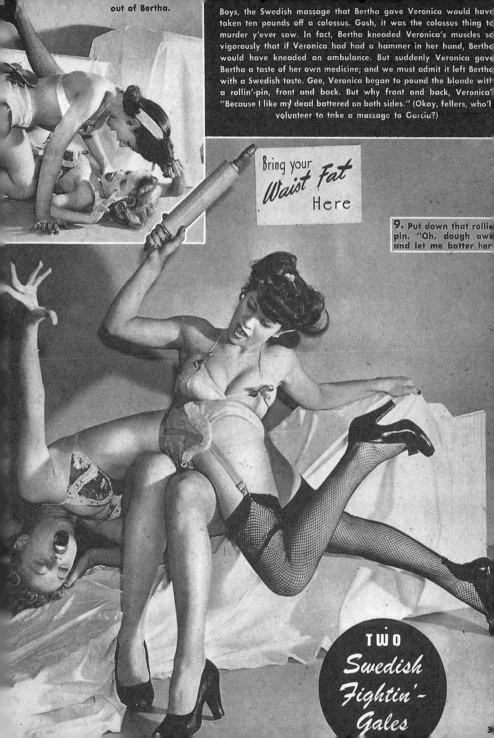

out of Bertha.

Boys, the Swedish massage that Bertha gave Veronica would have taken ten pounds off a colossus. Gosh, it was the colossus thing to murder y'ever saw. In fact, Bertha kneaded Veronica's muscles so vigorously that if Veronica had had a hammer in her hand, Bertha would have kneaded an ambulance. But suddenly Veronica gave Bertha a taste of her own medicine; and we must admit it left Bertha with a Swedish taste. Gee, Veronica began to pound the blonde with a rollin'-pin, front and back. But why front and back, Veronica? "Because I like my dead battered on both sides." (Okay, fellers, who'l volunteer to take a massage to Garciu?)

Bring your *Waist Fat* Here

9. Put down that rolli pin. "Oh, dough awe and let me batter her

TWO
Swedish Fightin'- Gales

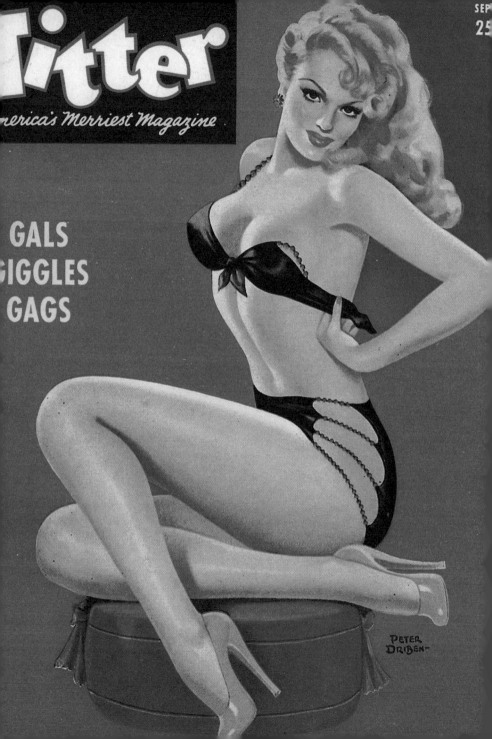

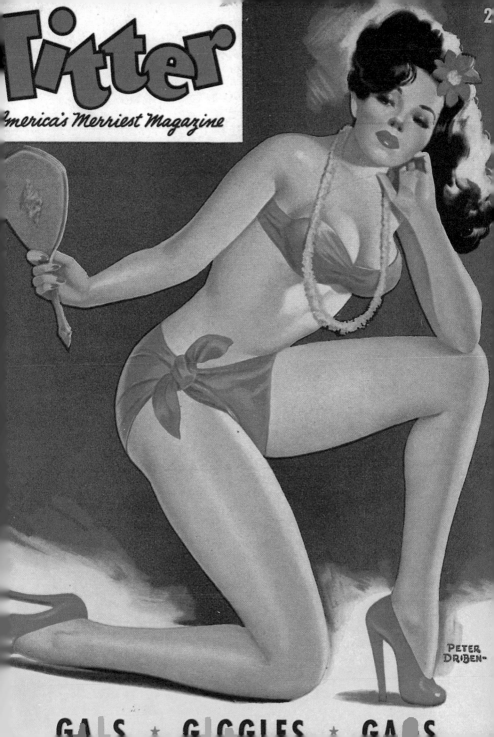

Titter
America's Merriest Magazine

2

PETER DRIBEN

GALS ★ GIGGLES ★ GAGS

HIGH HEEL HONEY

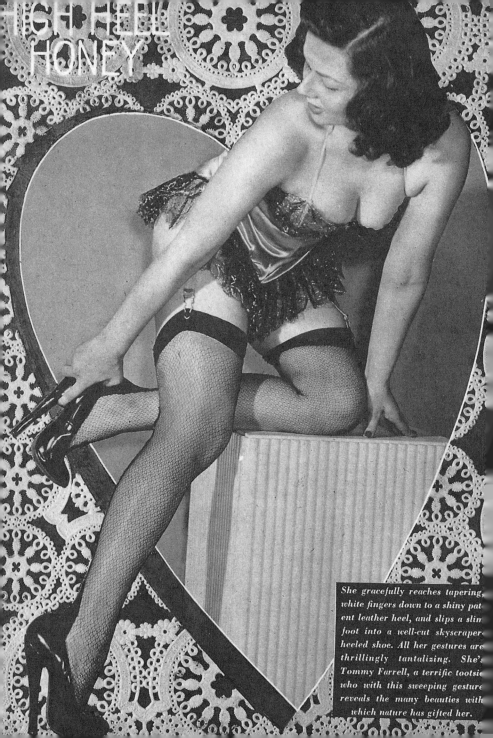

She gracefully reaches tapering, white fingers down to a shiny patent leather heel, and slips a slim foot into a well-cut skyscraper-heeled shoe. All her gestures are thrillingly tantalizing. She's Tommy Farrell, a terrific tootsie who with this sweeping gesture reveals the many beauties with which nature has gifted her.

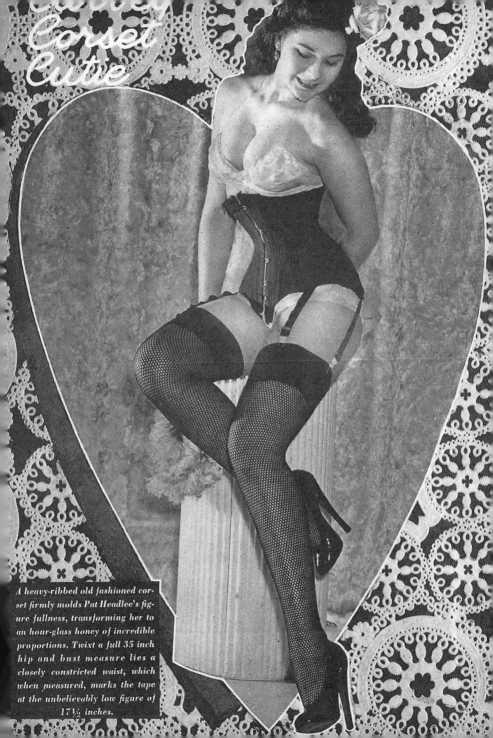

Corset
Cutie

A heavy-ribbed old fashioned corset firmly molds Pat Headlee's figure fullness, transforming her to an hour-glass honey of incredible proportions. Twixt a full 35 inch hip and bust measure lies a closely constricted waist, which when measured, marks the tape at the unbelievably low figure of 17½ inches.

Titter

merica's Merriest Magazine

JAN

25¢

GALS
GIGGLES
GAGS

PETER
DRIBEN

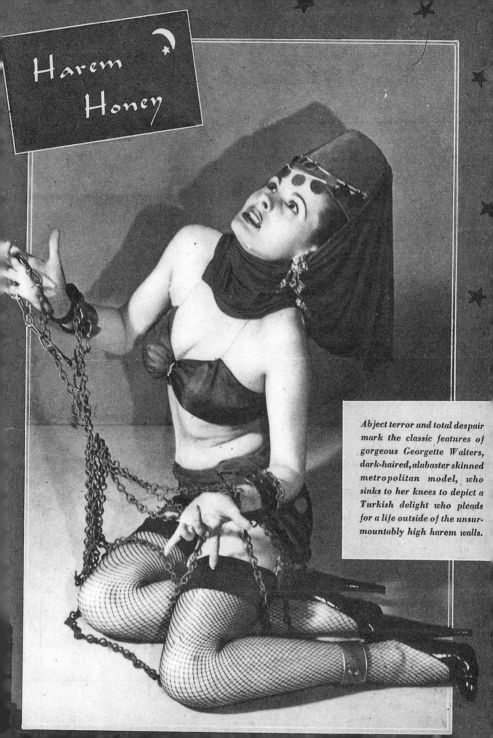

Harem Honey

Abject terror and total despair mark the classic features of gorgeous *Georgette Walters*, dark-haired, alabaster skinned metropolitan model, who sinks to her knees to depict a Turkish delight who pleads for a life outside of the unsurmountably high harem walls.

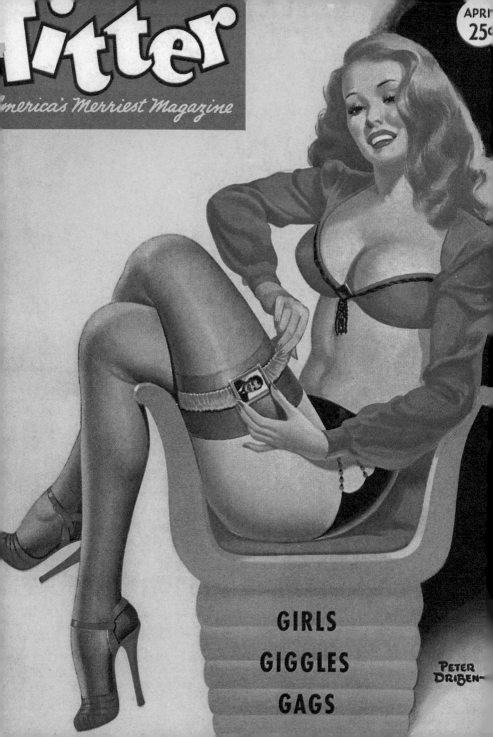

JUNE 25¢

Titter

America's Merriest Magazine

GIRLS
GIGGLES
GAGS

PETER DRIBEN

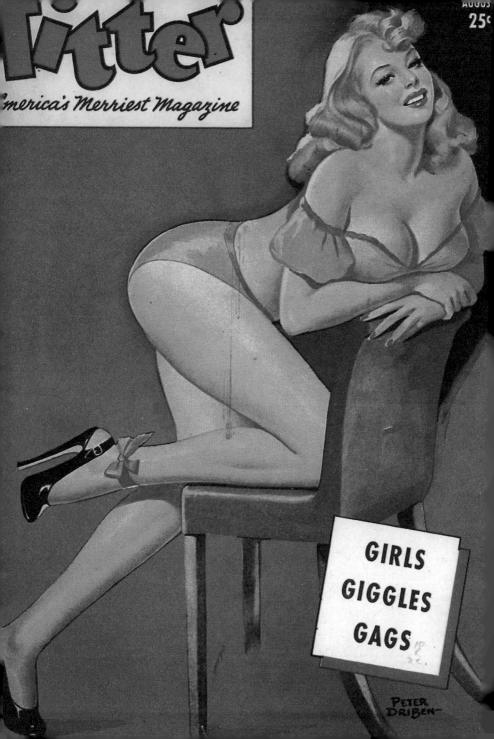

A brief, but encasing, black corset binds Arline Forest's waist in such a miraculous fashion as to reduce that naturally tiny contour to a 16½ inch measure. Thus, tightly laced, Arline is breathlessly, beautifully breathtaking.

Miracle
Mold

1. Now this is what we call Table d'Hot!

2. Ah-ha, we knew our sweet would end up under the table!

3. Gosh, here's a sight for saw eyes!

The Fix of Life

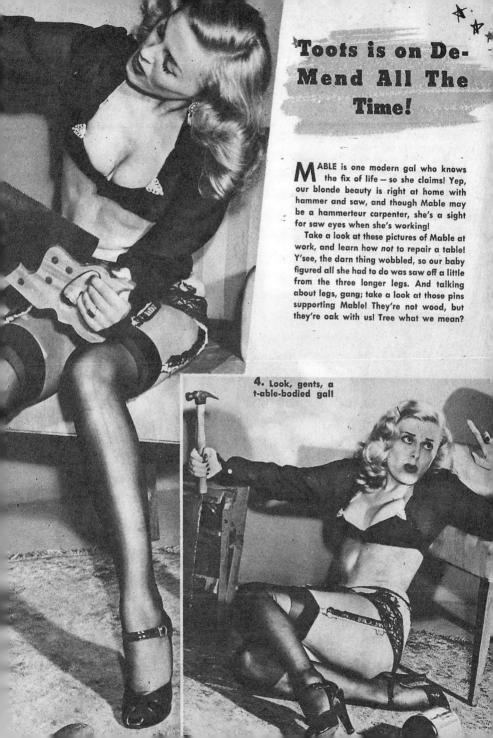

Toots is on De-Mend All The Time!

MABLE is one modern gal who knows the fix of life — so she claims! Yep, our blonde beauty is right at home with hammer and saw, and though Mable may be a hammerteur carpenter, she's a sight for saw eyes when she's working!

Take a look at these pictures of Mable at work, and learn how *not* to repair a table! Y'see, the darn thing wobbled, so our baby figured all she had to do was saw off a little from the three longer legs. And talking about legs, gang; take a look at those pins supporting Mable! They're not wood, but they're oak with us! Tree what we mean?

4. Look, gents, a t-able-bodied gal!

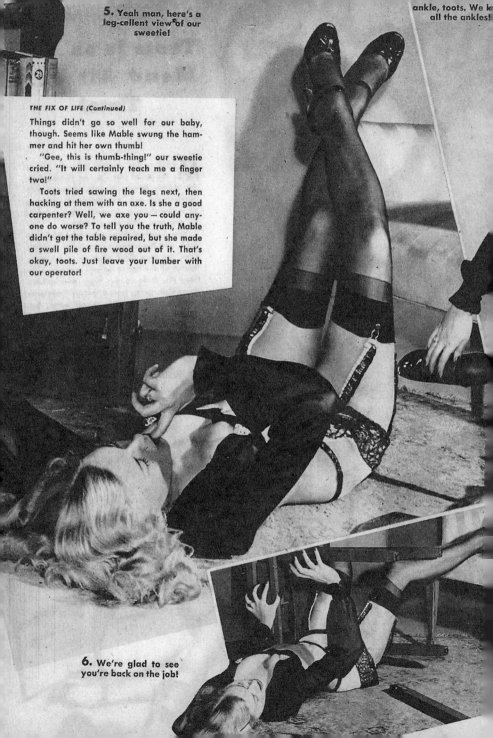

5. Yeah man, here's a leg-cellent view of our sweetie!

ankle, toots. We k all the ankles!

THE FIX OF LIFE (Continued)

Things didn't go so well for our baby, though. Seems like Mable swung the hammer and hit her own thumb!

"Gee, this is thumb-thing!" our sweetie cried. "It will certainly teach me a finger two!"

Toots tried sawing the legs next, then hacking at them with an axe. Is she a good carpenter? Well, we axe you — could anyone do worse? To tell you the truth, Mable didn't get the table repaired, but she made a swell pile of fire wood out of it. That's okay, toots. Just leave your lumber with our operator!

6. We're glad to see you're back on the job!

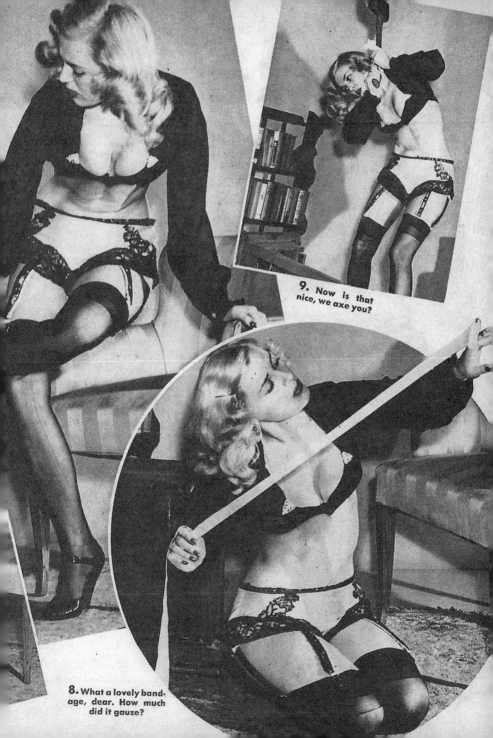

9. Now is that nice, we axe you?

8. What a lovely bandage, dear. How much did it gauze?

titter

america's Merriest Magazine

o
2

PETER

GALS ★ GAGS ★ GIGGLES

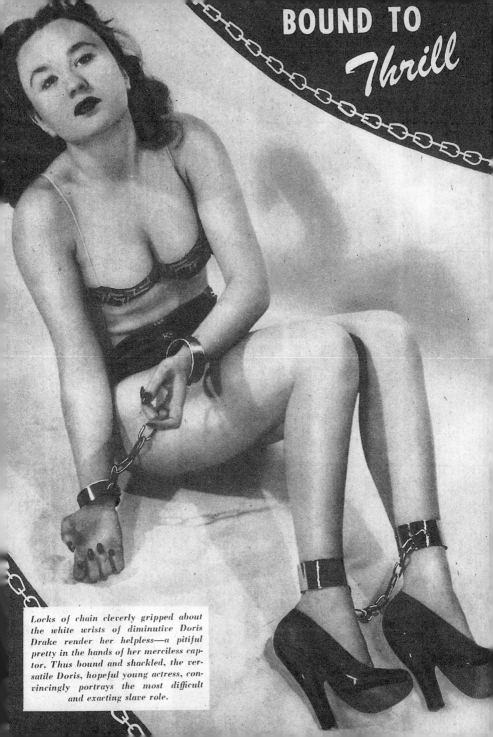

BOUND TO *Thrill*

Locks of chain cleverly gripped about the white wrists of diminutive Doris Drake render her helpless—a pitiful pretty in the hands of her merciless captor. Thus bound and shackled, the versatile Doris, hopeful young actress, convincingly portrays the most difficult and exacting slave role.

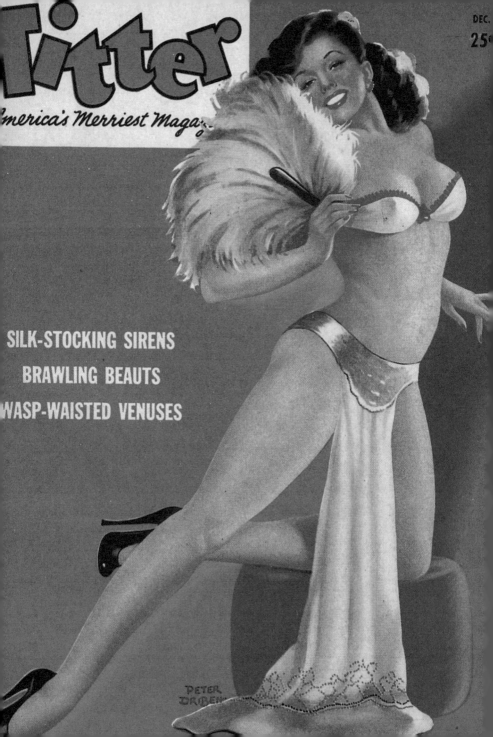

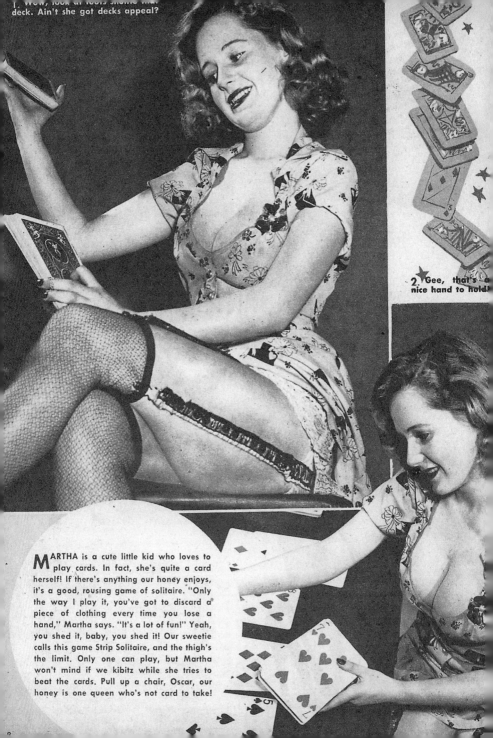

1. Wow, look at fools showing that deck. Ain't she got decks appeal?

2. Gee, that's a nice hand to hold!

MARTHA is a cute little kid who loves to play cards. In fact, she's quite a card herself! If there's anything our honey enjoys, it's a good, rousing game of solitaire. "Only the way I play it, you've got to discard a piece of clothing every time you lose a hand," Martha says. "It's a lot of fun!" Yeah, you shed it, baby, you shed it! Our sweetie calls this game Strip Solitaire, and the thigh's the limit. Only one can play, but Martha won't mind if we kibitz while she tries to beat the cards. Pull up a chair, Oscar, our honey is one queen who's not card to take!

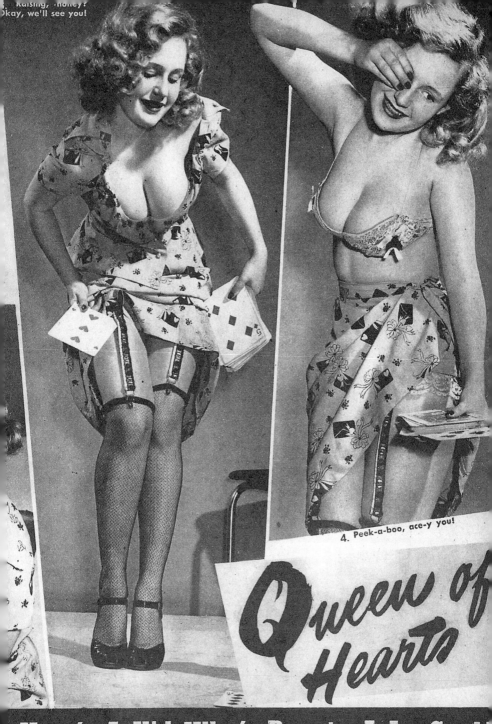

raising, honey?
Okay, we'll see you!

4. Peek-a-boo, ace-y you!

Queen of Hearts

Here's A Kid Who's Beauty A La Card!

5. Ah, yes, gents, here's one queen who'll always take the jack!

6. Look, cookie's losing her clothes, and that's not the calf of it!

Hose!

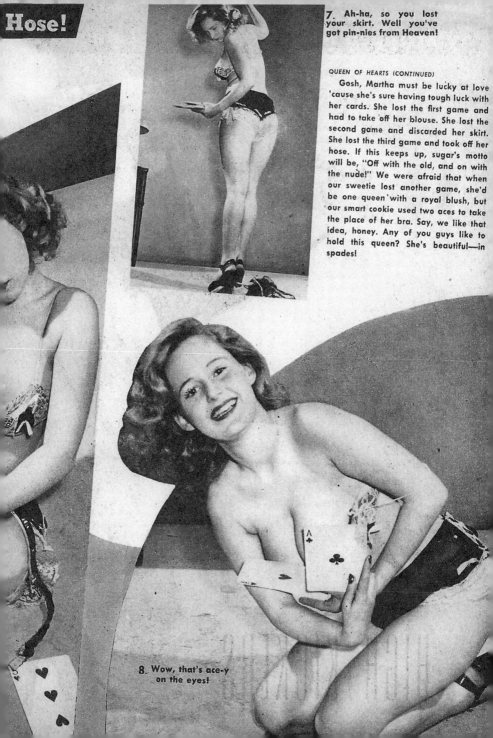

7. Ah-ha, so you lost your skirt. Well you've got pin-nies from Heaven!

QUEEN OF HEARTS (CONTINUED)

Gosh, Martha must be lucky at love 'cause she's sure having tough luck with her cards. She lost the first game and had to take off her blouse. She lost the second game and discarded her skirt. She lost the third game and took off her hose. If this keeps up, sugar's motto will be, "Off with the old, and on with the nude!" We were afraid that when our sweetie lost another game, she'd be one queen with a royal blush, but our smart cookie used two aces to take the place of her bra. Say, we like that idea, honey. Any of you guys like to hold this queen? She's beautiful—in spades!

8. Wow, that's ace-y on the eyes!

litter

erica's Merriest Mag

FEB.

25¢

Bevies of SILK STOCKING SIRENS

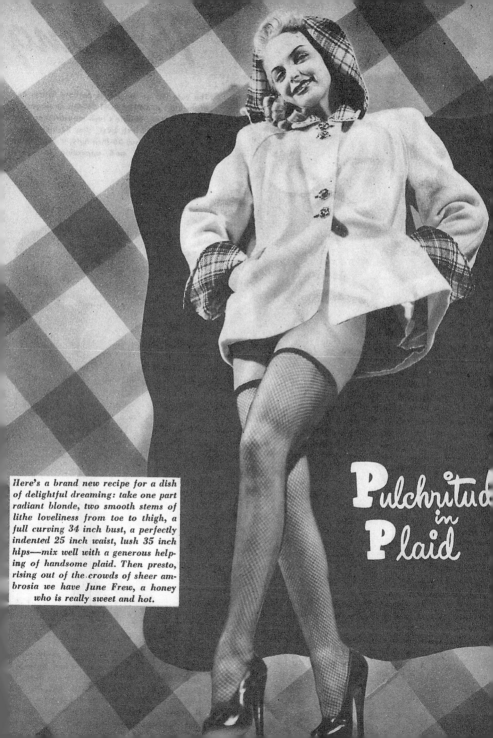

Here's a brand new recipe for a dish of delightful dreaming: take one part radiant blonde, two smooth stems of lithe loveliness from toe to thigh, a full curving 34 inch bust, a perfectly indented 25 inch waist, lush 35 inch hips—mix well with a generous helping of handsome plaid. Then presto, rising out of the crowds of sheer ambrosia we have June Frew, a honey who is really sweet and hot.

Pulchritude
in
Plaid

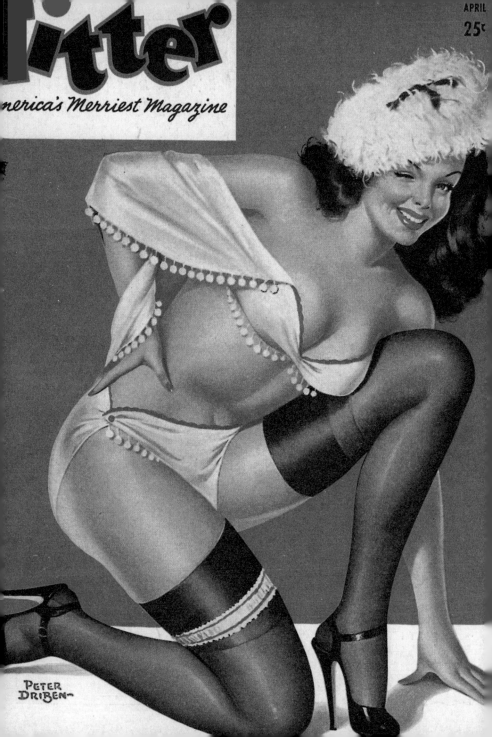

APRIL

25¢

Titter

america's Merriest Magazine

PETER DRIBEN—

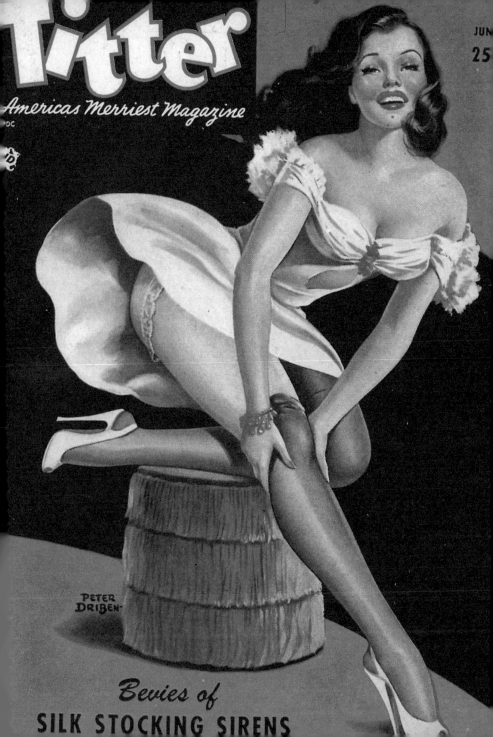

Titter

Americas Merriest Magazine

JUN

25

PETER DRIBEN

Bevies of
SILK STOCKING SIRENS

the Moaning after

BROADWAY'S favorite comedian, funnyman Teddy Werbel, scored such a success at his latest show in one of Gotham's brightest nite-spots that the guy just had to go out and celebrate. But the morning after! Wow! What a head Teddy had! So the wise lad hurried off to see lovely showgirl Nevada Smith. "She'll help me," Teddy figured. "Maybe she knows some easy way to get rid of those moaning-after blues!" Say, pal, one look at gorgeous Nevada would make a corpse sit up and take notice!

1. "Lishen, honey, the drunker I stand her the longer I get!"

Showgirl Nevada Smith and Comic T

3. "Don't put on that ice pack. I'll get a cold in the head!"

4. "I'm sorry, baby. I'll never touch the stuff again."

2. "Water? Ugh! They wash dishes in that!"

y Werbel Find Their Lost Week-End!

6. "Please, may I have a little sip of ginger ale?"

5. "No, no coffee! My gosh, Java hear of anything worse?"

THE MORNING AFTER (Continued)
Sure, Nevada knew just what to do, but do you think Teddy would listen? Not him! The poor, sick chump refused to do anything but suffer, and he really did that! "Say," murmured crafty Teddy, "maybe a hair of the dog what bit me might do some good. The last time I was here, I hid a crock in the chandelier, just for such an occasion!" Out came the jug, and our hero started celebrating again. Y'see, the guy thought so much of his charming companion, he wanted to drink so he could see double!

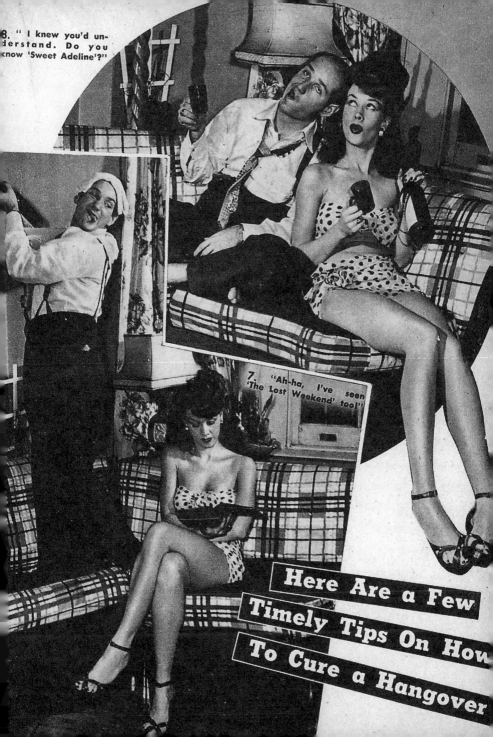

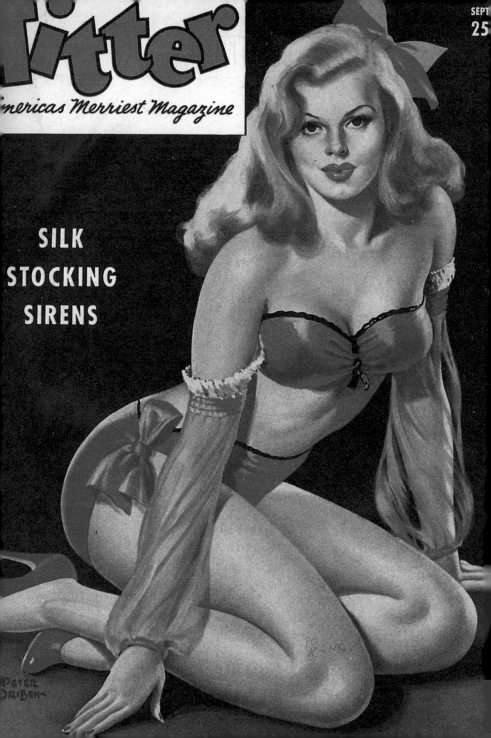

Titter

Americas Merriest Magazine

SEPT
25

SILK
STOCKING
SIRENS

Peter Driben

Titter

mericas Merriest Mag

NOV.
25¢

SILK
TOCKING
SIRENS

PETER
DRIBEN

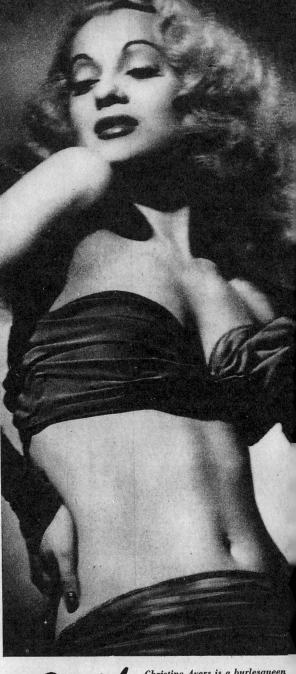

Torrid

Christine Ayers is a burlesqueen has thrilled audiences from coa coast. No wonder for her soft dimpled shoulders and fabul buxom form are thrilling to b

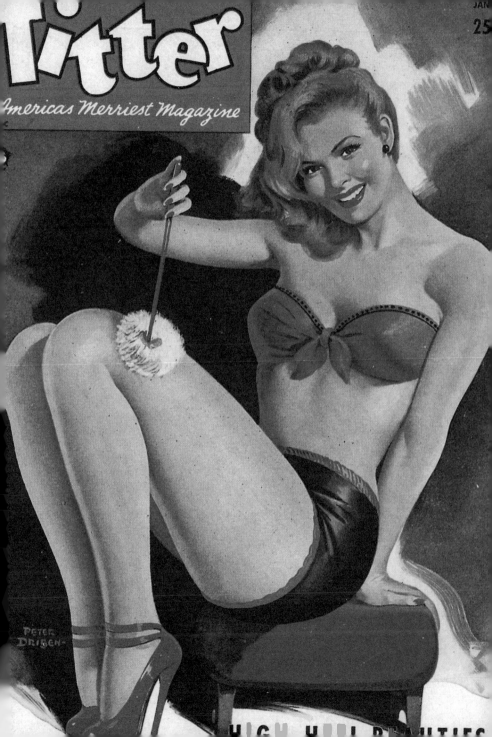

Titter

Americas Merriest Magazine

JAN
25

PETER
DRIBEN

HIGH HEEL BEAUTIES

Titter

America's Merriest Magazine

MARCH

25¢

PETER DRIBEN

SILK STOCKING SIRENS

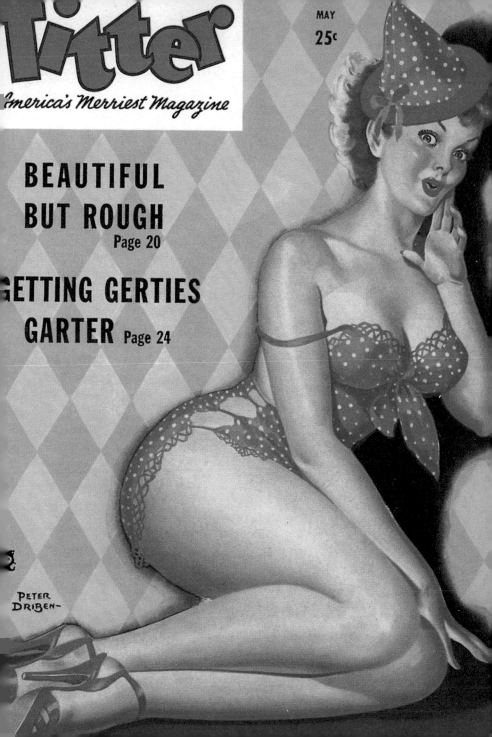

Titter

America's Merriest Magazine

MAY
25¢

BEAUTIFUL BUT ROUGH
Page 20

GETTING GERTIES GARTER Page 24

PETER DRIBEN—

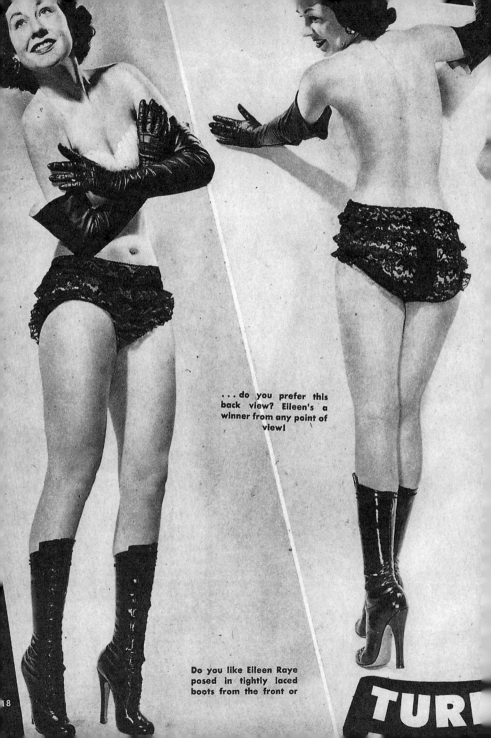

... do you prefer this back view? Eileen's a winner from any point of view!

Do you like Eileen Raye posed in tightly laced boots from the front or

TUR

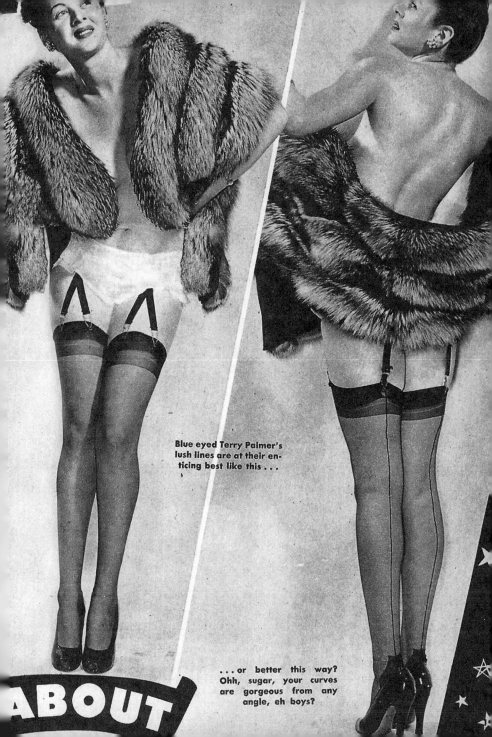

Blue eyed Terry Palmer's lush lines are at their enticing best like this . . .

. . . or better this way? Ohh, sugar, your curves are gorgeous from any angle, eh boys?

ABOUT

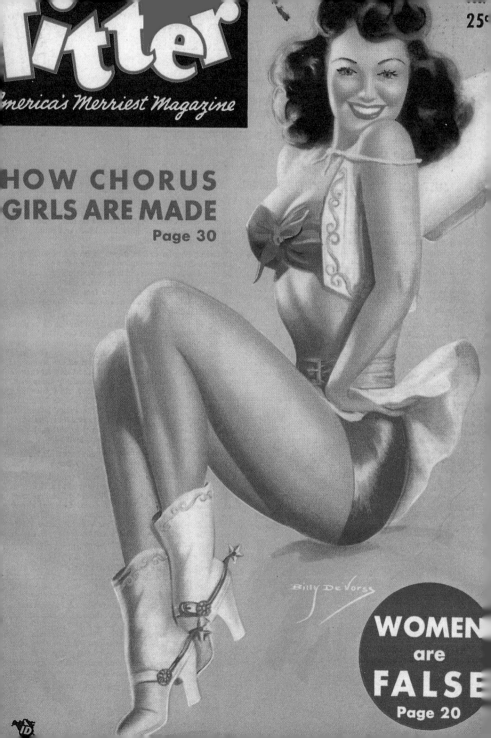

Titter

merica's Merriest Magazine

AUG.

25¢

ARRIED MEN
MAKE BAD
USBANDS Page 14

SIX COMMANDMENTS OF LOVE

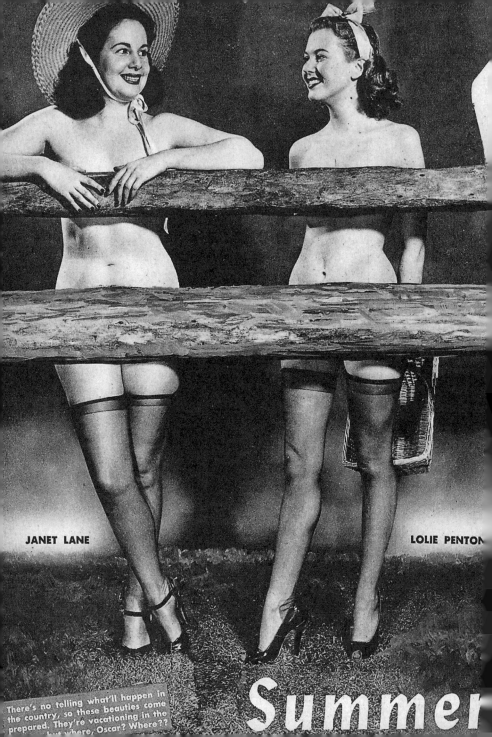

JANET LANE

LOLIE PENTON

There's no telling what'll happen in the country, so these beauties come prepared. They're vacationing in the ... but where, Oscar? Where??

Summer

ABS PENTELLE

TERRY DURSTO

Sweeties

On lazy, summer afternoons, curv
country gals like to shed excess gar
ments and enjoy the warming sun an
caressing breezes—In secluded spots

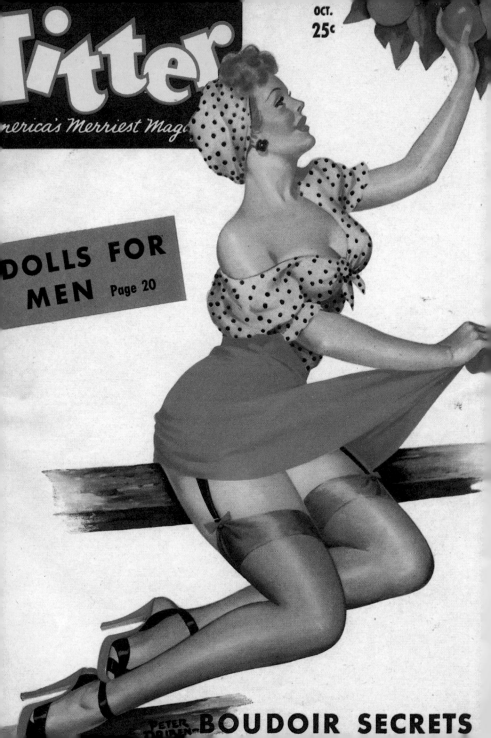

48

YOU SAID IT

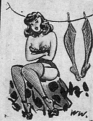

Dear Editor,
I agree with Gregg Sherwood, when she says, in your June issue, that no man will ever take her over his knee and spank her! Why the very idea! Me allow a husband or boy friend to wallop me with a hair brush across thin panties? Why my Mom stopped spanking me after my 14th birthday. I could NEVER love a man who'd spank my bottom!
Louise Barr, New York Ci-

Dear Editor,
Baby Lake is right! I could NEVER love a man wh- didn't take me across his knee and soundly spank me when I need it (which is often). My husband not only takes the hairbrush to me now — but he did when he was courting me. That's his privilege. It's very painful, because my hubby is thorough a- he leaves no protection on my seat of learning when he spanks me, but I recognize his right to wie- a hairbrush, strap, or any other corrective implement where it will do me the most good. I'm married to a MAN, and he takes no nonsense from me
Mrs. Charles L. M., Chicago, I-

Dear Editor,
I don't understand your American girls. When was a tiny tot my Mother spanked me with her palm. Later Mummy and Daddy slippered me or hairbrushed me — and jolly hard too. In school all of us girls were soundly birched on our panties when we were naughty (the boys were caned — I know because we peeked). But, where is the argument? Of COURSE women must be punished. I guess I'll never understand American women — nor American men if they don't assert their right to chastise their women!
Pamela B. T. L., Toronto.

Dear Editor,
You don't print enough pictures of gorgeous girls wearing tightly laced corsets. Maybe a lot of readers don't like them, but you are disappointing ME, I can tell you! PLEASE, Mr. Editor, more pictures of shapely damsels, laced until they can scarcely breathe. There is NO substitute for this essential beauty aid! More corsets!
Marvin R., Denver, Colo.

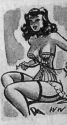

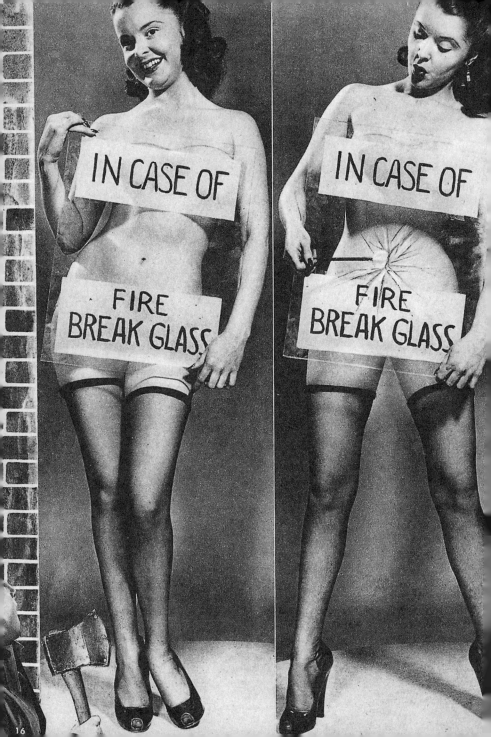

Blazing Redhead

SOUND the siren, Rollo! And hand me my helmet! This gal has lighted a fire in my heart! Redheaded Jackie Cavanaugh is such a sultry bundle of loveliness that the firemen are likely to get burned! In fact they look overcome already — and we can't blame 'em! A native of Old Ireland, 21-year-old Jackie adds up to spontaneous combustion no matter how you look at her, with her five-foot-six of soft curves, her flaming tresses and that tempting smile. She thought the "In Case Of Fire Break Glass" was a cute idea—and we expect a few hundred guys to dash out and join the nearest fire department. Outta our way, Oscar!

17

Titter

America's Merriest Magazine

DEC.
25¢

RAINY DAYS
ARE FUN

BABES LIKE IT ROUGH

Titter

America's Merriest Magazine

FEB.
25¢

FIVE WAYS BABES SAY NO

WHAT MAKES MEN BLUSH?

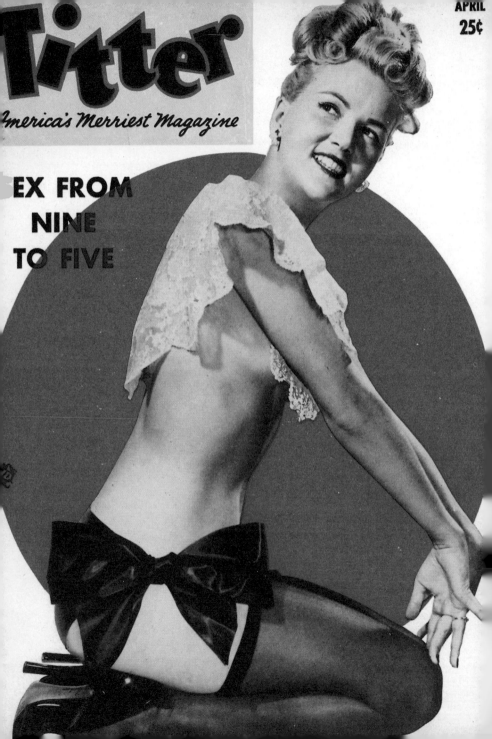

Titter

America's Merriest Magazine

APRIL
25¢

EX FROM NINE TO FIVE

HIPS and MISSES

There was a young girl from Peru,
Who decided her loves were too few.
So she walked from her door,
With a fig-leaf, no more,
And now she's in bed with the flu!

Louise: "Is Jimmy careful when you go riding with him at night?"

Emma: "I'll say he is. He comes to a full stop at every curve!"

He kissed Helen.
Hell ensued!
He Left Helen—
Helen sued!

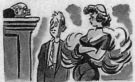

A smart girl is one that quits playing ball when she makes one good catch!

Miss Sixteen: "I want a man with a future."

Miss Thirty-Five: "I want a future with a man!"

Did you hear about the aging burlesque queen who thought about the good old days and heaved a thigh!

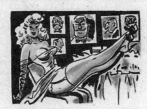

A boxer by name of O'Flynn
Who always was able to win,
Had a beautiful nude
On his tummy tattooed
And nobody noticed his chin.

"Junior. Jun—IOR!"
"Yeah, ma?"
"Are you spitting in the fish bowl?"
"No, but I'm coming pretty close!"

Frown: "I understand your girl friend is a typist. Does she use the touch system?"

Clown: "Well, you don't think she bought all those swell duds out of her salary, do you?"

A woman's face
may be a poem;
but she is always
careful to conceal the lines in it!

Dolly: "Only last week you said it was a great life if you didn't weaken."

Polly: "Yes, but since then I've found out it's sometimes a greater one if you weaken just a little bit!"

The Wife: "Perhaps my husband's secretary knows where my husband has gone?"

Office Boy: "I'll say she does. She's gone with him!"

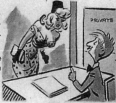

He gave up liquor, wine and food
He never went to bed;
He swore off smokes and women, too,
He had to—He WAS DEAD!

Irate Parent: "I'll teach you to make love to my daughter, sir."

Young Man: "I wish you would, old man, I'm not making much headway."

Bounder: "I know her well. She sat on my lap when she was little."

Rounder: "I know her better. She sat on mine last night."

Devastating Dolly says "the worst a girl's past the better presents she expects!"

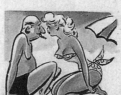

Beach Peach: "Ooooh, I can tell you're a man a girl can trust!"

Beach Rounder: "Hmmm, didn't I meet you here last summer? Your faith seems familiar."

Wacky Hats

from
GAY PAREE

OUI, OUI, messieurs, regardez ces chapeaux pour bebe, direct from Paris (Paris, Texas, that is, and fresh off the freight train), each and every one a unique creation of that style genius and madhatter, M. Guillaume Henri de Harrison-Schultz. Interviewed at his atelier where he was putting the finishing touches on a brimless, off-the-face frying pan for Lady Helpus, wife of the famous Lord Helpus, the master said he was trying to portray two scrambled eggs in mock flight over a beer barrel. "Le dernier cri," he said, "the latest cry"—though it looked more like the last gasp. Lovely hats, but they'll never replace the pinwheel beanie.

FRESH FRUIT CUP

BEATS THE BAND

PIXIE

DEALER'S CHOICE

Titter

America's Merriest Mag

JUN
25¢

ARE YOU A SAP WITH GALS?

ROZ GREENWOOD

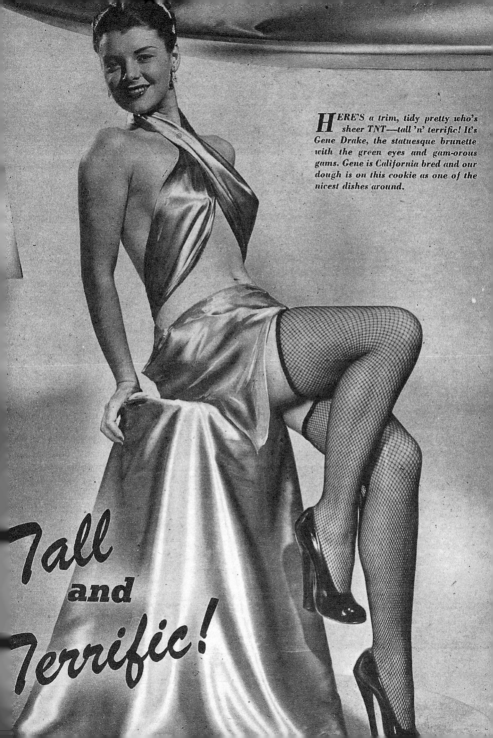

HERE'S a trim, tidy pretty who's sheer TNT—tall 'n' terrific! It's Gene Drake, the statuesque brunette with the green eyes and gam-orous gams. Gene is California bred and our dough is on this cookie as one of the nicest dishes around.

Tall and Terrific!

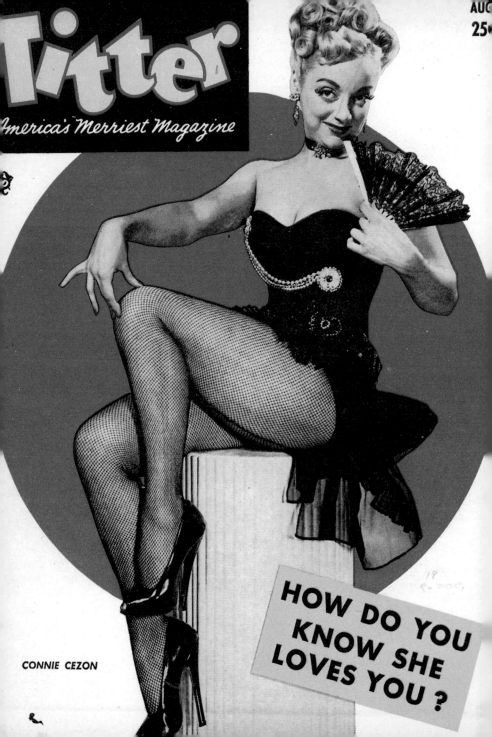

AUG

25¢

Titter
America's Merriest Magazine

CONNIE CEZON

HOW DO YOU KNOW SHE LOVES YOU ?

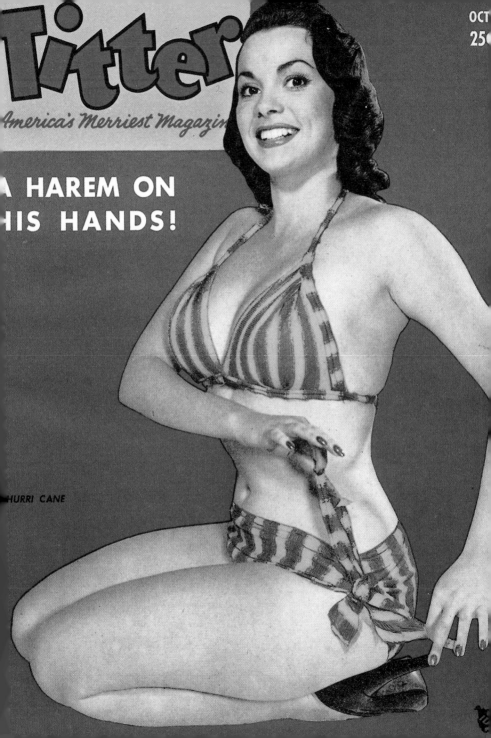

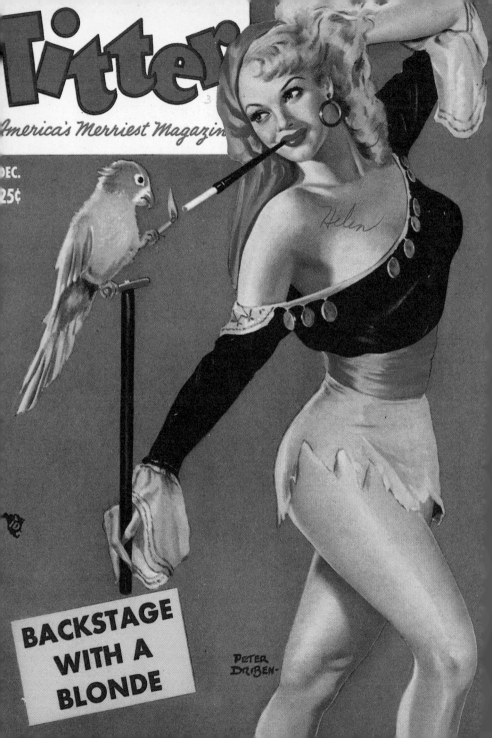

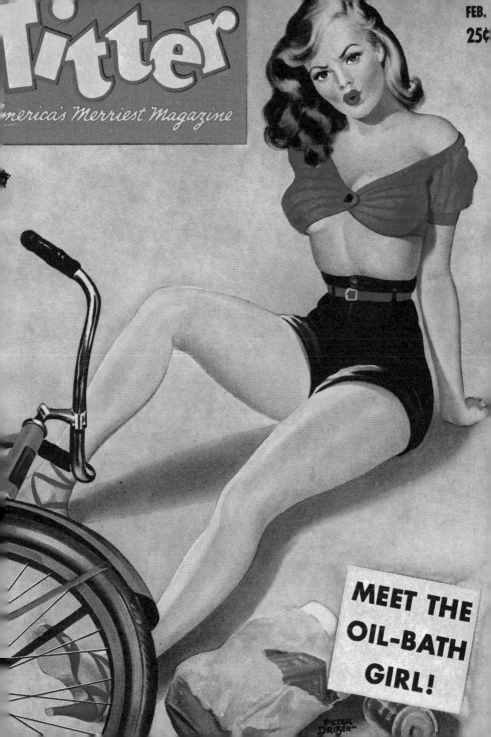

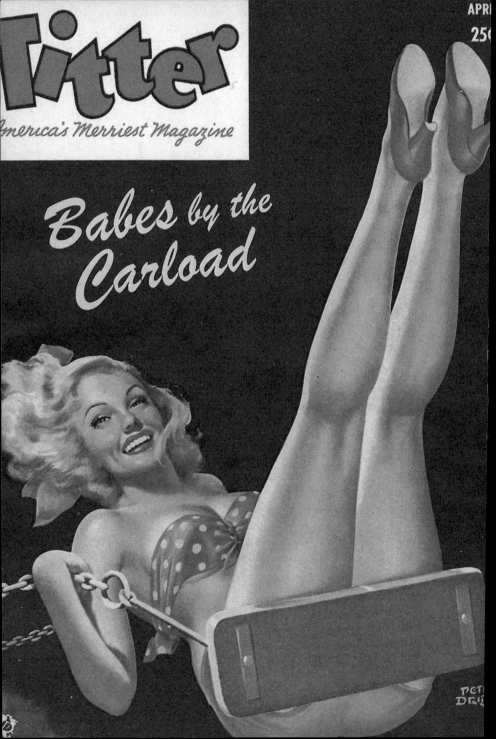

Titter

america's Merriest Magazine

JUNE

25¢

Making Merry With

BLONDES
BRUNETTES
REDHEADS

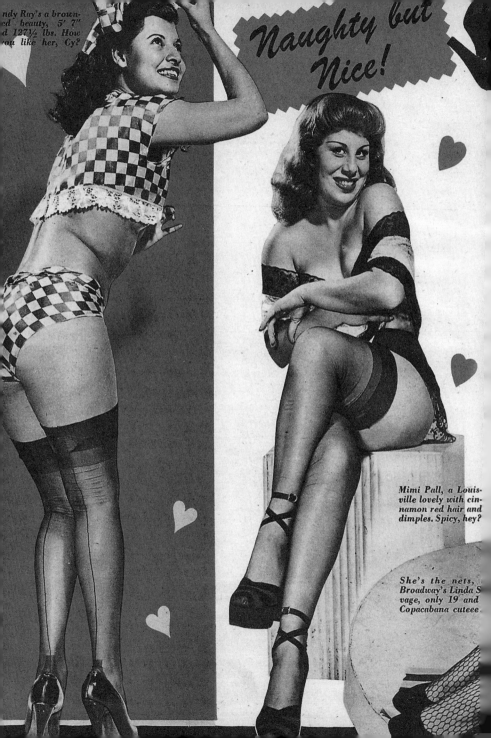

ndy Ray's a brown-
ed beauty, 5' 7"
d 127½ lbs. How
ou like her, Cy?

Naughty but Nice!

Mimi Pall, a Louis-
ville lovely with cin-
namon red hair and
dimples. Spicy, hey?

She's the nets,
Broadway's Linda S
vage, only 19 and
Copacabana cuteee.

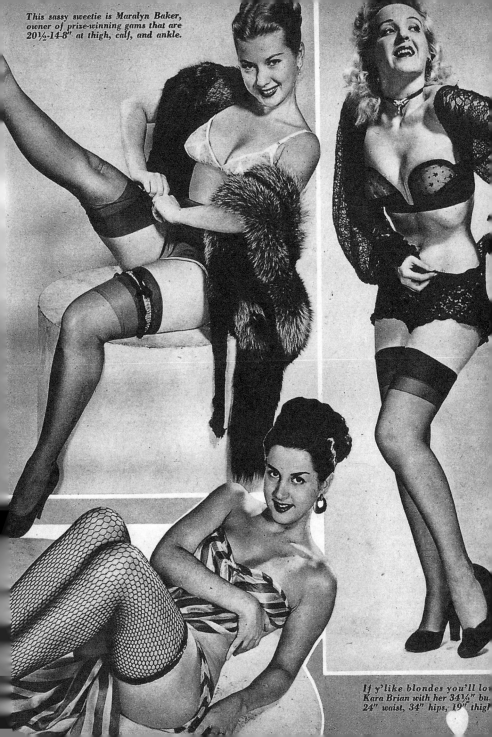

This sassy sweetie is Maralyn Baker, owner of prize-winning gams that are 20½-14-8" at thigh, calf, and ankle.

If y'like blondes you'll lov Kara Brian with her 34½" bu 24" waist, 34" hips, 19" thigl

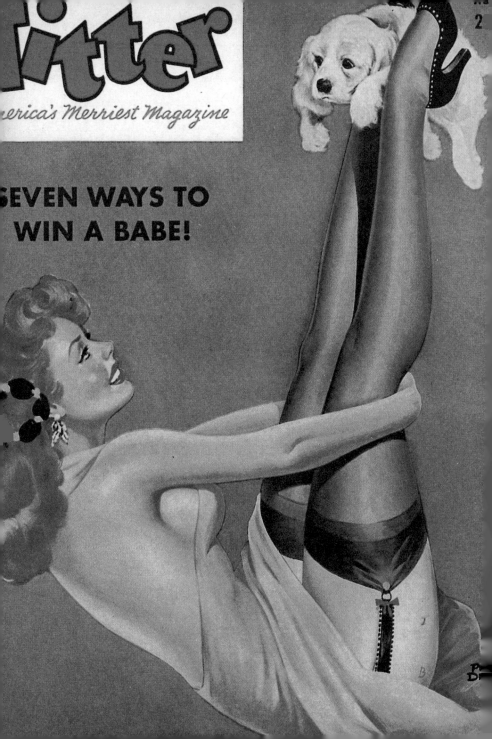

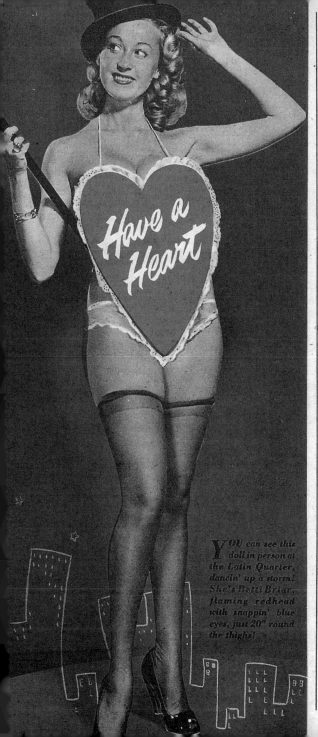

Have a Heart

YOU can see this doll in person at the Latin Quarter, dancin' up a storm! She's Betti Briar, flaming redhead with snappin' blue eyes, just 20" round the thighs!

47

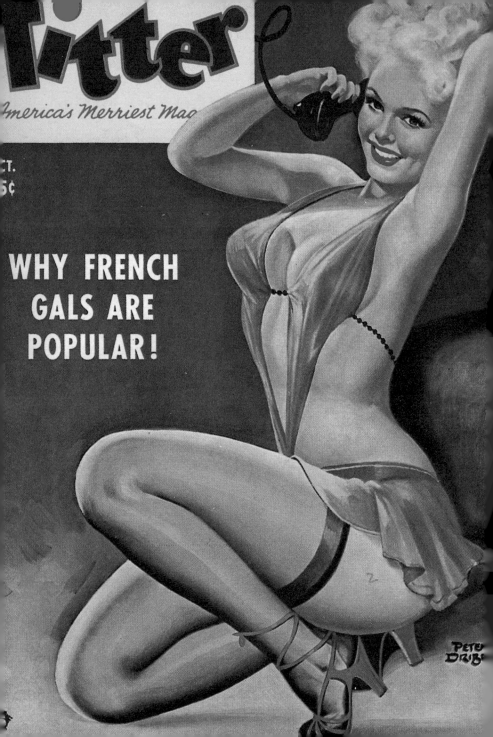

Titter

America's Merriest Mag

OCT.

5¢

WHY FRENCH GALS ARE POPULAR!

PETER DRIBEN

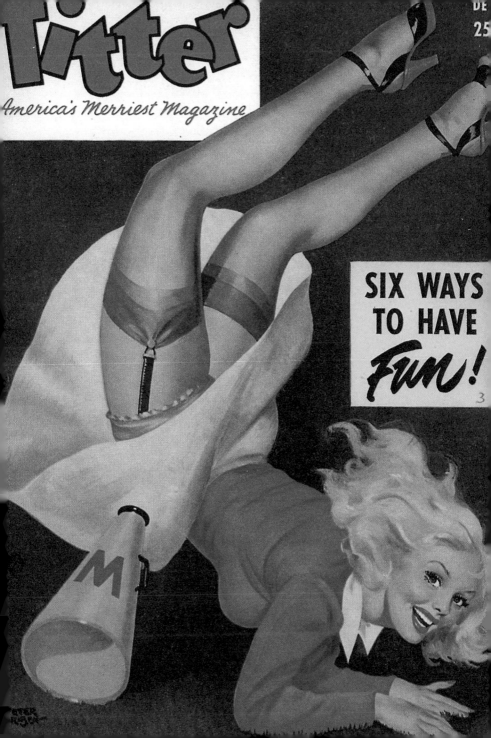

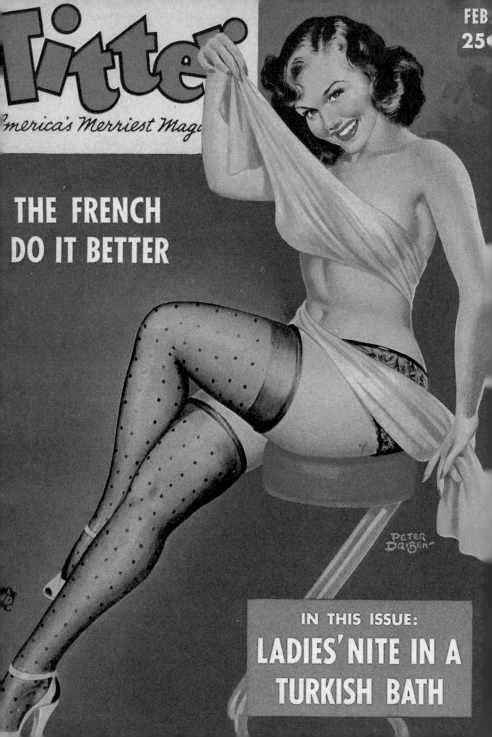

Titter

America's Merriest Magazine

APR
25

A GAL AND
A GIRDLE

LOVIN' ROUND
THE WORLD

PETER
DRIBEN

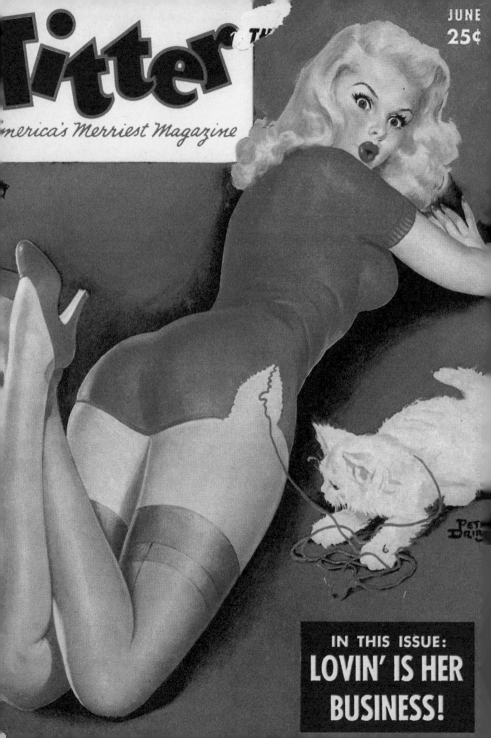

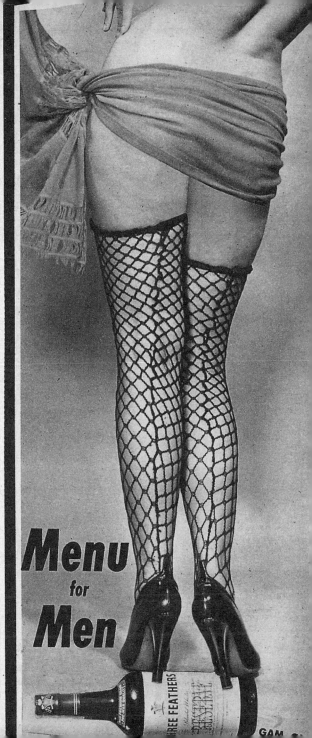

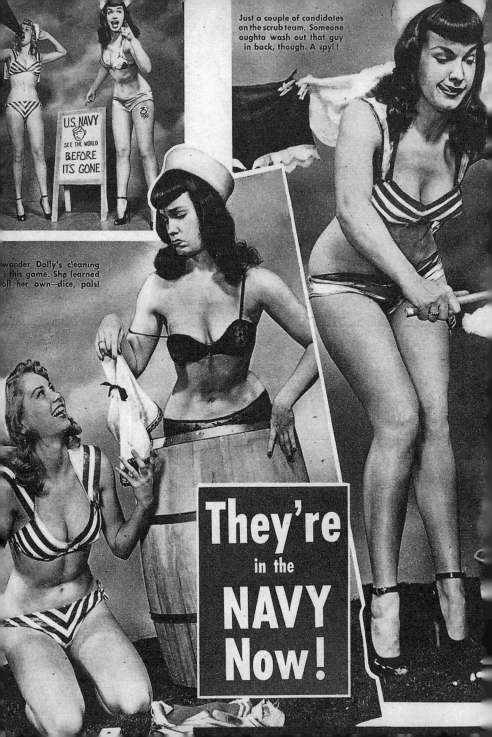

Just a couple of candidates on the scrub team. Someone oughta wash out that guy in back, though. A spy!!

U.S. NAVY
SEE THE WORLD
BEFORE
IT'S GONE

wonder Dolly's cleaning
this game. She learned
oll her own—dice, pals!

They're
in the
NAVY
Now!

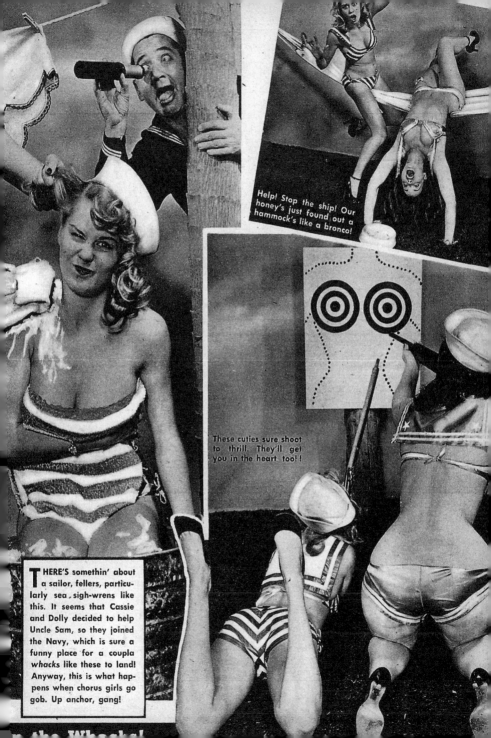

Help! Stop the ship! Our honey's just found out a hammock's like a bronco!

These cuties sure shoot to thrill. They'll get you in the heart, too!!

THERE'S somethin' about a sailor, fellers, particularly sea , sigh-wrens like this. It seems that Cassie and Dolly decided to help Uncle Sam, so they joined the Navy, which is sure a funny place for a coupla whacks like these to land! Anyway, this is what happens when chorus girls go gob. Up anchor, gang!

n the Whacks!

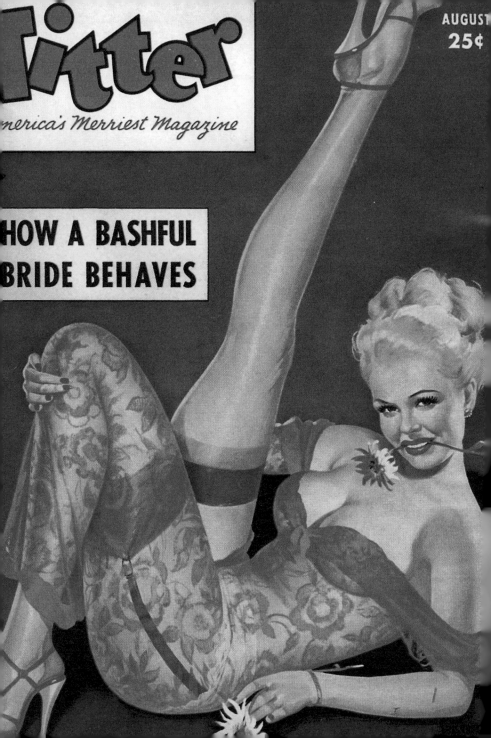

Titter

merica's Merriest Magazine

AUGUST
25¢

HOW A BASHFUL BRIDE BEHAVES

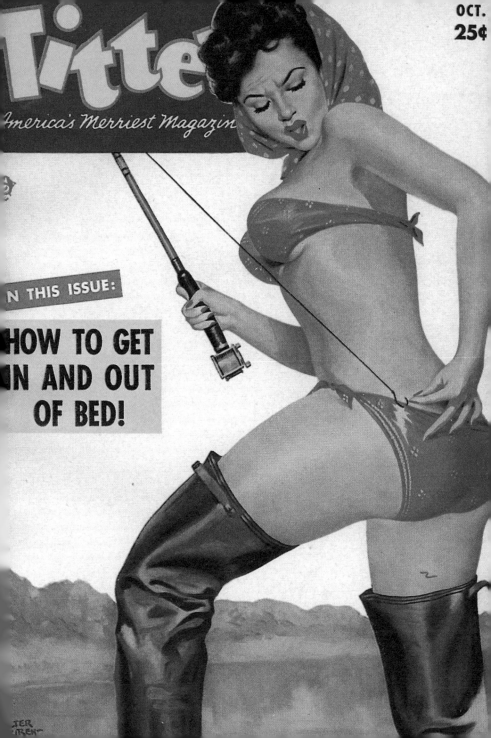

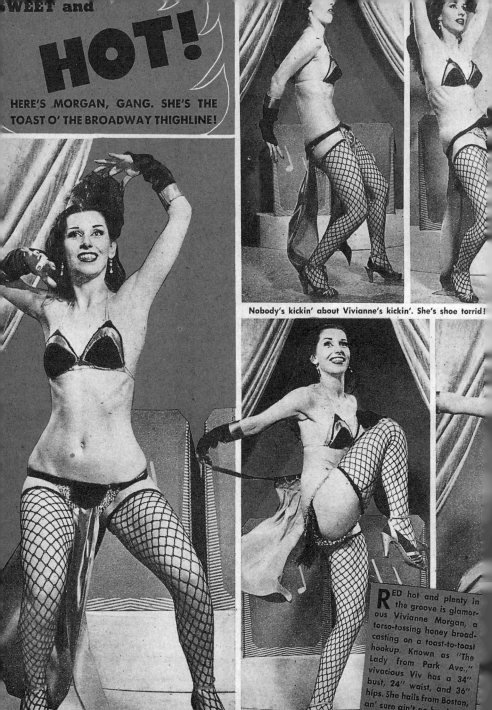

SWEET and HOT!

HERE'S MORGAN, GANG. SHE'S THE TOAST O' THE BROADWAY THIGHLINE!

Nobody's kickin' about Vivianne's kickin'. She's shoe torrid!

You gotta admit, fellers, that when Vivianne does her act — it's the nets!

RED hot and plenty in the groove is glamorous Vivianne Morgan, a torso-tossing honey broadcasting on a toast-to-toast hookup. Known as "The Lady from Park Ave.," vivacious Viv has a 34" bust, 24" waist, and 36" hips. She hails from Boston, an' sure ain't no has-bean!

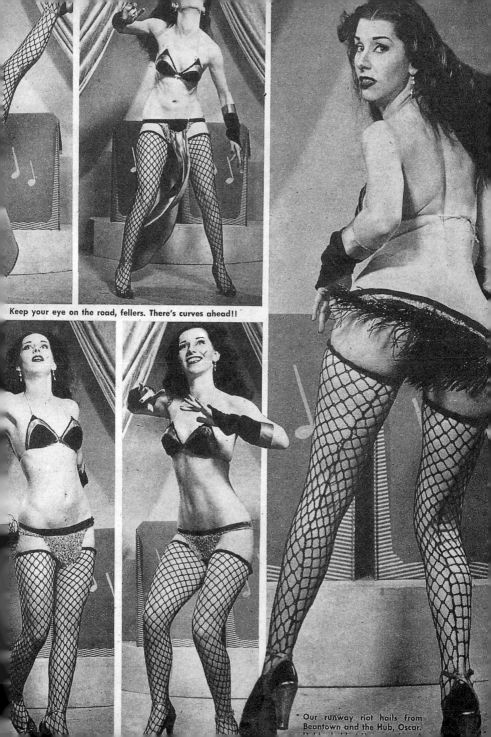

Keep your eye on the road, fellers. There's curves ahead!!

Our runway riot hails from Beantown and the Hub, Oscar.

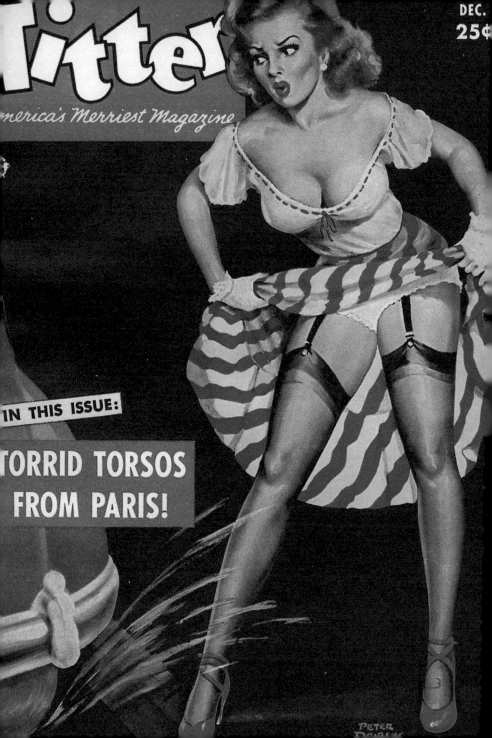

Titter

merica's Merriest Magazine

DEC.

25¢

PETER DRIBEN

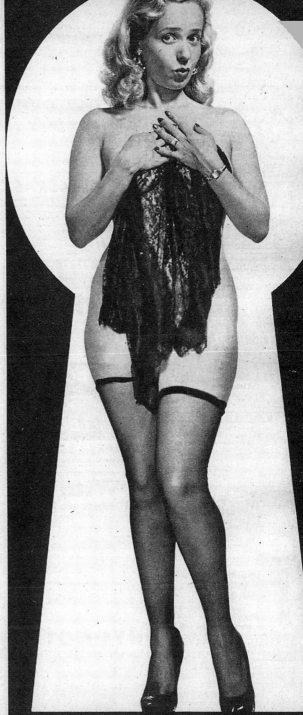

SNEAK A PEEK AT LOVELY MODEL LILI WAYNE, W

BEAT it BABY

Hit it! Nite-clubbers go mad when sizzling Susie steps a hot rhumba on bass drum!

A DOLL WITH A DRUM 'N' DAZZLE TAKES BROADWAY!

Hottest act on the nite club circuit consists of the cutest babe you ever saw, plus a set of trap drums and a world of rhythm! Curvy Susan Price has blasé Broadwayites in the aisles when she beats the skins and tosses her torrid torso to a boogie beat!

4

Bottoms up, full of rhythm, loaded with curves!

Swing it, Baby! From where we sit it's music

Susie shows plenty of form as she wrestles a solo to a blues note!

Knocked out in a wow finish! A cute number m

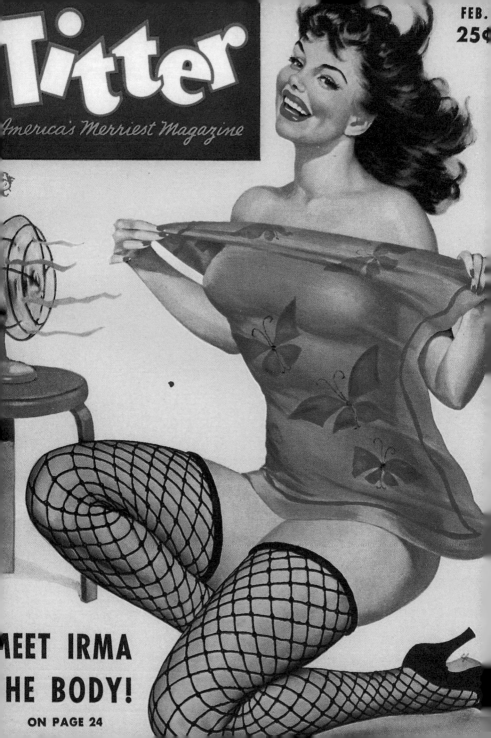

Undercover Girls

HERE'S A CHANCE TO SNEAK A PEEK AT
WHAT THE BROADWAY BABES COVER UP!

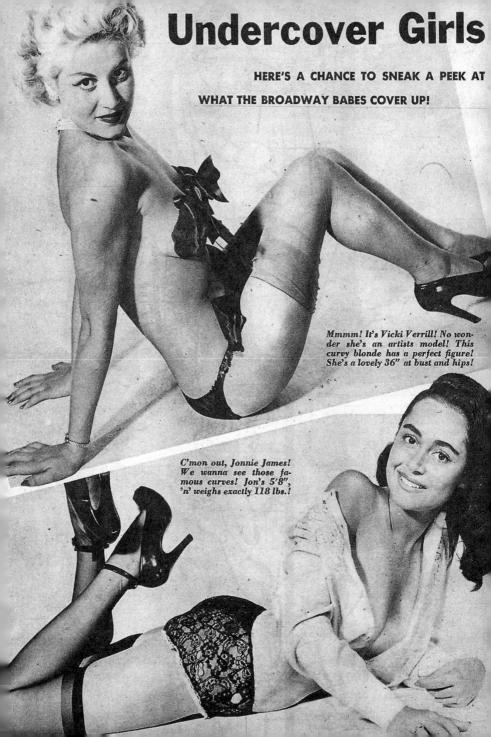

Mmmm! It's Vicki Verrill! No wonder she's an artists model! This curvy blonde has a perfect figure! She's a lovely 36" at bust and hips!

C'mon out, Jonnie James! We wanna see those famous curves! Jon's 5'8", 'n' weighs exactly 118 lbs.!

Titter

America's Merriest Magazine

APRIL

25¢

PETER DRIBEN

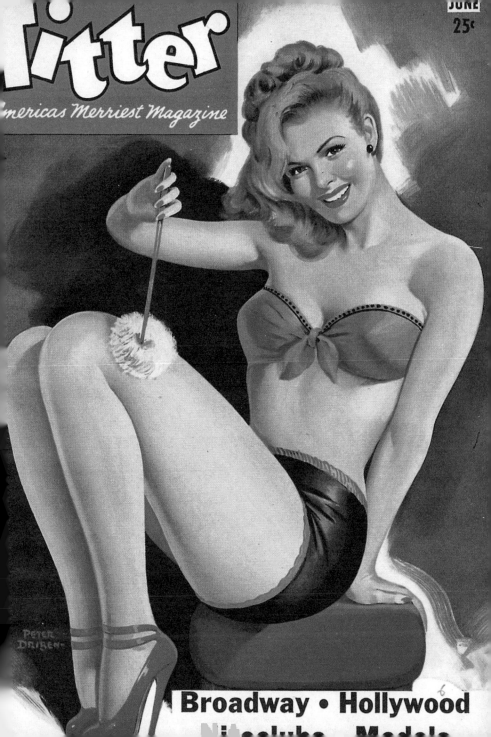

Titter

mericas Merriest Magazine

JUNE

25c

PETER
DRIBEN

Broadway • Hollywood

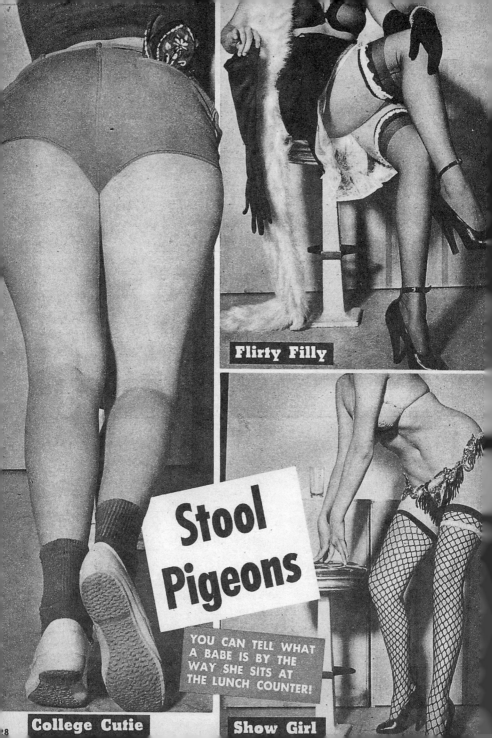

Flirty Filly

Stool Pigeons

YOU CAN TELL WHAT
A BABE IS BY THE
WAY SHE SITS AT
THE LUNCH COUNTER!

College Cutie

Show Girl

Cowgirl

Party Doll

Career Girl

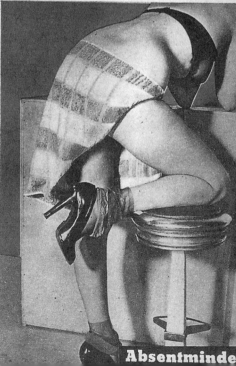
Absentminded

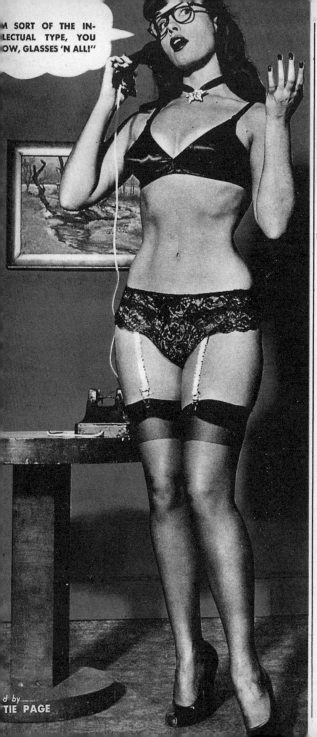

M SORT OF THE IN-
LECTUAL TYPE, YOU
OW, GLASSES 'N ALL!"

d by
TIE PAGE

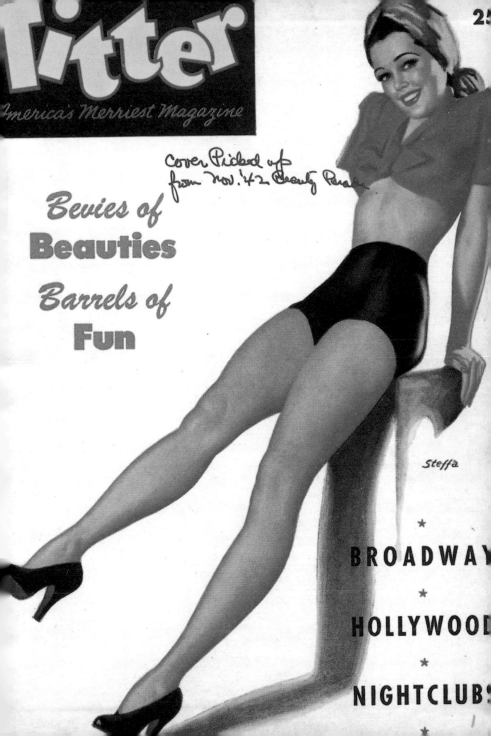

titter

nerica's Merriest Magazine

OCT.

25¢

GALS

and

GAGS

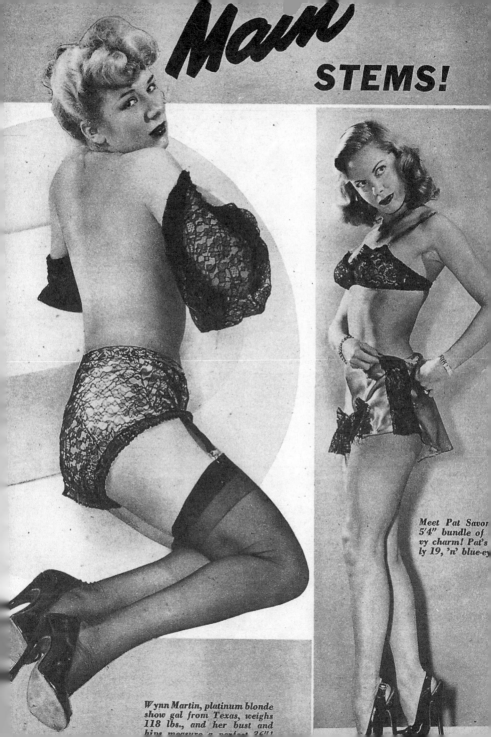

Main STEMS!

Wynn Martin, platinum blonde
show gal from Texas, weighs
118 lbs., and her bust and
hips measure a perfect 36"!

Well, fan my scalp! If all squaws shape up like Noreen Bates I'm a-headin' out West pronto! She's tall 'n' terrific! She'll do! Wahoo!

WANTA SEEK FEMME AND FORTUNE? "BETTER GO WEST, YOUNG MAN!" SAYS TWO-GUN TESSIE!

Titter

America's Merriest Mag

DEC.

25¢

ROADWAY

★

HOWGIRLS

★

OLLYWOOD

★

MODELS

★

IGHTLIFE

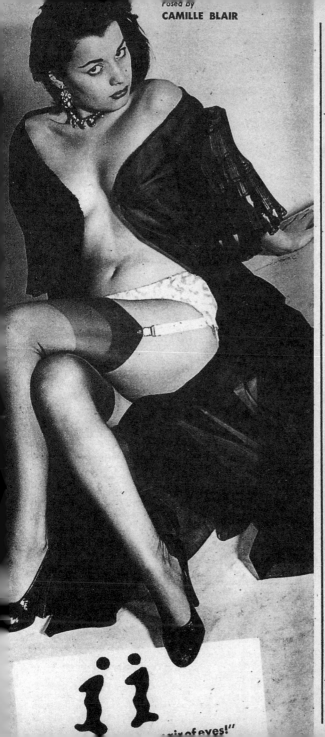

Posed by
CAMILLE BLAIR

"...pair of eyes!"

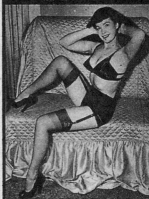

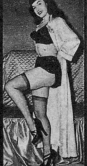

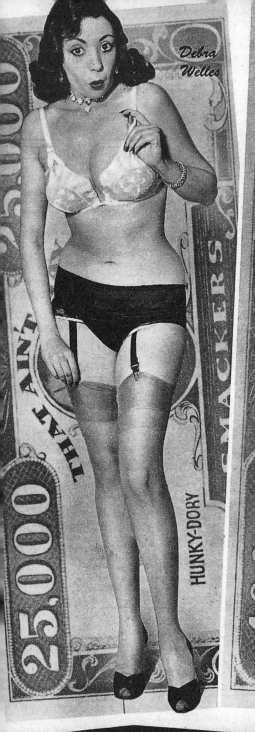

Debra Welles

25,000

THAT AIN'T

HUNKY-DORY

SMACKERS

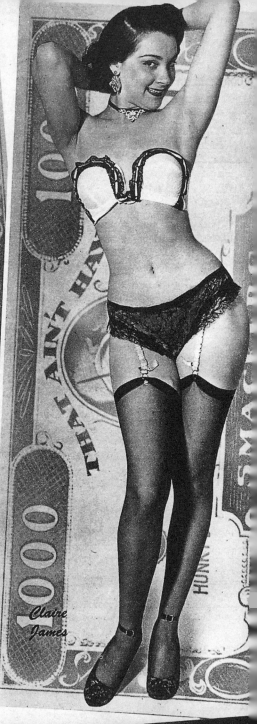

THAT AIN'T HA

1000

SMACKE

Claire James

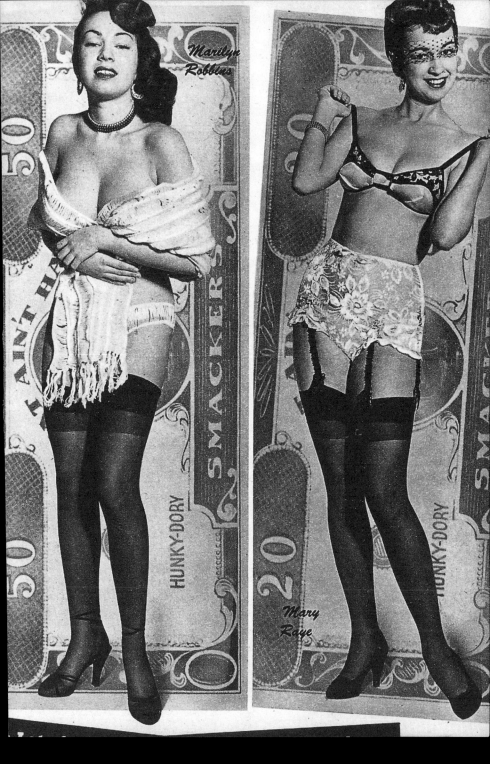

Marilyn Robbins

Mary Raye

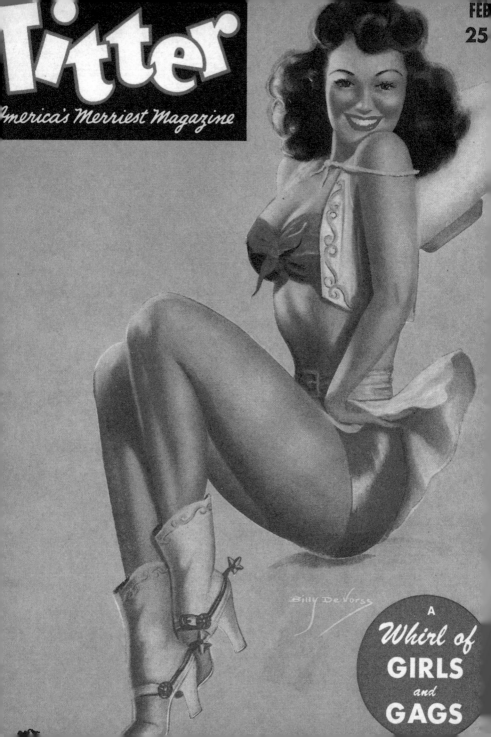

Titter

America's Merriest Magazin

APR

25¢

A
Whirl of
GIRLS
and
GAGS

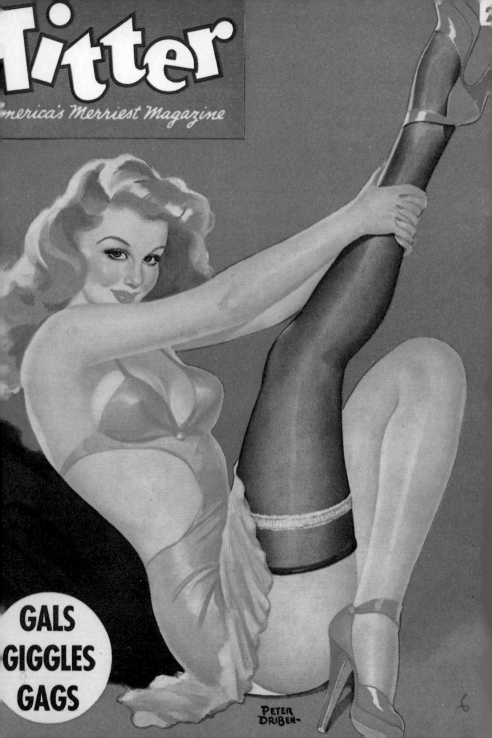

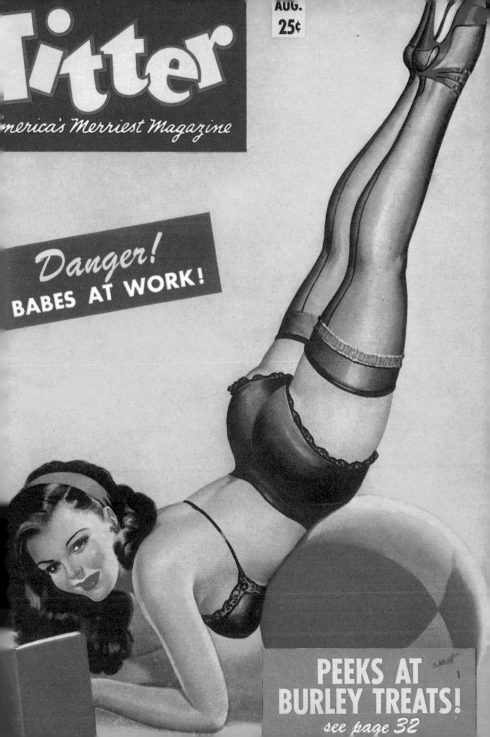

Will you be taken care of in your old age, like Daddy here? Check this! ←

Do you find it difficult raising the money for premiums? Try this trick, boy!

Strippers
LANGUAGE OF LOVE

EVERY LITTLE MOVEMENT HAS A MEANING ALL ITS OWN!

"My name is Venus! I'm a peeler, and I want all you

"Anybody here with a car? I'm taking off attire

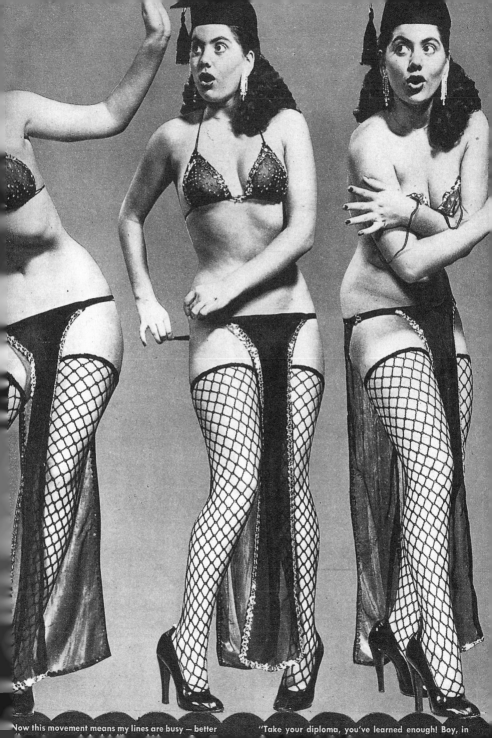

Now this movement means my lines are busy — better "Take your diploma, you've learned enough! Boy, in

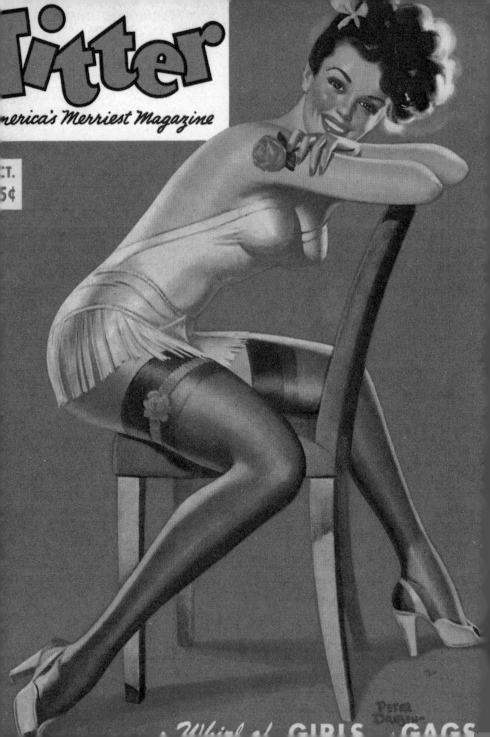

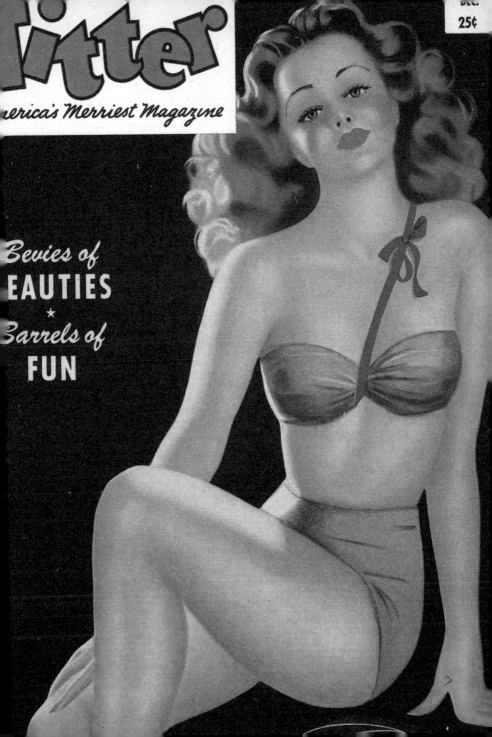

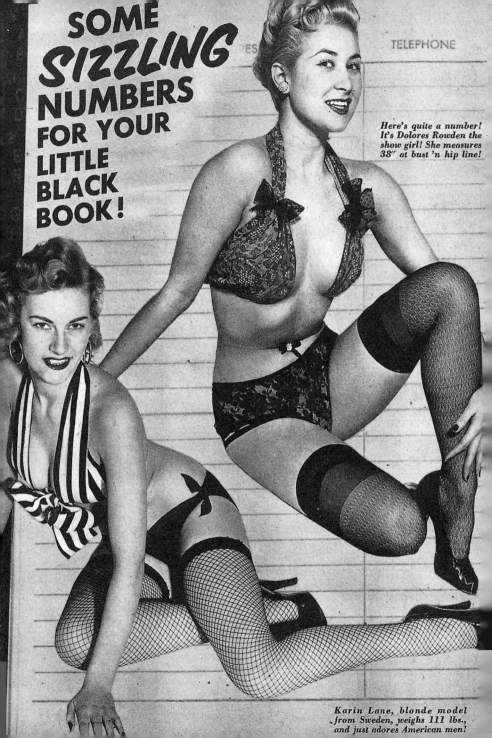

SOME SIZZLING NUMBERS FOR YOUR LITTLE BLACK BOOK!

Here's quite a number! It's Dolores Rowden the show girl! She measures 38" at bust 'n hip line!

Karin Lane, blonde model from Sweden, weighs 111 lbs., and just adores American men!

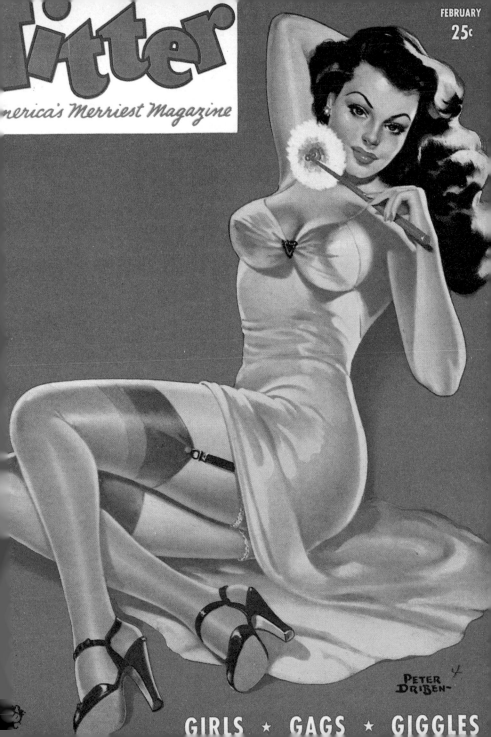

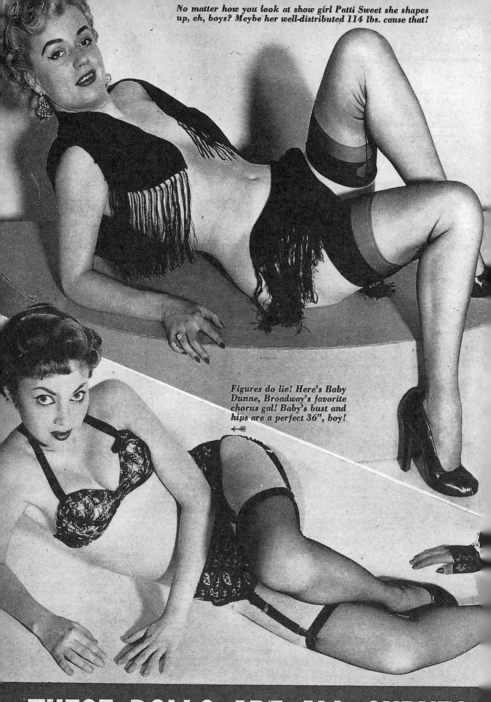

No matter how you look at show girl Patti Sweet she shapes up, eh, boys? Maybe her well-distributed 114 lbs. cause that!

Figures do lie! Here's Baby Dunne, Broadway's favorite chorus gal! Baby's bust and hips are a perfect 36", boy!

THESE DOLLS ARE ALL CURVES.

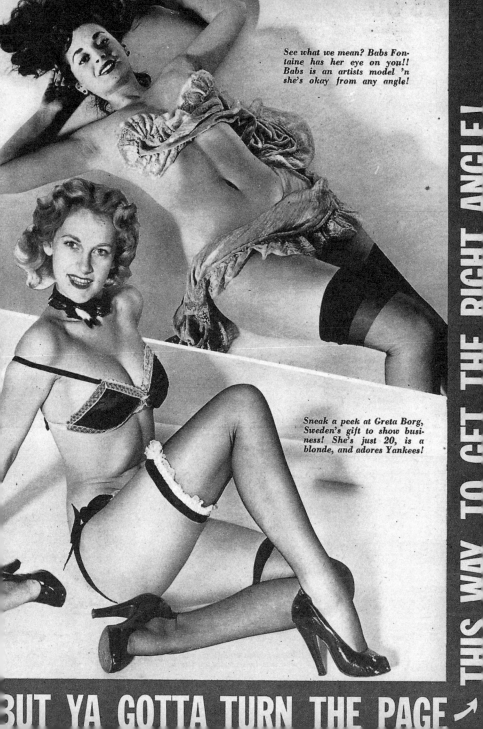

See what we mean? Babs Fontaine has her eye on you!! Babs is an artists model 'n she's okay from any angle!

Sneak a peek at Greta Borg, Sweden's gift to show business! She's just 20, is a blonde, and adores Yankees!

THIS WAY TO GET THE RIGHT ANGLE!

BUT YA GOTTA TURN THE PAGE

Titter

America's Merriest Magazine

APR.
25¢

WHY BABES LEAVE HOME

BRINGING UP BABY

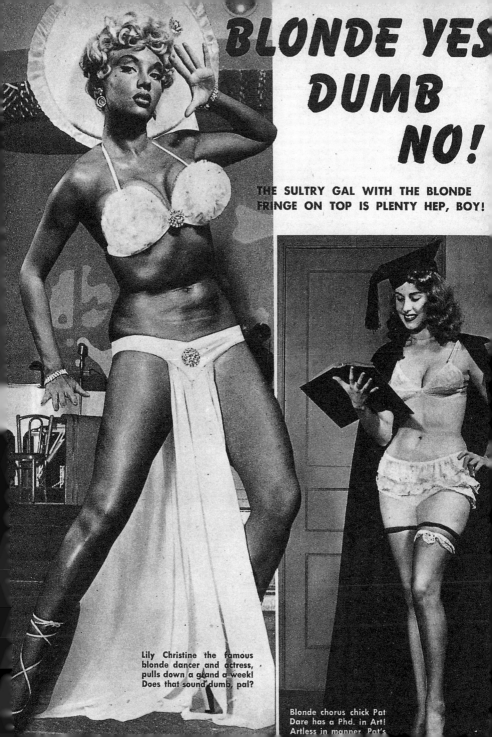

BLONDE YES DUMB NO!

THE SULTRY GAL WITH THE BLONDE FRINGE ON TOP IS PLENTY HEP, BOY!

Lily Christine the famous blonde dancer and actress, pulls down a grand a week! Does that sound dumb, pal?

Blonde chorus chick Pat Dare has a Phd. in Art! Artless in manner Pat's

ANATOMY IS SOMETHING

WE ALL HAVE ...But... IT LOOKS BETTER ON SHOW GAL *Pat Barnes!*

WI

A Whirl

NK
of Girls
1944–1955

As Harrison still had no real rivals, he simply went on copying himself. But Wink contained a number of innovations, one of which was to reprint, in the late 40s, John Willie's legendary "Sweet Gwendoline" comic strip in the form of a serialized double-page story. Willie had already published parts of his bondage saga about the dastardly Sir d'Arcy in his magazine "Bizarre", but this probably never got beyond a small underground circle of fans. The fresh air of the newsagent's stand above ground may have been something strange for him, but otherwise the circumstances were right. For commercial reasons a fetishistic interest had meanwhile been introduced into Harrison's magazines – girls in chains, whip-wielding "wild sirens", and spanking stories. The unglamorous, girl-next-door models of the photo-stories, who hoped no more than to turn an honest penny, were no doubt unhappy with these new melo-dramatic requirements, but that was what the readers wanted. The day shift at the Harrison headquarters be-gan, so Tom Wolfe liked to put it about, when the boss, who had once again spent the night in the office, was awoken by the sound of clanking chains, which some hapless model was dragging to the photo shoot herself.

Da ihm noch niemand richtig Konkurrenz machen wollte, kopierte sich Harrison weiter selbst. Zu den Besonderheiten von Wink zählt allerdings der Abdruck von John Willies legendärem „Sweet Gwendoline"-Comic als doppelseitige Fortsetzungsgeschichte Ende der 40er Jahre. Willie hatte Teile seiner Bondagesaga um den ruchlosen Sir d'Arcy bereits in seinem Magazin „Bizarre" veröffentlicht, doch dürfte dies nur ein kleiner Undergroundzirkel registriert haben. Die Luft über der Ladentheke war für ihn etwas Neues, aber die Rahmenbedingungen paßten: Models in Fesseln, peitschenschwingende „wilde Sirenen" und Spankinggeschichten waren den sauberen und jedem Melodram abholden Mädchen der Fotostories mittlerweile verkaufsfördernd an die Seite getreten. Die Tagschicht bei Harrison begann, so kolportiert Tom Wolfe, wenn der Chef, der mal wieder im Büro übernachtet hatte, vom Geräusch scheppernder Ketten geweckt wurde, die ein geplagtes Model eigenhändig zum Fototermin anschleppte.

Puisque personne ne voulait encore lui faire véritablement concurrence, Harrison continua à se copier lui-même. Il faut toutefois compter parmi les singularités de Wink la parution sur deux pages, sous forme de feuilleton, du célèbre comic «Sweet Gwendoline» de John Willie à la fin des années 40. Willie avait déjà publié dans son magazine «Bizarre» des extraits de sa saga sado-maso qui mettait en scène l'infâme Sir d'Arcy, mais seul un petit cercle d'initiés devait encore s'en souvenir. L'air qu'on respirait autour du comptoir était pour lui quelque chose de nouveau, mais les conditions de base étaient là : à côté des gentilles filles qui se souciaient tout aussi peu de glamour que de mélodrame, on avait fait apparaître entre-temps dans les histoires en photos des modèles enchaînés, des «sirènes lubriques» agitant des fouets et des histoires de fessées, dans le but de stimuler les ventes. Tom Wolfe rapporte que l'équipe de jour arrivait quand le patron, qui une fois de plus avait passé la nuit dans son bureau, était réveillé par un bruit de chaînes qu'on traînait et qu'un modèle résigné acheminait lui-même jusqu'à l'endroit de la séance photo.

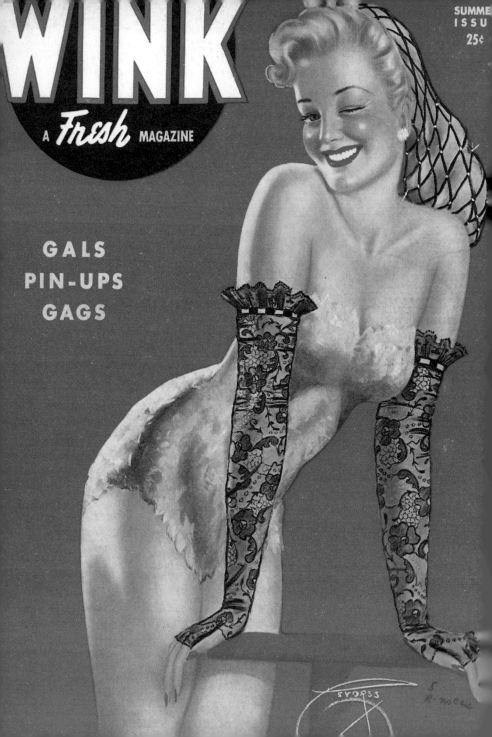

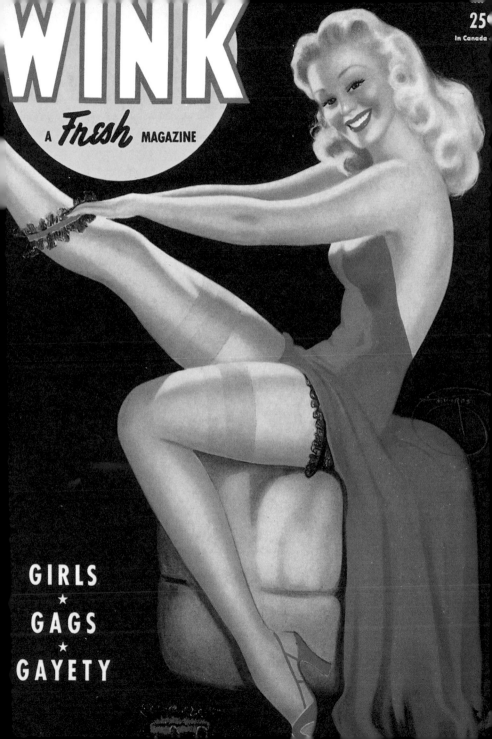

WINK

A *Fresh* MAGAZINE

25¢
In Canada

GIRLS
★
GAGS
★
GAYETY

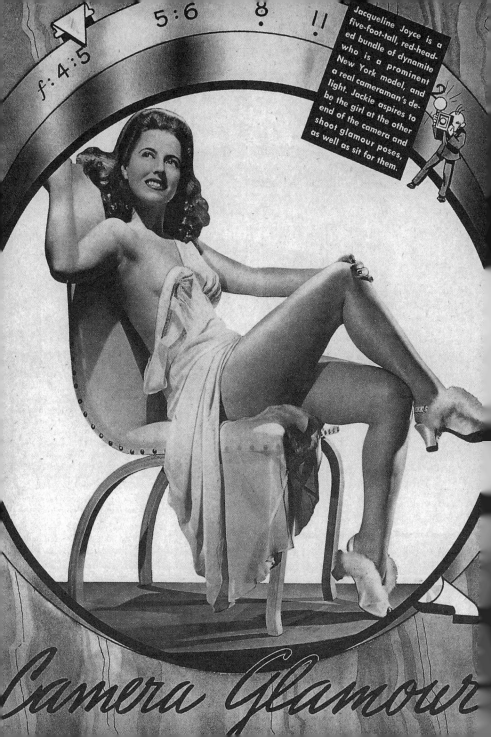

f: 4:5 5:6 8 !!

Jacqueline Joyce is a five-foot-tall, red-head-ed bundle of dynamite who is a prominent New York model, and a real cameraman's de-light. Jackie aspires to be the girl at the other end of the camera and shoot glamour poses, as well as sit for them.

Camera Glamour

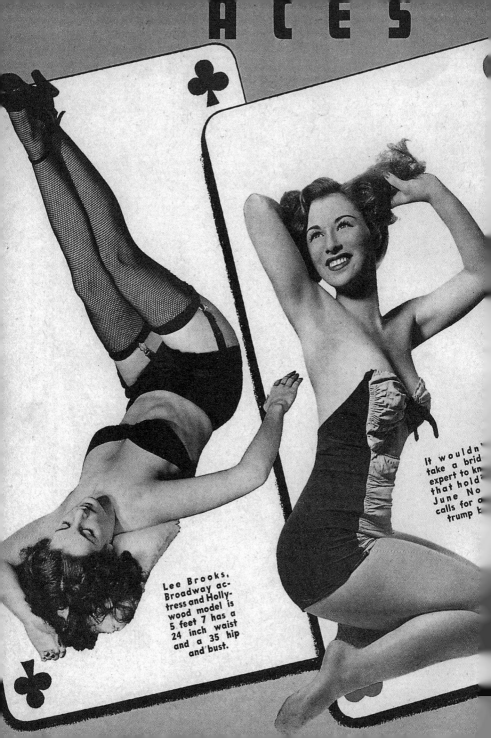

It wouldn'
take a brid
expert to kn
that hold
June No
calls for a
trump

Lee Brooks,
Broadway ac-
tress and Holly-
wood model is
5 feet 7 has a
24 inch waist
and a 35 hip
and bust.

HIGH

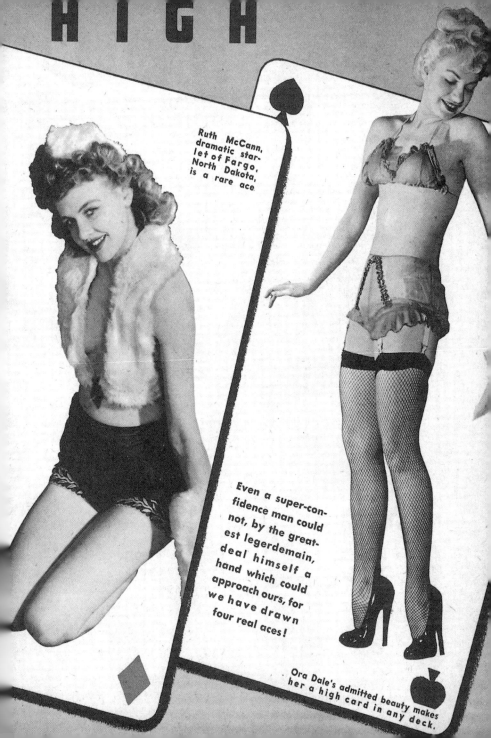

Ruth McCann, dramatic starlet of Fargo, North Dakota, is a rare ace.

Even a super-confidence man could not, by the greatest legerdemain, deal himself a hand which could approach ours, for we have drawn four real aces!

Ora Dale's admitted beauty makes her a high card in any deck.

25c

WINK

Fresh MAGAZINE

GIRLS ★ GAGS ★ GAYETY

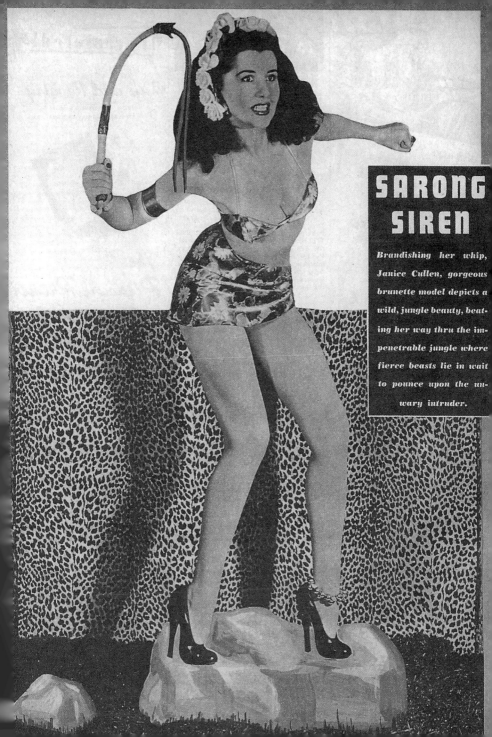

SARONG SIREN

Brandishing her whip, Janice Cullen, gorgeous brunette model depicts a wild, jungle beauty, beating her way thru the impenetrable jungle where fierce beasts lie in wait to pounce upon the unwary intruder.

JANUARY
25c

WINK

Fresh MAGAZINE

GIRLS
★
GAGS
★
GAYETY

PETER

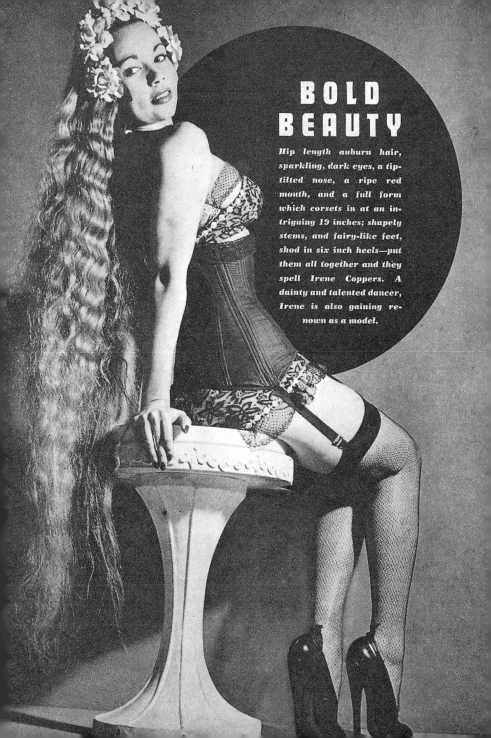

BOLD BEAUTY

Hip length auburn hair, sparkling, dark eyes, a tip-tilted nose, a ripe red mouth, and a full form which corsets in at an intriguing 19 inches; shapely stems, and fairy-like feet, shod in six inch heels—put them all together and they spell Irene Coppers. A dainty and talented dancer, Irene is also gaining renown as a model.

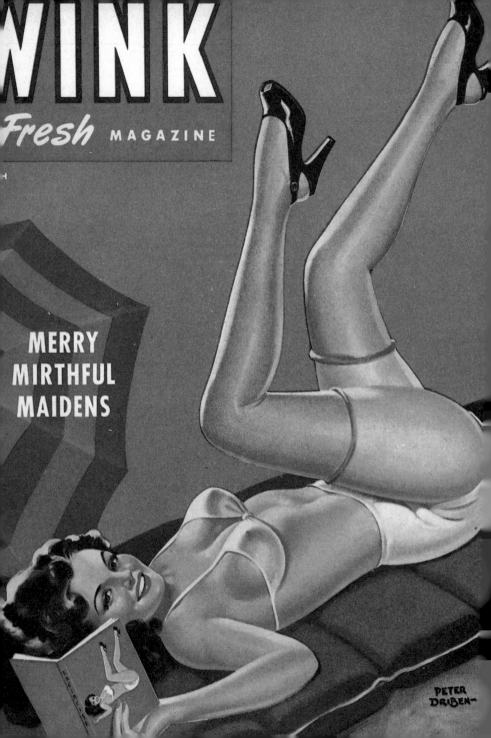

JAILED
Venus

This streamlined image of enslaved loveliness is June Raymond, golden-haired model, who a la Lamour, sinks to her shapely knees, lifts her graceful hands and pleads for mercy. June's enactment of an imprisoned siren, begging for release is so enchantingly dramatic as to stamp this 19-year-old lovely as a likely candidate for stage and screen conquests.

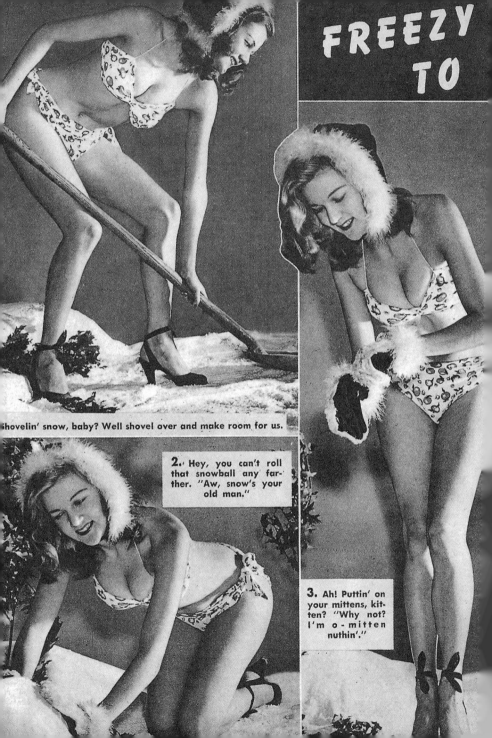

FREEZY
TO

shovelin' snow, baby? Well shovel over and make room for us.

2. Hey, you can't roll that snowball any farther. "Aw, snow's your old man."

3. Ah! Puttin' on your mittens, kitten? "Why not? I'm o - mitten nuthin'."

LOOK AT

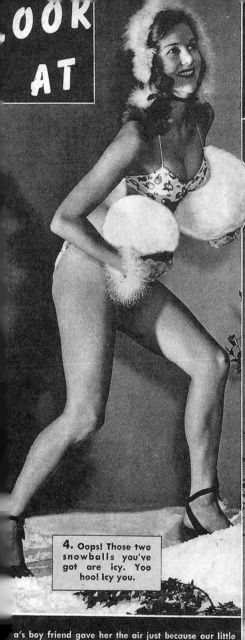

4. Oops! Those two snowballs you've got are icy. Yoo hoo! Icy you.

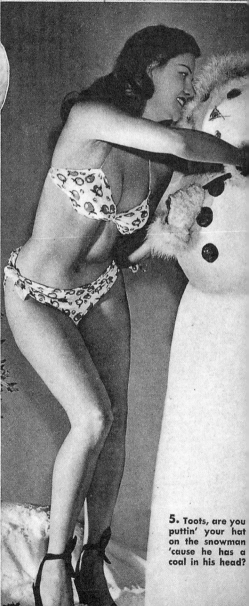

5. Toots, are you puttin' your hat on the snowman 'cause he has a coal in his head?

...a's boy friend gave her the air just because our little ...ander wouldn't sit on his knees. And Helga's so lone- ...for him that the chick decided to build a snowman to ...his place. Gee, Helga worked like an Eskimo dog in the ...; and so great was her puppy love that to keep her ...moving, the babe kept calling, "Mush! Mush! Mush!" ...st, Helga built up such a big pile of snow it was easy ...t the drift of what our honey was doing. Hey, Helga, ...now looks like an airplane. "Oh, yeah? Well, I have ...e it (get it, fellers). Gosh, boys, the way Helga carried

SHE PUT HER PILE IN A SNOW BANK

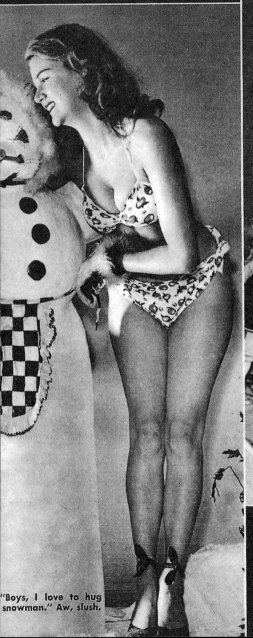

"Boys, I love to hug snowman." Aw, slush.

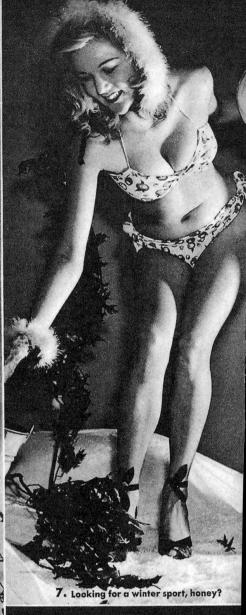

7. Looking for a winter sport, honey?

Well, Helga finally got her snowman built up and eve[r]
her hat and an apron on him—yes, and a pipe in his m[outh.]
Why the apron, honey? "Well, fellers, I figured if I cu[ddled]
up to him, his heart would melt, and—gee, I wouldn't [want]
him to soil his nice new snowsuit." Gosh, honey, if [your]
snowman's heart melts, it'll be the icest thing you ever [saw.]
Did he smoke the pipe? "Only for a minute. Y'see he w[anted]
to trade a can of tobacco for a nice toboggan, but h[e had]
no tobacco toboggan with." Stop it, sister, you're sle[ighing]
us; and when Helga goes sleighin' there's snowma[n ...]

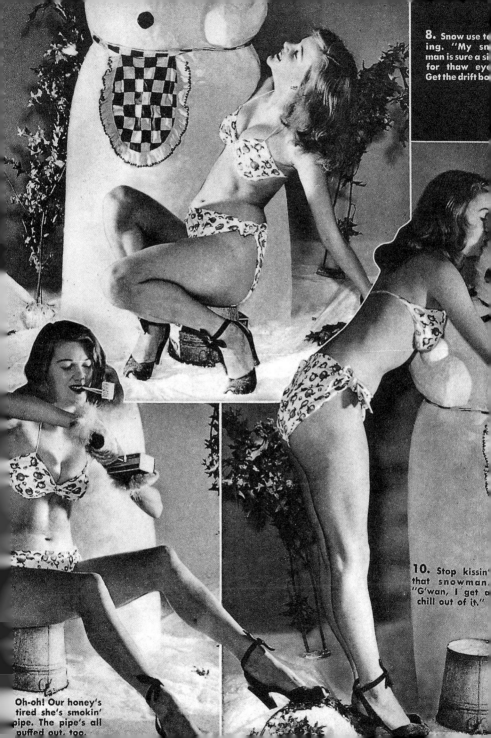

8. Snow use te
ing. "My sn
man is sure a si
for thaw eye
Get the drift bo

10. Stop kissin'
that snowman.
"G'wan, I get a
chill out of it."

Oh-oh! Our honey's
tired she's smokin'
pipe. The pipe's all
puffed out, too.

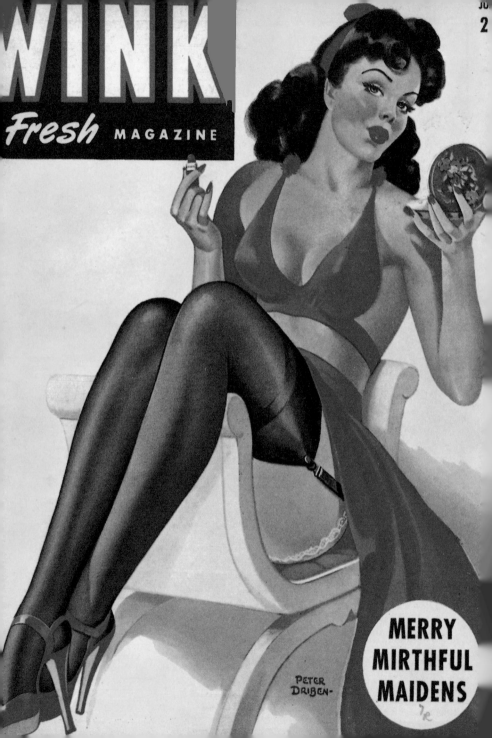

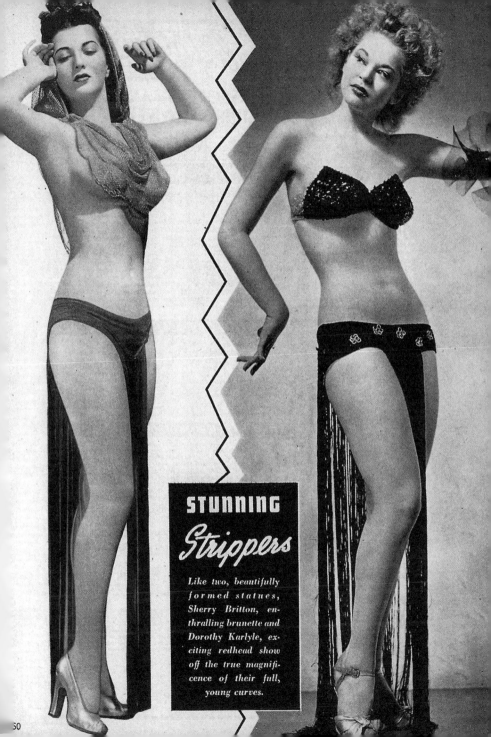

STUNNING
Strippers

Like two, beautifully formed statues, Sherry Britton, enthralling brunette and Dorothy Karlyle, exciting redhead show off the true magnificence of their full, young curves.

LEOPARD LADY

Hey, fellers, remember the last time you went to the circus and you thought you were drinkin' Ballantine's 'cause you saw three rings all the time? Well, do you remember Bedelia, the death-defyin' tamer of leopards? Of course you do! Well, boys, Bedelia's back again with her ferocious leopard for a limited encagement. "But this time, fellers, I'm feedin' my leopard homogenized milk." Why milk, honey? "So he'll have Vitamin D and not Bite-a-man—see?" (If he were our leopard, we'd feed him Carbona to knock the spots out of 'im.) But just the same, Bedelia's the bravest gal who ever stepped behind the bars of a leopard's cage. And in front of bars—Oh, brother, can Bedelia tame wolves.

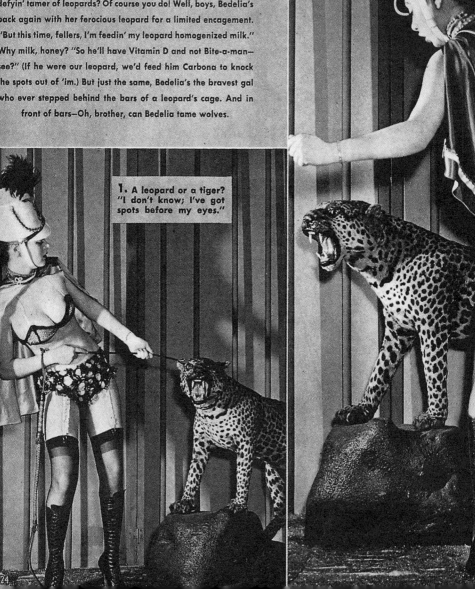

2. Put down that whip! A leopard's not a dog. "But I wanna whippet."

1. A leopard or a tiger? "I don't know; I've got spots before my eyes."

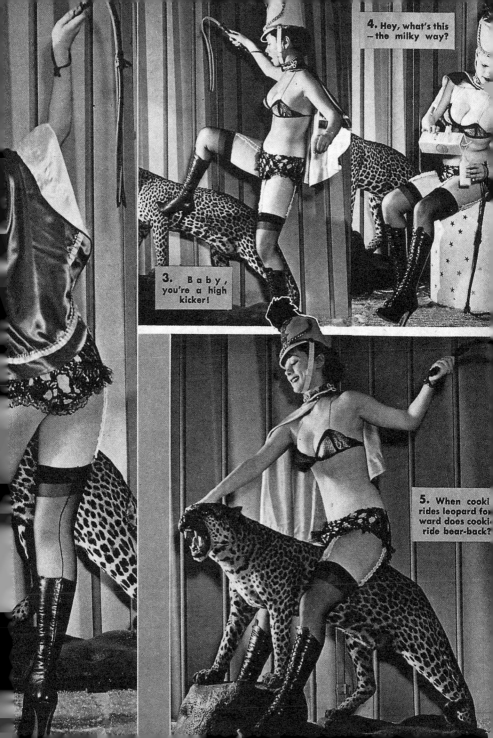

4. Hey, what's this — the milky way?

3. Baby, you're a high kicker!

5. When cooki rides leopard for ward does cooki ride bear-back?

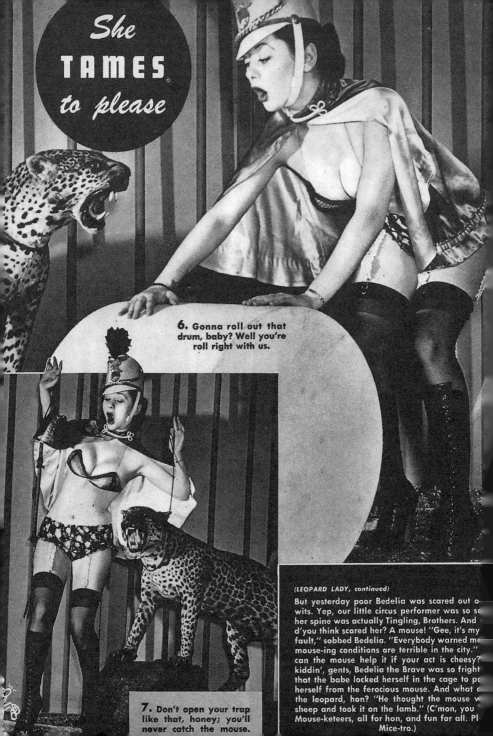

She
TAMES
to please

6. Gonna roll out that drum, baby? Well you're roll right with us.

7. Don't open your trap like that, honey; you'll never catch the mouse.

(LEOPARD LADY, continued)

But yesterday poor Bedelia was scared out o
wits. Yep, our little circus performer was so s
her spine was actually Tingling, Brothers. And
d'you think scared her? A mouse! "Gee, it's my
fault," sobbed Bedelia. "Everybody warned me
mouse-ing conditions are terrible in the city."
can the mouse help it if your act is cheesy?
kiddin', gents, Bedelia the Brave was so frigh
that the babe locked herself in the cage to pr
herself from the ferocious mouse. And what d
the leopard, hon? "He thought the mouse w
sheep and took it on the lamb." (C'mon, you
Mouse-keteers, all for hon, and fun for all. Pl
Mice-tro.)

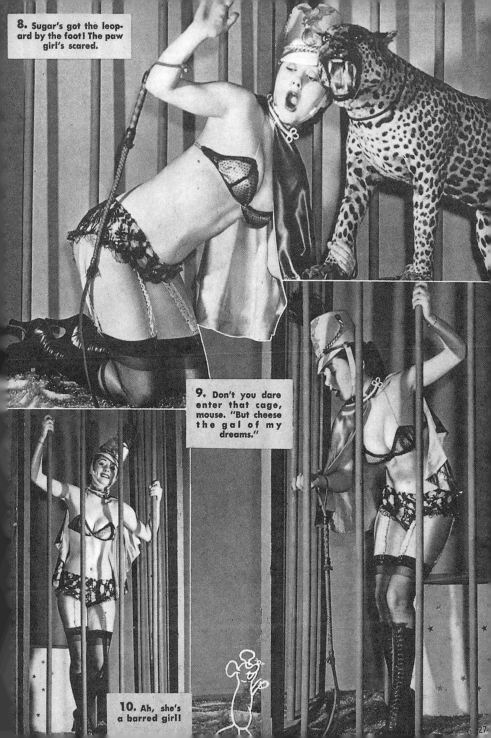

8. Sugar's got the leopard by the foot! The paw girl's scared.

9. Don't you dare enter that cage, mouse. "But cheese the gal of my dreams."

10. Ah, she's a barred girl!

27

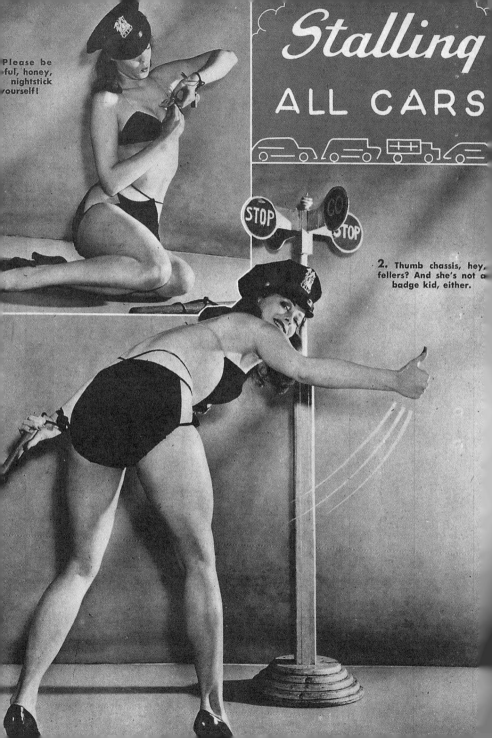

Stalling
ALL CARS

Please be ·ful, honey, nightstick ·ourself!

2. Thumb chassis, hey, fellers? And she's not a badge kid, either.

STOP GO STOP

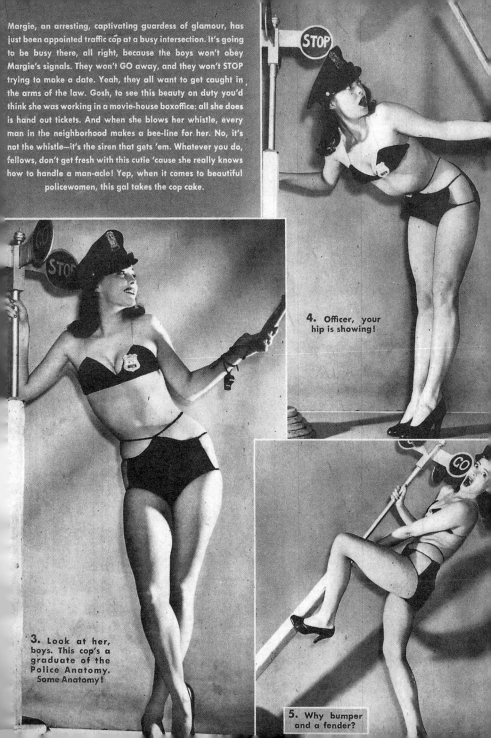

Margie, an arresting, captivating guardess of glamour, has just been appointed traffic cop at a busy intersection. It's going to be busy there, all right, because the boys won't obey Margie's signals. They won't GO away, and they won't STOP trying to make a date. Yeah, they all want to get caught in the arms of the law. Gosh, to see this beauty on duty you'd think she was working in a movie-house boxoffice: all she does is hand out tickets. And when she blows her whistle, every man in the neighborhood makes a bee-line for her. No, it's not the whistle—it's the siren that gets 'em. Whatever you do, fellows, don't get fresh with this cutie 'cause she really knows how to handle a man-acle! Yep, when it comes to beautiful policewomen, this gal takes the cop cake.

4. Officer, your hip is showing!

3. Look at her, boys. This cop's a graduate of the Police Anatomy. Some Anatomy!

5. Why bumper and a fender?

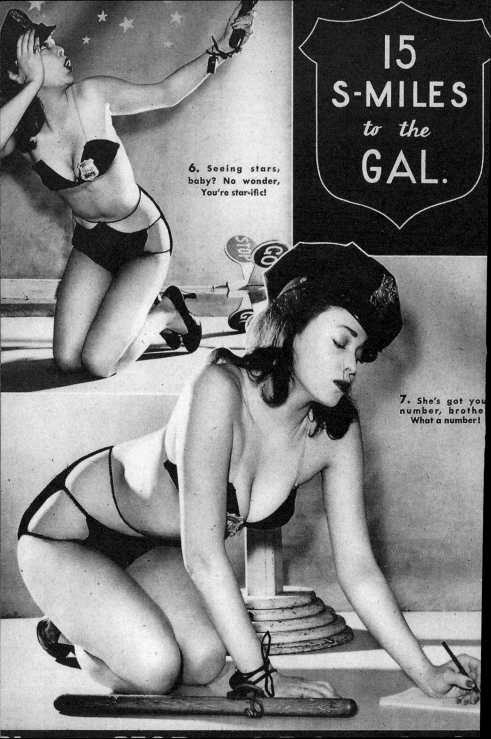

15 S-MILES to the GAL.

6. Seeing stars, baby? No wonder, You're star-ific!

7. She's got you number, brothe What a number!

Margie's been standing so long between northbound and southbound traffic that she's almost muscle-bound. But the drivers--they're spellbound! As a matter of fact, if anybody passes Margie without looking at her shield, the cop on the next corner gives him a ticket for passing a keen sight. Yes, boys, here's copper that's pure gold. Even in plainclothes her luscious figure is detectable— and that's no bull. Margie got her training on the homicide squad, and you can see she really knows how to wear clues! For awhile our honey was a quarter cop (That's right, Oscar, she had two-beats!), but recently toots was promoted for capturing the most dangerous criminal in town. Ah, yes, our baby's really tops in throbbers!

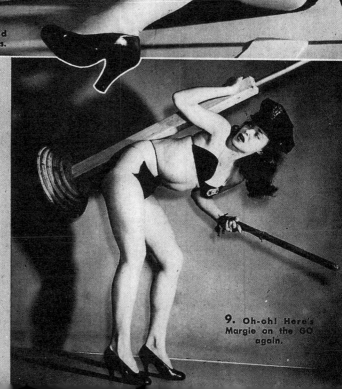

8. Having a ripping good time? That's the ticket, toots.

She Whistles While She Works

9. Oh-oh! Here's Margie on the GO again.

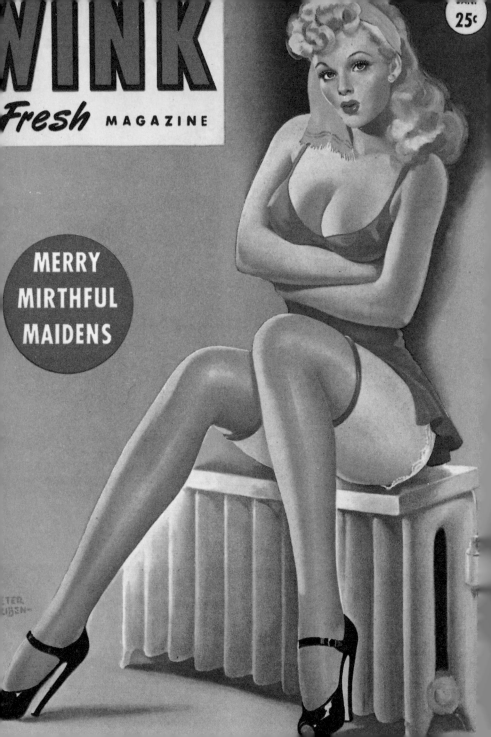

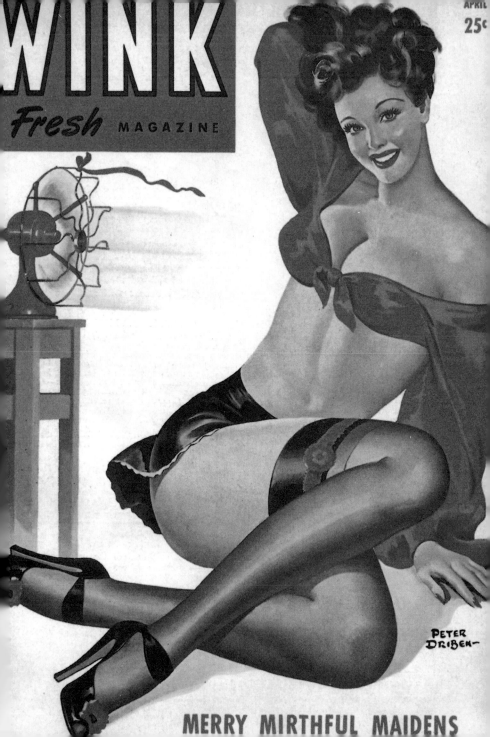

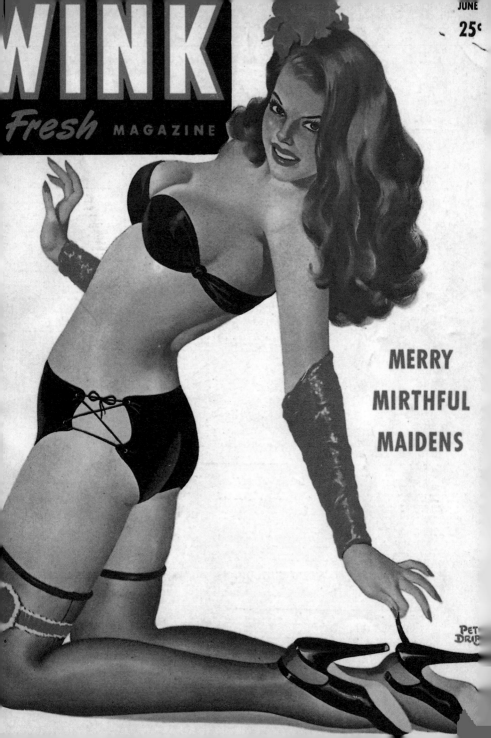

WINK

Fresh MAGAZINE

AUG
25¢

MERRY MIRTHFUL MAIDENS

SWEET

A PADLOCK SNAPS IN PLACE. GWEN'S DOOM IS SEALED! - AH! BUT WHO IS THIS MYSTERIOUS FIGURE WATCHING SIR d'ARCY'S EVERY MOVE!

I THINK I'LL INVESTIGATE WHEN THEY'VE GONE

THE MYSTERY WOMAN TAKES SOMETHING FROM HER HEEL-A THIN WIRE!

TEN MINUTES LATER SHE PICKS THE LOCK AND ENTERS THE HUT! - TO REAPPEAR LATER FROM THE BACK! SHE RELOCKS THE DOOR AND DISAPPEARS BEHIND THE HUT ONCE MORE! WHAT IS SHE DOING? HAS SHE FOUND GWEN IS SHE TOO IN THE PLOT?

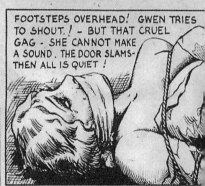

FOOTSTEPS OVERHEAD! GWEN TRIES TO SHOUT. ! - BUT THAT CRUEL GAG - SHE CANNOT MAKE A SOUND. THE DOOR SLAMS - THEN ALL IS QUIET!

ALL HOPE IS LOST - GWEN'S STRUGGLES ARE IN VAIN- THE CORDS ONLY BECOME TIGHTER - EXHAUSTED SHE RESIGNS HERSELF TO HER FATE. THE DASTARDLY D'ARCY HAS DONE HIS WORK WELL! - BUT WHAT IS THAT SOUND UPSTAIRS?

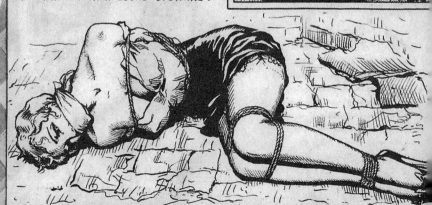

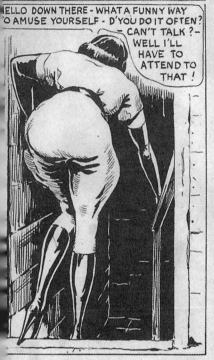

HELLO DOWN THERE - WHAT A FUNNY WAY TO AMUSE YOURSELF - D'YOU DO IT OFTEN? - CAN'T TALK? - WELL I'LL HAVE TO ATTEND TO THAT!

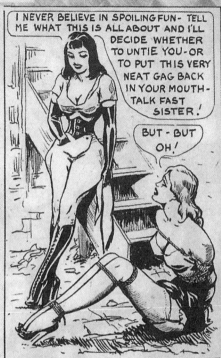

I NEVER BELIEVE IN SPOILING FUN - TELL ME WHAT THIS IS ALL ABOUT AND I'LL DECIDE WHETHER TO UNTIE YOU - OR TO PUT THIS VERY NEAT GAG BACK IN YOUR MOUTH - TALK FAST SISTER!

BUT - BUT OH!

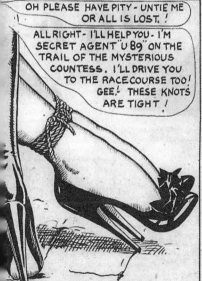

SO GWENDOLINE EXPLAINS -

OH PLEASE HAVE PITY - UNTIE ME OR ALL IS LOST!

ALL RIGHT - I'LL HELP YOU - I'M SECRET AGENT "U 89" ON THE TRAIL OF THE MYSTERIOUS COUNTESS. I'LL DRIVE YOU TO THE RACECOURSE TOO! GEE! THESE KNOTS ARE TIGHT!

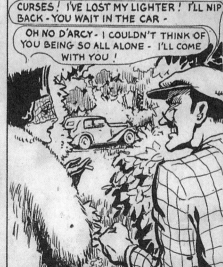

WILL THE GIRLS ESCAPE IN TIME? SEE THE NEXT EPISODE.

CURSES! I'VE LOST MY LIGHTER! I'LL NIP BACK - YOU WAIT IN THE CAR -

OH NO D'ARCY - I COULDN'T THINK OF YOU BEING SO ALL ALONE - I'LL COME WITH YOU!

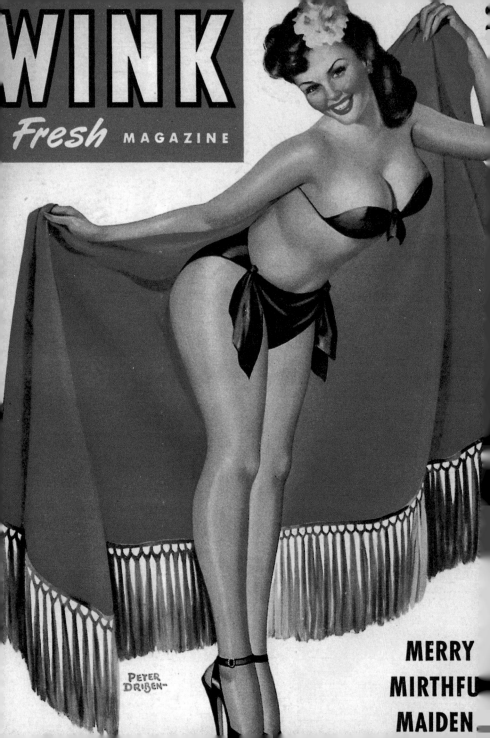

WINK
Fresh MAGAZINE

PETER
DRIBEN

**MERRY
MIRTHFU
MAIDEN**

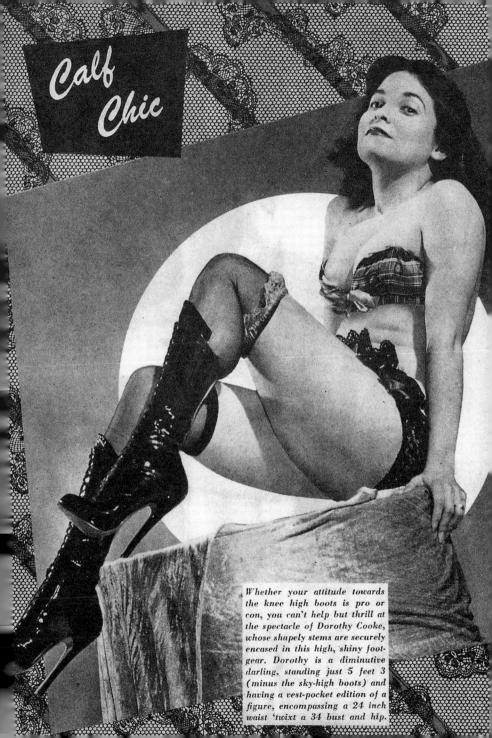

Calf Chic

Whether your attitude towards the knee high boots is pro or con, you can't help but thrill at the spectacle of Dorothy Cooke, whose shapely stems are securely encased in this high, shiny footgear. Dorothy is a diminutive darling, standing just 5 feet 3 (minus the sky-high boots) and having a vest-pocket edition of a figure, encompassing a 24 inch waist 'twixt a 34 bust and hip.

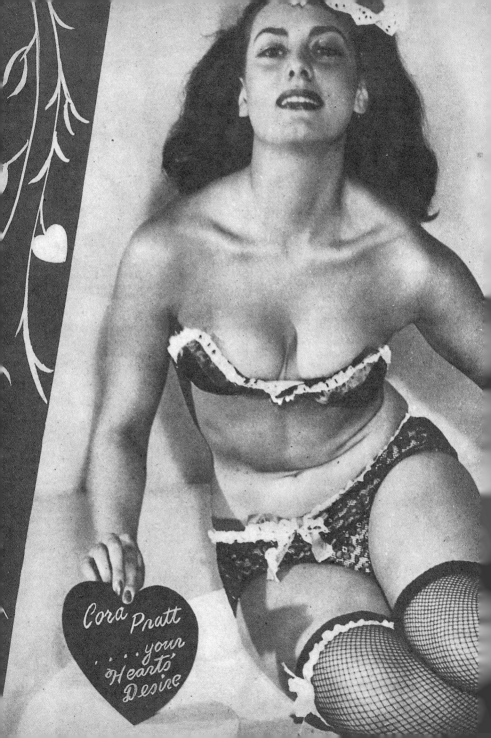

Cora Pratt
...your
Heart's
Desire

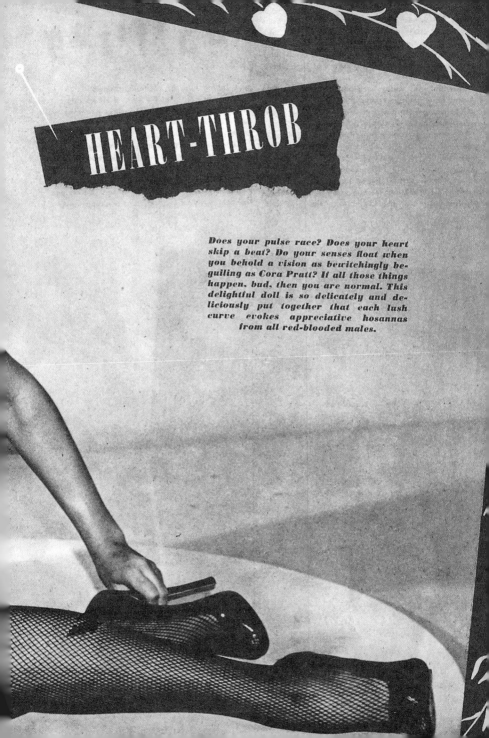

HEART-THROB

Does your pulse race? Does your heart skip a beat? Do your senses float when you behold a vision as bewitchingly beguiling as Cora Pratt? If all those things happen, bud, then you are normal. This delightful doll is so delicately and deliciously put together that each lush curve evokes appreciative hosannas from all red-blooded males.

WINK
Fresh MAGAZINE

DEC.

25¢

HIGH-HEELED HONEYS

FIGHTIN' FEMMES

CURVEY CORSET CUTIES

LONG-HAIRED LOVELIES

PIN-UP PRETTIES

PETER
DRIBEN

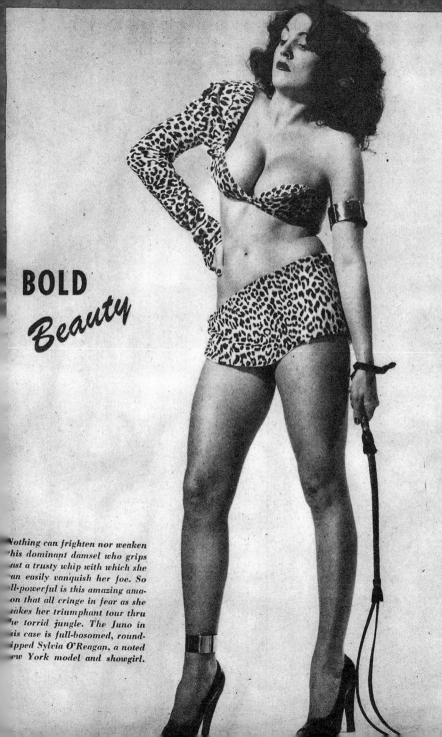

BOLD
Beauty

Nothing can frighten nor weaken
this dominant damsel who grips
fast a trusty whip with which she
can easily vanquish her foe. So
all-powerful is this amazing ama-
zon that all cringe in fear as she
makes her triumphant tour thru
the torrid jungle. The Juno in
this case is full-bosomed, round-
hipped Sylvia O'Reagan, a noted
New York model and showgirl.

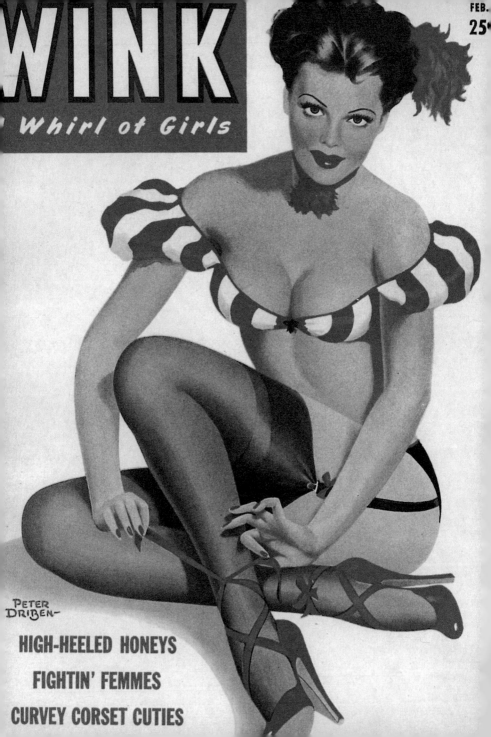

WINK

APRIL
25c

HIGH-HEELED HONEYS
FIGHTIN' FEMMES
CURVEY CORSET CUTIES
LONG-HAIRED LOVELIES

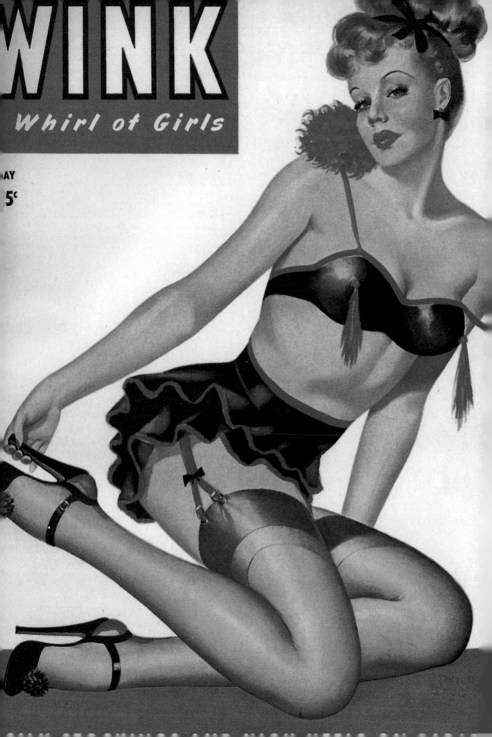

WINK

Whirl of Girls

MAY

5c

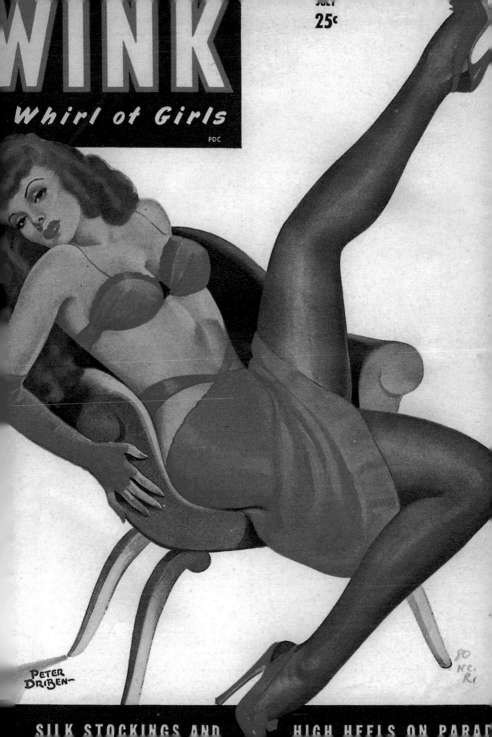

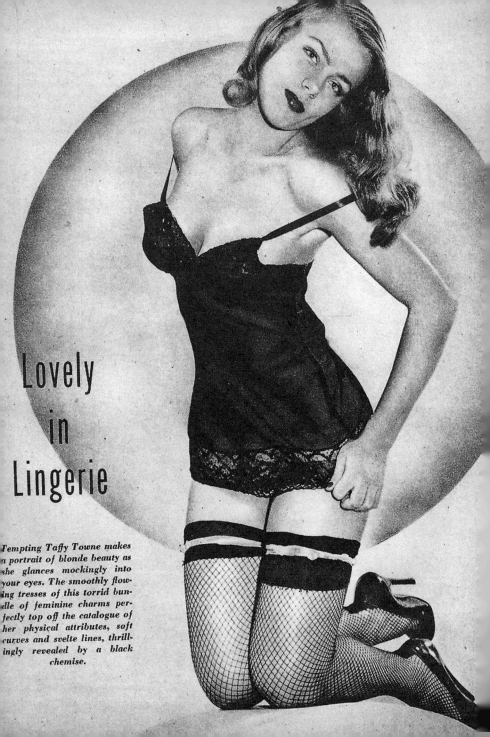

Lovely
in
Lingerie

Tempting Taffy Towne makes a portrait of blonde beauty as she glances mockingly into your eyes. The smoothly flowing tresses of this torrid bundle of feminine charms perfectly top off the catalogue of her physical attributes, soft curves and svelte lines, thrillingly revealed by a black chemise.

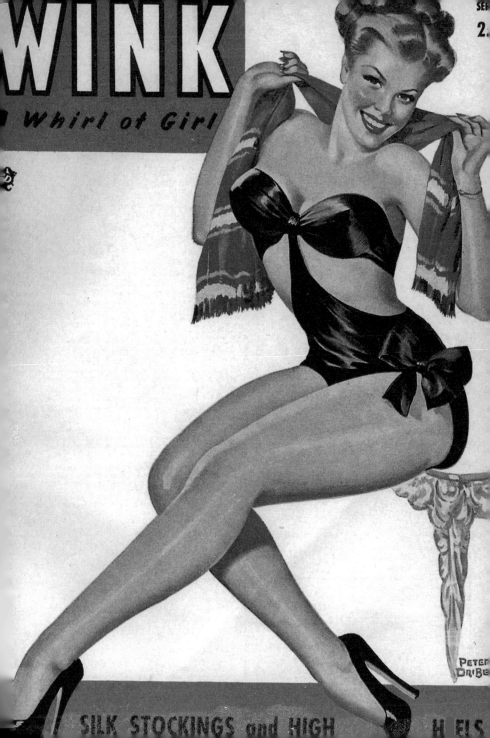

WINK
Whirl of Girl

SEP
2.

PETER
DRIBE

SILK STOCKINGS and HIGH H ELS

UL FRED

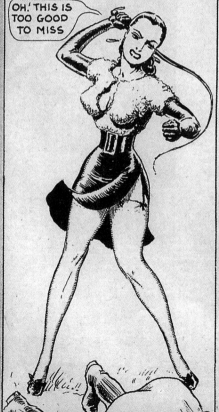

OP

GWENDOLINE

EIGHTH EPISODE

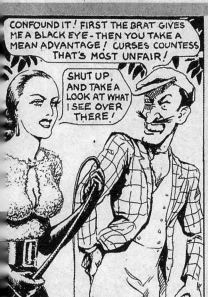

CONFOUND IT! FIRST THE BRAT GIVES ME A BLACK EYE - THEN YOU TAKE A MEAN ADVANTAGE! CURSES COUNTESS THAT'S MOST UNFAIR!

SHUT UP, AND TAKE A LOOK AT WHAT I SEE OVER THERE!

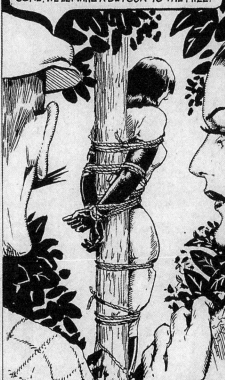

GAD! YOU'RE RIGHT - IT'S ONE OF THEM! BUT WE MUSTN'T LET HER SEE US YET. COME! WE'LL MAKE A DETOUR TO THE MILL!

SIR D'ARCY

IT'S VERY QUIET IN HERE D'ARCY - AND CAN SEE NOTHING BUT A JUMBLE OF ROPES ON THE FLOOR! SWEETHEART T LOOKS AS IF YOUR PIGEON HAS FLOWN!

BUT I TELL YOU SHE MUST BE HERE! THEY LEFT HER HERE!

YEAH? - WELL SHE LEFT THIS - TAPE WITH LIPSTICK ON IT!! USE YOUR BRAINS - SHERLOCK!

THE COU

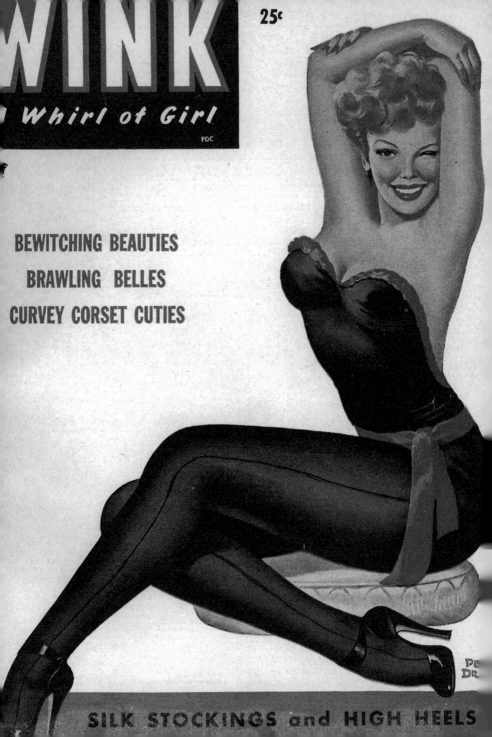

WINK

A Whirl of Girls

PDC

25c

SILK STOCKINGS
and
HIGH HEELS

PETER DRIBEN—

Footlight Favorites

Glorious gams in any man's language. It shouldn't be too hard to match these to the chic brunette on the opposite page.

These shapely legs belong to a dazzling blonde whose dancing has thrilled many a cheering nightclub and burlesque crowd.

These entrancing limbs in black mesh hose belong to a talented dancer with an exotic name. Does that supply a clue?

No more gorgeous legs ever twinkled across the footlights than these, property of a languid lovely on the opposite page.

Slender but cur are the graceful l of this fair charme In case you need clue, her last nam rhymes with "Sailor."

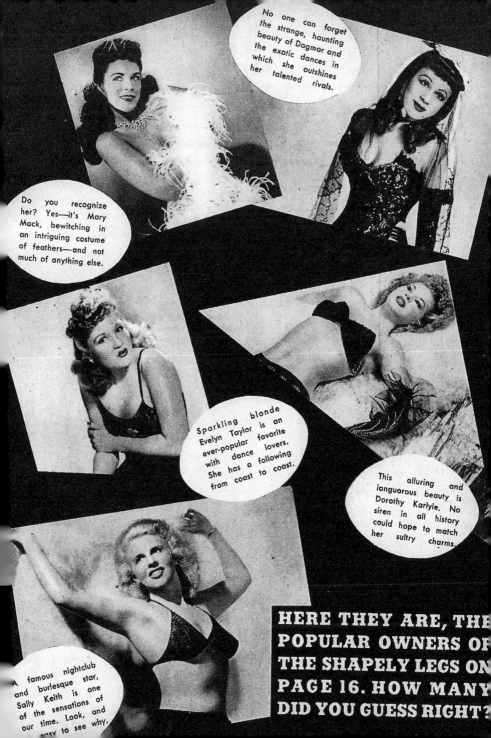

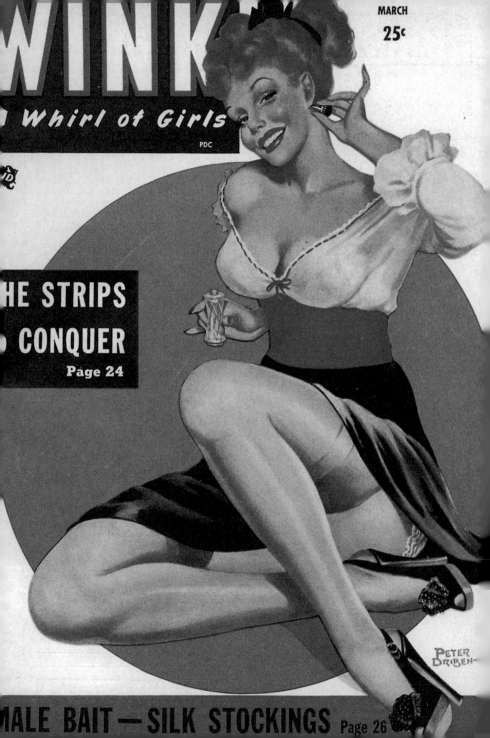

Yep, gents, this parcel posed is wrapped perfect for the males!

Ah, just an old American costume! Ain't it cute, gents?

Lovely June Raymond's Form Took Broadway By Storm! Wow!

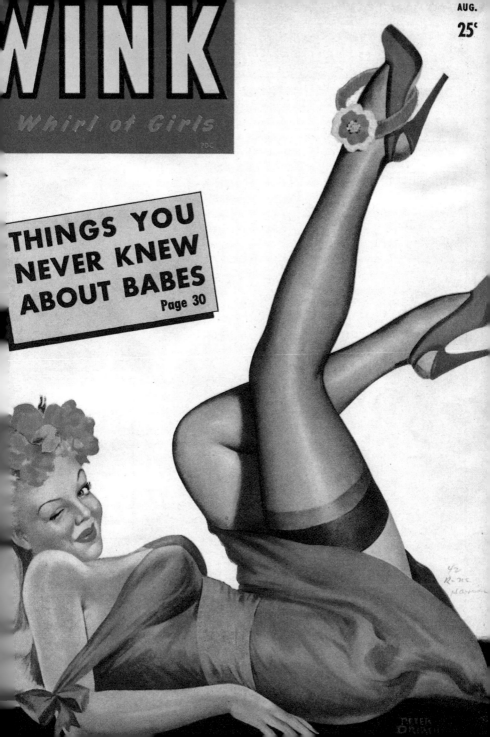

POP FAITHFUL FRED SWEE

UNABLE TO RESIST, GWEN SUBMITS QUIETLY AS ZAZA CARRIES OUT SIR D'ARCY'S ORDERS...

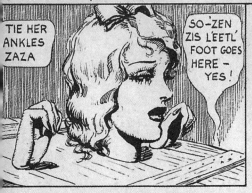

TIE HER ANKLES ZAZA

SO-ZEN ZIS L'EETL' FOOT GOES HERE — YES!

AN'ZIS OTHER FOOT OVER HERE SO! - YES?

BUT NOW HER ARMS ARE FREE !- THE BRAVE GIRL STRUGGLES GAMELY-ALAS 'TIS ALL IN VAIN!

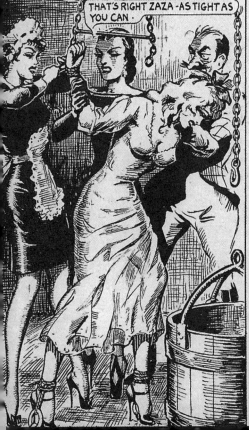

THAT'S RIGHT ZAZA -AS TIGHT AS YOU CAN·

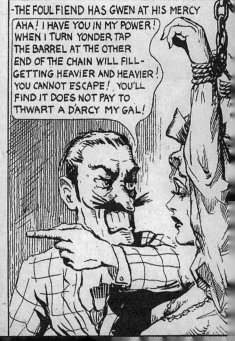

-THE FOUL FIEND HAS GWEN AT HIS MERCY

AHA! I HAVE YOU IN MY POWER! WHEN I TURN YONDER TAP THE BARREL AT THE OTHER END OF THE CHAIN WILL FILL- GETTING HEAVIER AND HEAVIER! YOU CANNOT ESCAPE! YOU'LL FIND IT DOES NOT PAY TO THWART A D'ARCY MY GAL!

GWENDOLINE
Episode Thirteen

 SIR D'ARCY D'ARCY THE COUNTESS

EEDLESS OF THE HOPELESS ODDS OUR HEROINE REFUSES LIGHTLY TO ADMIT DEFEAT—IS ALL LOST ?

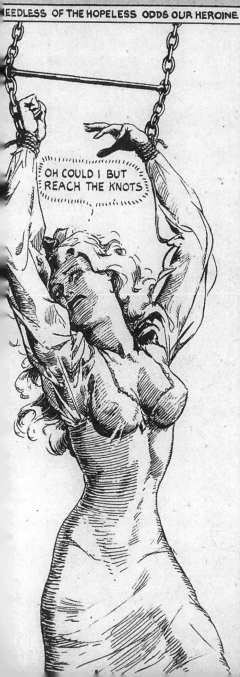

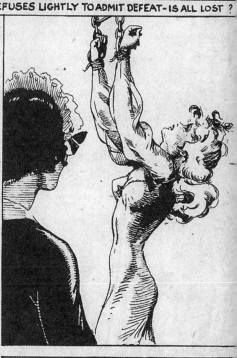

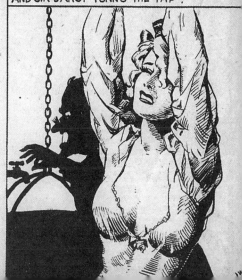

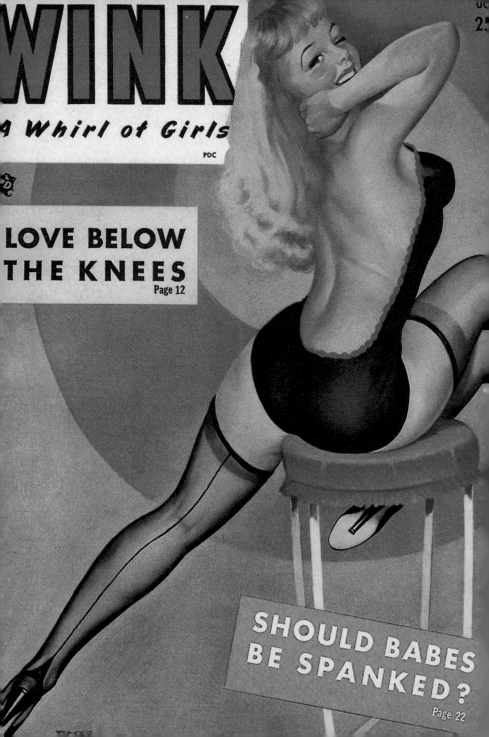

WINK

A Whirl of Girls

PDC

LOVE BELOW
THE KNEES
Page 12

SHOULD BABES
BE SPANKED?
Page 22

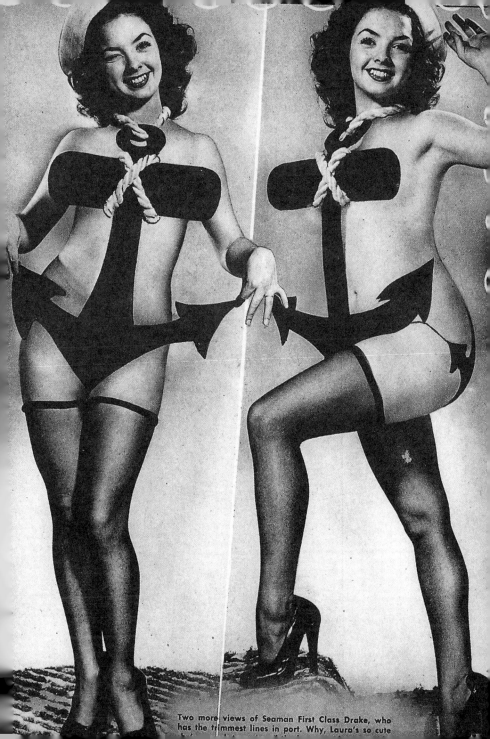

Two more views of Seaman First Class Drake, who
has the trimmest lines in port. Why, Laura's so cute

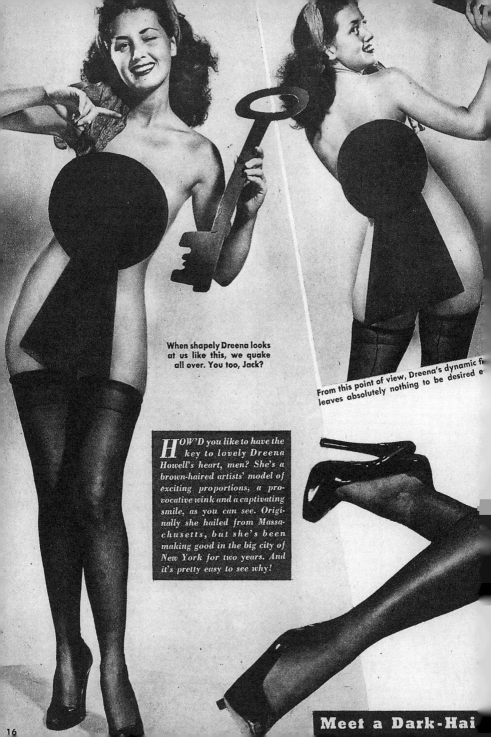

When shapely Dreena looks at us like this, we quake all over. You too, Jack?

From this point of view, Dreena's dynamic fi... leaves absolutely nothing to be desired e...

*H*OW'D you like to have the key to lovely Dreena Howell's heart, men? She's a brown-haired artists' model of exciting proportions, a provocative wink and a captivating smile, as you can see. Originally she hailed from Massachusetts, but she's been making good in the big city of New York for two years. And it's pretty easy to see why!

Meet a Dark-Hai

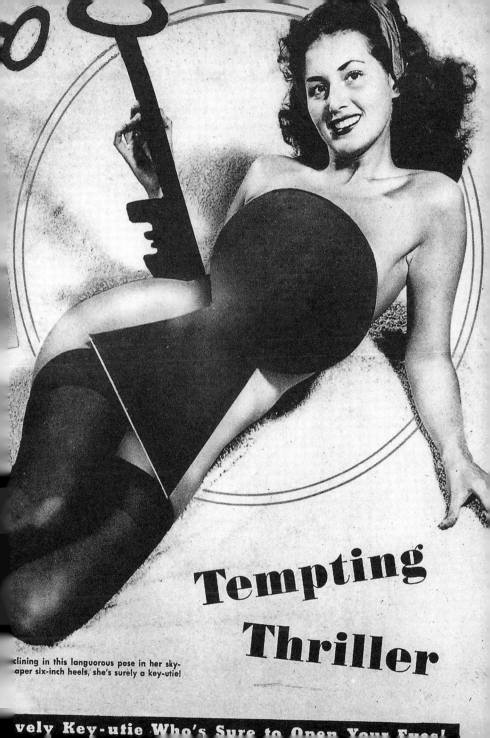

Tempting
Thriller

clining in this languorous pose in her sky-
aper six-inch heels, she's surely a key-utie!

vely Key-utie Who's Sure to Open Your Eyes!

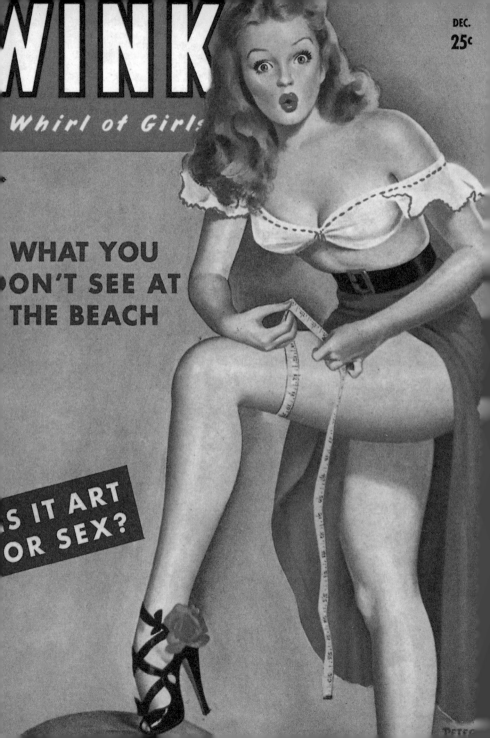

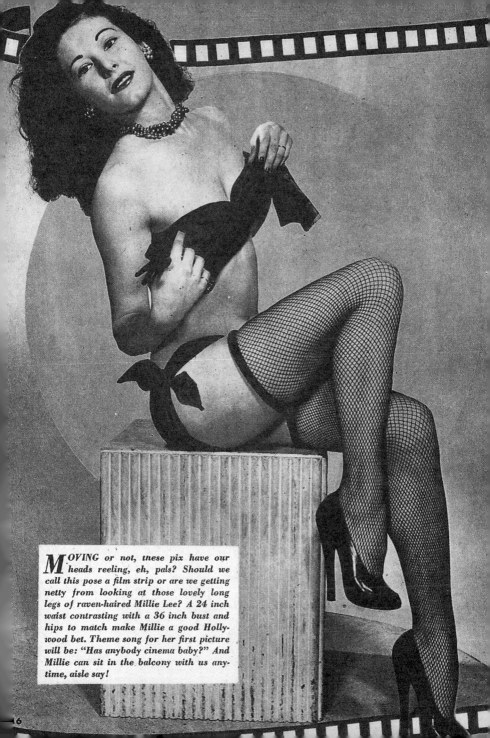

MOVING or not, these pix have our heads reeling, eh, pals? Should we call this pose a film strip or are we getting netty from looking at those lovely long legs of raven-haired Millie Lee? A 24 inch waist contrasting with a 36 inch bust and hips to match make Millie a good Hollywood bet. Theme song for her first picture will be: "Has anybody cinema baby?" And Millie can sit in the balcony with us anytime, aisle say!

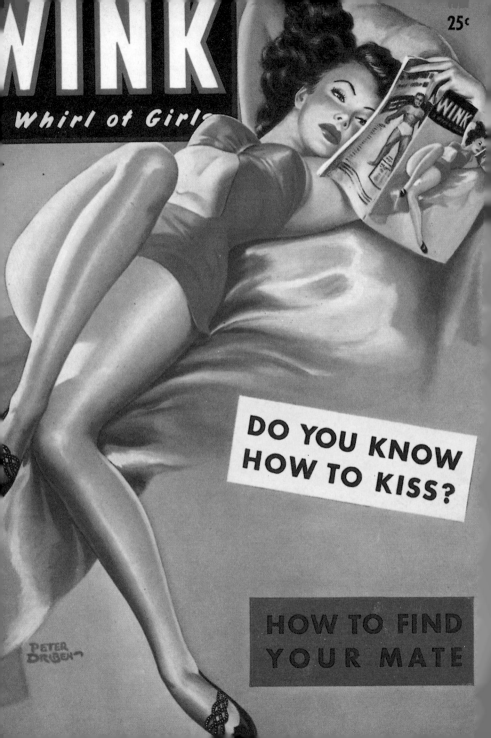

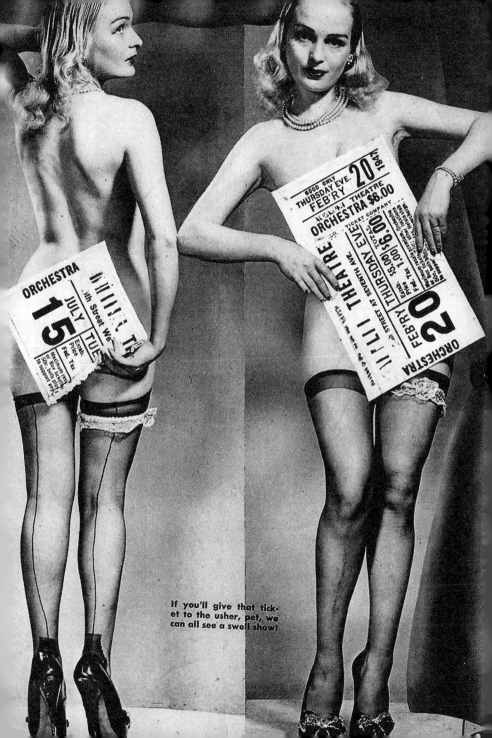

If you'll give that tick-
et to the usher, pet, we
can all see a swell show!

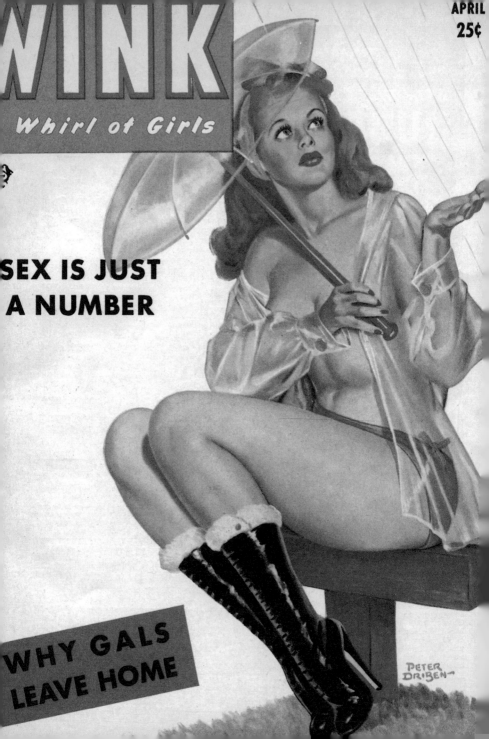

Sunnie Thomsen

WINK

A *Fresh* MAGAZIN

Trademark Reg. U. S. Pat. Office

VOLUME 5 APRIL 1950 NUMBER

★

Harry Roberts, Editor Art Direction by

Contents

★

Wink is published bi-monthly by Wink, Inc., 201 W
52nd Street, New York, N. Y. Copyright 1949 by Wi
Inc. Entered as second-class matter August 26, 1948,
the post office at New York, N. Y., under the act
March 3, 1879. Single copy 25c — Yearly subscription
$1.50 — Foreign subscription $2.50. All rights reser
by Wink, Inc. All material submitted will be given car
attention, but such material must be accompanied by s
cient postage for return and is submitted at the auth
risk. Printed in U. S. A.

Be Your Own Casting Director

How Would You Score These Gals for Emotional Range and Realism?

EMOTION! Expression! lights, action, camera! Quiet — this is a take! You're directing a film for Fiasco Pictures to be called "Three Cheers for Chicks!" and you've got all roles filled but that of the ingenue part, which you must pick from these pages. She will play Priscilla Prufrock, hounded and persecuted by the cad, Cadwallader Wasservogel, retired poopdeck manufacturer. She's living in an abandoned air shaft in Harlem and Cadwallader, who owns the shaft, has her evicted, hoping to lure the homeless waif into a lush Park Avenue penthouse that's all her'n—if she will only be his'n. But Priscilla prefers death to dishonor, the dope, and throws herself in front of a taxi driven by poor but honest Herman Hardheel. Well, write the rest your-self. It's all your'n. Music up and under!

Anger

Sorrow

Joy

Fear

TOTAL

TOTAL

KERRY KEITH

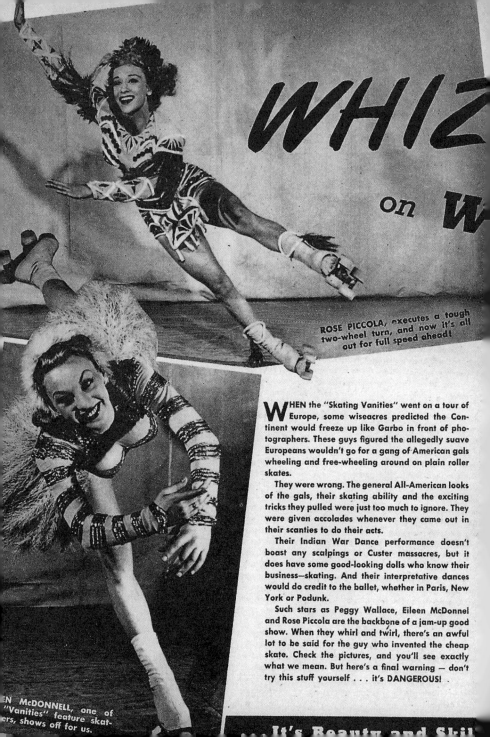

WHIZ
on W

ROSE PICCOLA, executes a tough two-wheel turn, and now it's all out for full speed ahead!

EN McDONNELL, one of "Vanities" feature skat-ers, shows off for us.

WHEN the "Skating Vanities" went on a tour of Europe, some wiseacres predicted the Continent would freeze up like Garbo in front of photographers. These guys figured the allegedly suave Europeans wouldn't go for a gang of American gals wheeling and free-wheeling around on plain roller skates.

They were wrong. The general All-American looks of the gals, their skating ability and the exciting tricks they pulled were just too much to ignore. They were given accolades whenever they came out in their scanties to do their acts.

Their Indian War Dance performance doesn't boast any scalpings or Custer massacres, but it does have some good-looking dolls who know their business—skating. And their interpretative dances would do credit to the ballet, whether in Paris, New York or Podunk.

Such stars as Peggy Wallace, Eileen McDonnel and Rose Piccola are the backbone of a jam-up good show. When they whirl and twirl, there's an awful lot to be said for the guy who invented the cheap skate. Check the pictures, and you'll see exactly what we mean. But here's a final warning — don't try this stuff yourself . . . it's DANGEROUS!

It's Beauty and Ski

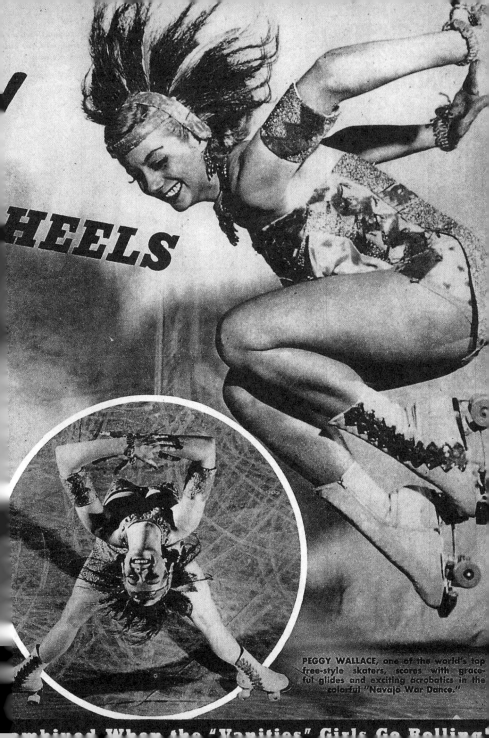

HEELS

PEGGY WALLACE, one of the world's top free-style skaters, scores with graceful glides and exciting acrobatics in the colorful "Navajo War Dance."

ombined When the "Vanities" Girls Go Rolling

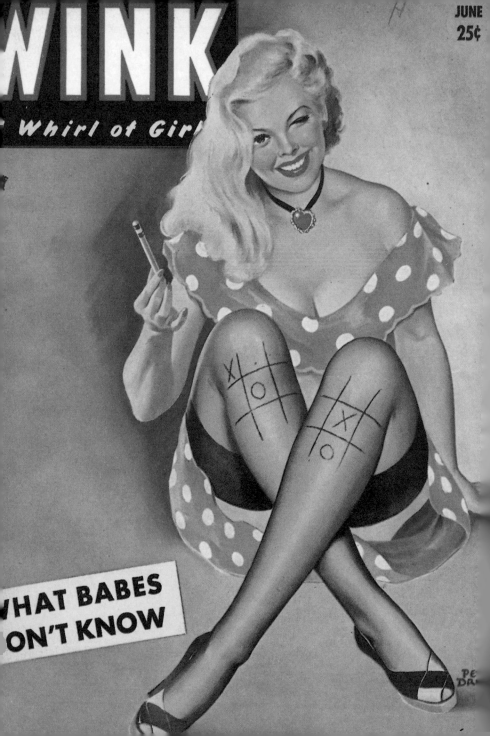

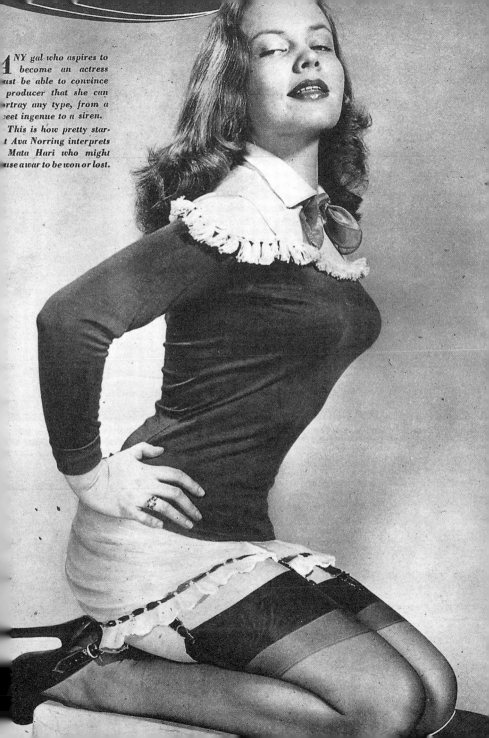

ANY gal who aspires to become an actress must be able to convince a producer that she can portray any type, from a sweet ingenue to a siren. This is how pretty starlet Ava Norring interprets Mata Hari who might cause a war to be won or lost.

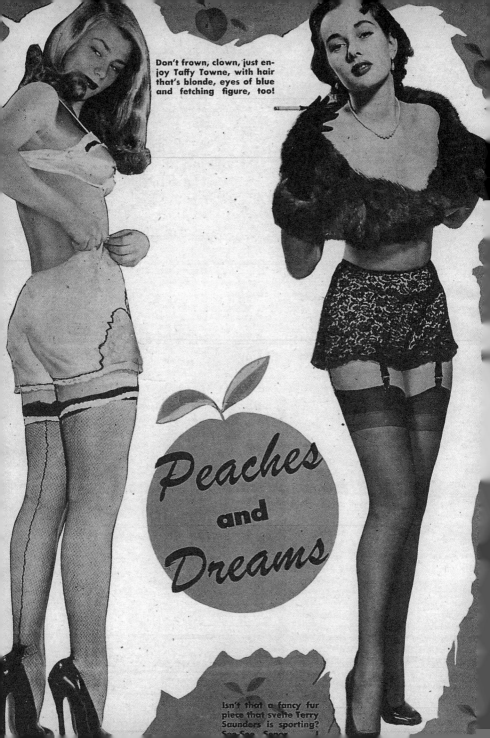

Don't frown, clown, just enjoy Taffy Towne, with hair that's blonde, eyes of blue and fetching figure, too!

Peaches
and
Dreams

Isn't that a fancy fur piece that svelte Terry Saunders is sporting?

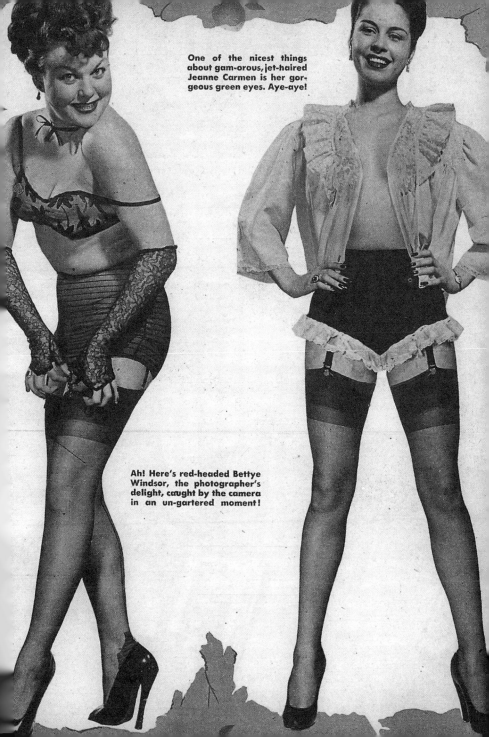

One of the nicest things about gam-orous, jet-haired Jeanne Carmen is her gorgeous green eyes. Aye-aye!

Ah! Here's red-headed Bettye Windsor, the photographer's delight, caught by the camera in an un-gartered moment!

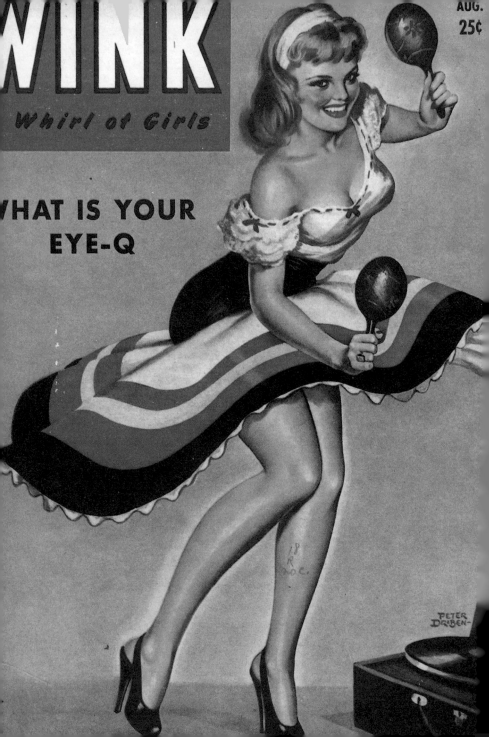

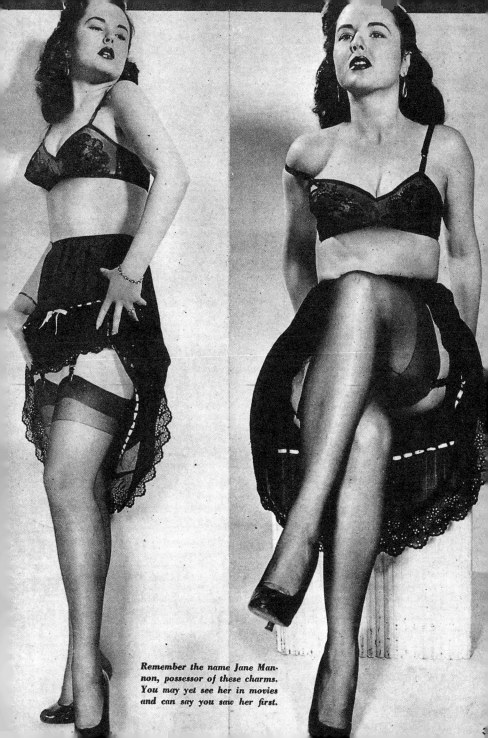

Remember the name Jane Mannon, possessor of these charms. You may yet see her in movies and can say you saw her first.

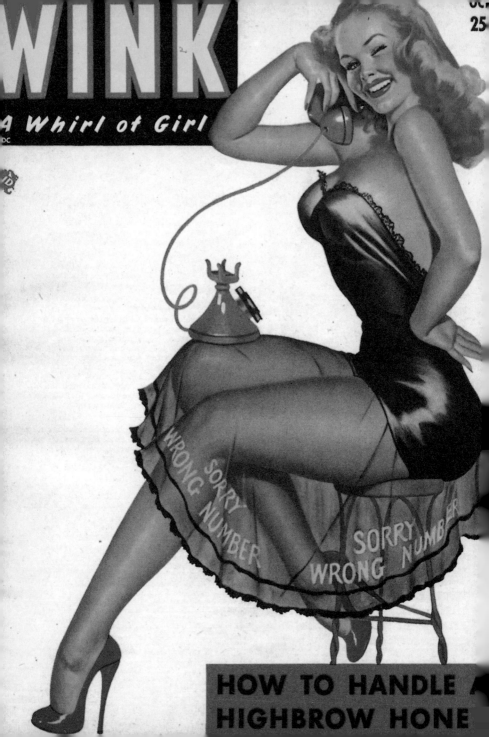

Naughty but *Nice*

THERE'S a little bit of spice in every good little gal and a little bit of sugar in every bad little gal — and that's what makes them so naughty but nice. The good little gal here is Nina Marbin, who can pose her 5′ 5″ with such poise! Please to note that Nina refused to go in for that crazy fad of the short, boyish bob. Congrats, Nina!

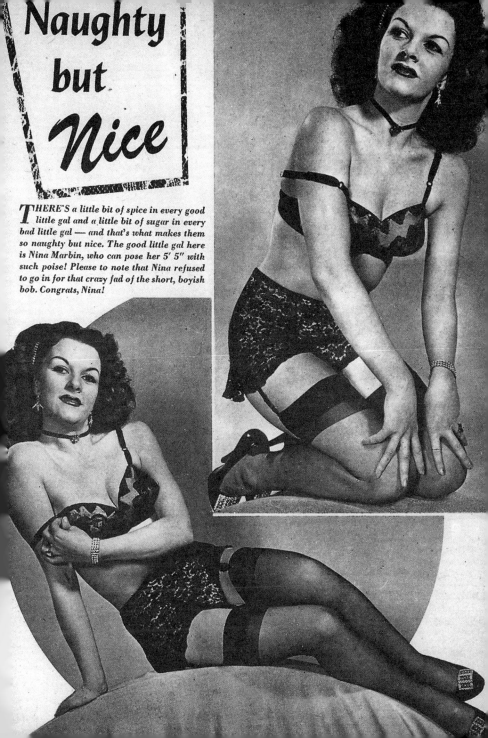

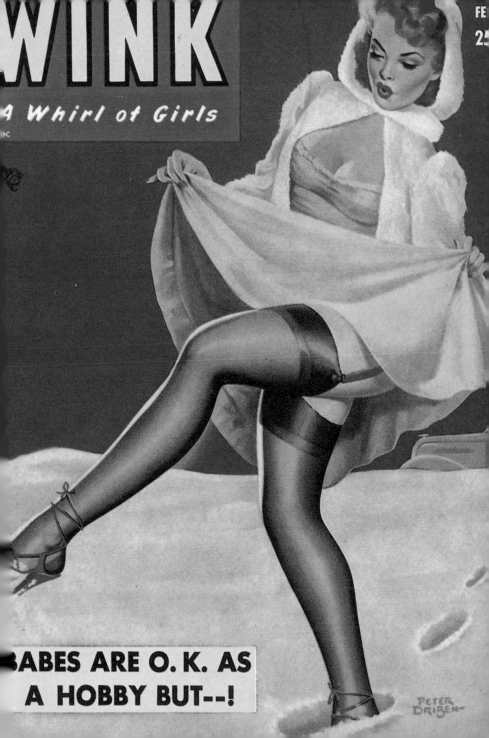

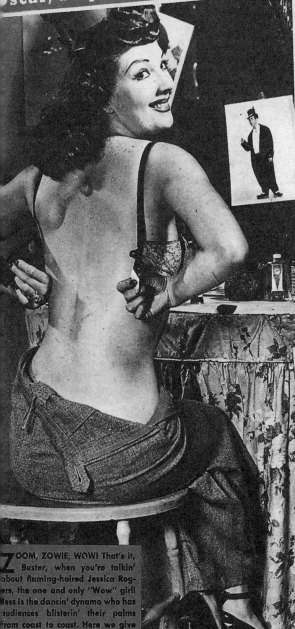

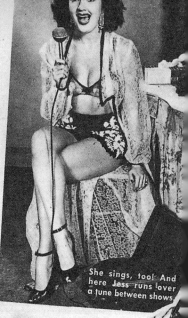

She sings, too! And here Jess runs over a tune between shows.

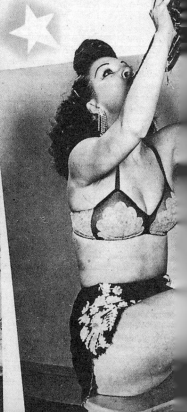

Z OOM, ZOWIE, WOW! That's it, Buster, when you're talkin' about flaming-haired Jessica Rogers, the one and only "Wow" girl! Jess is the dancin' dynamo who has audiences blisterin' their palms from coast to coast. Here we give you a peek behind the scenes as this titanic redhead kills a little time in her dressing room between shows. Wow!!!

Jessica always watches her weight 'cause she knows the boys all do!

"Wow Girl!"

Flash! Scoop! Jessica discloses that her secret ambition is to toot a trumpet like Harry James.

WINK

A Whirl of Girls

AP
2.

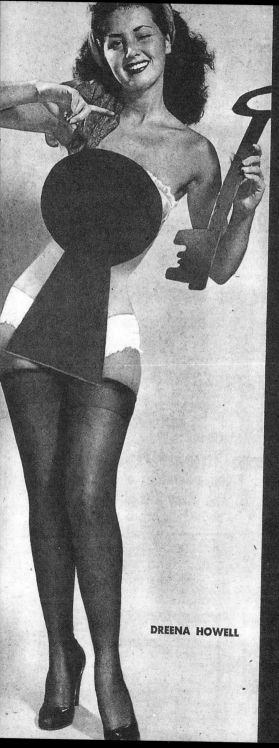

DREENA HOWELL

WINK

A *Fresh* MAGAZINE

Trade-Mark Reg. U. S. Pat. Off.

VOLUME 6 JUNE 1951 NUMBER 6

Harry Roberts, Editor Art Direction by Reale

Contents

★

Be-Bop Betty

GATHER round gates, an' grab a gander at this real gone gal leading her jivesters down the rocky road of a be-bop jam session. Now when those blue notes are rollin', this kid is so gone she knows from nothin' but notes, and the world could come to an end. Stay with us — here we go!

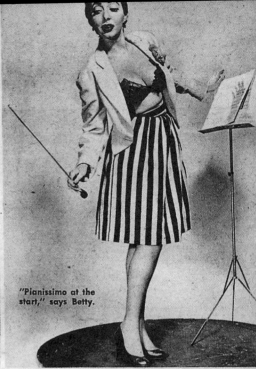

"Pianissimo at the start," says Betty.

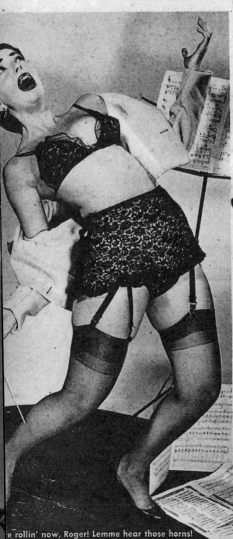

...e rollin' now, Roger! Lemme hear those horns!

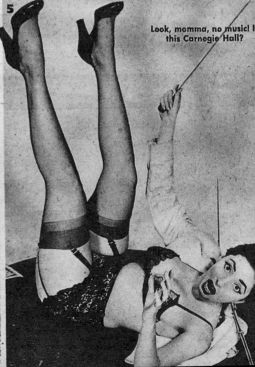

Look, momma, no music! I... this Carnegie Hall?

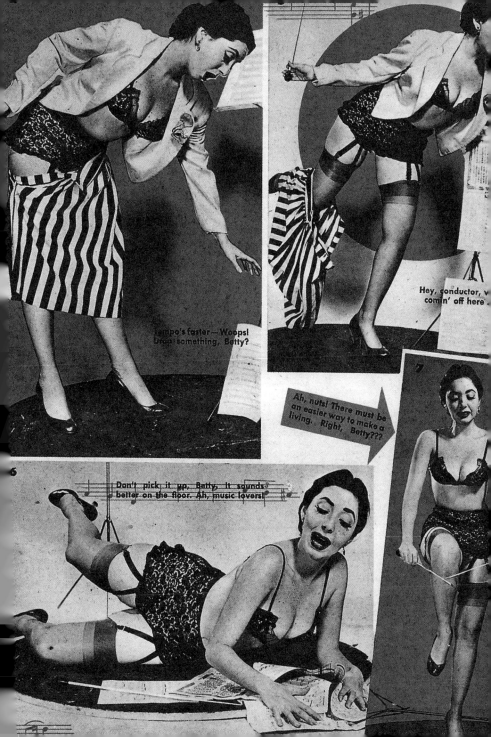

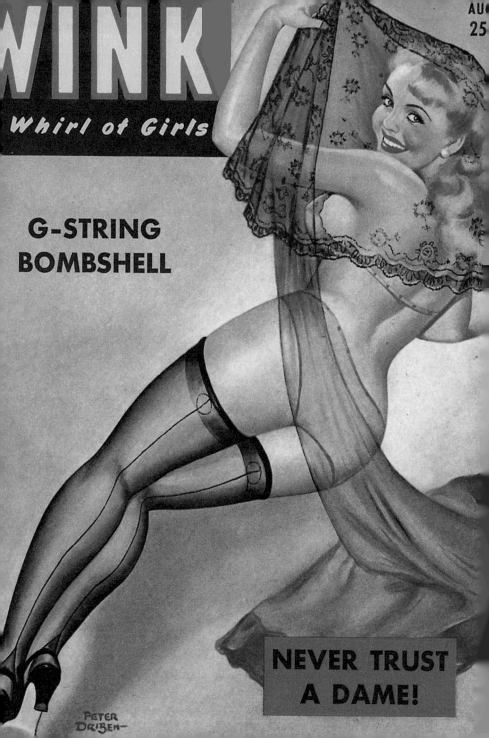

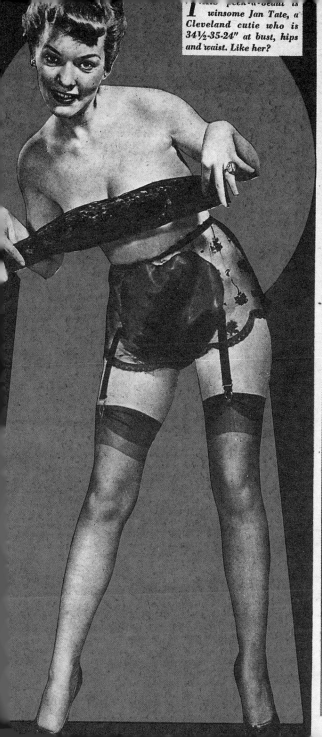

...peek-a-beau is winsome Jan Tate, a Cleveland cutie who is 34½-35-24" at bust, hips and waist. Like her?

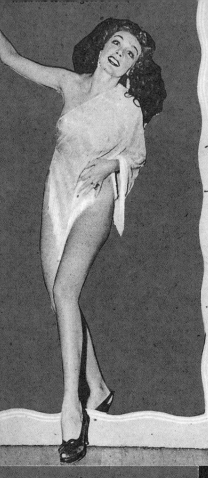

Fifty million Frenchmen went wild about this shadow g

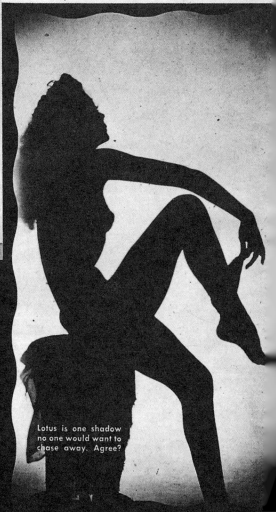

Lotus is one shadow no one would want to chase away. Agree?

Shadow Magic

YOU'VE certainly seen a dream walking, pals, but now you can see a shadow dancing, in the curvy person of lovely Lotus Du Bois as she performs her shadow magic. Lotus is a French cutie, straight from Paris. She's just 23, is 5'10", has green eyes and red hair. Her bust is 36, waist 25, hips 36½" and she tips the beam at 135. Let's know how you like this "screen test," fellers!

Lovely Lotus Du Bois Makes You Glad You're N

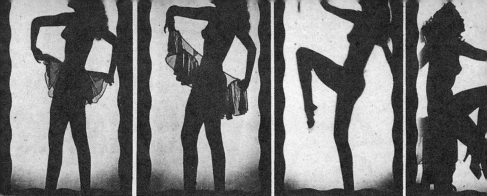

This ought to prove, fellers, that you should never be afraid of shadows, especially when they're like this eyeful.

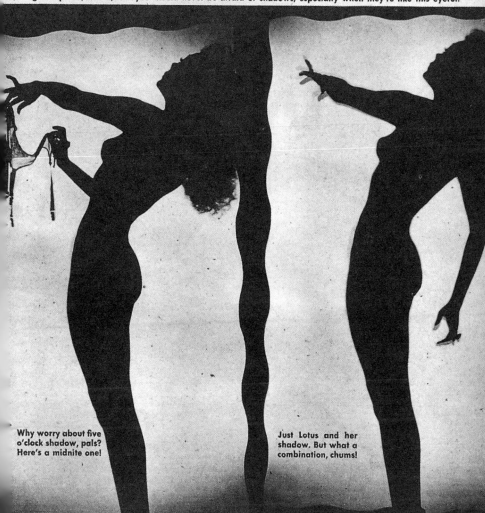

Why worry about five o'clock shadow, pals? Here's a midnite one!

Just Lotus and her shadow. But what a combination, chums!

fraid of Shadows, Pal. She's the Thrill of Paree!

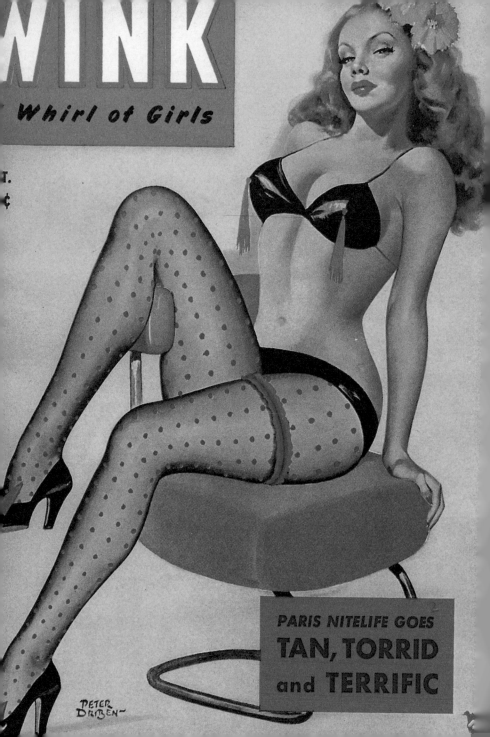

WINK

Whirl of Girls

PARIS NITELIFE GOES
TAN, TORRID
and **TERRIFIC**

PETER
DRIBEN~

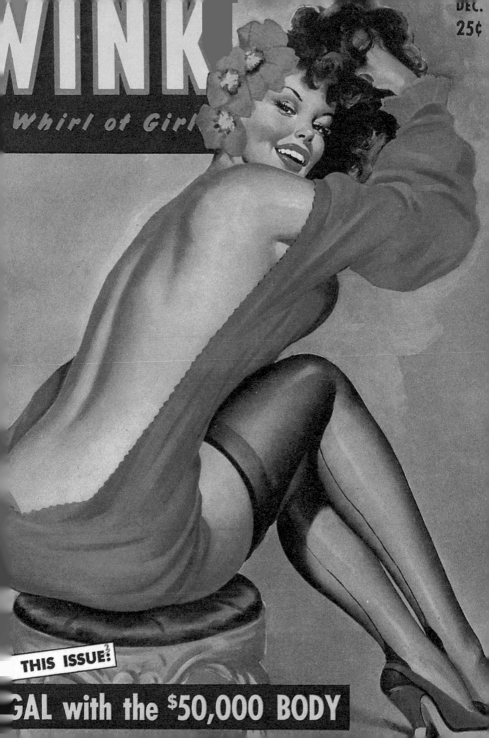

DEC.
25¢

WINK
Whirl of Girls

THIS ISSUE?

GAL with the $50,000 BODY

Lili's a champagne blonde, with green eyes.

Insurance men worry about risk.
We dunno if Lili's risky, but
she sure is frisky!

Gal
with the
$50,000
BODY!

HERE she is, boys, the one 'n'
only Lili St. Cyr, greatest ex-
otic dancer of 'em all, the gal
with the $50,000 frame!

Yessir, that's the figure a bunch
of insurance men recently placed
on her, and y'can't beat figures,
especially Lili's!

Let's face it, pals, this is one
blonde who's gold-plated!

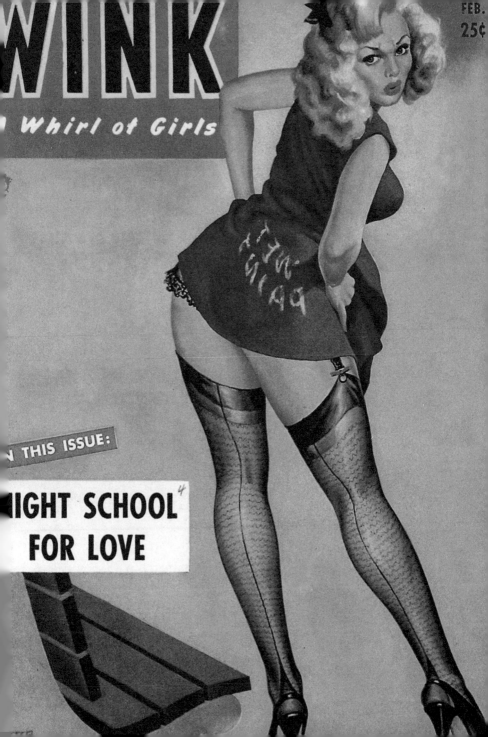

WINK

Whirl of Girls

FEB.

25¢

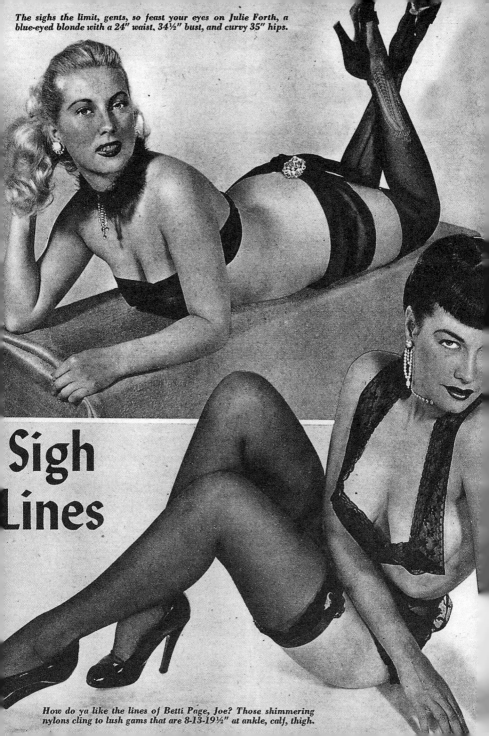

The sighs the limit, gents, so feast your eyes on Julie Forth, a blue-eyed blonde with a 24" waist, 34½" bust, and curvy 35" hips.

Sigh Lines

How do ya like the lines of Betti Page, Joe? Those shimmering nylons cling to lush gams that are 8-13-19½" at ankle, calf, thigh.

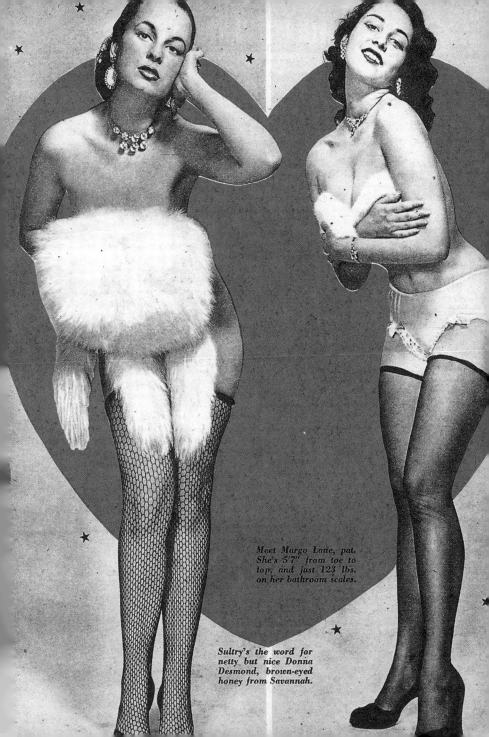

Meet Margo Lane, pal. She's 5'7" from toe to top, and just 123 lbs. on her bathroom scales.

Sultry's the word for netty but nice Donna Desmond, brown-eyed honey from Savannah.

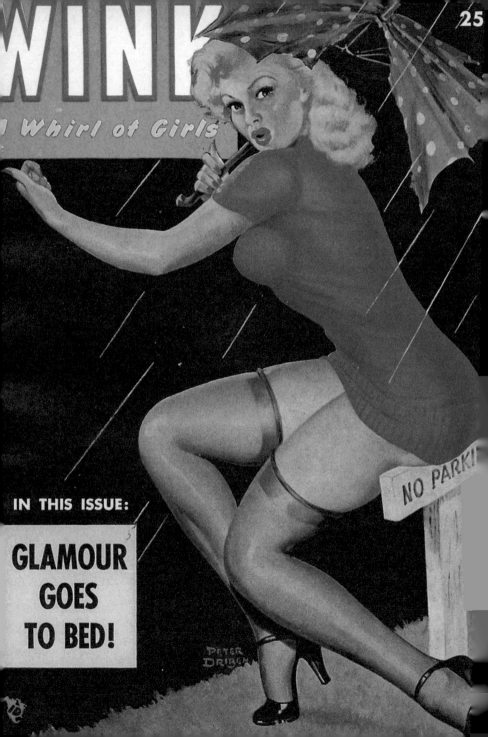

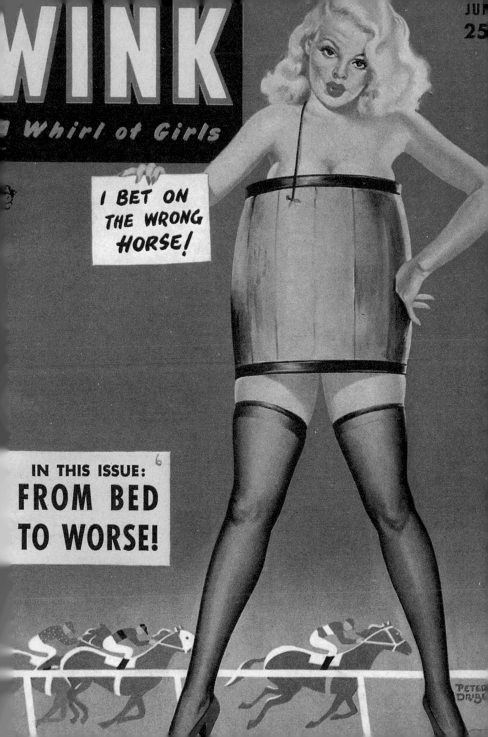

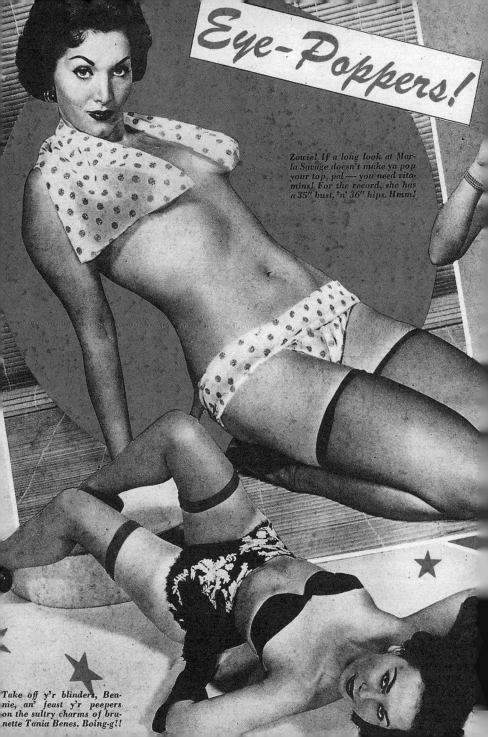

Eye-Poppers!

Zowie! If a long look at Marla Savage doesn't make ya pop your top, pal — you need vitamins! For the record, she has a 35" bust, 'n' 36" hips. Hmm!

Take off y'r blinders, Bennie, an' feast y'r peepers on the sultry charms of brunette Tania Benes. Boing-g!!

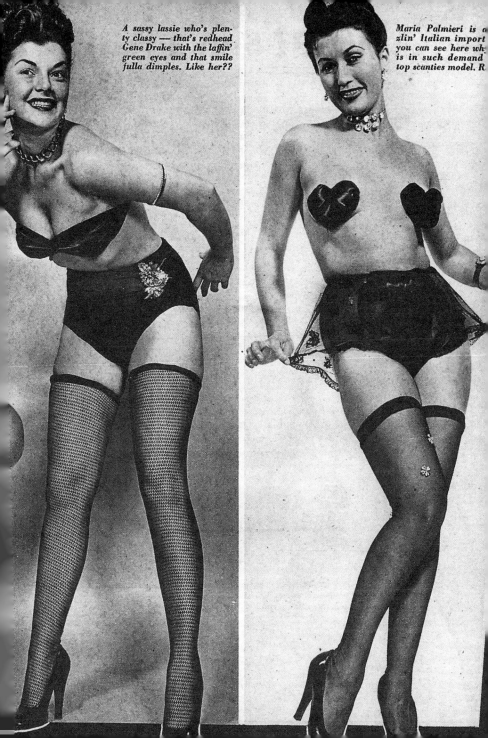

A sassy lassie who's plenty classy — that's redhead Gene Drake with the laffin' green eyes and that smile fulla dimples. Like her??

Maria Palmieri is a zlin' Italian import you can see here why is in such demand top scanties model. R

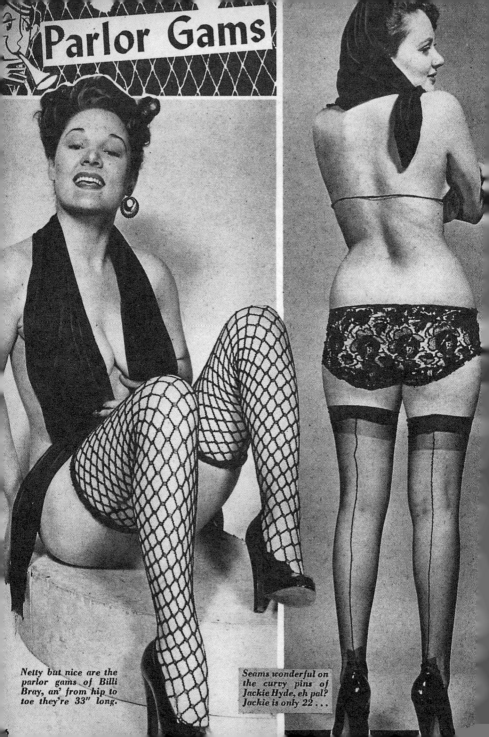

Parlor Gams

Netty but nice are the parlor gams of Billi Bray, an' from hip to toe they're 33" long.

Seams wonderful on the curvy pins of Jackie Hyde, eh pal? Jackie is only 22 . . .

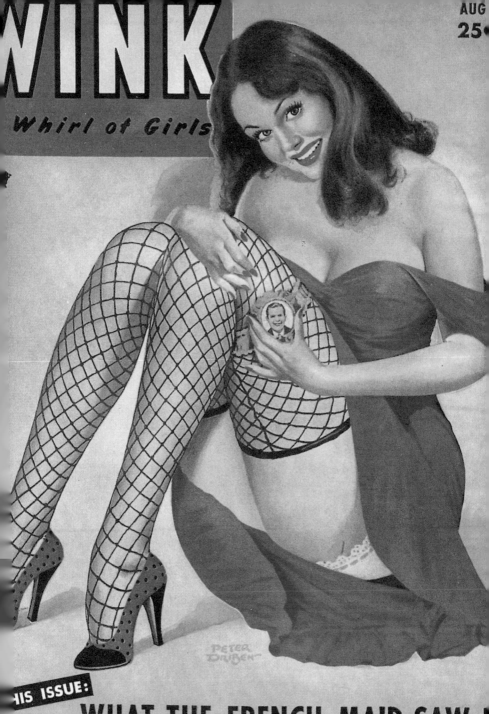

WINK

Whirl of Girls

AUG
25¢

PETER
DRIBEN

HIS ISSUE:
WHAT THE FRENCH MAID SAW

WINK

Whirl of Gi...

PARIS
PEEP
SHOW

LOVE BELOW
THE KNEES

PETER
DRIBEN

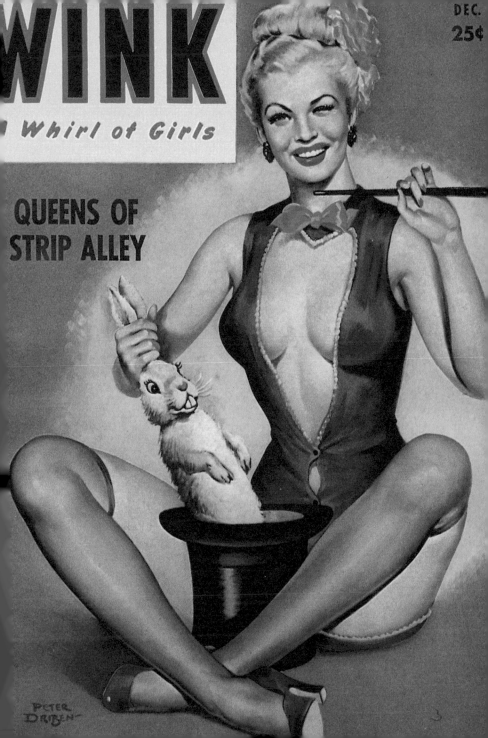

Ginny Ware Ann Drew

Ruth Long — Amy Kell

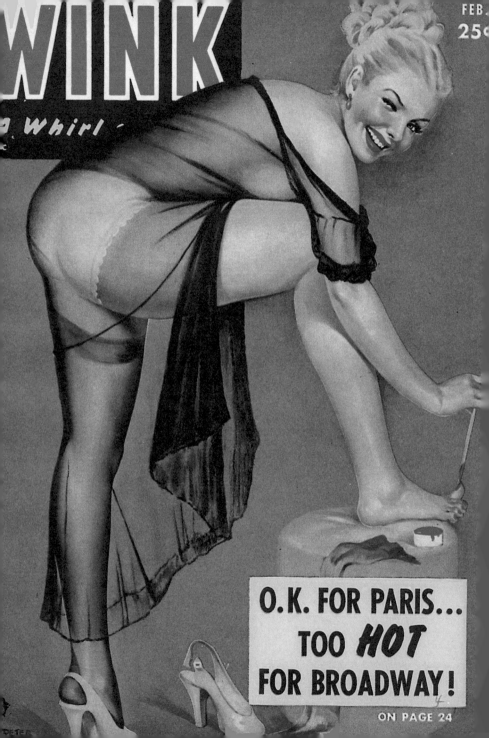

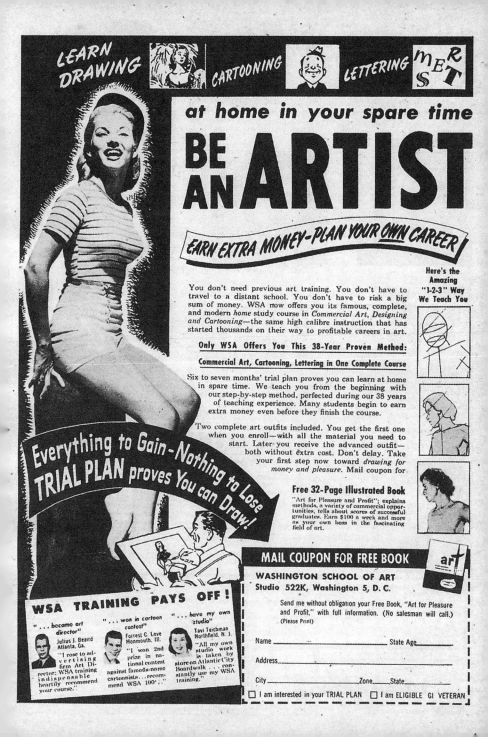

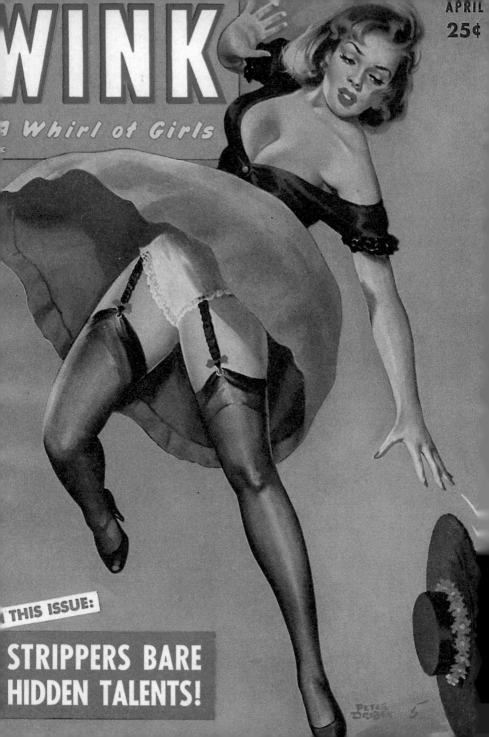

APRIL
25¢

WINK

a Whirl of Girls

THIS ISSUE:

STRIPPERS BARE HIDDEN TALENTS!

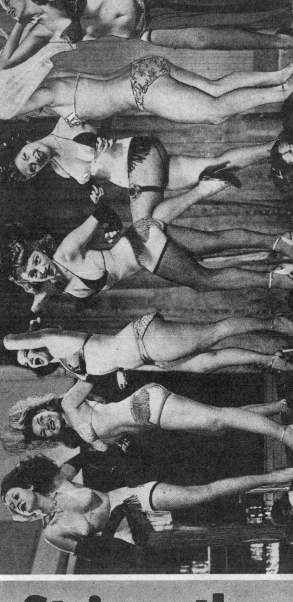

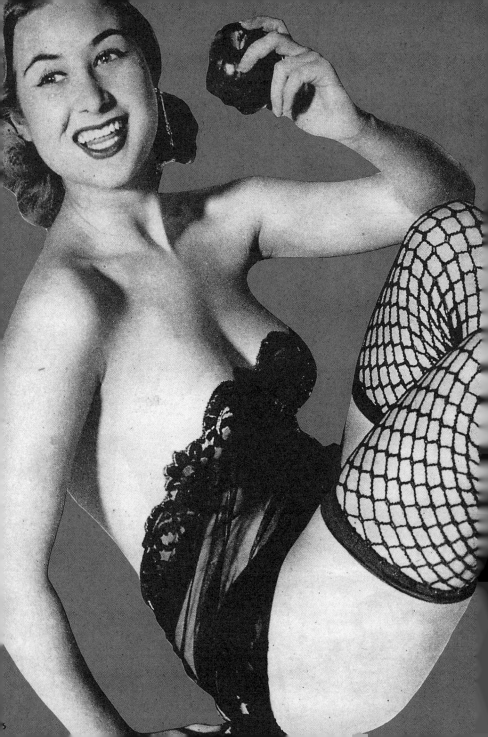

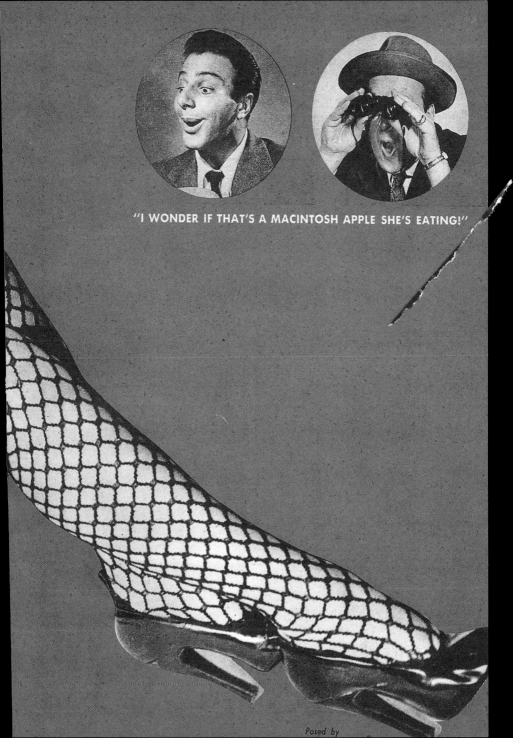

"I WONDER IF THAT'S A MACINTOSH APPLE SHE'S EATING!"

Posed by

WINK

Fresh MAGAZINE

AUG
25

GIRLS ★ GAGS ★ GAYETY

EXCLUSIVE — See Page 24

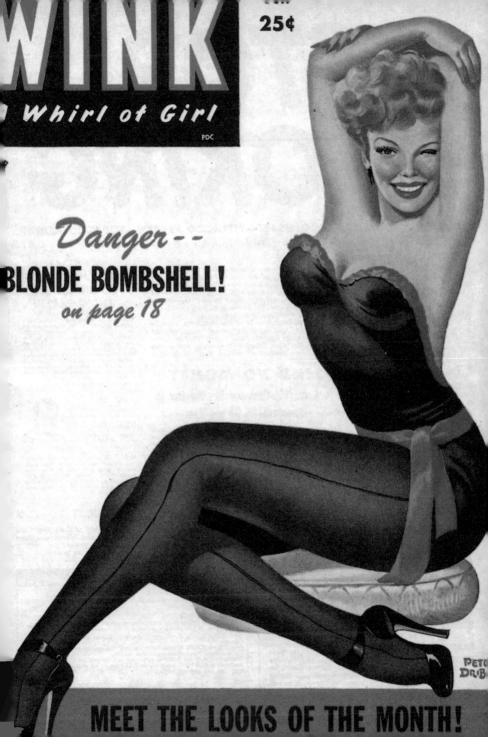

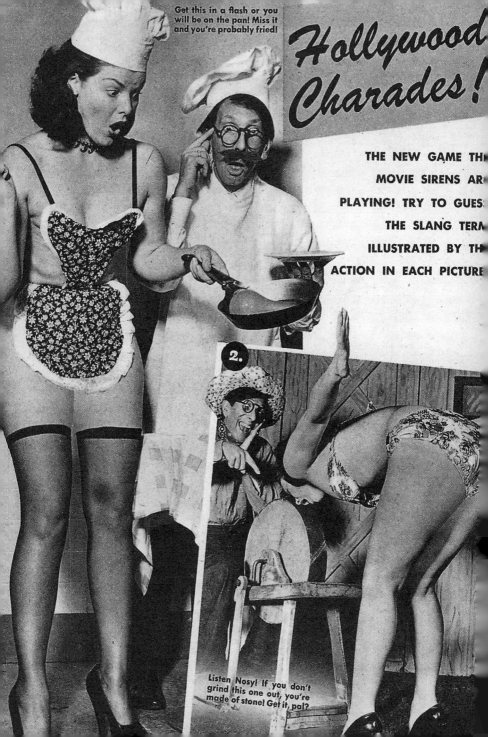

Get this in a flash or you will be on the pan! Miss it and you're probably fried!

Hollywood Charades!

THE NEW GAME TH
MOVIE SIRENS AR
PLAYING! TRY TO GUES
THE SLANG TERM
ILLUSTRATED BY TH
ACTION IN EACH PICTURE

2.

Listen Nosy! If you don't grind this one out, you're made of stone! Get it, pal?

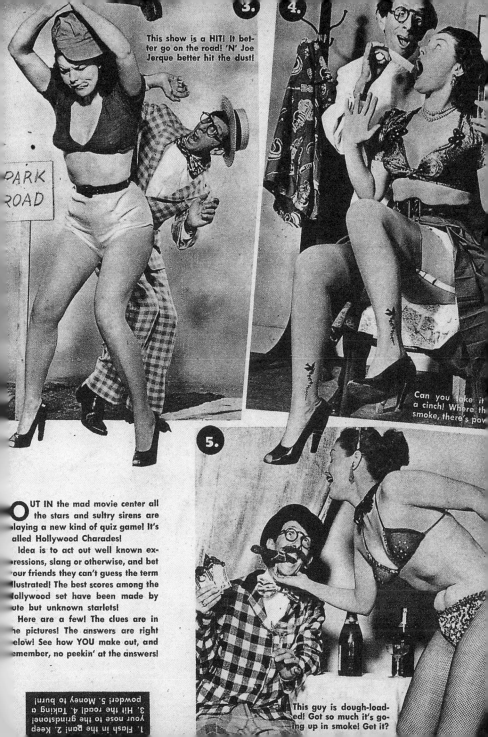

3. This show is a HIT! It better go on the road! 'N' Joe Jerque better hit the dust!

PARK ROAD

4.

Can you take it a cinch! Where th smoke, there's pov

5.

OUT IN the mad movie center all the stars and sultry sirens are playing a new kind of quiz game! It's called Hollywood Charades!

Idea is to act out well known expressions, slang or otherwise, and bet your friends they can't guess the term illustrated! The best scores among the Hollywood set have been made by cute but unknown starlets!

Here are a few! The clues are in the pictures! The answers are right below! See how YOU make out, and remember, no peekin' at the answers!

This guy is dough-loaded! Got so much it's going up in smoke! Get it?

1. Flash in the pan! 2. Keep your nose to the grindstone! 3. Hit the road! 4. Taking a powder! 5. Money to burn!

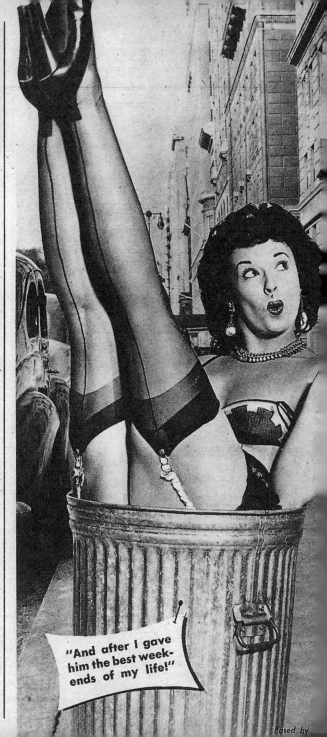

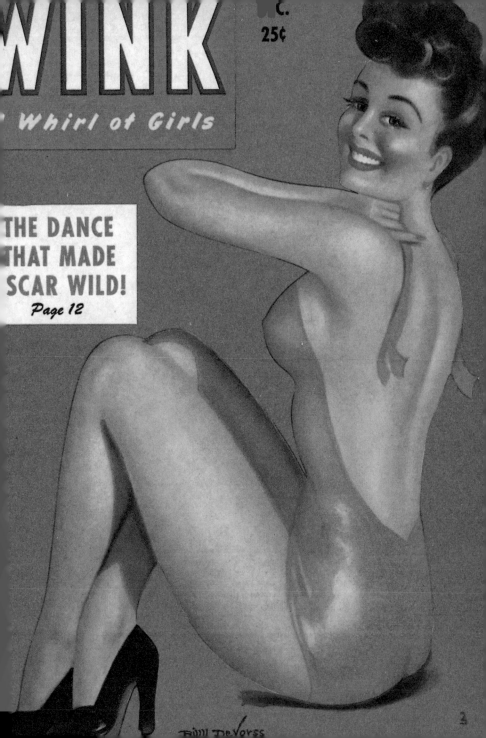

WINK
Whirl of Girls

25¢

THE DANCE
THAT MADE
SCAR WILD!
Page 12

Bill DeVorss

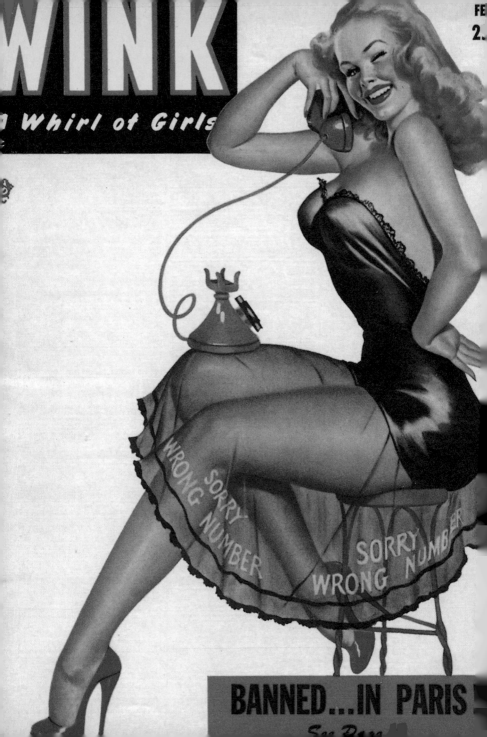

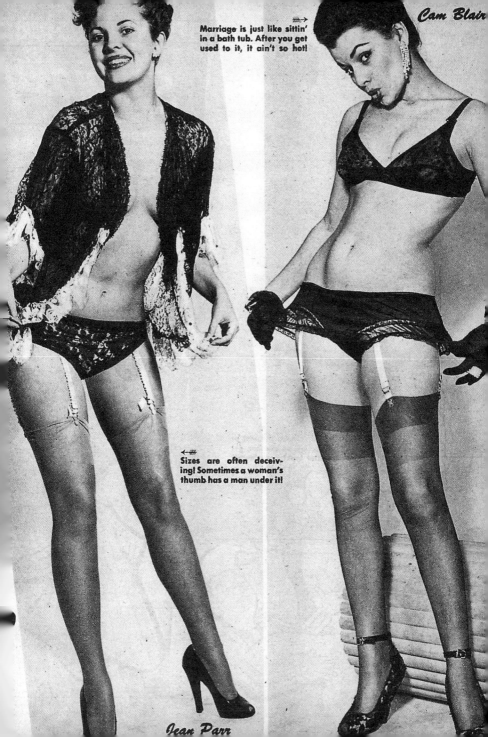

Marriage is just like sittin' in a bath tub. After you get used to it, it ain't so hot!

Cam Blair

← Sizes are often deceiving! Sometimes a woman's thumb has a man under it!

Jean Parr

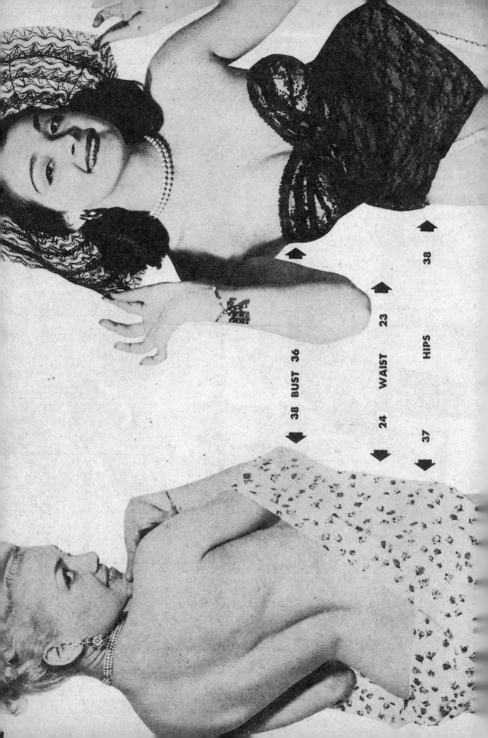

BUST 36
38

WAIST 23
24

HIPS 38
37

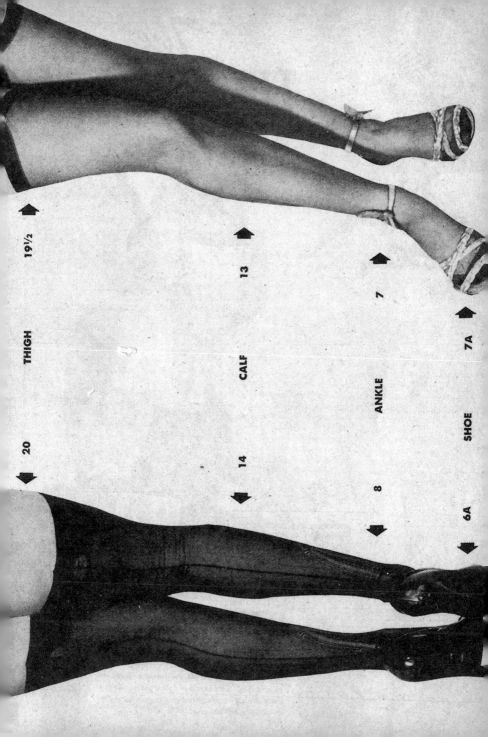

THIGH 19½ 20

CALF 13 14

ANKLE 7 8

SHOE 7A 6A

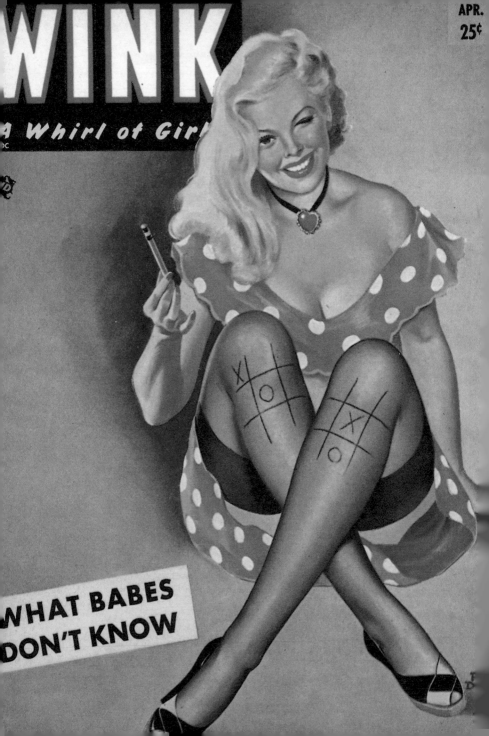

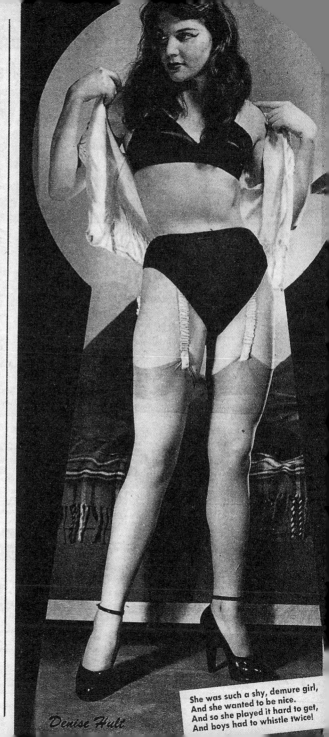

Denise Hult

She was such a shy, demure girl,
And she wanted to be nice.
And so she played it hard to get,
And boys had to whistle twice!

THEY *ain't* NO

GENTLEMEN

TLEMEN

GENTLEMEN!

GAL TO ADORE OPENS WRONG DOOR — AND GETS FRAMED!

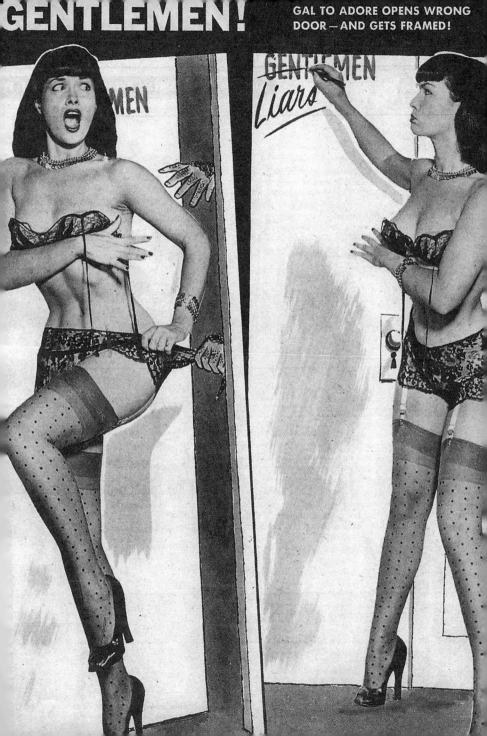

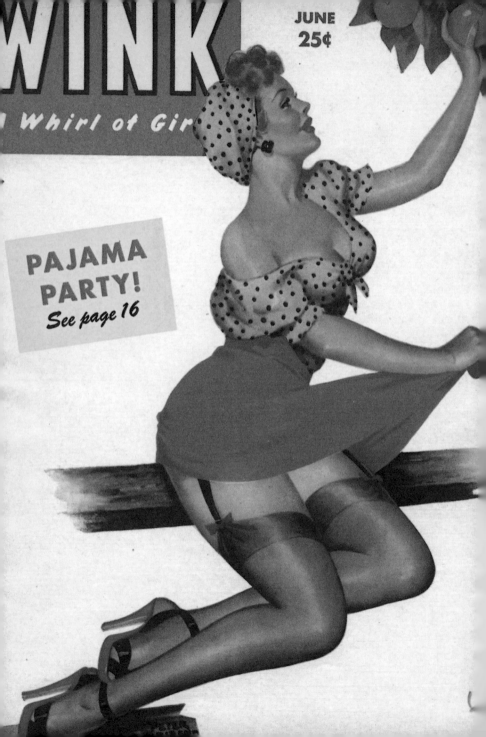

WINK

a Whirl of Girls

JUNE
25¢

PAJAMA PARTY!
See page 16

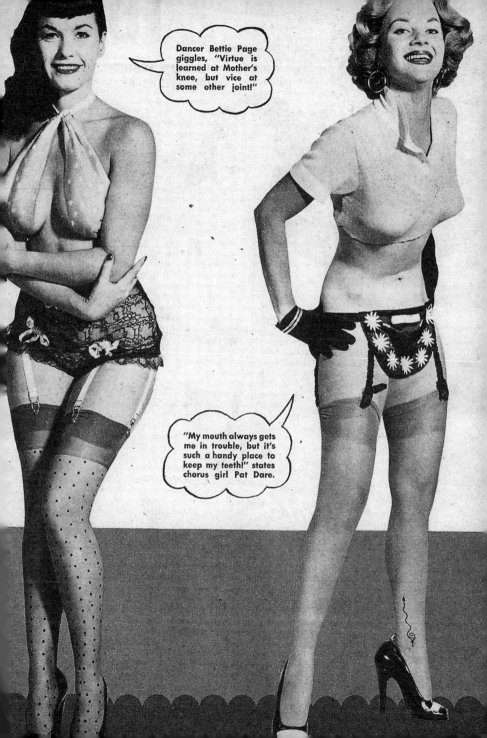

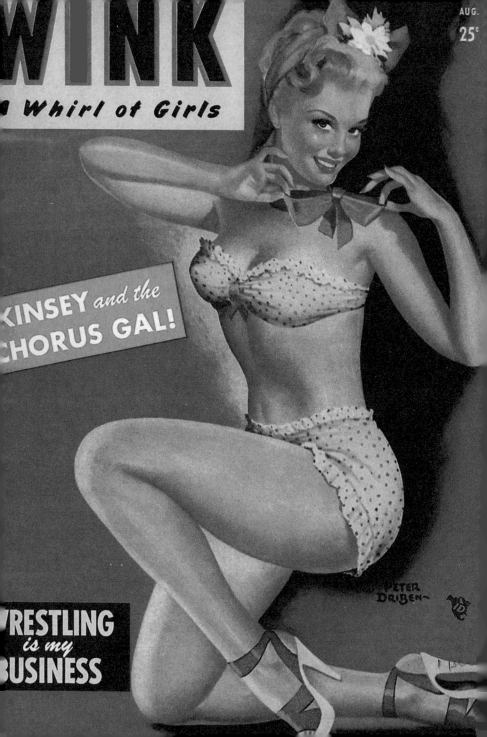

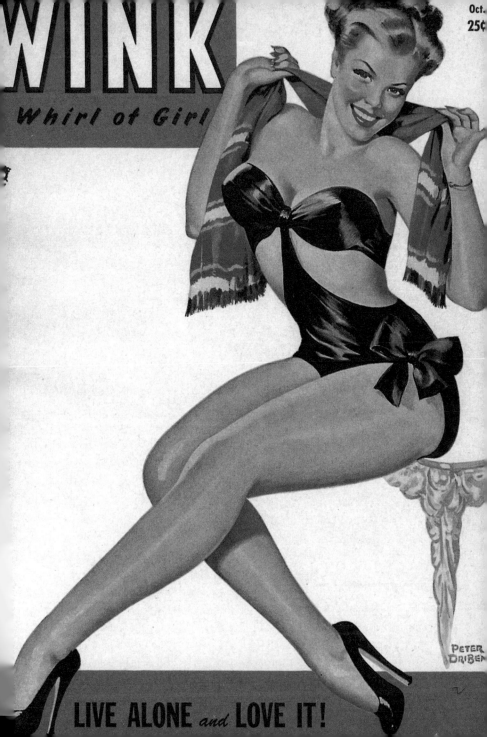

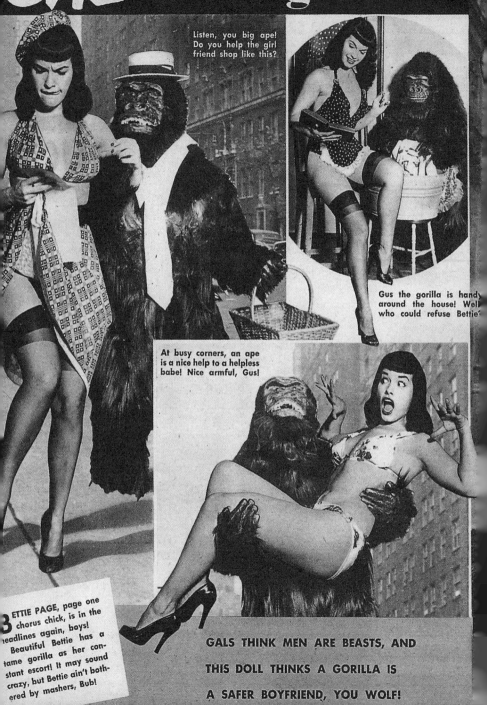

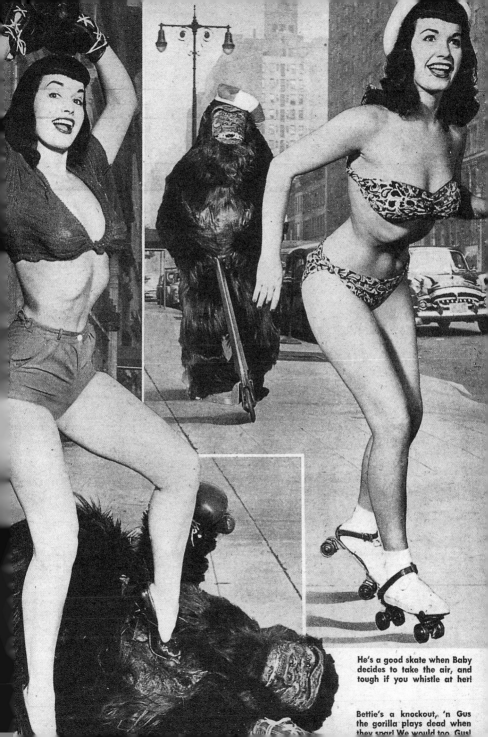

He's a good skate when Baby decides to take the air, and tough if you whistle at her!

Bettie's a knockout, 'n Gus the gorilla plays dead when they snarl We would too, Gus!

DEC.
25c

WINK
Whirl of Girls

GIRLS
*
GAGS
*
GAYETY

PETER
DRIBEN

Special Offer: **FOR TIRED BUSINESS MEN**

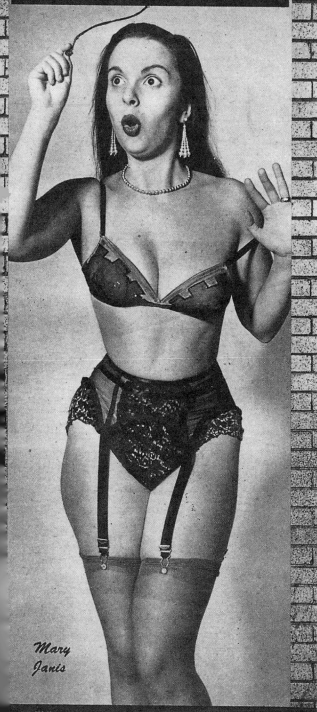

Mary Janis

"MY MOTHER ALWAYS TOLD ME TO PULL
THE SHADE BUT SHE DIDN'T SAY WHEN"

WINK

FEB.
25¢

A Whirl of Girls

PDC

PETER
DRIBEN

ECIPE FOR FUN

GUY'S GUIDE TO GALS

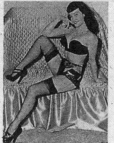 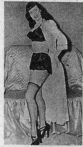

WINK

a Whirl of Girls

APR.
25¢

GAY
Nighties

BABES IN THE WOOD!

YOU UP A TREE? AN EYEFUL AND AN EARFUL AND YOU'LL BE OKAY!

Freda Olsen says, "My new boy friend must be a gentleman farmer. He tips his hat to every tomato he passes!"

"A bachelor," says Marilyn Martin, "Is a guy who never Mrs. anything!"

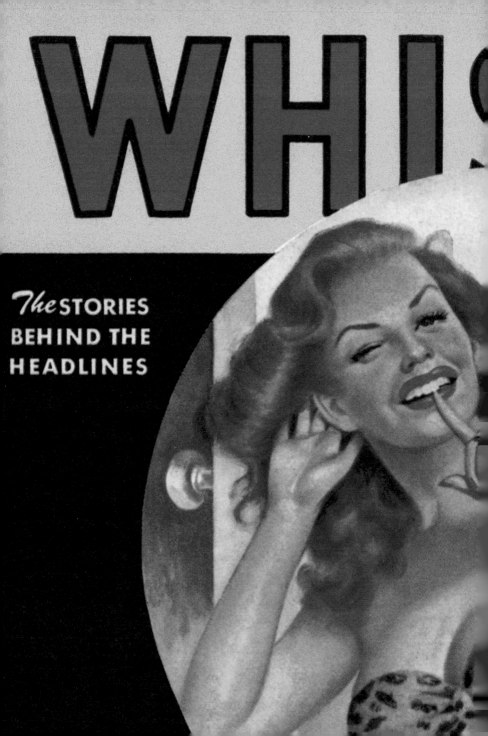

WHIS

The STORIES
BEHIND THE
HEADLINES

SPER

MARCH

25¢

1946–1958

When Whisper landed in the kiosks in April 1946, its outsize format announced that this time Harrison had come up with something special. Peter Driben has designed for the cover a loud, pulp-style action scene that actually related to a real article inside. The contents cited authors' names, and Harrison's clientele, which until then had been quietly forgetting the world of war in the largely peaceful land of oh-la-la, found themselves being transported helter-skelter to a squalid paradise of sexual-ethical disorientation, violent excesses and increasingly sordid scandals. "Babylon" was the destination on the train ticket, and Harrison stoked the engine's boiler with growing enthusiasm.

Whisper never achieved sales figures higher than about 600,000 copies (compared to 4 million for "Confidential") but it was a wild heady magazine. After Harrison was compelled to sell it together with "Confidential" in 1958, it eked out an existence in various publishers' hand until the early 70s.

Bereits das Überformat, in dem Whisper im April 1946 an die Kioske kam, deutete an, daß Harrison sich hier etwas Besonderes ausgedacht hatte. Peter Driben hatte für das Cover eine laute Actionszene im Pulpstil entworfen, die tatsächlich Bezug zu einem richtigen Artikel hatte. Das Inhaltsverzeichnis nannte Autoren, und Harrisons Klientel, die bislang die kriegerische Welt hatte vergessen können, fand sich plötzlich auf dem Weg in ein aufregendes Schmuddelparadies sexual-ethischer Desorientierung, gewalttätiger Exzesse und zunehmend wüsterer Skandale. „Babylon" stand auf dem Fahrschein, und Harrison heizte mit zunehmender Begeisterung den Kessel an.

Die höchsten Verkaufszahlen, die Whisper erreichte, lagen bei 600.000. Exemplaren (im Vergleich: an die 4 Millionen bei „Confidential"), aber es war ein aufregendes und wildes Magazin. Nachdem es Harrison 1958 zusammen mit „Confidential" verkaufen mußte, siechte es noch bis zum Beginn der Siebziger Jahre unter wechselnden Herausgebern dahin.

Le grand format de Whisper, qui sortit dans les kiosques en avril 1946, indiquait que Harrison venait d'imaginer là quelque chose de spécial : la couverture criarde qu'avait conçue Peter Driben et qui représentait une scène d'action dans un style très peu relevé, avait effectivement rapport à un article. Un vrai article, et le sommaire mentionnait les noms des auteurs ! Les lectures de Harrison, qui avaient pu jusqu'ici oublier la guerre dans la contrée paisible des frivolités émoustillantes, se retrouvaient dans un train traversant un paradis sordide et trouble où régnait la désorientation sexuelle et éthique, où tout n'était qu'excès violents et ramassis de scandales. Destination «Babylone», c'était inscrit sur leurs billets, et Harrison chauffait la chaudière avec enthousiasme.

Les meilleures ventes de Whisper tournèrent autour de 600.000 exemplaires (celles de «Confidential», par comparaison, dans les 4 millions), mais c'était un magazine excitant et même hard. Après qu'Harrison se fut résolu en 1958 à les vendre tous les deux, Whisper changea souvent d'éditeur avant de s'éteindre doucement au début des années 70.

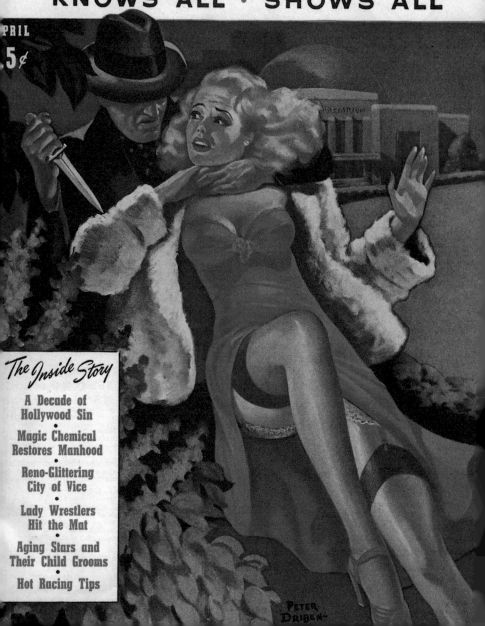

WHISPER

KNOWS ALL · SHOWS ALL

PRIL

5¢

The Inside Story

- **A Decade of Hollywood Sin**
- **Magic Chemical Restores Manhood**
- **Reno-Glittering City of Vice**
- **Lady Wrestlers Hit the Mat**
- **Aging Stars and Their Child Grooms**
- **Hot Racing Tips**

PETER DRIBEN

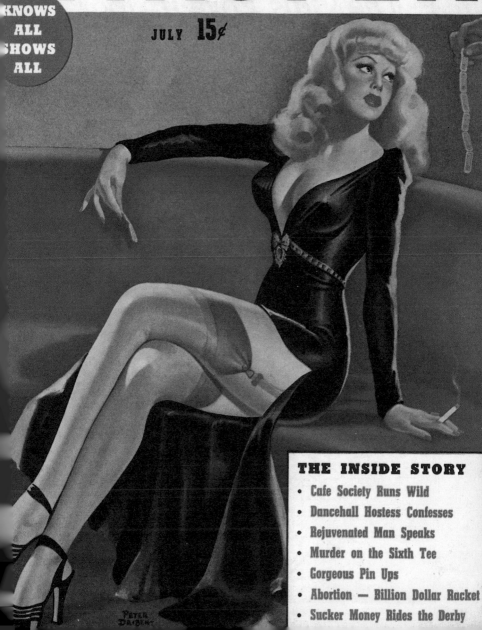

WHISPER

KNOWS ALL SHOWS ALL

JULY 15¢

THE INSIDE STORY

- Cafe Society Runs Wild
- Dancehall Hostess Confesses
- Rejuvenated Man Speaks
- Murder on the Sixth Tee
- Gorgeous Pin Ups
- Abortion — Billion Dollar Racket
- Sucker Money Rides the Derby

PETER DRIBEN

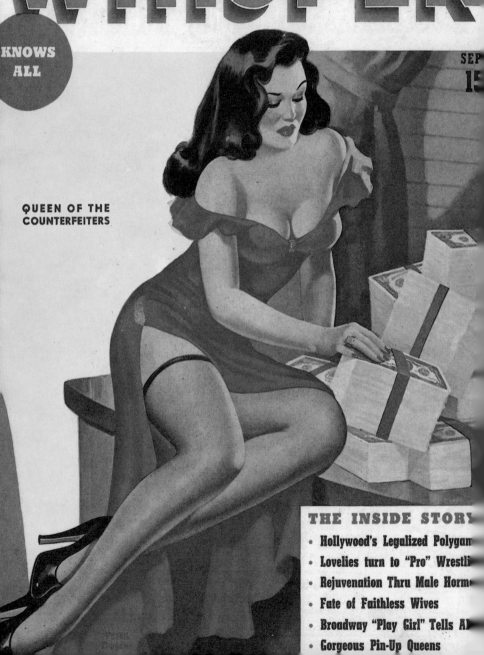

WHISPER

KNOWS ALL

SEP
15

QUEEN OF THE
COUNTERFEITERS

THE INSIDE STORY

- Hollywood's Legalized Polygam
- Lovelies turn to "Pro" Wrestli
- Rejuvenation Thru Male Horm
- Fate of Faithless Wives
- Broadway "Play Girl" Tells A
- Gorgeous Pin-Up Queens

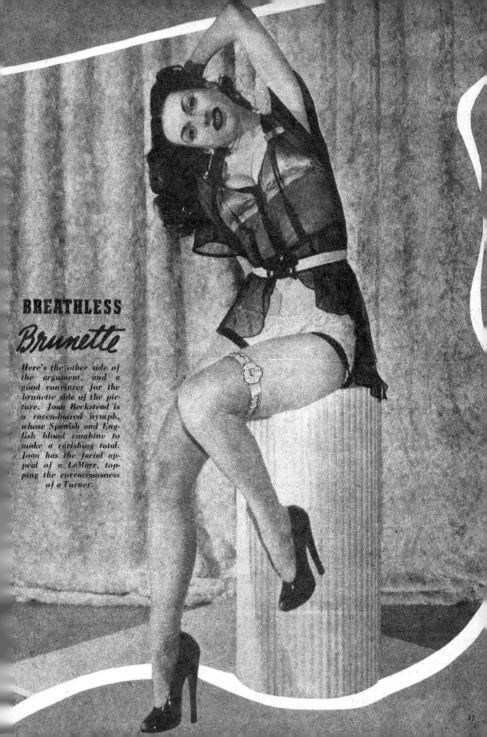

BREATHLESS
Brunette

Here's the other side of the argument, and a good convincer for the brunette side of the picture. Joan Beckstead is a raven-haired nymph, whose Spanish and English blood combine to make a ravishing total. Joan has the facial appeal of a LaMarr, topping the curvaceousness of a Turner.

WHISPER

DECEMI

15.

THRU
THE
KEYHOLE

True Facts Revealed

- Branded By Love
- Wild Matrons Corrupt Youths
- Exposing Film's Phoney Glamour
- Heiresses Elope With Hired Help
- Murder Stalks A Strange Affair
- Brawny Beauts Wrestle
- Enchanting, Eye-Filling Pin-Ups

RACKET GALS *EXPOSED!*

WHISPER

THRU *the* KEYHOLE

NOVEMBER

MORE **PAGES**
MORE **PHOTOS**
MORE **FEATURES**

True Facts Revealed

- **Lashed to Death**
- **Cross Country Vice**
- **New Grappling Queens**
- **Gorgeous Pin-Ups**

PETER
DRIBEN

INSIDE THE *HAREMS* OF AMERICA!

WHISPER

THRU *the* YHOLE

MARCH

PETER DRIBEN

True Facts Revealed

- ✓ How Heiresses Buy Love
- ✓ Shakedown Sweeties Exposed
- ✓ Stage and Screen Go Brutal
- ✓ Ferocious Fighting Femmes

25¢

WHISPER

PETER DRIBEN

rue Facts Revealed

Party Girls and Big Business

Strange Rituals of Cultists

B'way's Side-Street Sirens

Brawny Battling Babes

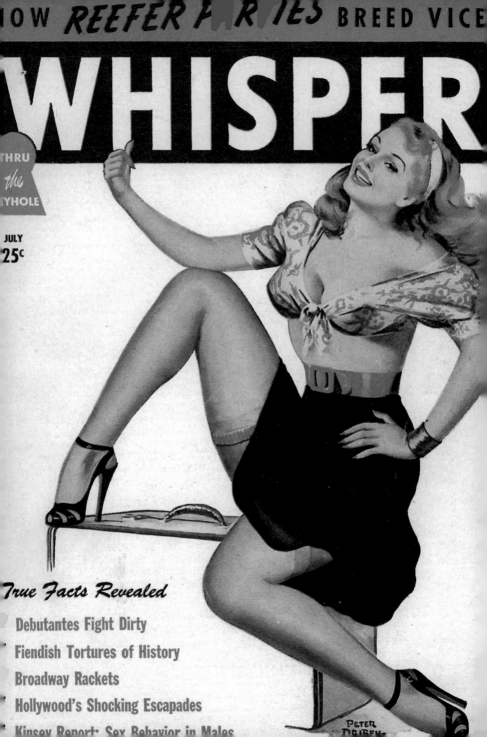

NOW *REEFER PARTIES* BREED VICE!

WHISPER

THRU *the* EYHOLE

JULY
25¢

True Facts Revealed

Debutantes Fight Dirty

Fiendish Tortures of History

Broadway Rackets

Hollywood's Shocking Escapades

Kinsey Report: Sex Behavior in Males

PETER DRIBEN

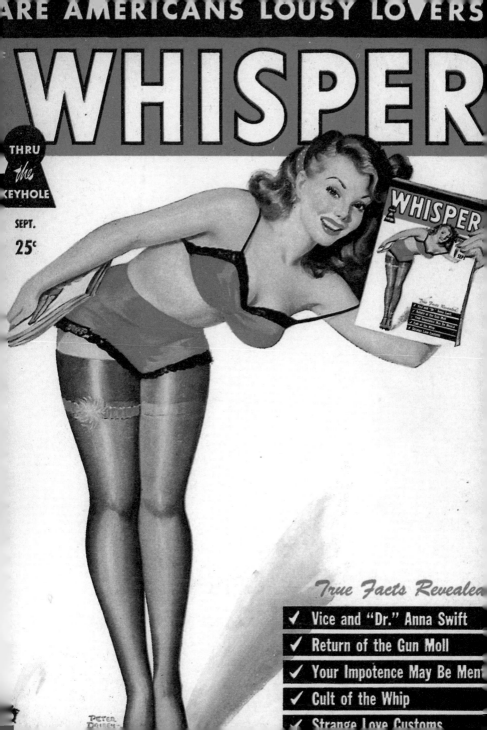

WHITE SLAVERY STILL FLOURISHE

WHISPER

True Facts Reve

✓ **Tortured For Love**
✓ **Lure of Easy Money**
✓ **Are You Emotionally Nor**

TER

ARE NUDISTS INDECENT?

Page 3

WHISPER

THRU *the* EYHOLE

MAR.
25c

PETER DRIBEN

✓ **Daughters For Sale**
✓ **Men Without Women**
✓ **Licensed Killers**
✓ **Suckers For Pickpocket**

S THERE A THIRD SEX?

WHISPER

HRU
the
WHOLE

MAY
25¢

PETER
DRIBEN—

EENS OF VICE • LIFE in an INSANE ASYLU

E HAREM • BEGGARS WIT BAN O

VILLAGE OF FREE LOVE Page

WHISPER

THRU
the
KEYHOLE

SEPT
25¢

PETER
DRIBEN

OUSE OF SCARLET MEN • BLOOD MONEY

HOW OLD ARE YOU SEXUALLY?

WHISPER

NOV.
25c

BENZEDRINE PARTIES • CAN YOU STAND TORTUR

CAN SCIENCE SWITCH SEXES?

WHISPER

JAN.
25¢

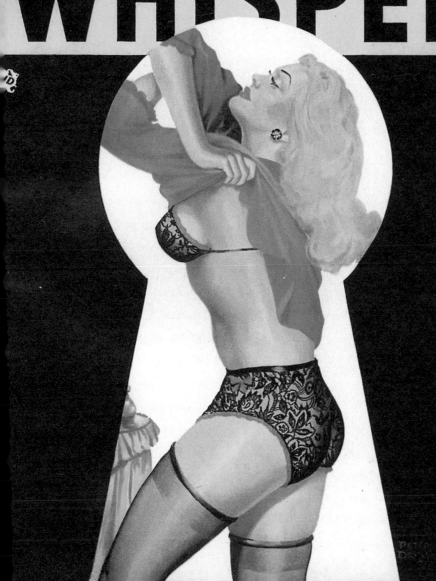

ONFESSIONS OF A NUDIST! • WIFE SWAPPIN
APE OF THE MOON • CULT OF HUMAN LEOPARD

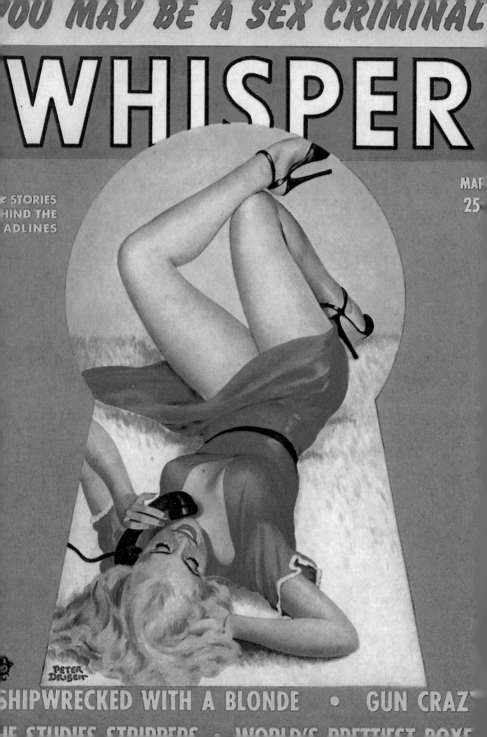

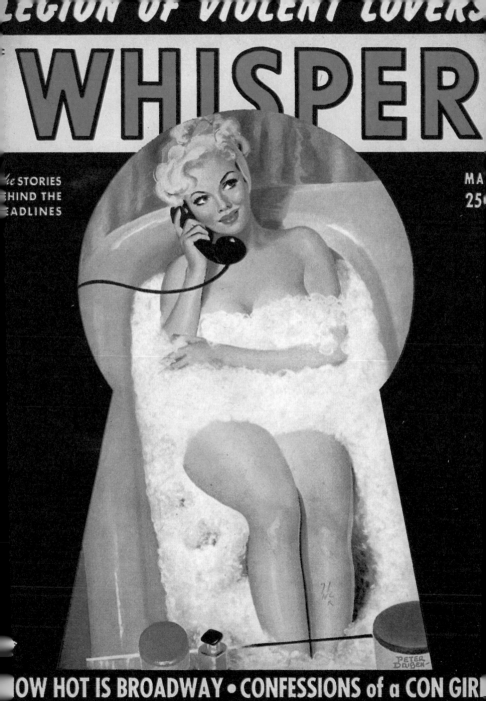

LEGION OF VIOLENT LOVERS

WHISPER

he STORIES
HIND THE
ADLINES

MA
25

PETER
DRIBEN

OW HOT IS BROADWAY • CONFESSIONS of a CON GIRL

VILL INSECTS RULE THE WORLD? • DIVORCE MAD

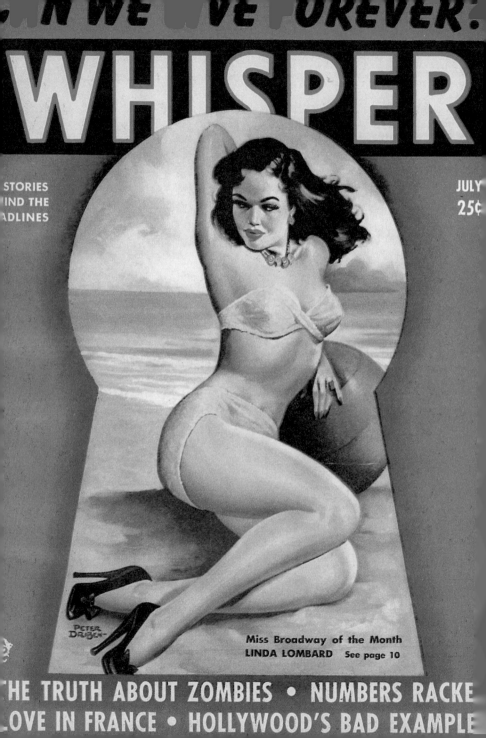

N WE ~VE FOREVER?

WHISPER

STORIES
ND THE
ADLINES

JULY
25¢

PETER
DRIBEN

Miss Broadway of the Month
LINDA LOMBARD See page 10

THE TRUTH ABOUT ZOMBIES • NUMBERS RACKE
OVE IN FRANCE • HOLLYWOOD'S BAD EXAMPLE

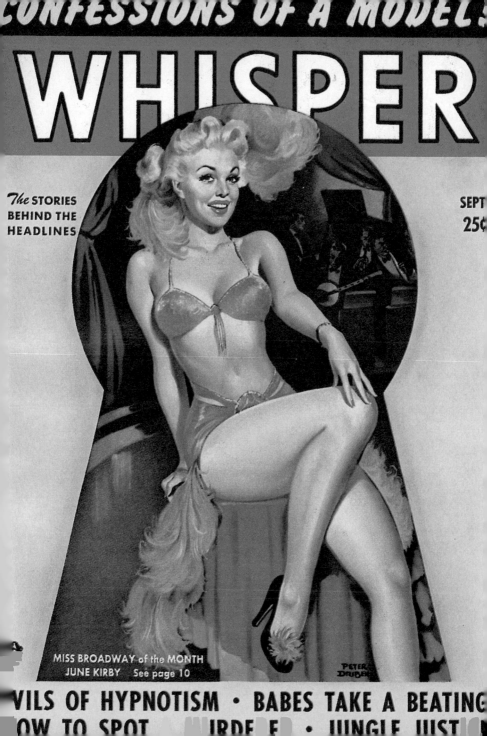

CONFESSIONS OF A MODEL!

WHISPER

The STORIES
BEHIND THE
HEADLINES

SEPT
25¢

MISS BROADWAY of the MONTH
JUNE KIRBY See page 10

PETER
DRIBEN

VILS OF HYPNOTISM · BABES TAKE A BEATING
OW TO SPOT A MURDERER · JUNGLE JUSTIC

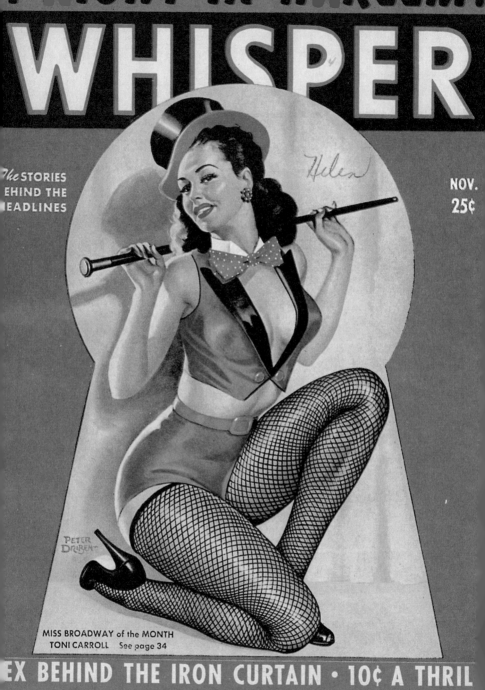

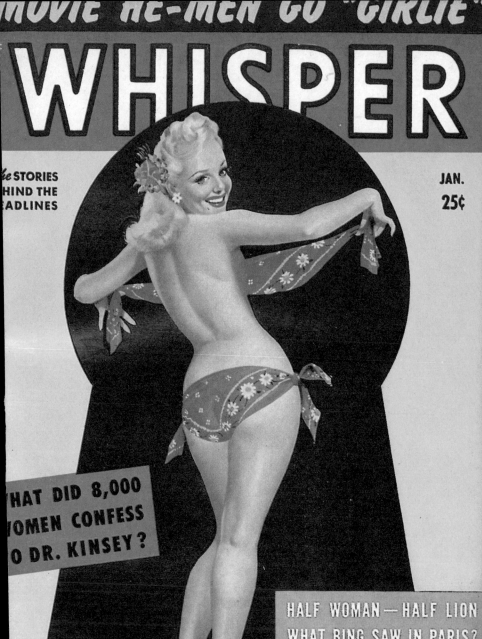

MOVIE HE-MEN GO "GIRLIE"

WHISPER

JAN.
25¢

THE STORIES
BEHIND THE
HEADLINES

WHAT DID 8,000
WOMEN CONFESS
TO DR. KINSEY?

HALF WOMAN—HALF LION
WHAT BING SAW IN PARIS?
INSIDE WHITE SLAVE RINGS
DO WIVES RUIN ATHLETES?

PETER
DRIBEN

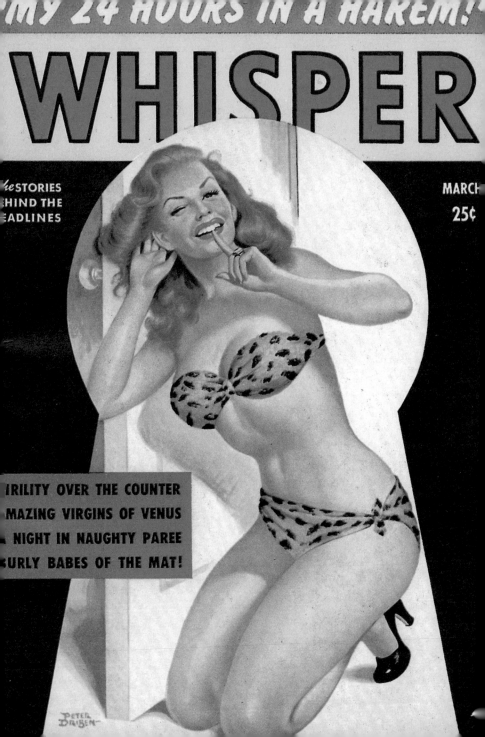

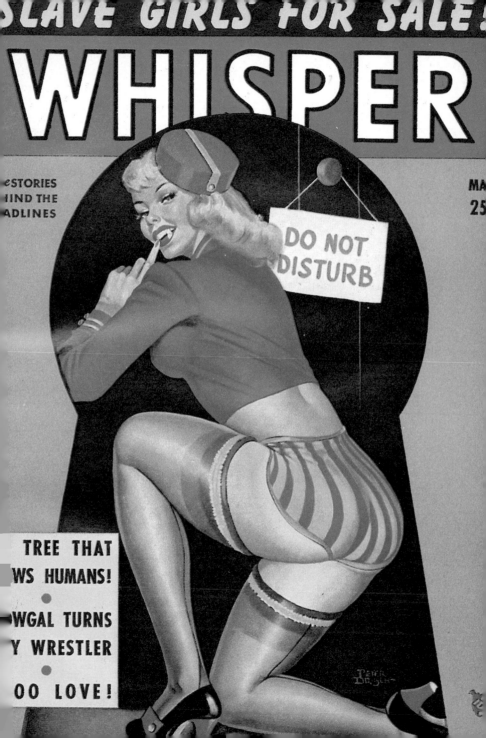

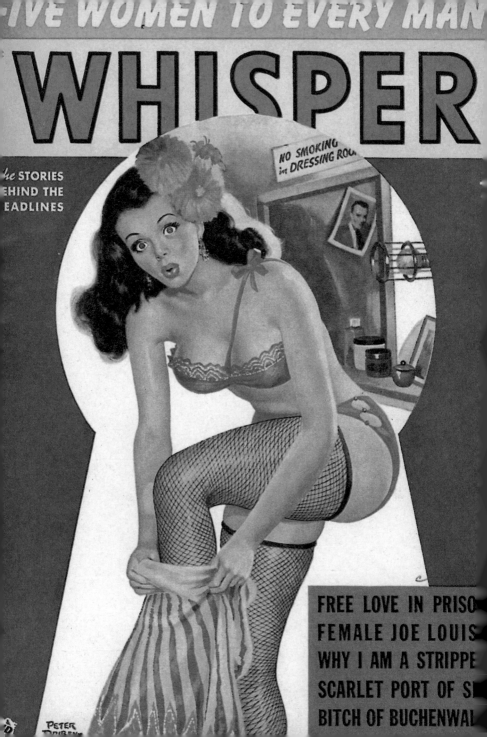

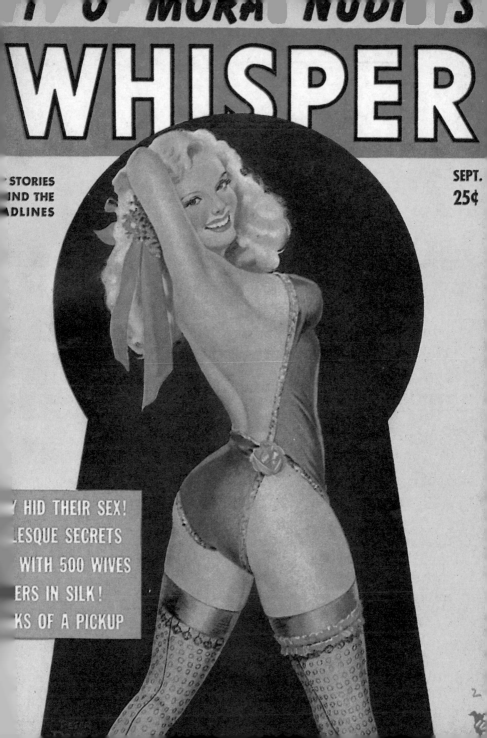

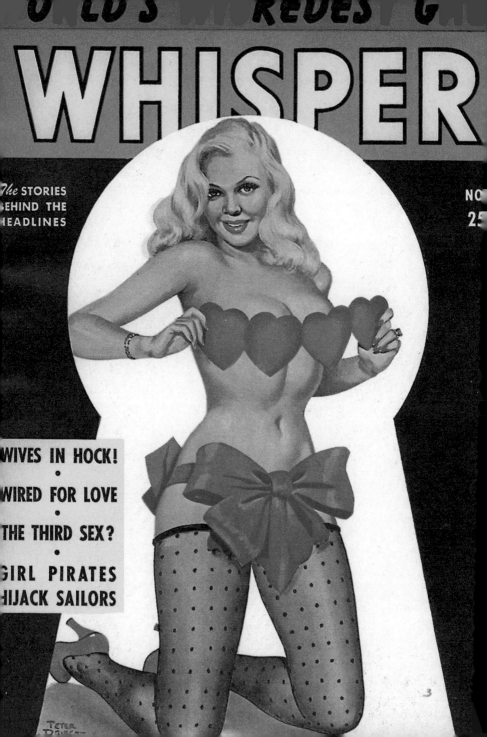

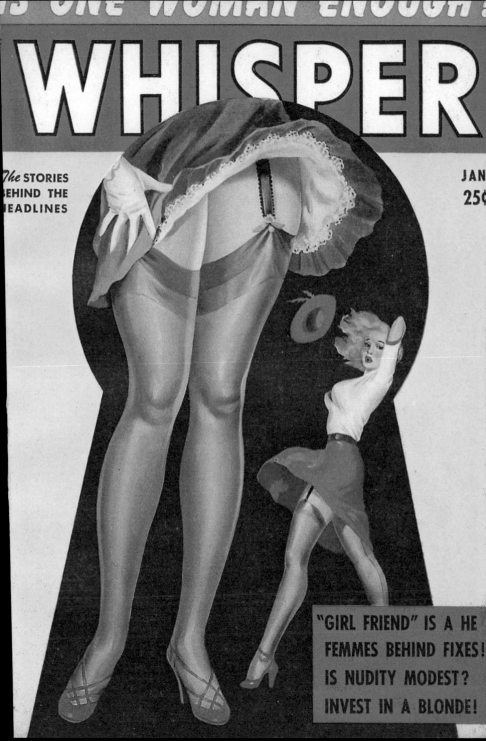

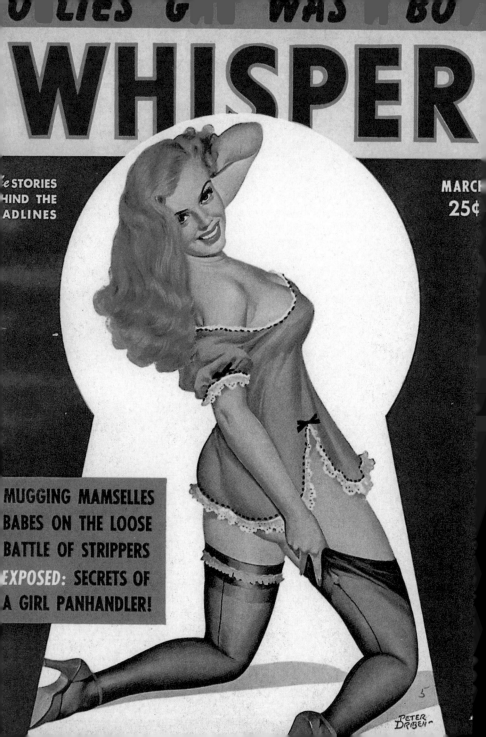

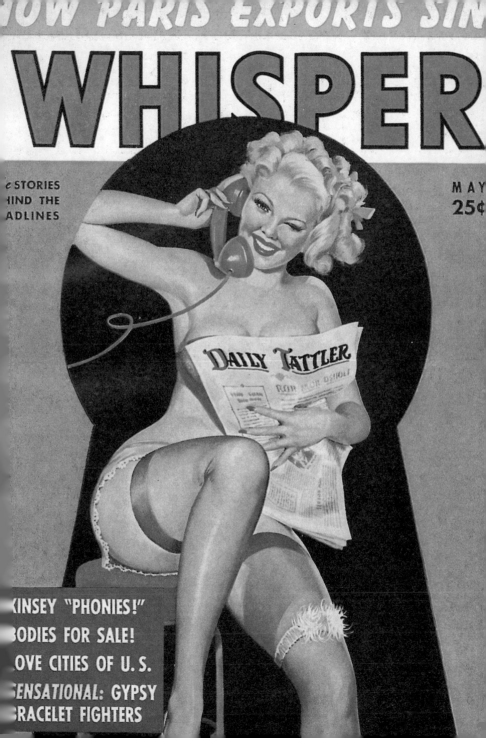

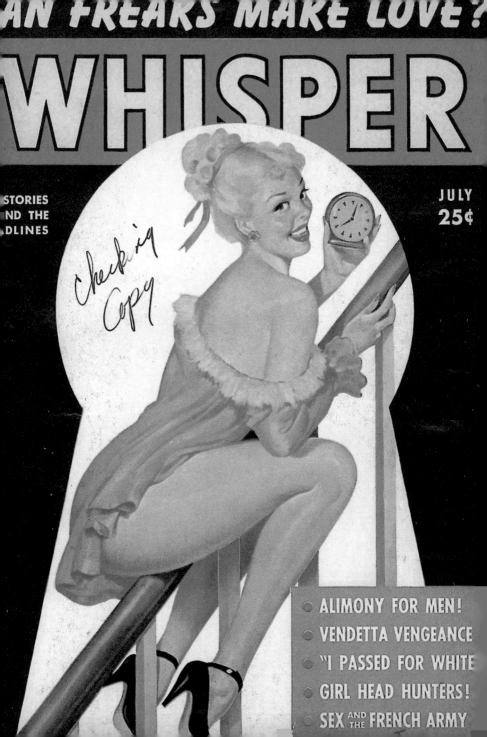

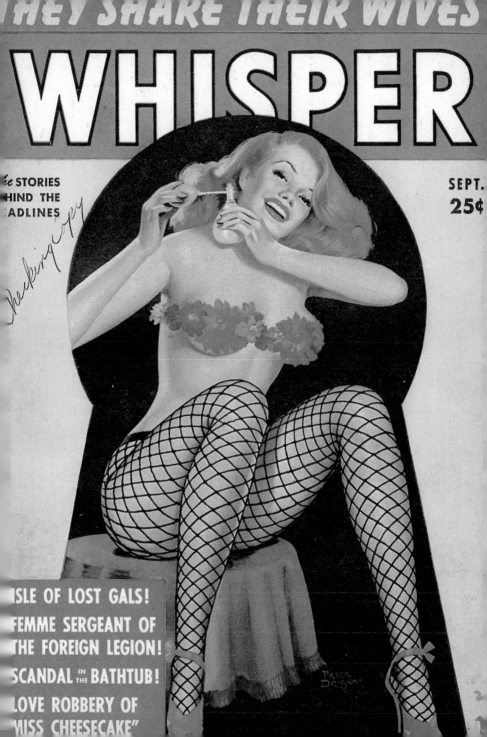

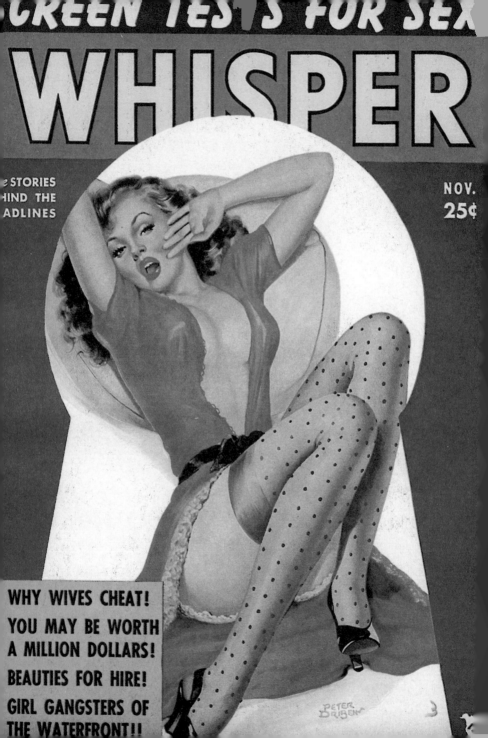

CREEN TESTS FOR SEX

WHISPER

STORIES
HIND THE
ADLINES

NOV.
25¢

WHY WIVES CHEAT!
YOU MAY BE WORTH
A MILLION DOLLARS!
BEAUTIES FOR HIRE!
GIRL GANGSTERS OF
THE WATERFRONT!!

PETER
DRIBEN

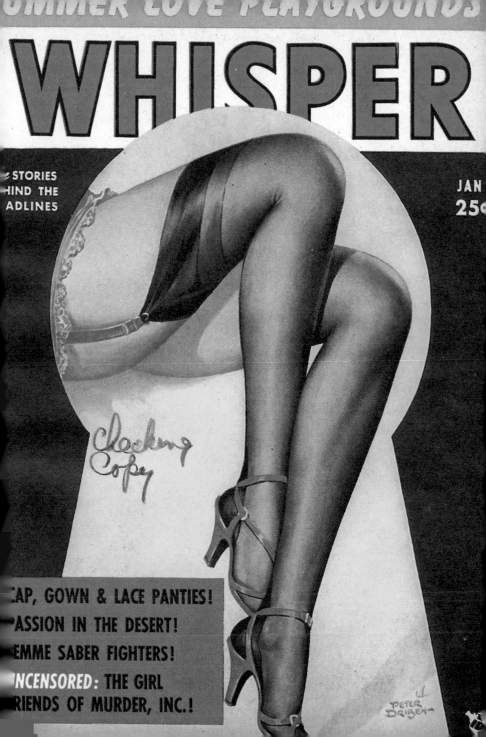

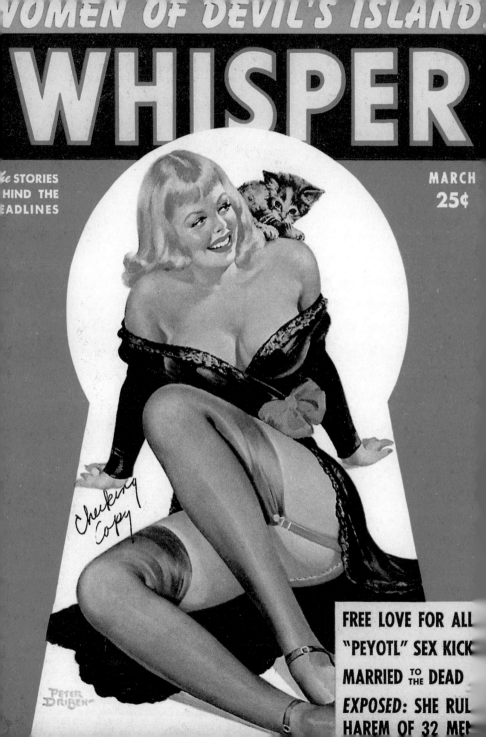

WOMEN OF DEVIL'S ISLAND

WHISPER

he STORIES
HIND THE
EADLINES

MARCH
25¢

Checking Copy

PETER
DRIBEN

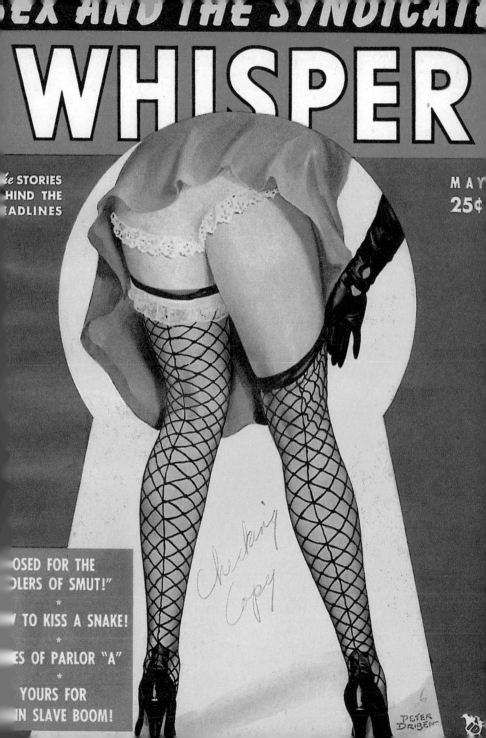

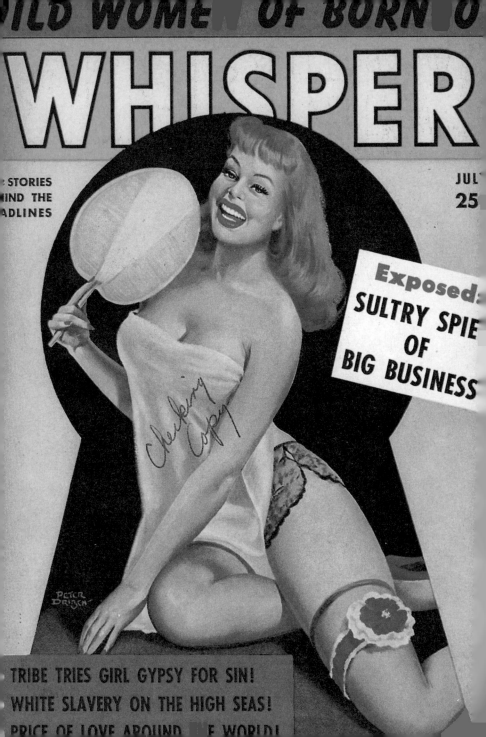

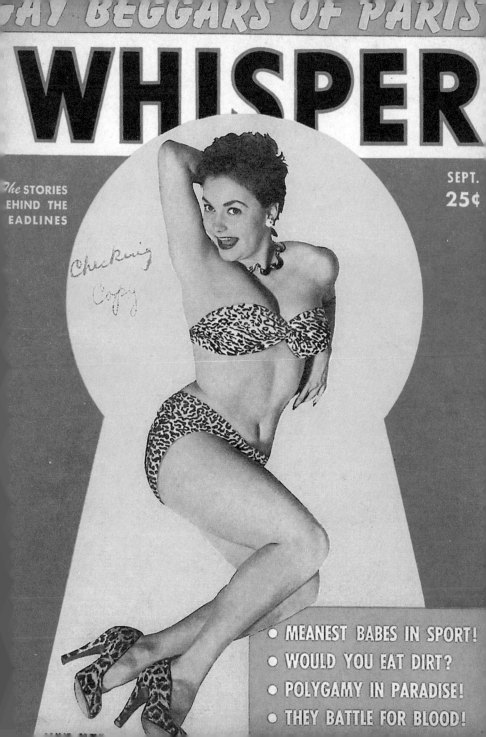

GAY BEGGARS OF PARIS

WHISPER

SEPT.
25¢

The STORIES
BEHIND THE
HEADLINES

Checking
Copy

- MEANEST BABES IN SPORT!
- WOULD YOU EAT DIRT?
- POLYGAMY IN PARADISE!
- THEY BATTLE FOR BLOOD!

WHISPER

STORIES BEHIND THE HEADLINES *Checking Copy* JAN. 25c

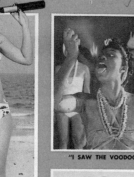

"I SAW THE VOODOO VIRGINS"

SHE GOT 30 DAYS! BOOTY AND BEAUTIES DON'T MIX

WHISPER

PDC THE STORIES BEHIND THE HEADLINES *Checking Copy* MAR.

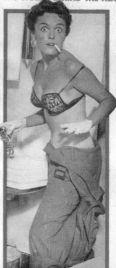

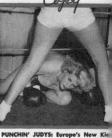

PUNCHIN' JUDYS: Europe's New Kic

EXCLUSIVE

WIVES ON THE LAM DANCING HOUSE BOYS!

NIGHT IN THE CASBAH RENT A WIFE FOR A MONT

WHISPER

STORIES BEHIND THE HEADLINES *Checking Copy* MAY 25c

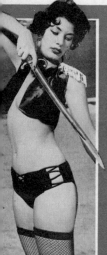

DUEL TO THE DEATH WITH FIRE!

WHISPER

PDC THE STORIES BEHIND THE HEADLINES JUL

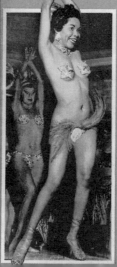

BABES ARE BOOBY TRAPS

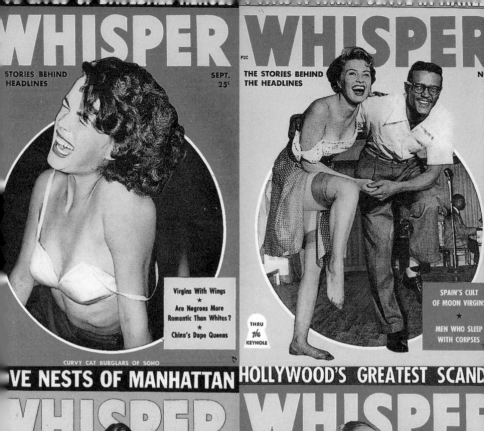

WHISPER

STORIES BEHIND
HEADLINES

SEPT.
25c

Virgins With Wings
★
Are Negroes More
Romantic Than Whites?
★
China's Dope Queens

CURVY CAT BURGLARS OF SOHO

WHISPER

PDC

THE STORIES BEHIND
THE HEADLINES

N

THRU
the
KEYHOLE

SPAIN'S CULT
OF MOON VIRGINS
★
MEN WHO SLEEP
WITH CORPSES

VE NESTS OF MANHATTAN

HOLLYWOOD'S GREATEST SCAND

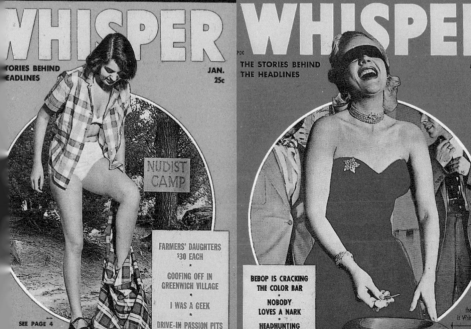

WHISPER

TORIES BEHIND
EADLINES

JAN.
25c

NUDIST
CAMP

FARMERS' DAUGHTERS
$30 EACH
•
GOOFING OFF IN
GREENWICH VILLAGE
•
I WAS A GEEK
•
DRIVE-IN PASSION PITS

SEE PAGE 4

WHISPER

PDC

THE STORIES BEHIND
THE HEADLINES

MA

BEBOP IS CRACKING
THE COLOR BAR
•
NOBODY
LOVES A NARK
•
HEADHUNTING
IS FOR WOMEN

the Wh
is Whisperin

WHISPER

WHISPER

STORIES BEHIND
HEADLINES

APRIL
25c

June

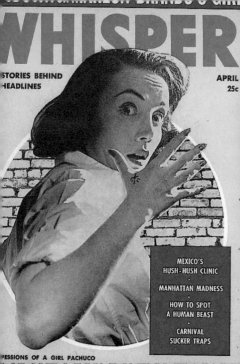

WHY THE SAN FRANCISCO HEIRESS
CALLED PAUL ROBESON "ALL AMERICA"

ALL NEW

The REAL Stories
BEHIND
The Headlines

HARVARD MEN
ARE LOUSY LOVERS!

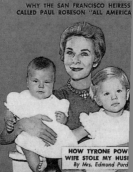

HOW TYRONE POW...
WIFE STOLE MY HUS...
By Mrs. Edmund Purd...

MEXICO'S
HUSH-HUSH CLINIC

MANHATTAN MADNESS

HOW TO SPOT
A HUMAN BEAST

CARNIVAL
SUCKER TRAPS

...FESSIONS OF A GIRL PACHUCO

...RLON BRANDO'S BIG SECRET ...ACKIE ROBINSON'S DARKEST HO...

WHISPER

WHISPER

Aug. 25c

Sept. 25c

DEANNA DURBIN
NEVER COME BACK!

...OW HONEST ARE
...SEBALL UMPIRES?

HOLLYWOOD'S
No. 1 MADAME

...HY RED SKELTON'S
...ONES ARE RATTLING!

JOAN CRAWFORD
THE STAR THEY LOVE TO HATE

BLACKBOARD JUNGLE:
THE MOVIE THAT
MAKES DELINQUENTS

UNTOLD STORY OF
VICTOR MATURE

WHAT THE KIDS
DON'T KNOW ABOUT
PINKY LEE

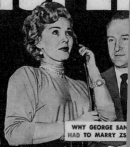

WHY GEORGE SAN...
HAD TO MARRY ZS...

PEARL BAILEY HOOKED A WHITE HUSBAND

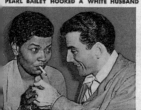

78388
POLICE DEPT
CLEVELAND O

I WAS DR. SAM'S CELLMATE

The Frank That
Should Be Roasted

How Gloria Vanderbilt
Gets Her Men

The Scott Brady
Pajama Game

WHISPER

ct. 25c

ARA HUTTON'S STRANGEST LOVE

AVA GARDNER
THE TOMATO
THEY FORGOT TO CAN

WHISPER

PDC

Nov

MADAME SUN YAT SEN'
AMERICAN LOVER
—
THE SKELETON
IN CHARLIE BARNET'S
BACKYARD
—
THE GIRL WHO SAID "NO!"
TO TOMMY MANVILLE
—
WHY YOUR SPORTS PAGES
ARE OFTEN
PACKED WITH LIES!

A MAN WITH A NOSE FOR WOMEN

RILYN MONROE'S
MISSING MOLE"
—
HOW LEX PUT
HE HEX ON LANA
—
THE BIGGEST BUM
IN BOXING
—
HE MOST CORRUPT
RISON IN THE WORLD

EXCLUSIVE: IS
FATHER DIVINE DEAD?

WHEN HEMINGWAY
BACKED OUT OF A DUEL

PAT WARD'S
STRANGE INTERLUDE

HARRY BELAFONTE MONIQUE VAN VOO
THE LOVE LIFE OF AN INTERNATIONAL PLA

WHISPER

Dec. 25c

Man With Whom GARBO
WANTS TO BE ALONE

WHISPER

Jan.
25c

LIFE AND LOVES OF LANA TURNER
—
ABORTION: THE SHAME OF THE NATIC
—
THE WOMAN JOE LOUIS REALLY LOV
—
VIXENS, VICE AND VASSAR

MEANWHILE, BACK AT THE RANCH
This OPEN LETTER TO SAMMY DAVIS JR.
tells what really happened there!

HILDEGARDE'S
DARKEST NIGHT

R THE PIT:
CK HAYMES
—
TRUTH ABOUT
TANTE DRUNKS
—
RLING HAYDEN:
OD'S No. 1 PATSY
—
CESAREANS
RE NO CINCH
—
SIMONE SILVA'S
ERICAN AFFAIR

BILL ZECKENDORF AT
THE NUDIST WEDDING?

JUDY GARLAND AND
THE GOOFBALL CAPER

WHISPER WHISPER

RY MARCIANO'S SECRET SHAME

JAMES DEAN'S BLACK MADONNA
The most chilling and tragic love story in Hollywood history

- SIX DAYS AND NIGHTS WITH HURRICANE TALLULAH
- WHY JUNE HAVER'S MOTHER WAS JEALOUS
- ARE NEGRO BOXERS WASHED UP?
- BETTY HUTTON: THE BELLE WITH THE BRASSY RING
- WHAT THE CENSORS MISS ON THE COVER OF "PUNCH"!

Mar.

he Purgatory of
rs. Edmund Purdom

PEN LETTER
BETTY GARRETT

BIGGEST GHOST
HE OLD PAYOLA

GEORGE RAFT:
$10,000 PATSY

LTERY: AMERICA'S
ST GROWING CRIME

HOW TO HAVE
EW CAR EVERY YEAR

IN THE PIT:
EARTHA KITT

CORNELIUS VANDERBILT'S
REFORM SCHOOL WIFE

What John Barrymore Jr.
Won't Tell His Teenage Fans

SOCIETY'S JULIET AND HER DUSKY ROMEO

MES DEAN'S FANS TALK BACK HE GIRL WHO GOT WILLIE MA

WHISPER WHISPER

- JOHN AGAR'S NIGHT OF LOVE
- PREP SCHOOLS: HOTBEDS OF SCANDAL
- RITA HAYWORTH: THE CHICK WHO KEEPS LAYING EGGS

XCLUSIVE: What Her PRINCE
esn't Know About GRACE KELLY

ATWATER KENT:
GOODBYE, SUCKER!

JUN

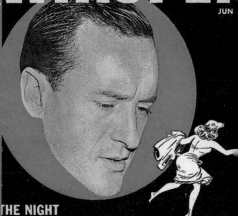

THE NIGHT
GEORGE SANDERS STRUCK OUT

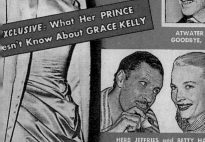

HERB JEFFRIES and BETTY HAYDEN 4
MISBEHAVIN' AGAIN!

- LIBERACE: THE HAM THAT WAS OVERDONE ○ YOUR VIRILITY CAN HAVE 9 L
- EXCLUSIVE: BEHIND THE SCENES AT THE $64,000 QUESTION ○
- SALLY RAND AND HER LALLA-POP ○ STOP KICKING OUR SERVICEMEN AROL

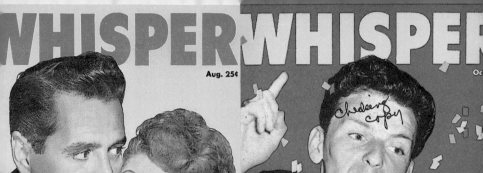

WHISPER

Aug. 25¢

The Night
SI ARNAZ
sn't Even
alf Safe!

TTER TO BILLY DANIELS • THE CURSE OF ADLAI STEVENSON •
OINT: SCHOOL FOR SADISTS? • AVA GARDNER AND THE LATIN-AMERICAN AFFAIR •
YNE MEADOWS IS SAYING "I'VE GOT A SECRET!" • PIGEON KILLERS, INC. •

WHISPER

Oc

Checking Copy

The WILD PARTY That
Helped SINATRA Forget
AVA GARDNER

RS. CARRADINE'S OTHER JOHN • THE MARINES' TOUGHEST F
• HOW I SOLD TV SETS • OPEN LETTER TO SUSAN HAYWAR
AYNE MANSFIELD: CC OF MM • NEW DRUG ELIMINATES OLD

MES DEAN Vs. ELVIS PRESLEY

WHISPER

Dec
25¢

Checking copy

FROM HERE TO MATERNITY
Starring: GRACE KELLY
(Assistant Producer: PRINCE RAINIER)

RL'S OVERNIGHT POP • DANA ANDREWS: 100 PROOF LOVER
ARD CARLSON'S "THRILL-A-MINUTE" PARTY • TV WRECKS •
AMES' HOT SOLO • PILLS MAKE COLORED PERSONS WHITE •

ELVIS PRESLEY FANS SPIT BA

WHISPER

Feb. 25c

Checking copy

Liz Taylor and Monty Clift: The Match That Burned Up A Town

HOW JAMES DEAN GOT AN OSCAR • WYATT EARP AND THE F
BEWARE OF BARGAINS • KIM NOVAK AND THE BANK ROBB
ANA TURNER'S HOT NIGHTS AT HOME • LIVE WITHOUT WORK

WHISPER

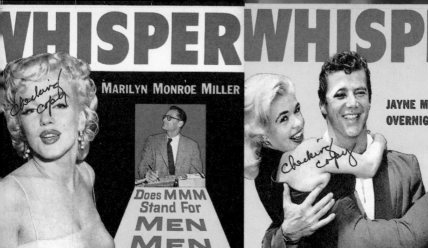

Checking Copy

MARILYN MONROE MILLER

Does MMM Stand For
**MEN
MEN
MEN**

• DORS' PEEPHOLE PARTIES • 10 WAYS TO MAKE HEADLINES •
AILEY PROVED HE'S ALL MAN • DENISE DARCEL'S 3 ADAMS •
PIDGEON AND THE CHICK • PONCHO DAY AT WEST POINT

NCREASE YOUR VIRILITY—HARMLESSLY!

WHISPER

June

JAYNE MANSFIELD'S OVERNIGHT MICKEY

Checking Copy

ANE CLARK'S BEDTIME STORY • THE REDHEAD UP IN RUBI'S RO
• LINDA CHRISTIAN'S CHUMMY CHA-CHA-CHA •
LY DANIELS AND THE CALL GIRL • HOW TO SPOT A SEX PSYC

ARRY BELAFONTE'S BIG PROBL

WHISPER

Checking Copy Aug. 25c

WHY ROME BURNED WHILE
SOPHIA LOREN FIDDLED

D DUFF'S FORMER EYES • THE MEN WHO MADE KIM NOVAK •
RACKET IN HUMAN EYES • BURL IVES AND THE CALL GIRL •
TUCKER AND HIS STRIP "TEAS" • SCOTT BRADY'S LOVE NEST

WHISPER

What Makes Rosse
Run . . . From
INGRID BERGMA

IKE WILDING'S WILDEST NIGHT • 10 WAYS TO PICK UP A C
• ANN BLYTH: THE GIRL WHO SHOCKED HOLLYWOOD •
Y MADISON AND THE FILLY • HOW WOMEN CHANGE THEIR

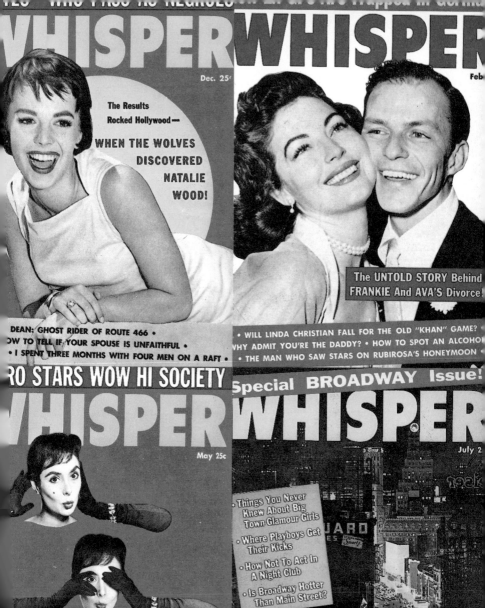

WHISPER

Dec. 25¢

The Results
Rocked Hollywood—

**WHEN THE WOLVES
DISCOVERED
NATALIE
WOOD!**

DEAN: GHOST RIDER OF ROUTE 466 •
OW TO TELL IF YOUR SPOUSE IS UNFAITHFUL •
• I SPENT THREE MONTHS WITH FOUR MEN ON A RAFT •

WHISPER

Feb

**The UNTOLD STORY Behind
FRANKIE And AVA'S Divorce!**

• WILL LINDA CHRISTIAN FALL FOR THE OLD "KHAN" GAME?
WHY ADMIT YOU'RE THE DADDY? • HOW TO SPOT AN ALCOHOL
• THE MAN WHO SAW STARS ON RUBIROSA'S HONEYMOON

RO STARS WOW HI SOCIETY

WHISPER

May 25c

Special BROADWAY Issue!

WHISPER

July 2

• Things You Never
Knew About Big
Town Glamour Girls
• Where Playboys Get
Their Kicks
• How Not To Act In
A Night Club
• Is Broadway Hotter
Than Main Street?

ock'n'Roll
cts Couldn't Sleep
cts About
nale Fashions
e Jelly—
Royal Flop?
in $10,000-a-Year
the Horses

Fl

A FRESH

irt

AGAZINE

1947–1955

It seems that Harrison did not quite trust the new recipe that he was trying out in Whisper. Whereas there he was already practising a cheap trash aesthetic, retailing neighbourhood models as black-magic priestesses or as the victims of brutal gypsy rites in the Balkans, or flatly maintaining that the craters on the Moon were bomb craters resulting from an interstellar dispute, the latecomer from Harrison's stable remained true to the old cocktail of "Girls, Gags & Giggles" with a couple of fetishistic themes tossed in for good measure.

The first issue boasted "highlights" such as "How to become a playboy", a centrefold model in chains, and a double-page pin-up poster urging readers to buy enough copies of the magazine to redecorate their flats. It was a rather stale old brew, but the mixture still worked. Harrison looked to see what the war had left of the "famous Parisian boudoirs", and his copywriting hacks – men of letters to the last – delighted in a new vocabulary when they came to wax lyrical about sensuality: "As devastating as the mysterious atom bomb is Paula Stratton..."!

Offensichtlich traute Harrison der neuen Mischung, die er mit Whisper ausprobierte, noch nicht recht. Während er sich dort bereits in einer „esthétique du schlock" übte und Models aus der Nachbarschaft als Schlangenpriesterinnen oder Opfer rüder Zigeunerbräuche auf dem Balkan verkaufte und Mondkrater kurzerhand zu Bombentrichtern einer interstellaren Meinungsverschiedenheit erklärte, hielt sich der Nachzügler in Harrisons Stall getreu an die alte Rezeptur aus „Girls, Gags & Giggles" und ein paar Fetischmotiven. Zu den „Highlights" zählten der Ratgeber „Wie werde ich ein Playboy?", ein Centerfold in Ketten und eine Doppelseite mit einer Pin-up-Tapete nebst Aufforderung, möglichst so viele Exemplare des Magazins zu kaufen, daß es für eine Wohnungsrenovierung reicht. Ein etwas altmodisches Pflänzchen, das Harrison da in sein Bukett gesteckt hatte, aber die Mischung zog noch. Man schaute nach, was der Krieg von den „berühmten Pariser Boudoirs" übriggelassen hatte, und Harrisons Texter erfreuten sich an einigen neuen Vokabeln, wenn es darum ging, das Hohelied der Sinnlichkeit beherzt anzustimmen: „As devastating as the mysterious atom bomb is Paula Stratton"

Manifestement, Harrison n'osait pas encore se fier entièrement à la nouvelle mouture qu'il expérimentait avec Whisper. Tandis qu'il s'essayait, dans ce magazine, à une «esthétique du schlock», qu'il vendait des modèles pris dans son voisinage comme des prêtresses contorsionnistes ou des victimes des coutumes barbares de gitans des Balkans ou encore déclarait carrément que les cratères lunaires étaient des entonnoirs de bombes dus à des guerres interstellaires, le benjamin de l'écurie de Harrison s'en tenait à la vieille recette de «Girls, Gags & Giggles» et à l'adjonction de quelques fétiches. Parmi les «têtes d'affiche» qui devaient attirer les lecteurs, le premier numéro proposait en page centrale un modèle enchaîné, une page-conseils expliquant comment devenir un play-boy, ainsi qu'une petite spécialité de la maison, à savoir deux pages de papier peint dont les motifs représentaient des pin ups, avec conjointement une invitation à acheter autant d'exemplaires qu'il serait nécessaire pour refaire un appartement complet. Un cocktail certes un peu démodé mais qui marchait encore. On se mit après la guerre à examiner ce qui restait des «célèbres boudoirs parisiens», et les infatigables rédacteurs d'Harrison, qui avaient tous la plume facile, s'en donnèrent à cœur joie: «Paula Stratton fait autant de ravages que la mystérieuse bombe atomique.»

Flirt

DEC.

25¢

Bevies of
HIGH-HEEL
BEAUTIES

Billy DeVorss

A NEW FRESH MAGAZINE

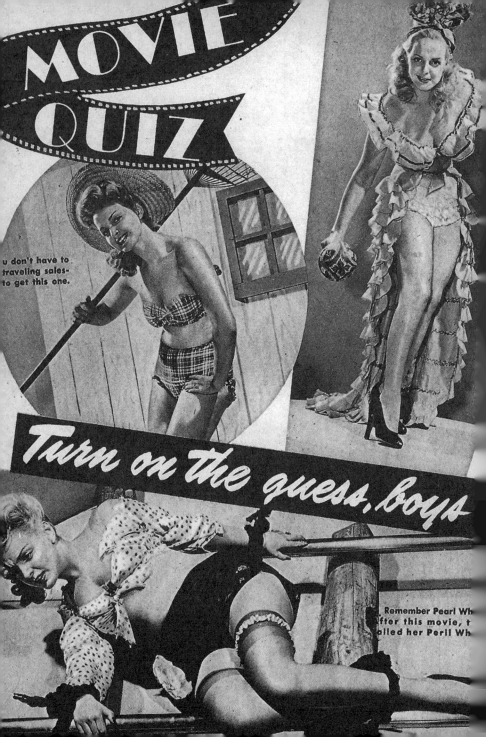

MOVIE QUIZ

u don't have to
traveling sales-
to get this one.

Turn on the guess, boys

Remember Pearl Wh
fter this movie, t
alled her Peril Wh

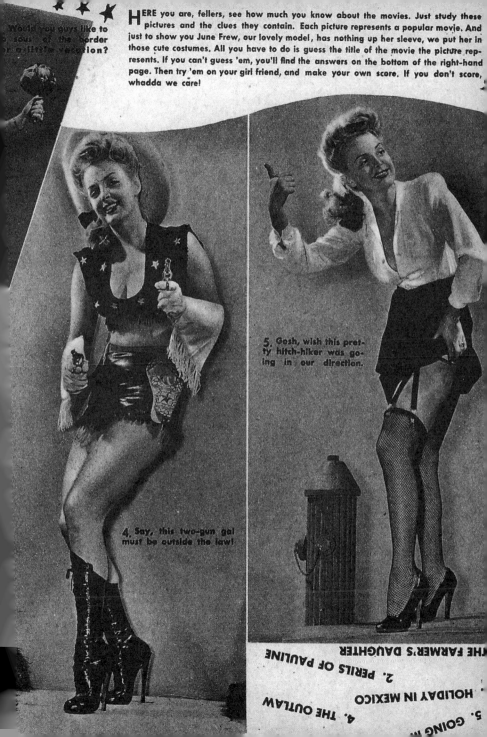

HERE you are, fellers, see how much you know about the movies. Just study these pictures and the clues they contain. Each picture represents a popular movie. And just to show you June Frew, our lovely model, has nothing up her sleeve, we put her in those cute costumes. All you have to do is guess the title of the movie the picture represents. If you can't guess 'em, you'll find the answers on the bottom of the right-hand page. Then try 'em on your girl friend, and make your own score. If you don't score, whadda we care!

Would you guys like to go sous of the border for a little vacation?

5. Gosh, wish this pretty hitch-hiker was going in our direction.

4. Say, this two-gun gal must be outside the law!

THE FARMER'S DAUGHTER

2. PERILS OF PAULINE

4. THE OUTLAW

5. GOING IN HOLIDAY IN MEXICO

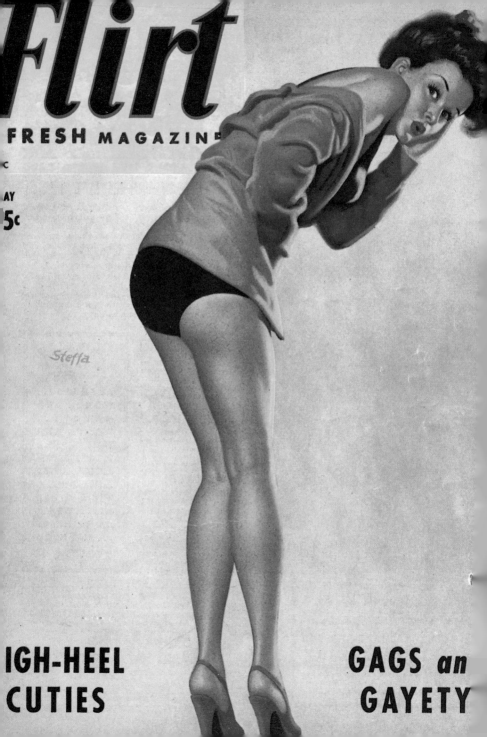

Flirt

FRESH MAGAZINE

AY
5c

Steffa

IGH-HEEL
CUTIES

GAGS an
GAYETY

AUGUST
25c

Flirt

FRESH MAGAZINE

Bevies of

HI-HEEL

ONEYS

PETER
DRIBEN-

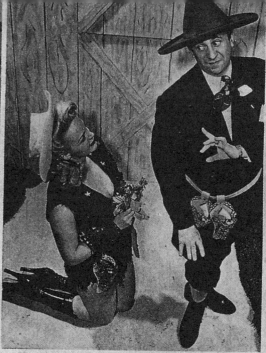

1. "used to dream that I could be a cowboy,
 a-ridin' and a-ropin' where the wind is free.
 Now I'm sorry that I'm a cowboy, 'cause
 look what's gone and happened to me."

2. "I used to be a lady-killin' dandy,
 The women liked my huggin' and my kissin' too.
 I allers used to bring 'em flowers and candy
 I used to love them gals—but what can I do?"

4. "But now I guess she'd better wed another,
 'Cause for me she'd have a heck of a wait."

I CAN'T GET OFFA MY HORSE"

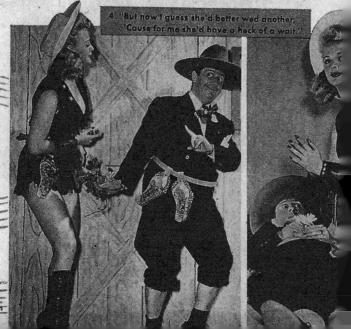

and Music by Morey Amsterdam
ht 1947, Leo Feist, Inc.

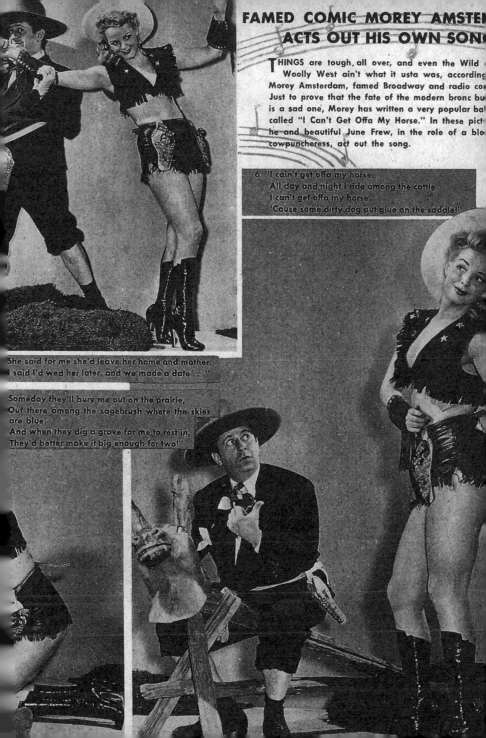

FAMED COMIC MOREY AMSTER
ACTS OUT HIS OWN SONG

THINGS are tough, all over, and even the Wild
Woolly West ain't what it usta was, according
Morey Amsterdam, famed Broadway and radio com
Just to prove that the fate of the modern bronc bu
is a sad one, Morey has written a very popular ba
called "I Can't Get Offa My Horse." In these pict
he and beautiful June Frew, in the role of a blo
cowpuncheress, act out the song.

6. "I cain't get offa my horse,
All day and night I ride among the cattle.
I can't get offa my horse,
'Cause some dirty dog put glue on the saddle!"

She said for me she'd leave her home and mother.
I said I'd wed her later, and we made a date . . ."

Someday they'll bury me out on the prairie,
Out there among the sagebrush where the skies
are blue,
And when they dig a grave for me to rest in,
They'd better make it big enough for two!"

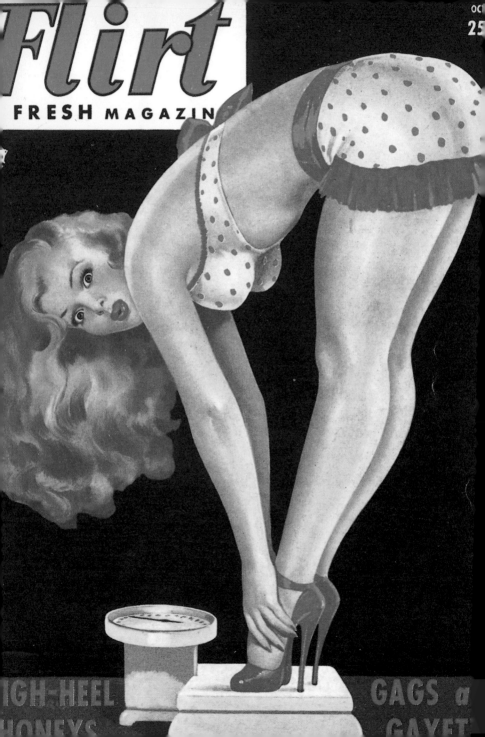

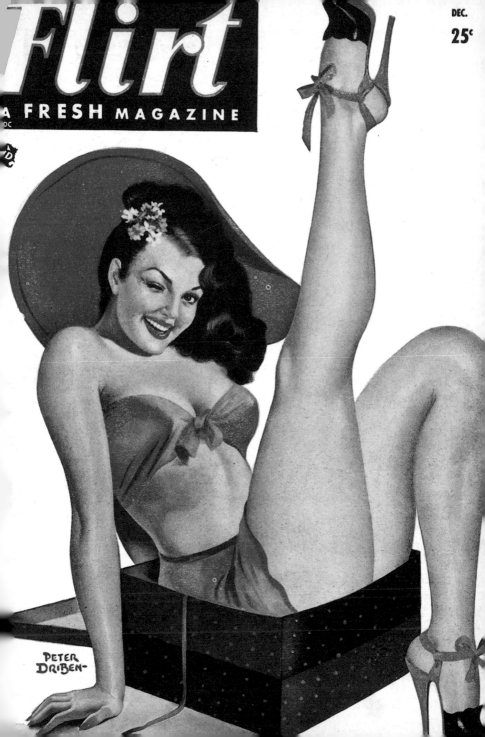

The Diary of a

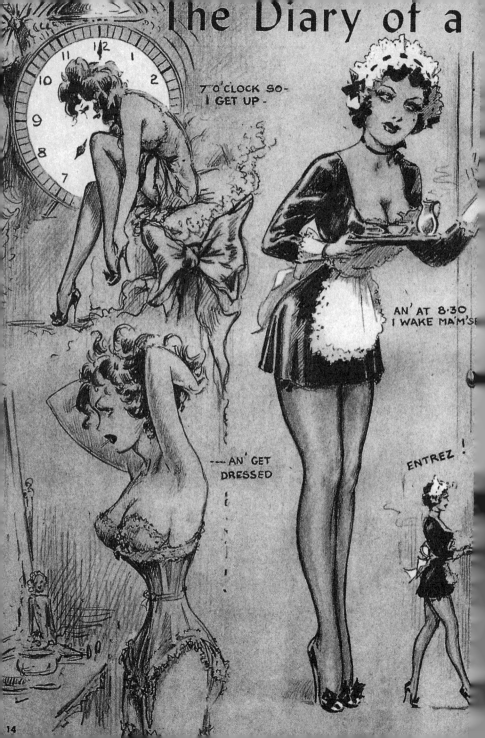

7 O'CLOCK SO -
I GET UP -

AN' AT 8·30
I WAKE MA'M'S

--- AN' GET
DRESSED

ENTREZ !

ench Maid

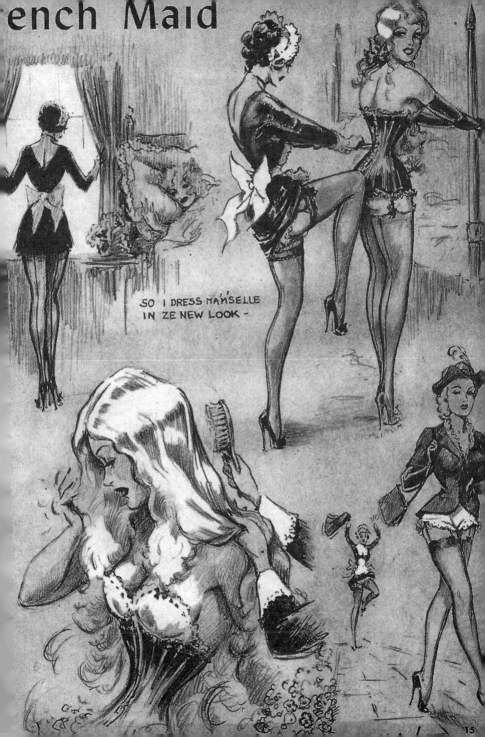

SO I DRESS MAM'SELLE
IN ZE NEW LOOK ~

15

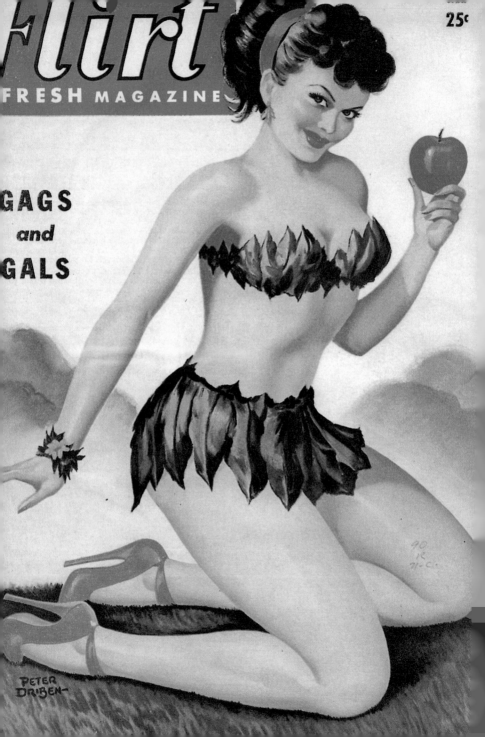

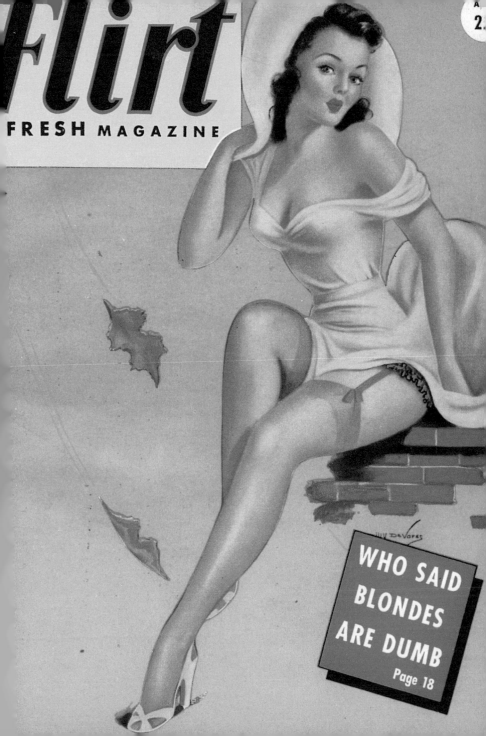

Flirt

FRESH MAGAZINE

A.
2.

WHO SAID
BLONDES
ARE DUMB
Page 18

Let's Have Fun

PARDON, MY ARRER

IS IT TRUE WHAT THEY SAY ABOUT DIXIE?

HOME ON THE RANGE

DOIN' HER DAILY DOZIN'

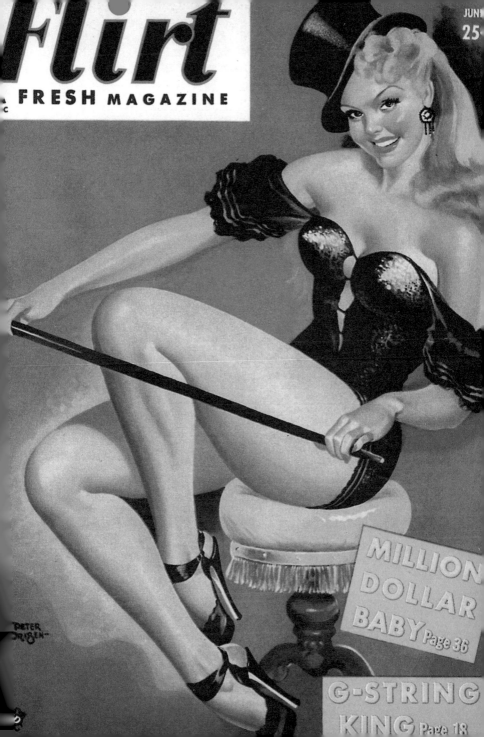

Flirt

FRESH MAGAZINE

JUNE
25¢

PETER
DRIBEN

MILLION
DOLLAR
BABY Page 36

G-STRING
KING Page 18

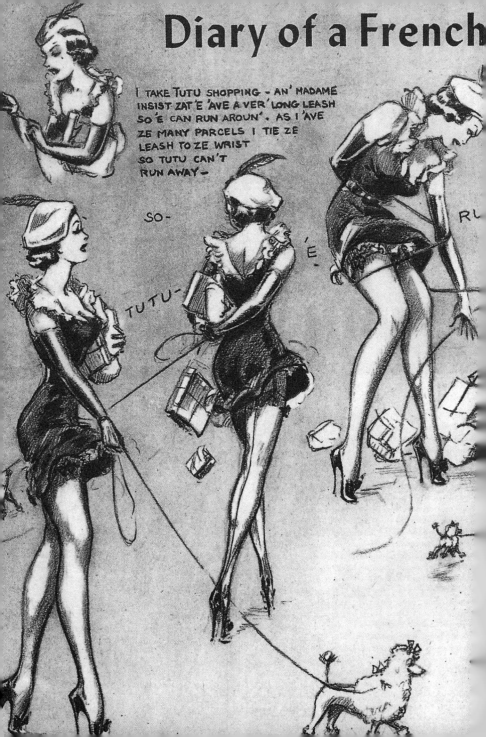

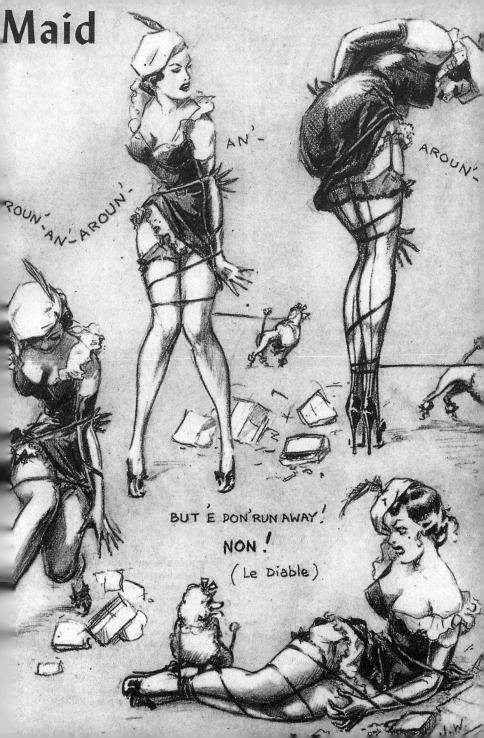

AUG.

25¢

Flirt

FRESH MAGAZINE

HINTS FOR BASHFUL BACHELORS
Page 18

CHOOL for STRIPPERS
Page 26

PETE
DRIB

It's time to retire, says Christine, and if you guys will just turn your backs, she'll be off to the Land of Nod. To that we say nodding doing!

Ready for beddy, these glamorous pajamazons are sure to widen YOUR peepers

Retiring Misses

OCT
25

FUN AFTER MIDNIGHT

Page 14

WHAT GALS LIKE IN MEN Page 22

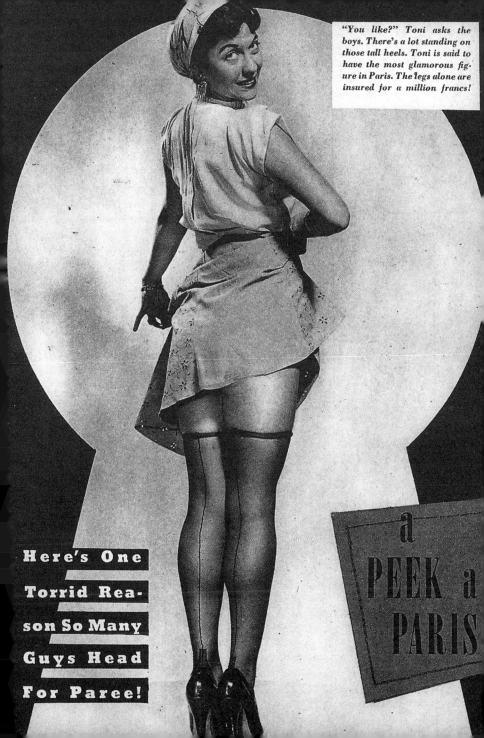

"You like?" Toni asks the boys. There's a lot standing on those tall heels. Toni is said to have the most glamorous figure in Paris. The legs alone are insured for a million francs!

Here's One Torrid Reason So Many Guys Head For Paree!

a PEEK a PARIS

Doris Mackey

A Cute Eye-Dear

Ungartered Moment

Bonnie Blair

Gloria Reines

The Thigh's
The Limit

Maid
For Love

Heart
to
Beat

Laura Drake

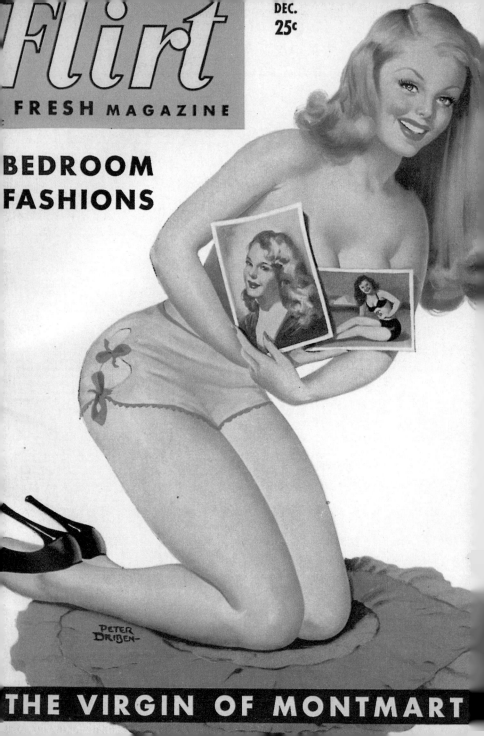

FEB.

25¢

flirt

FRESH MAGAZINE

FUN IN THE BOUDOIR

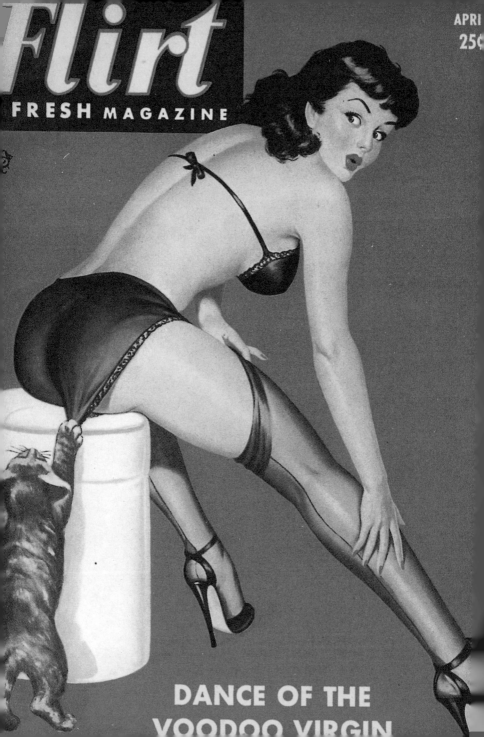

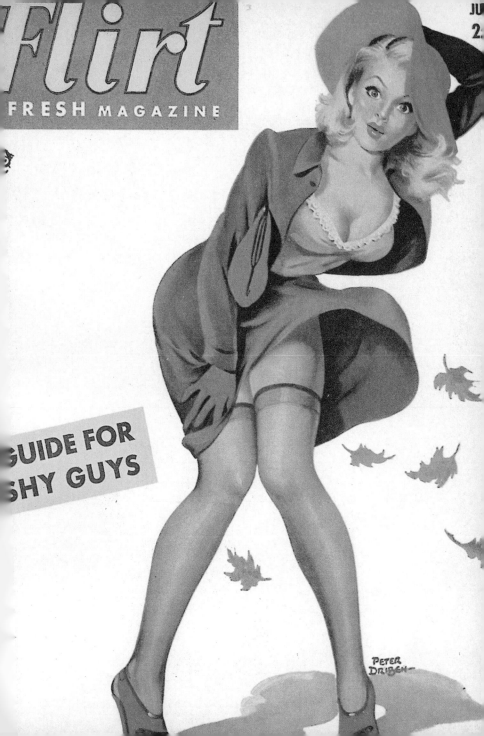

flirt
FRESH MAGAZINE

ABES ARE NO MYSTERY

PETER
DRUBEN

Luscious Lovely

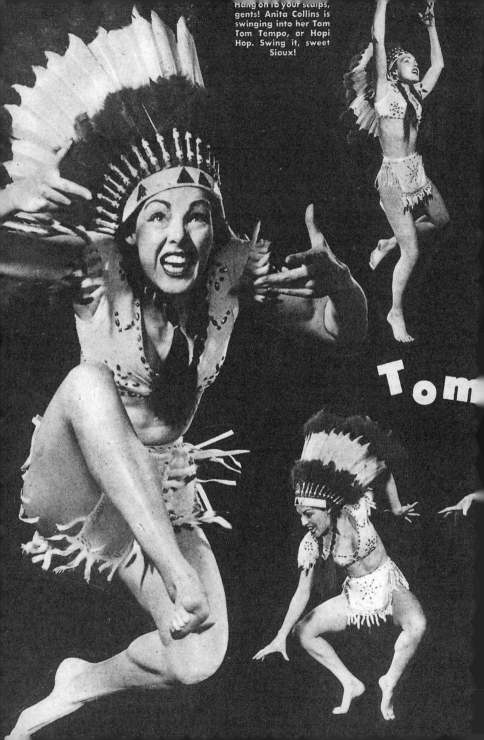

Hang on to your scalps, gents! Anita Collins is swinging into her Tom Tom Tempo, or Hopi Hop. Swing it, sweet Sioux!

Tom

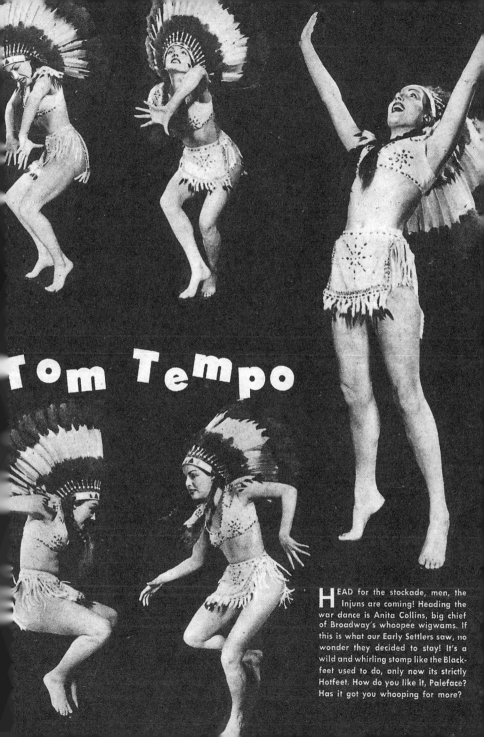

Tom Tempo

HEAD for the stockade, men, the Injuns are coming! Heading the war dance is Anita Collins, big chief of Broadway's whoopee wigwams. If this is what our Early Settlers saw, no wonder they decided to stay! It's a wild and whirling stomp like the Blackfeet used to do, only now its strictly Hotfeet. How do you like it, Paleface? Has it got you whooping for more?

Flirt

FRESH MAGAZINE

PEROXIDE AND WRESTLING

PETER DRIBEN

Gregg Sherwood
Turns Cartoonist

OH, brother, plenty can happen when a lovely showgirl decides to turn cartoonist and offer competition to strips like Lil Abner and things like that. But you certainly can't blame our platinum-blonde beauty from Wisconsin for trying. A college-bred eyeful, glamorous Gregg always did have a yen for a career in art, only nobody wanted to take Chinese money. So Gregg set up her own studio and what happened to her makes a comic strip in itself. What we wanna know is why Gregg has to worry about pencil lines when her own are so famous already. Betcha all agree, tho, that she's a real art throb!

Yessir, fellers, Gregg's an art-working showgir

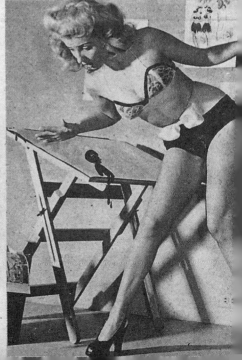

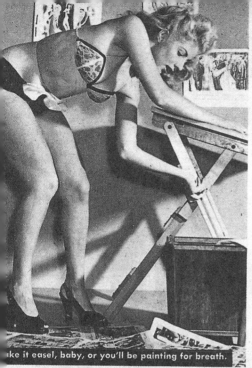

ke it easel, baby, or you'll be painting for breath.

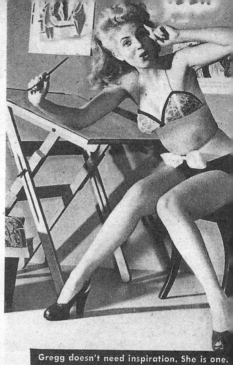

Gregg doesn't need inspiration. She is one.

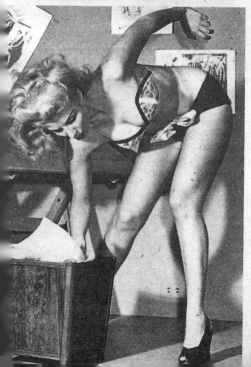

7

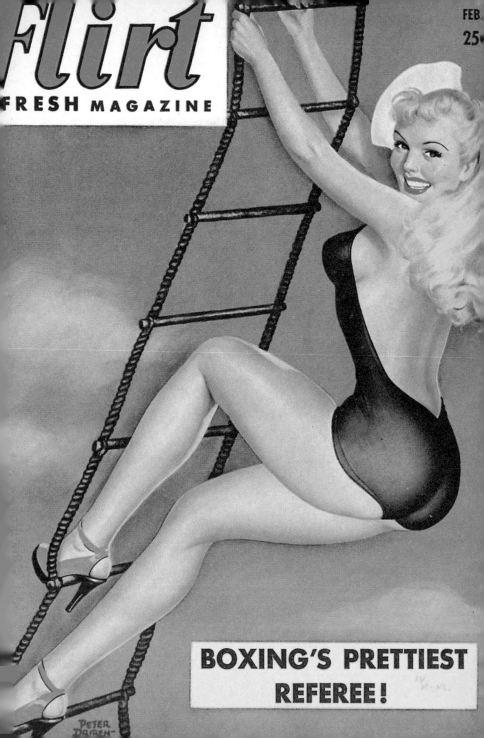

flirt
FRESH MAGAZINE

FEB.
25¢

BOXING'S PRETTIEST
REFEREE!

PETER
DRIBEN

10 NIGHTS IN A BARRED ROOM!!!

Jane went to jail — not hers the fault!
She beat an egg; they charged assault.
She burned the toast; "Arson!" they said.
Cheating at solitaire? "Not guilty," she pled.

For "crooked seams" in her nylon gams
The prison gate behind her slams.
The mean old judge gave her ten days
But the guys gave Jane loud hurrays!

Once, playing ball, Jane "stole" a base.
Against poor Jane they built a case.
She'd like to be some guy's soul-mate
But now she's jailed — and no cell-mate!

The warden said, "Start breakin" stones!
"From those big rocks, make little ones!"

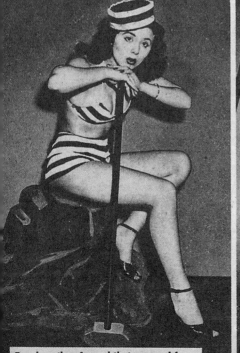

Ten days they framed that poor gal for

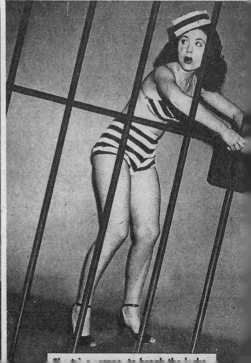

She tries a screwy to break the jocks

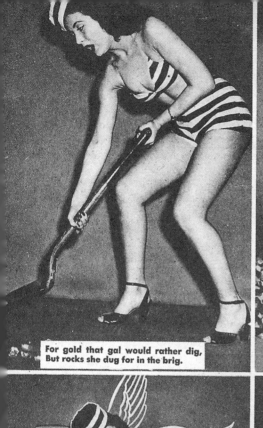

For gold that gal would rather dig,
But rocks she dug for in the brig.

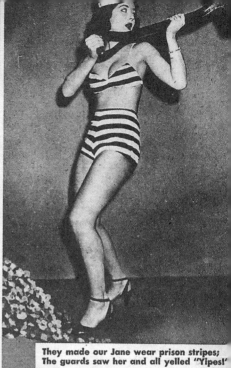

They made our Jane wear prison stripes;
The guards saw her and all yelled "Yipes!"

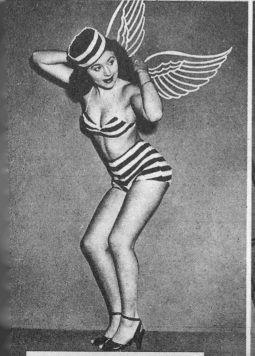

The warden fell, said "You're a dove!!!"

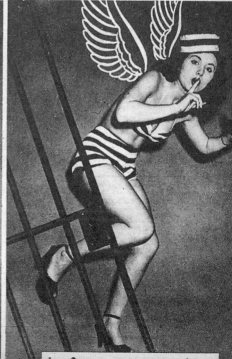

Flirt

FRESH MAGAZINE

GALS, GAGS and GAYETY

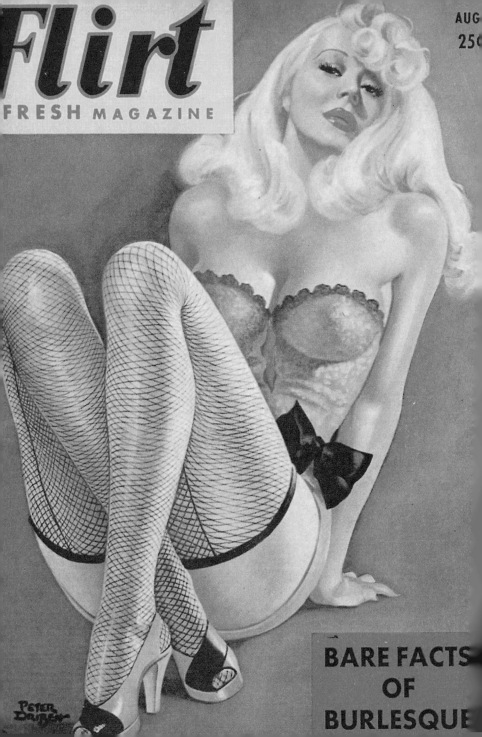

▲▲ *After a tough evening watchin' TV. This is China Corey, who earns nylon money by modeling sweaters in Chicago. China brings to her job a 35½" bust, 25" waist, 35" hips— and 19½ thighs, just for good measure!*

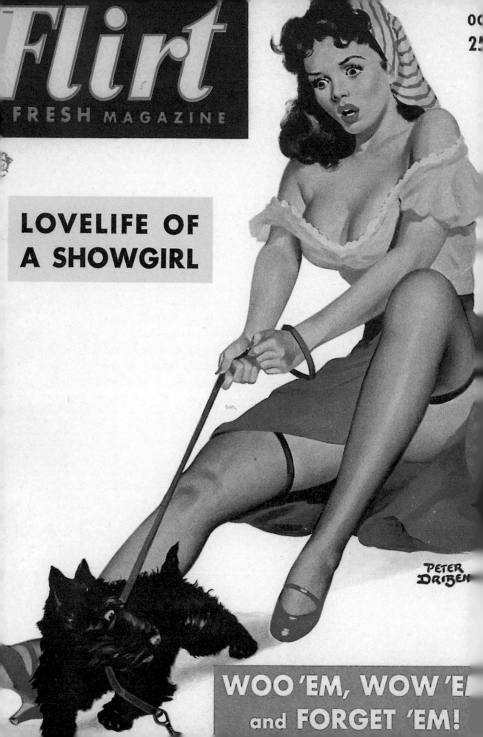

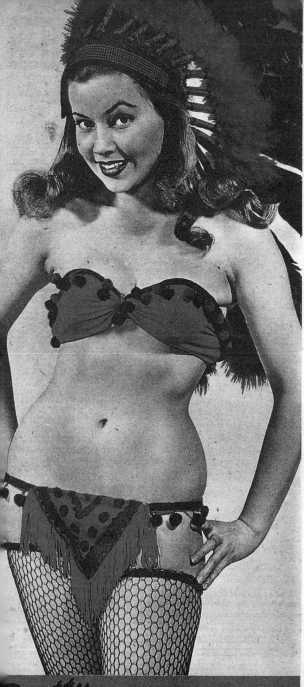

Pretty Papoose — OUT for your scalp, Joe, is heap curvy Injun princess Ava Norring. With or without warpaint, Ava is 25" at the waist, 34" at bust, 35"

Flirt

FRESH MA

The

IGH COST

F LOVIN'

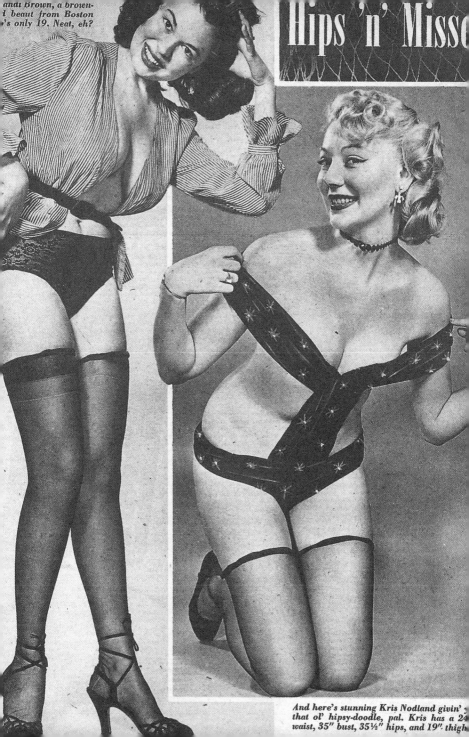

andi Brown, a brown-
l beaut from Boston
's only 19. Neat, eh?

Hips 'n' Misse

And here's stunning Kris Nodland givin' :
that ol' hipsy-doodle, pal. Kris has a 24
waist, 35" bust, 35½" hips, and 19" thigh

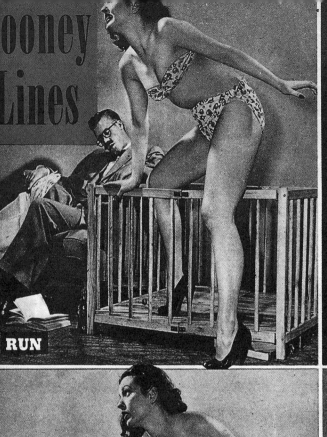

ooney

Lines

RUN

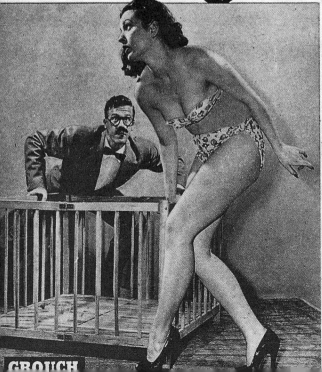

GROUCH

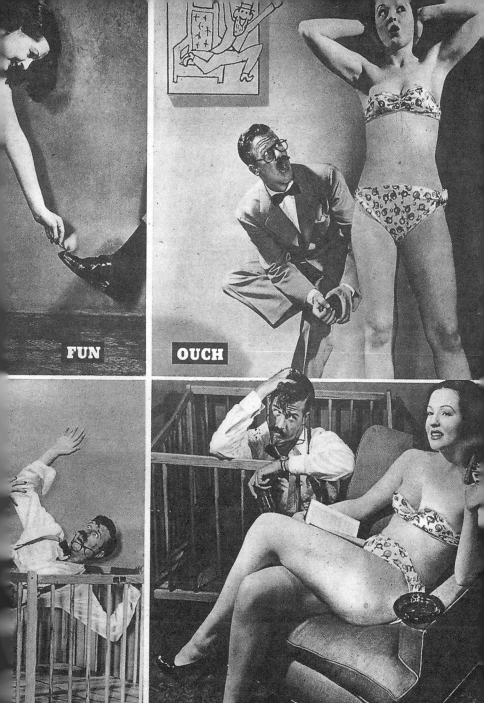

FUN

OUCH

Flirt
FRESH MAGAZINE

FE
2.

IN THIS ISSUE:

How to
KEEP YOUR
HONEY WARM

PETER
DRIBEN

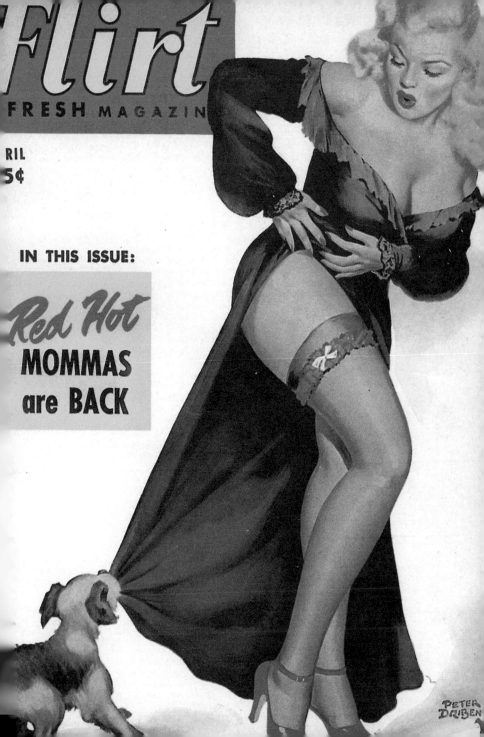

*H*EY, *Oscar, pull up a chair and feast your peepers on the curvesome charms of Holly Day. She's a lassie with a classy chassis, an' we can prove it. F'rinstance, Holly's 5'8" from top to tootsies, a neatly packaged 133 lbs. and she's 34" at the bust, 24" waist, and 35" round the hips. Only 19, Holly comes from way down yonder in Arizona, but she's now modeling in Gotham. When it comes to guys, she likes 'em tall, handsome 'n' rugged. Well?*

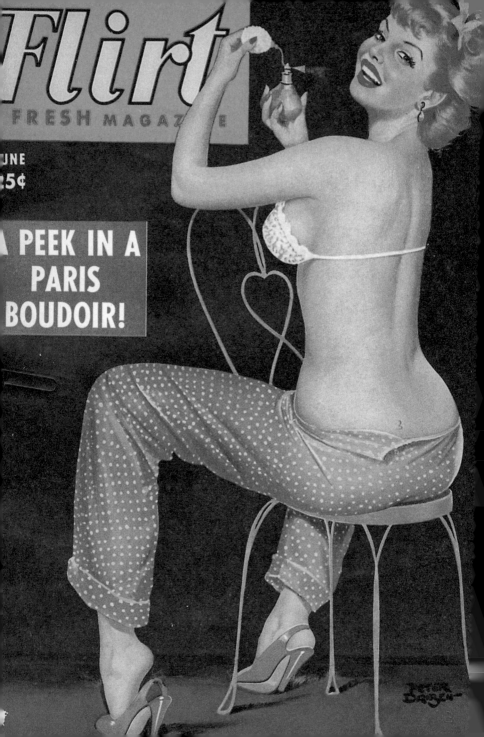

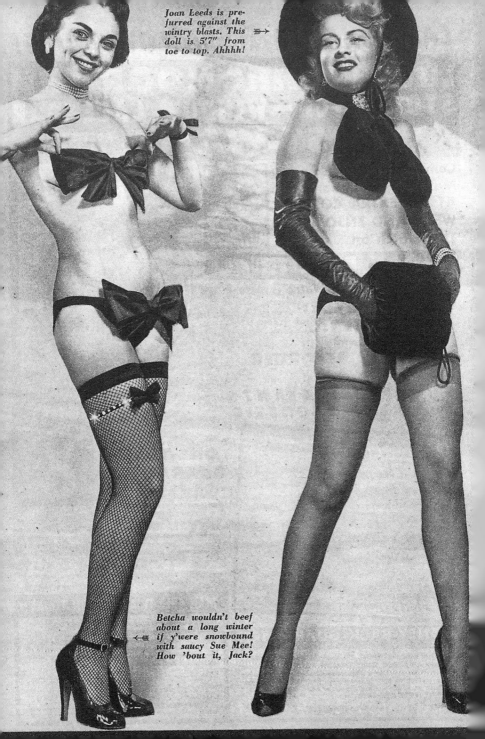

Joan Leeds is pre-furred against the wintry blasts. This doll is 5'7" from toe to top. Ahhh! ➡

Betcha wouldn't beef about a long winter if y'were snowbound with saucy Sue Mee! How 'bout it, Jack? ⬅

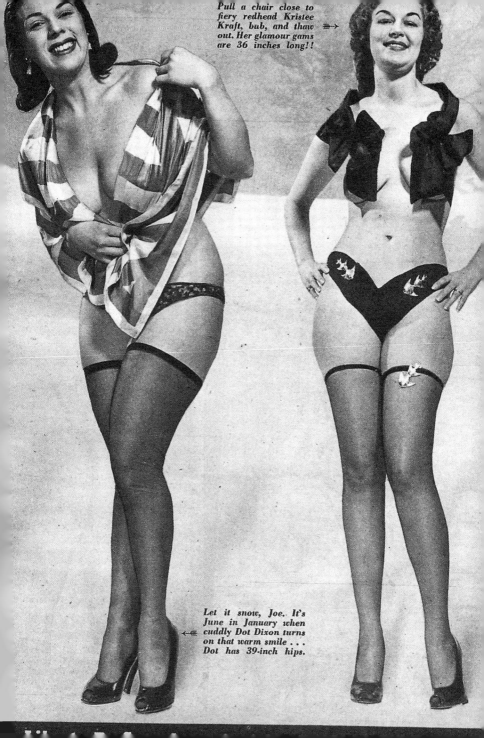

Pull a chair close to fiery redhead Kristee Kraft, bub, and thaw out. Her glamour gams are 36 inches long!! ⇒⇒

← ← Let it snow, Joe. It's June in January when cuddly Dot Dixon turns on that warm smile . . . Dot has 39-inch hips.

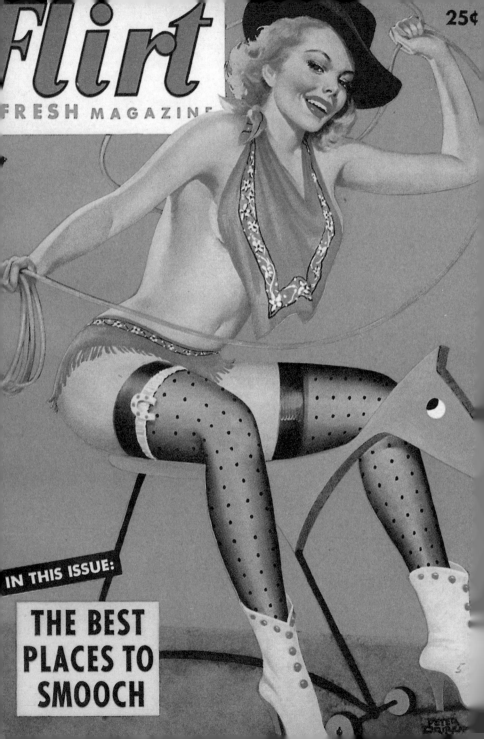

Flirt
FRESH MAGAZINE

25¢

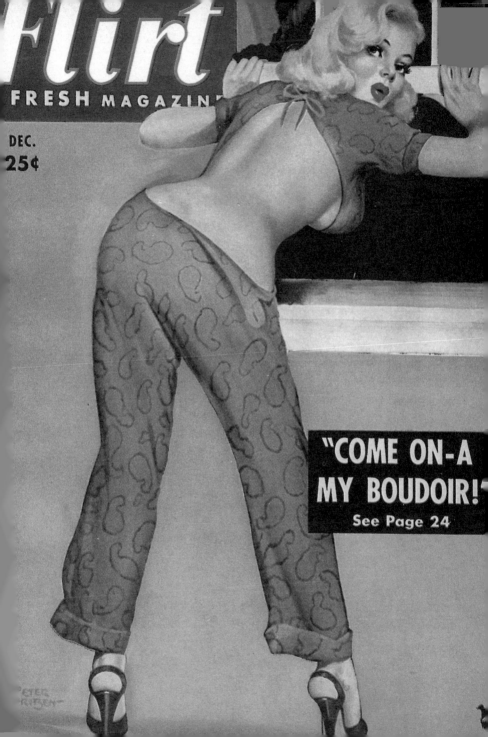

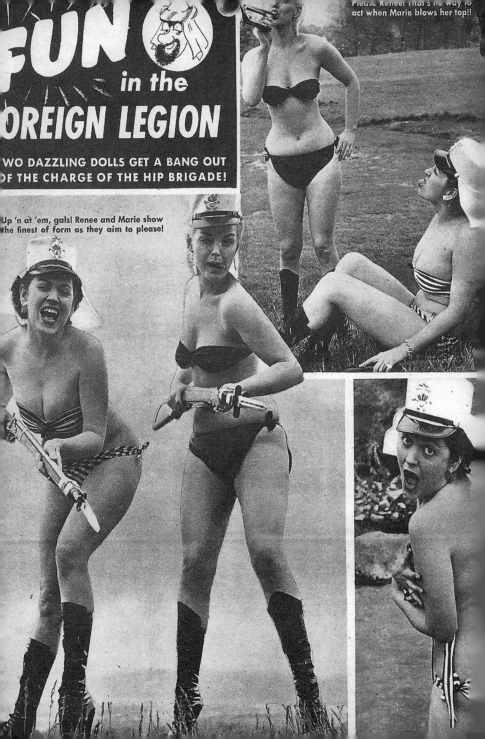

FUN in the FOREIGN LEGION

TWO DAZZLING DOLLS GET A BANG OUT OF THE CHARGE OF THE HIP BRIGADE!

Please Renee! That's no way to act when Marie blows her top!!

Up 'n at 'em, gals! Renee and Marie show the finest of form as they aim to please!

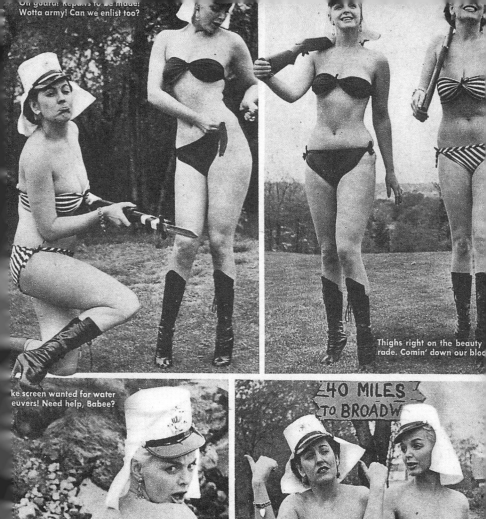

On guard! Repairs to be made!
Wotta army! Can we enlist too?

Thighs right on the beauty
rade. Comin' down our bloc

ke screen wanted for water
euvers! Need help, Babee?

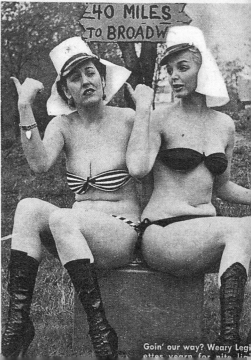

40 MILES TO BROADW

Goin' our way? Weary Legi
ettes yearn for nite li

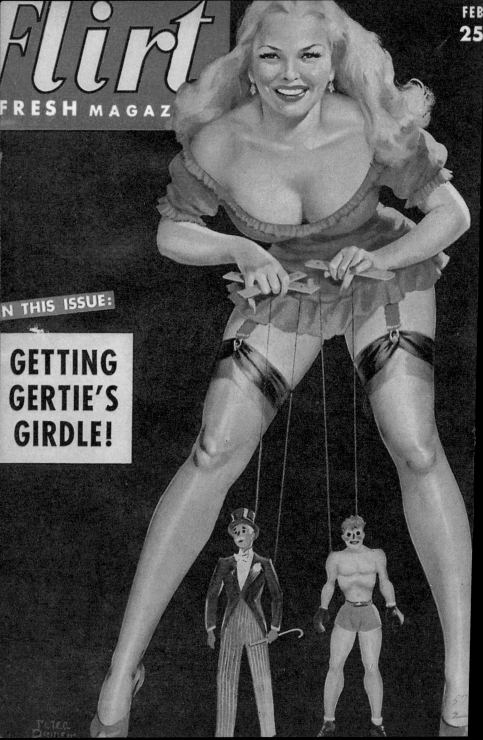

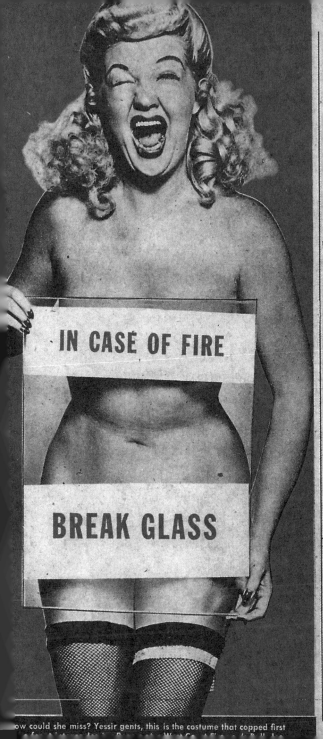

IN CASE OF FIRE

BREAK GLASS

ow could she miss? Yessir gents, this is the costume that copped first

flirt

FRESH MAGAZINE

APRI

25¢

IN THIS ISSUE:

DON'T MISS Page 24!

PETER DRIBEN

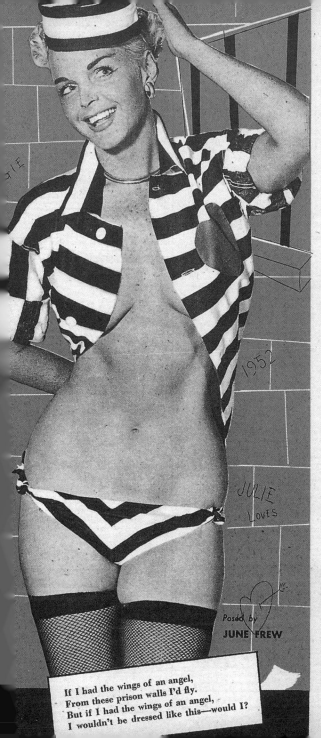

Posed by
JUNE FREW

If I had the wings of an angel,
From these prison walls I'd fly.
But if I had the wings of an angel,
I wouldn't be dressed like this—would I?

flirt

FRESH MAGAZINE

JUNE

25c

Cover Picked up flirt
from May 1948

steffa

VIES of
AUTIES

Flirt

FRESH MAGAZINE

GUST
5¢

Steffa

GH-HEEL
CUTIES

GAGS and
GAYETY

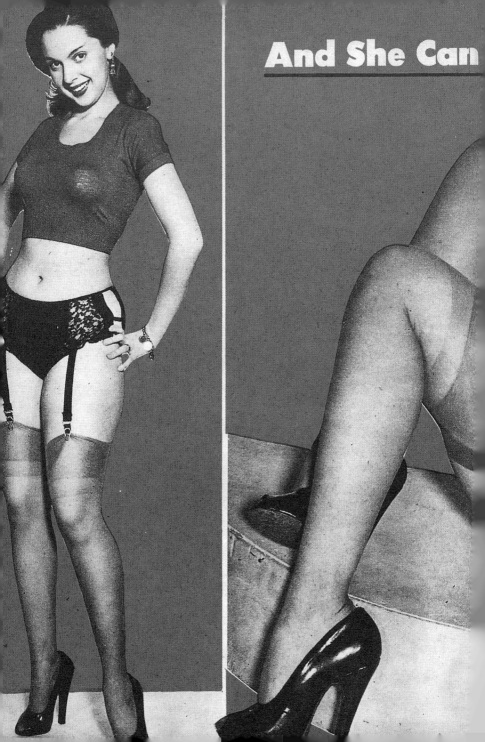

And She Can

Cook, Too!

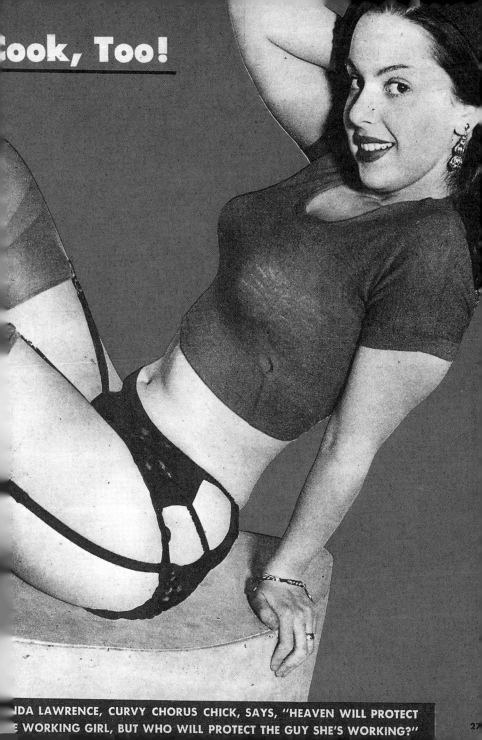

IDA LAWRENCE, CURVY CHORUS CHICK, SAYS, "HEAVEN WILL PROTECT
E WORKING GIRL, BUT WHO WILL PROTECT THE GUY SHE'S WORKING?"

27

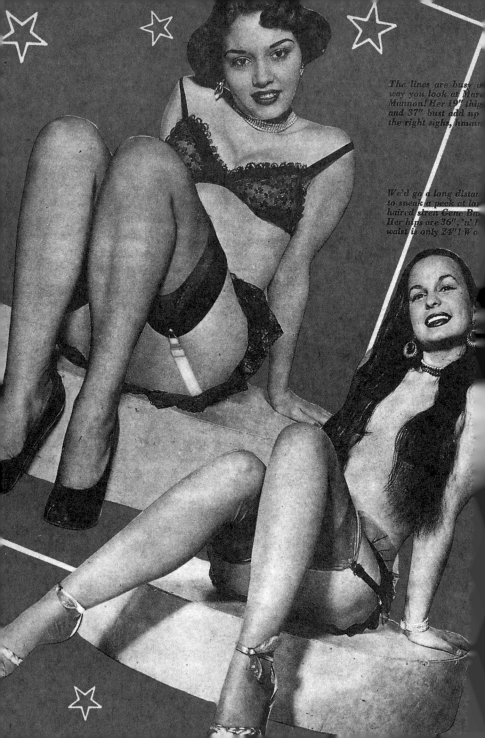

The lines are busy a
way you look at Mar
Mannon! Her 19" thig
and 37" bust add up
the right sighs, hmm

We'd go a long dista
to sneak a peek at lo
haired siren Gene Ba
Her hips are 36", 'n' I
waist is only 24"! W o

Flirt

FRESH MAGAZINE

CT.
5¢

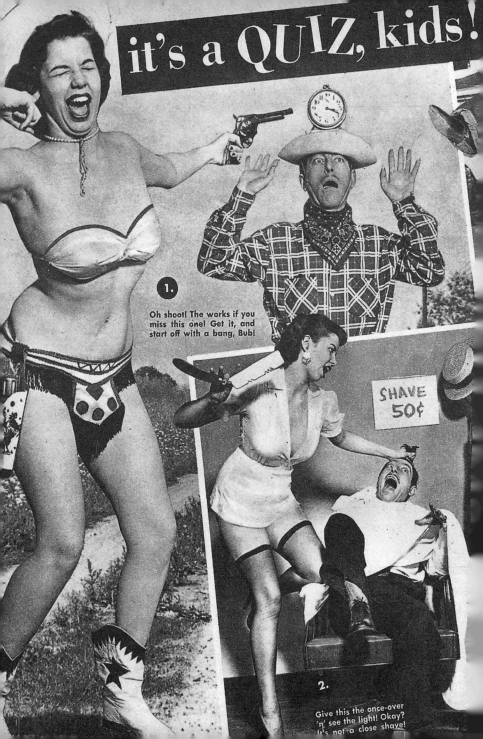

it's a QUIZ, kids!

1.
Oh shoot! The works if you miss this one! Get it, and start off with a bang, Bub!

SHAVE 50¢

2.
Give this the once-over 'n' see the light! Okay? It's not a close shave!

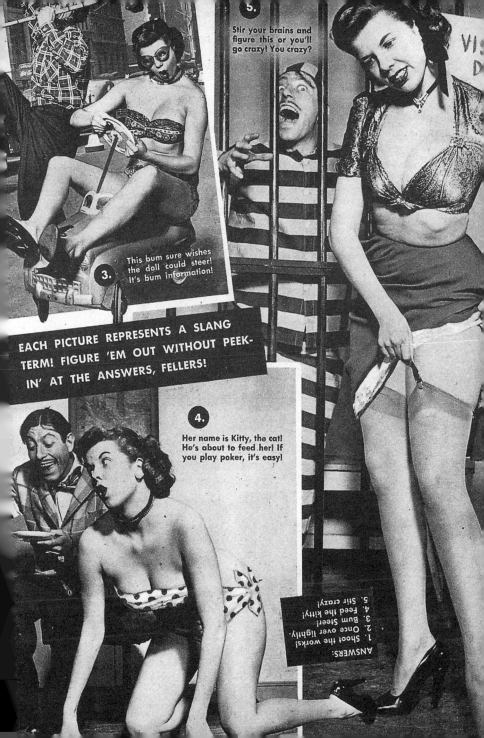

This bum sure wishes the doll could steer! It's bum information!

3.

5. Stir your brains and figure this or you'll go crazy! You crazy?

VIS
D

EACH PICTURE REPRESENTS A SLANG TERM! FIGURE 'EM OUT WITHOUT PEEK-IN' AT THE ANSWERS, FELLERS!

4.
Her name is Kitty, the cat! He's about to feed her! If you play poker, it's easy!

ANSWERS:
1. Shoot the works!
2. Once over lightly.
3. Bum Steer!
4. Feed the kitty!
5. Stir crazy!

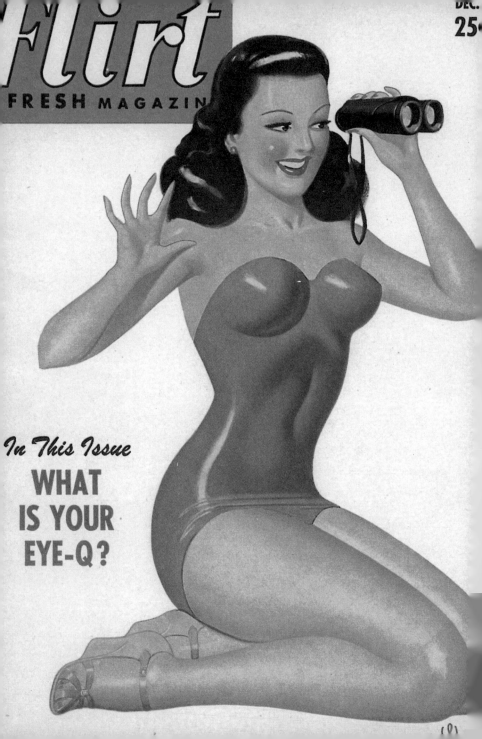

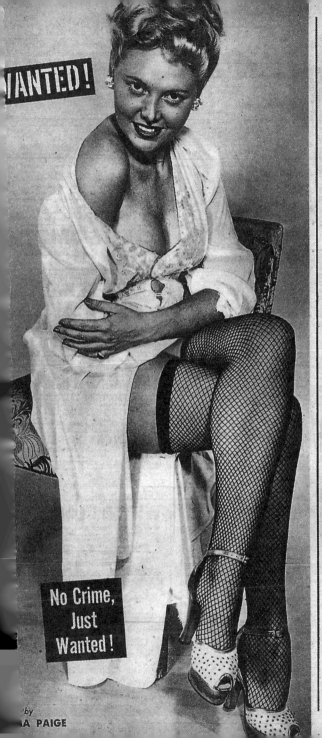

WANTED!

No Crime, Just Wanted!

by
A PAIGE

4

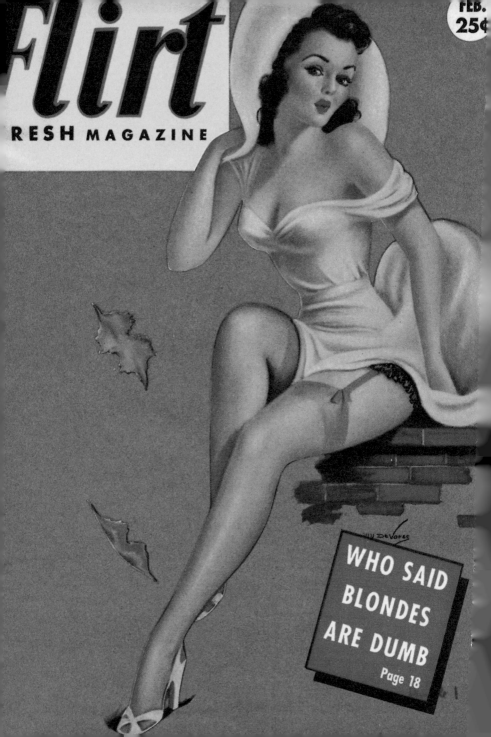

Admiring males pop their peepers as Bettie fights against the naughty wind!

OH!

Bettie Page starts out for a walk, and her skirt is caught in the breeze!

Life Is Like That!

A SKIRT TOSSED BY A NAUGHTY BREEZE ATTRACTS MORE EYES THAN A BIKINI!

GOSH!

Whatever will the poor girl do? Well, the audience ain't kicking!

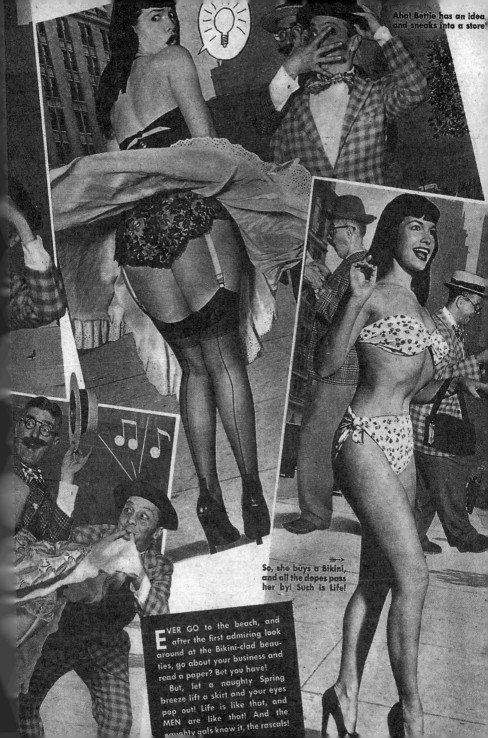

Aha! Bettie has an idea and sneaks into a store"

So, she buys a Bikini, and all the dopes pass her by! Such is Life!

EVER GO to the beach, and after the first admiring look around at the Bikini-clad beauties, go about your business and read a paper? Bet you have! But, let a naughty Spring breeze lift a skirt and your eyes pop out! Life is like that, and MEN are like that! And the naughty gals know it, the rascals!

Flirt

FRESH MAGAZINE

APR.
25¢

Bevies of
HIGH-HEEL
BEAUTIES

Billy DeVorss

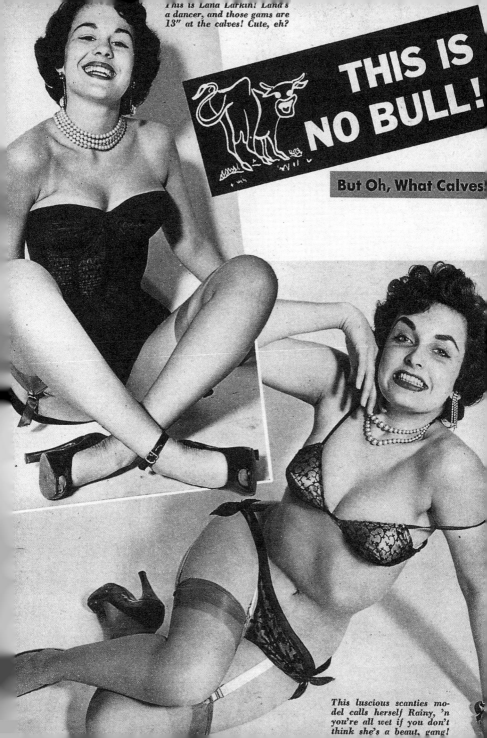

This is Lana Larkin! Lana's a dancer, and those gams are 13" at the calves! Cute, eh?

THIS IS NO BULL!

But Oh, What Calves!

This luscious scanties model calls herself Rainy, 'n you're all wet if you don't think she's a beaut, gang!

JUNE
25¢

Flirt

FRESH MAGAZINE

BEST BETS
OF THE
BROADWAY
PETS!

GHTING FEMMES of FRANCE!

PETER
DRIBEN

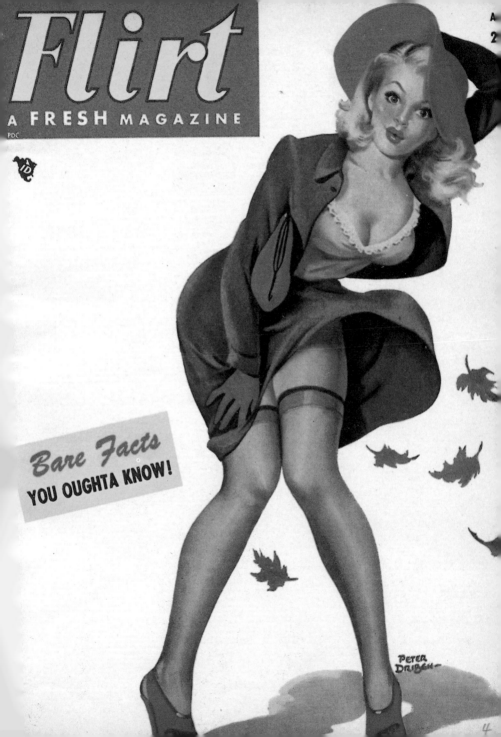

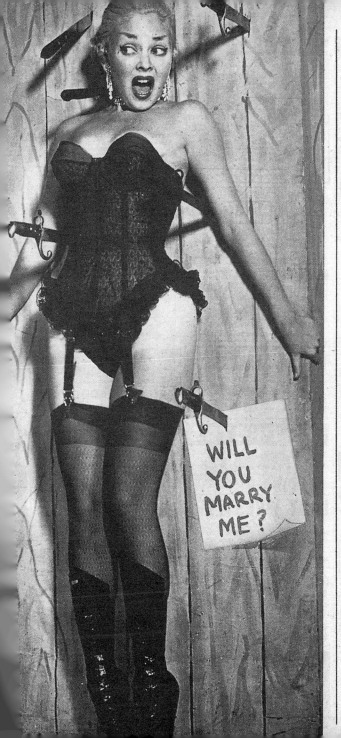

WILL YOU MARRY ME?

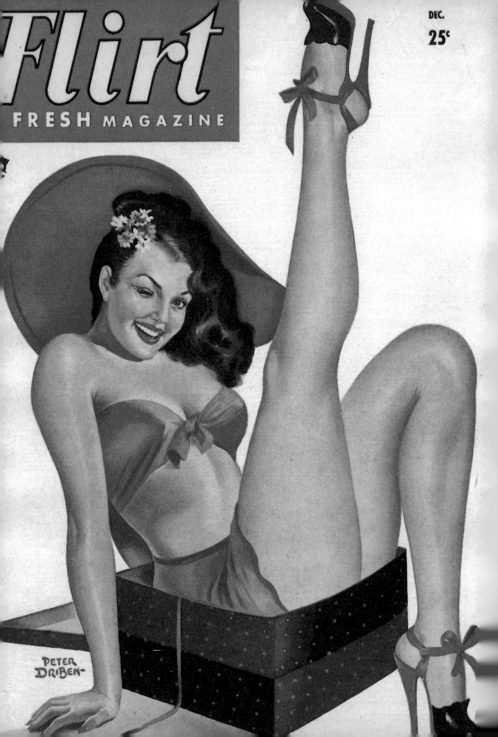

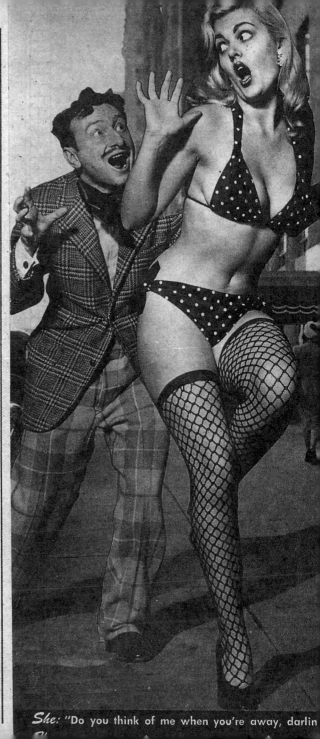

She: "Do you think of me when you're away, darlin

Meet Bettie Page, artist model! Is she Irish, or maybe French? Nope! She hails from Tennessee, suh! ⇛ →

This is Jane Russ. Her bust and hips measure a perfect 36". Where's she from? Jane's a Londoner.

6

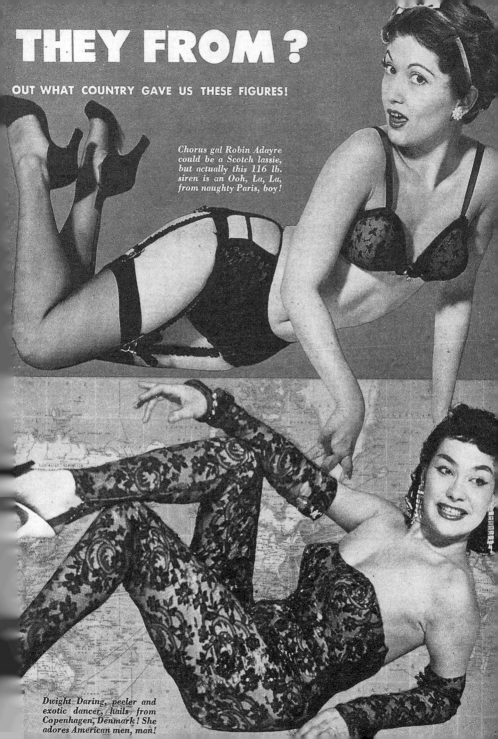

THEY FROM ?

OUT WHAT COUNTRY GAVE US THESE FIGURES!

Chorus gal Robin Adayre could be a Scotch lassie, but actually this 116 lb. siren is an Ooh, La, La, from naughty Paris, boy!

Dwight Daring, peeler and exotic dancer, hails from Copenhagen, Denmark! She adores American men, man!

FEB.

25¢

flirt

FRESH MAGAZINE

A Peek In A
PARIS BOUDOIR

 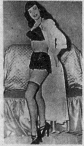 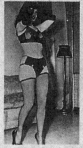 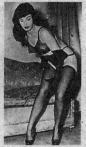 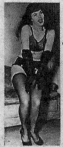

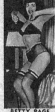

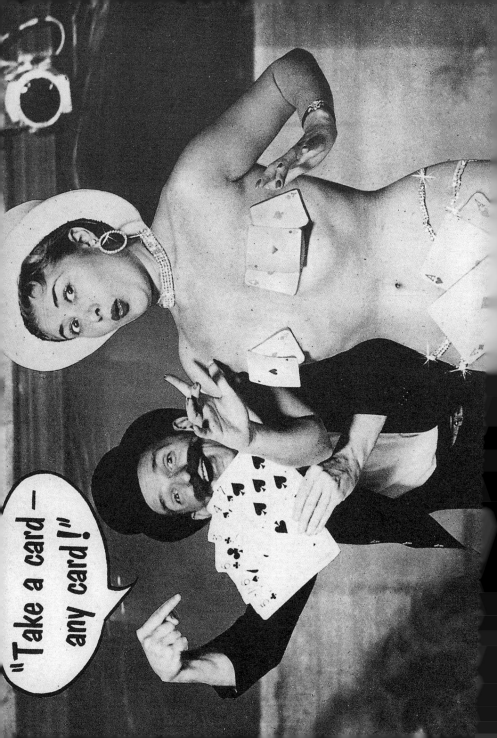

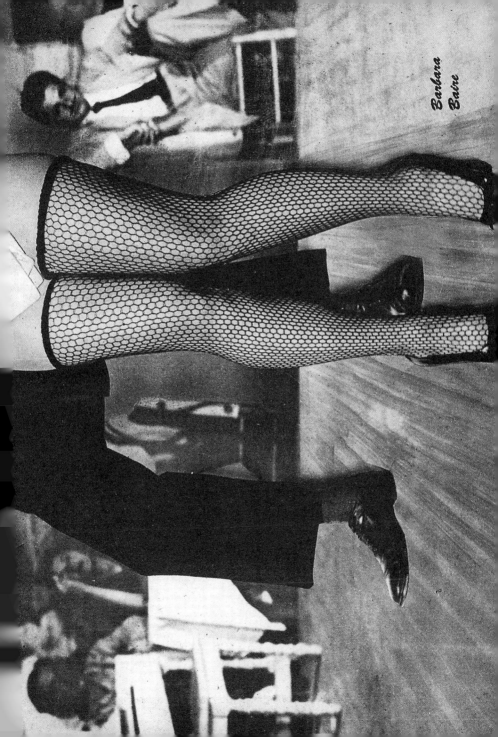

Barbara
Baire

Flirt

FRESH MAGAZINE

APR.
25¢

FIVE WAYS TO GET A DATE

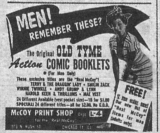

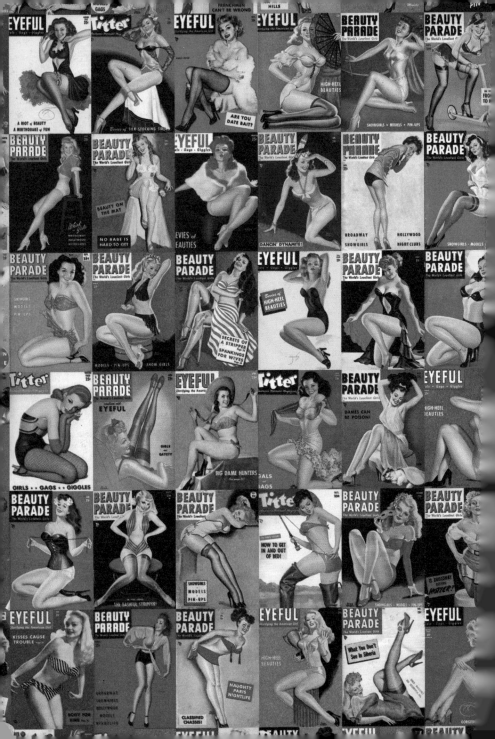